Chile

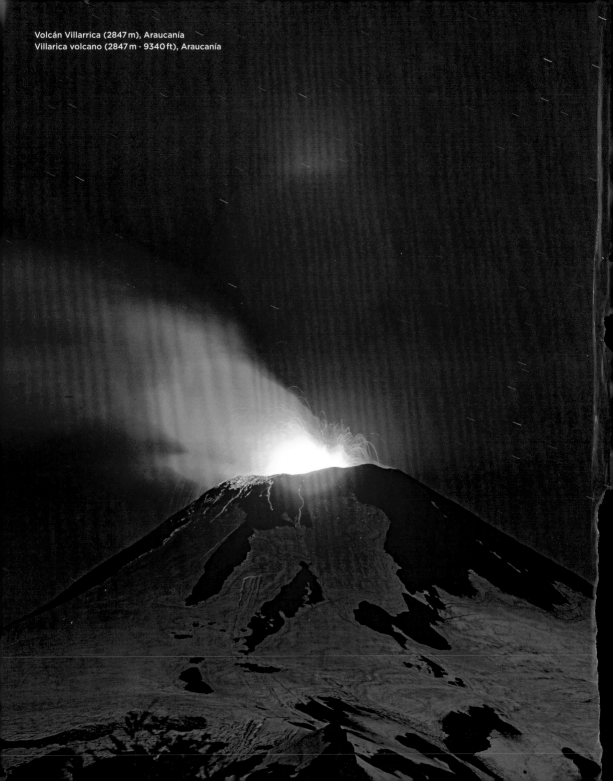

Volcán Villarrica (2847 m), Araucanía
Villarica volcano (2847 m · 9340 ft), Araucanía

Chile

Marion Trutter

ÉDITIONS
PLACE DES
VICTOIRES

KÖNEMANN

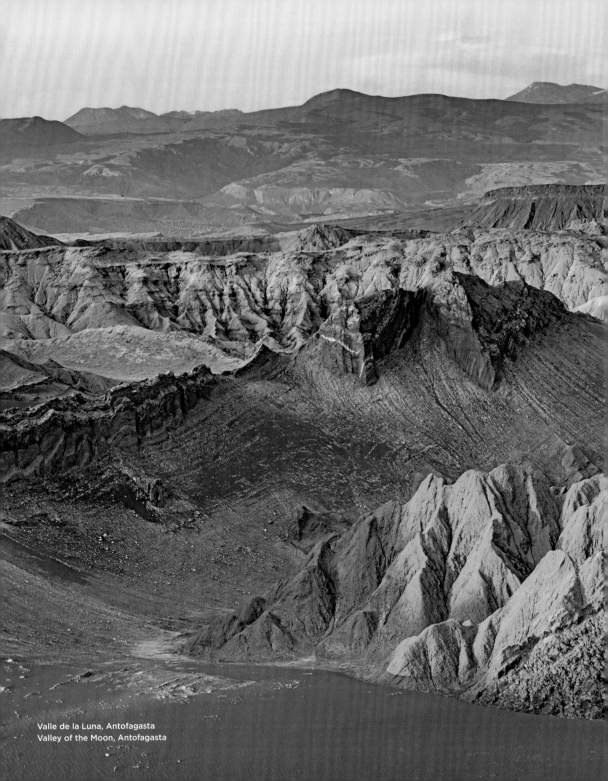

Valle de la Luna, Antofagasta
Valley of the Moon, Antofagasta

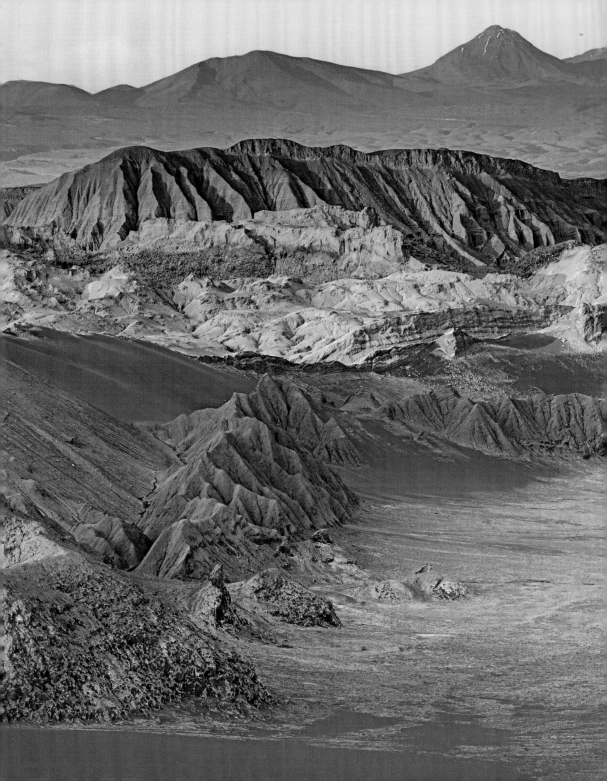

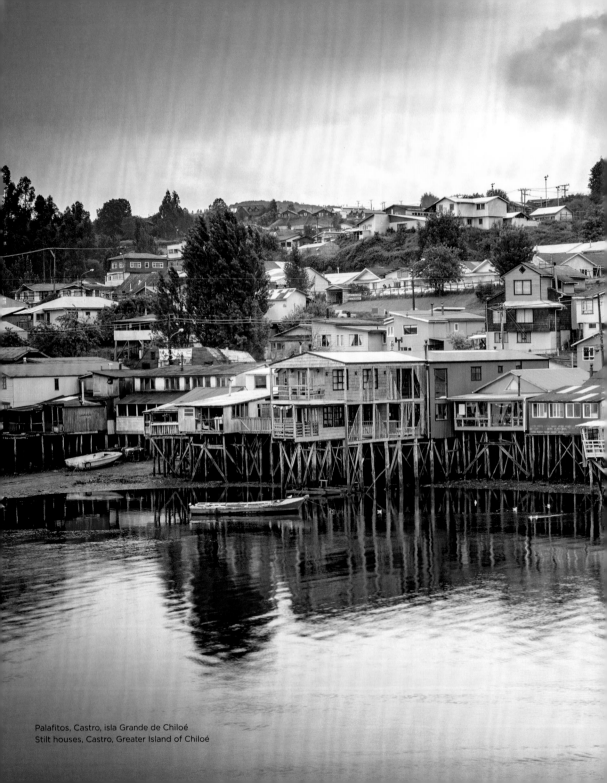

Palafitos, Castro, isla Grande de Chiloé
Stilt houses, Castro, Greater Island of Chiloé

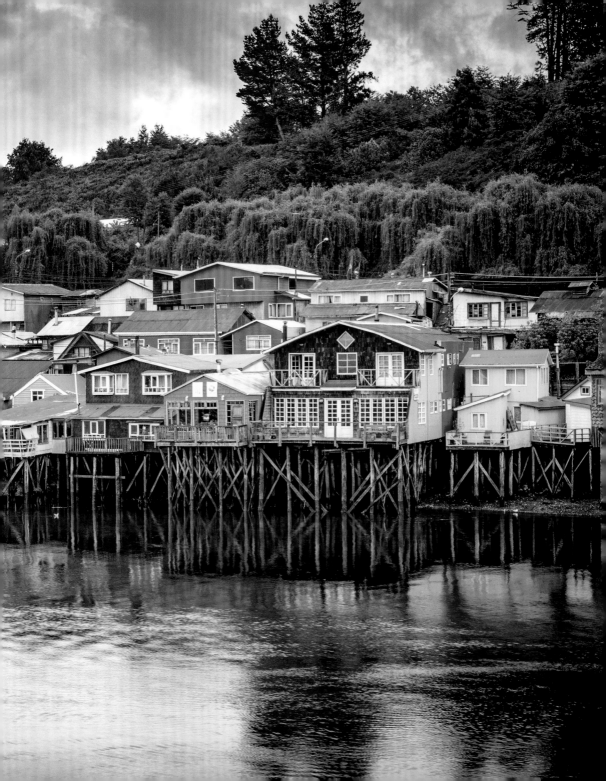

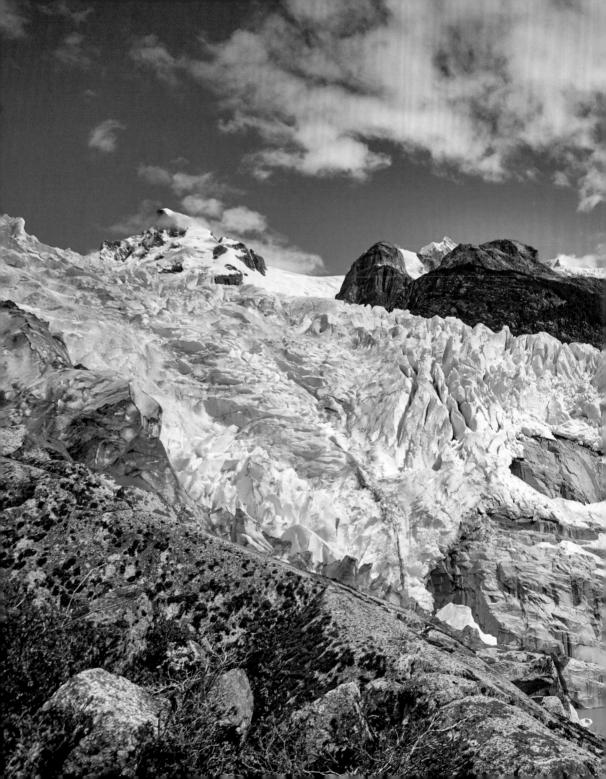

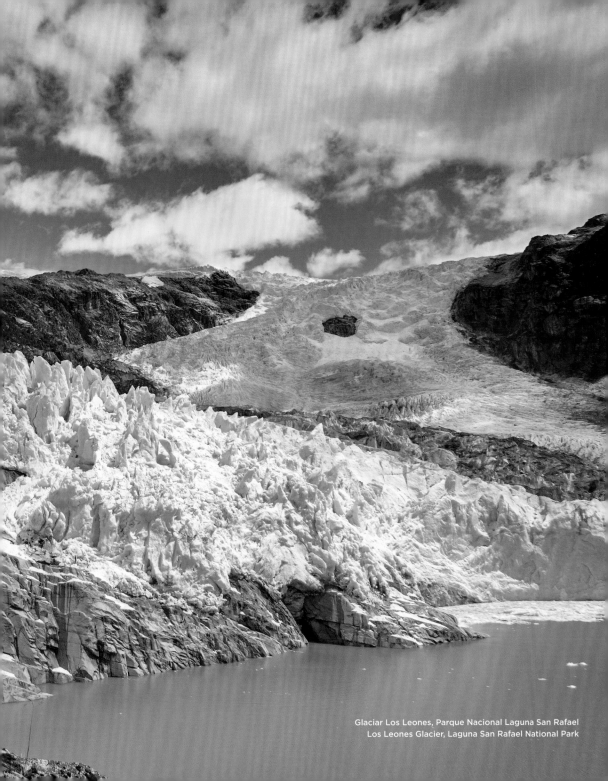

Glaciar Los Leones, Parque Nacional Laguna San Rafael
Los Leones Glacier, Laguna San Rafael National Park

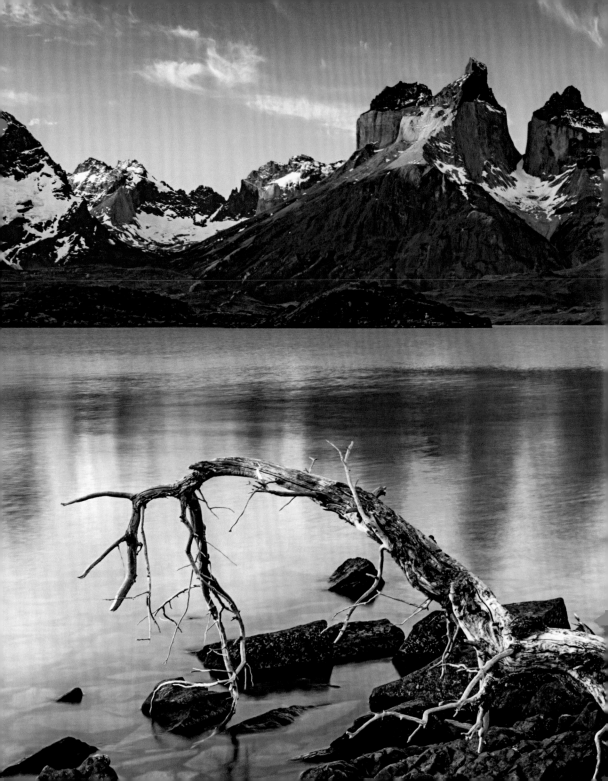

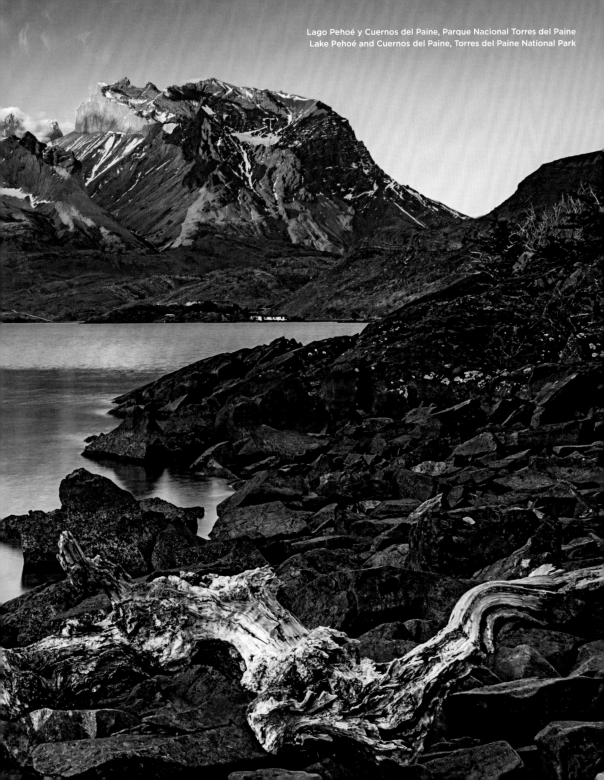

Lago Pehoé y Cuernos del Paine, Parque Nacional Torres del Paine
Lake Pehoé and Cuernos del Paine, Torres del Paine National Park

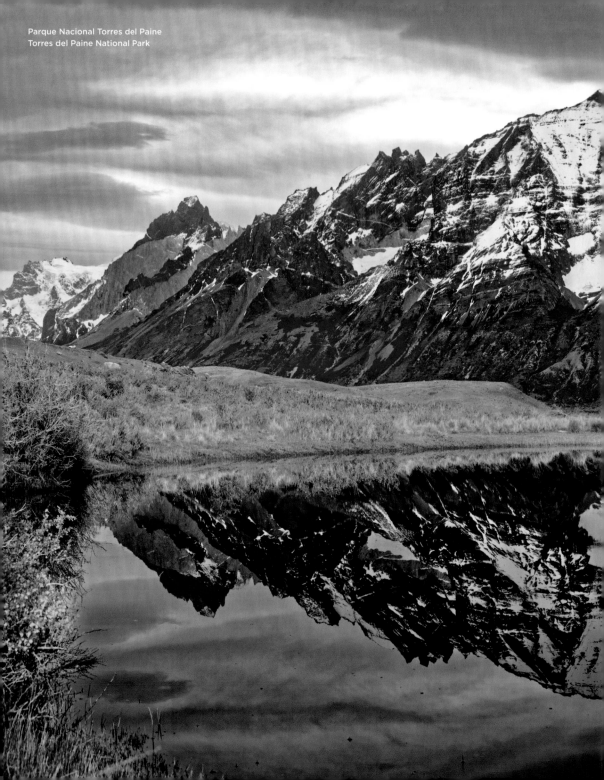

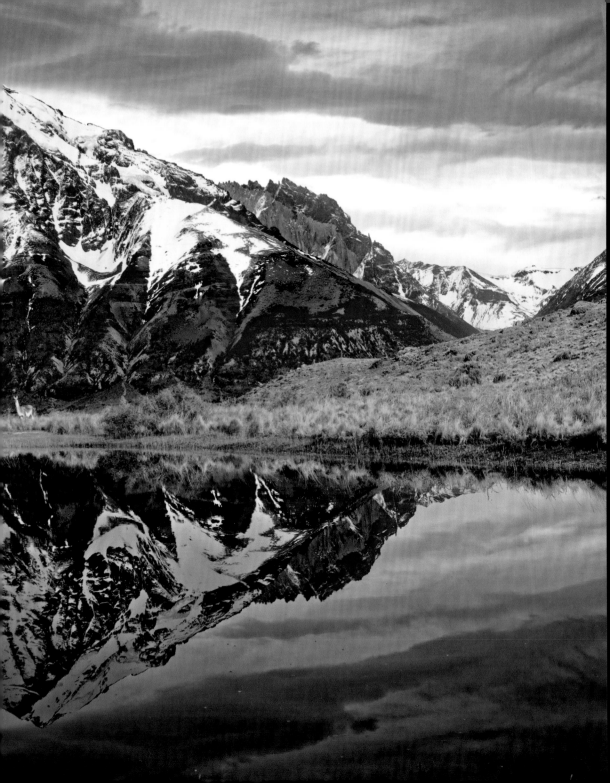

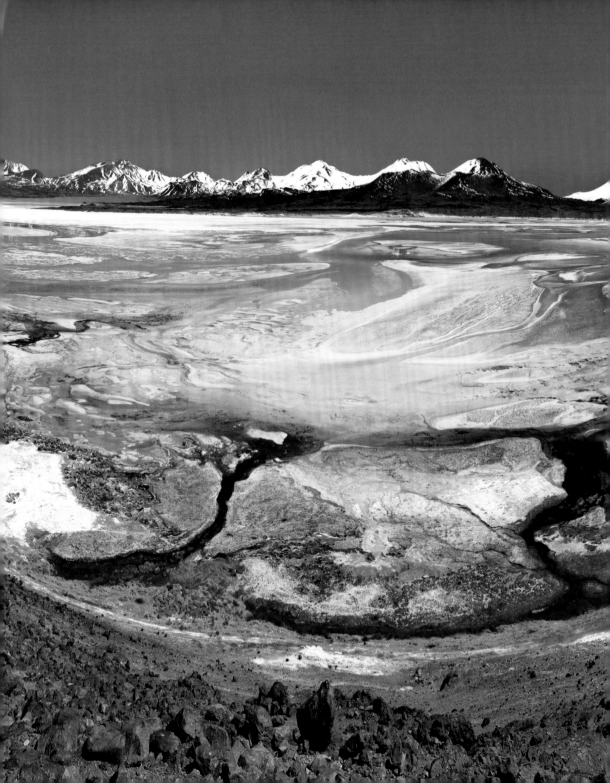

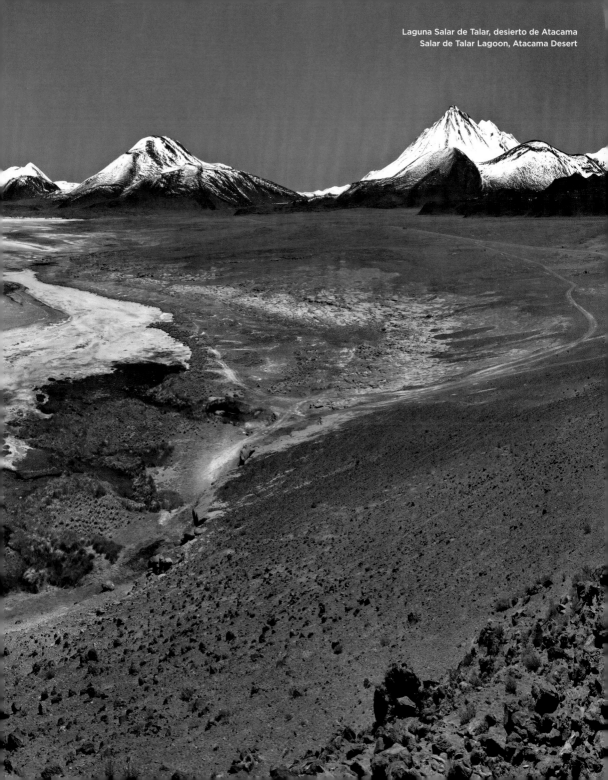

Laguna Salar de Talar, desierto de Atacama
Salar de Talar Lagoon, Atacama Desert

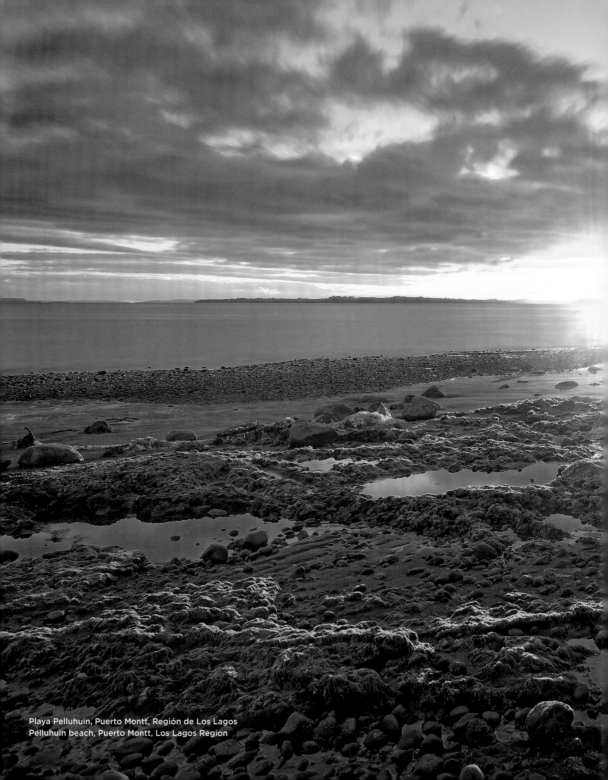

Playa Pelluhuin, Puerto Montt, Región de Los Lagos
Pelluhuin beach, Puerto Montt, Los Lagos Region

Laguna Miscanti, Región de Antofagasta
Miscanti Lagoon, Antofagasta Region

Índice · Contents · Sommaire · Inhalt · Indice · Inhoud

Chile

A long, narrow ribbon of land hugging the southern Pacific Coast of South America, with landscapes ranging from the world's driest desert in the north of the country to extensive woodlands dotted with lakes and down to the glaciers at the edge of the Antarctic. The longest country in the world (4329 km · 2690 mi) has more than 8000 km (4970 mi) of coastline. The country measures an average of 180 km (110 mi) across from the Pacific in the west to its borders with Bolivia and Argentina in the east, even as the altitudes rise from sea level to almost 7000 m (23,000 ft) with the summits of the Andes. The land is also home to more than 2000 volcanoes, including 500 or so that remain active.

The fact that Chile stretches across 39 degrees of latitude means that its borders contain the extremes of earth's ecosystems. The north features barren deserts with volcanoes and salt lakes. The center of the country is home to many lakes, forests, and sun-drenched valleys, as well as a rich flora and fauna. The south is a fascinating world of mountains, glaciers, islands, and fjords. The 755,776 km² (291,807 sq mi) is home to just 18 million people. The isolated position of Chile on the edge of the continent also means that about half of the country's five to six thousand plant species are unique to this beautiful land.

Chili

Sur la carte, le Chili prend la forme d'une bande étroite, le long de laquelle se succèdent, du nord au sud, divers paysages. Le désert le plus aride du monde, fait place à une vaste zone de forêts et de lacs qui s'étire jusqu'aux glaciers limitrophes du cercle Antarctique. Étendu sur 4329 km, ce pays, le plus long de la planète, possède plus de 8000 km de côtes. Sa largeur moyenne se limite à 180 km entre le Pacifique à l'ouest et ses frontières avec la Bolivie et l'Argentine à l'est. Pourtant, sur ces courtes distances, l'altitude peut passer du niveau de la mer à pratiquement 7000 m au sommet des Andes. Le pays compte au total plus de 2000 volcans, dont 500 sont considérés comme actifs par les géologues.

S'étendant, du nord au sud, sur 39 degrés de latitude, le Chili offre des paysages très variés. Le Nord se caractérise par des déserts très arides, des volcans et des lacs salés. Au centre se répartissent lacs, forêts et vallées ensoleillées qui abritent une faune et une flore très riches. Le Sud, enfin, présente un paysage fascinant de montagnes, glaciers, îles et fjords. Le pays compte une superficie totale de 755 776 km², pour une population atteignant seulement 18 millions d'individus. Conséquence de sa situation isolée, environ la moitié des 5000 à 6000 espèces de plantes du Chili sont réellement endémiques.

Chile

Auf der Landkarte ein langes, schmales Band, das von der trockensten Wüste der Welt im Norden über ausgedehnte Wald- und Seenlandschaften bis zu den Gletschern am Rand der Antarktis reicht. Das mit 4329 km längste Land der Erde verfügt über mehr als 8000 km Küstenlinie. Nur durchschnittlich 180 km sind es vom Pazifik im Westen bis zur Grenze mit Bolivien und Argentinien im Osten – und auf dieser kurzen Strecke steigt das Land vom Meeresspiegel an bis zu den Gipfeln der Anden mit fast 7000 m. Im ganzen Land ragen mehr als 2000 Vulkane in den Himmel, von denen 500 als geologisch aktiv gelten.

Durch seine Nord-Süd-Ausdehnung über 39 Breitengrade zeigt sich Chile landschaftlich extrem vielfältig: karge Wüstenlandschaften mit Vulkanen und Salzseen im Norden. Seen, Wälder, sonnendurchflutete Täler sowie eine reiche Flora und Fauna in der Mitte des Landes. Und eine faszinierende Welt aus Bergen, Gletschern, Inseln und Fjorden im Süden. Auf 755 776 km² leben nur rund 18 Millionen Menschen. Dafür hat die abgeschottete Lage Chiles dazu geführt, dass von den 5000 bis 6000 Pflanzenarten des Landes etwa die Hälfte wirklich nur in Chile vorkommen.

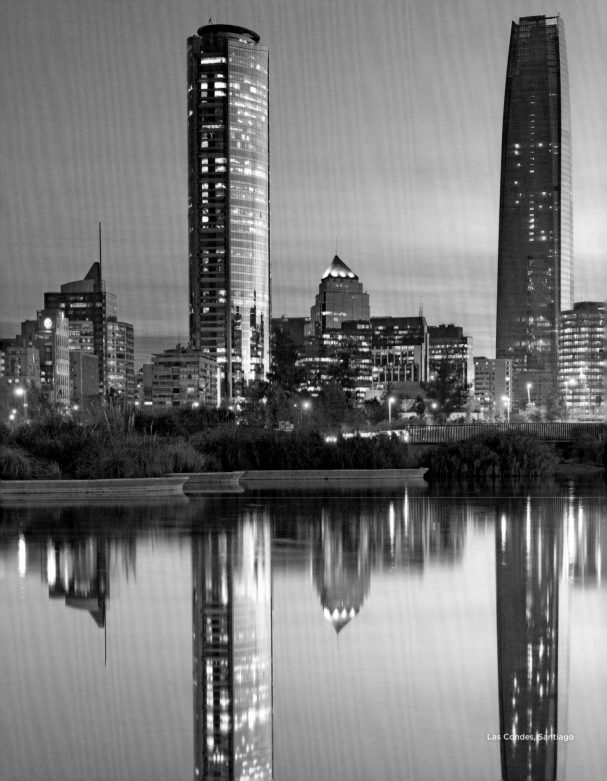

Las Condes, Santiago

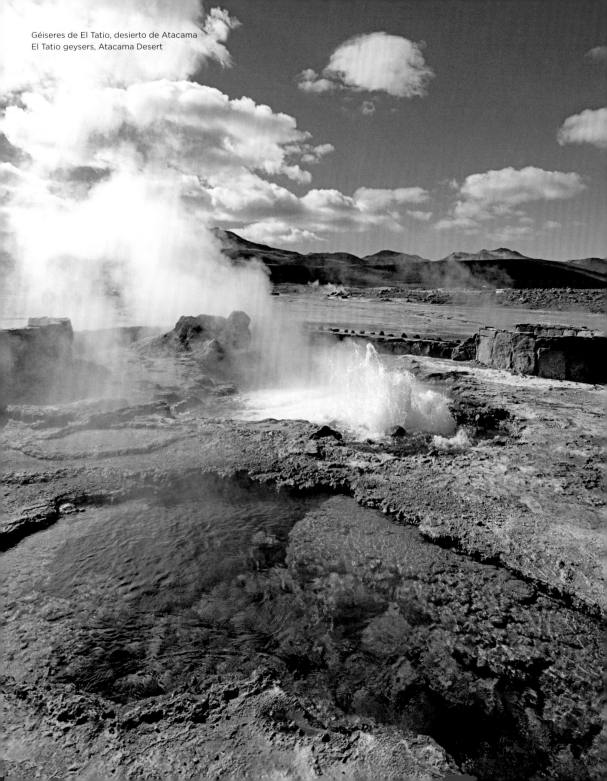

Géiseres de El Tatio, desierto de Atacama
El Tatio geysers, Atacama Desert

Chile

En el mapa, una banda estrecha y larga se extiende desde el desierto más seco del mundo en el norte hasta los grandes bosques y lagos de los glaciares en el borde de la Antártica. Con 4329 km, es el país más largo del mundo y cuenta con algo más de 8000 km de costa. Hay una distancia media de 180 km desde el Océano Pacífico en el oeste hasta la frontera con Bolivia y Argentina, al este – y en este corto tramo, la tierra se eleva desde el nivel del mar hasta las cumbres de los Andes, con casi 7000 m. En todo el país, más de 2000 volcanes se elevan hacia el cielo, de los cuales 500 están geológicamente activos.

Con su extensión norte-sur de unos 39 grados de latitud, Chile muestra unos paisajes extremadamente diversos: los paisajes del desierto árido con volcanes y salares en el norte. Lagos, bosques, valles soleados y una rica flora y fauna en el centro del país. Y un fascinante mundo de montañas, glaciares, islas y fiordos en el sur. En 755 776 km², viven sólo cerca de 18 millones de personas. Debido a esta condición compartimentada de Chile, de las 5000 a 6000 especies de plantas del país, aproximadamente la mitad de ellas son endémicas de Chile.

Cile

Sulla carta geografica è una striscia lunga e stretta, che passa dal deserto più secco del mondo a nord ad estesi paesaggi boscosi e lacustri fino ai ghiacciai al margine dell'Antartico. La nazione più lunga del pianeta, con i suoi 4329 km, dispone di più di 8000 km di linea costiera. Dal Pacifico nell'ovest fino al confine con la Bolivia e l'Argentina ad est vi sono in media solo 180 chilometri, e su questo breve tratto il paese si innalza dallo specchio del mare fino alle cime delle Ande con quasi 7000 m. In tutto il paese svettano verso il cielo più di 2000 vulcani, dei quali 500 sono considerati geologicamente attivi.

Grazie alla sua estensione da nord verso sud per 39 gradi di latitudine, il Cile vanta paesaggi estremamente vari: deserti aridi con vulcani e laghi salati nel nord. Laghi, boschi, valli soleggiate e una ricca flora e fauna nel centro del paese, e un affascinante mondo di montagne, ghiacciai, isole e fiordi a sud. Su 755 776 km² vivono soltanto circa 18 milioni di persone. A causa della sua posizione isolata, in Cile vi sono tra le 5000 e 6000 specie di piante, ma soltanto circa la metà può veramente sopravvivere.

Chili

Op de kaart ziet Chili eruit als een langgerekte strook land, die zich van de droogste woestijn op aarde in het noorden, via bos- en merenlandschappen in het centrum tot aan de gletsjers in het zuiden, aan de rand van Antarctica, uitstrekt. Met 4329 km is dit het langste land ter wereld, met meer dan 8000 km aan kustlijn. Vanaf de Stille Oceaan in het westen tot de grens met Bolivia en Argentinië in het oosten is Chili gemiddeld slechts 180 km breed – en binnen die korte afstand stijgt het land van zeeniveau tot aan de bijna 7000 m hoge bergtoppen van de Andes. In het hele land verrijzen ruim 2000 vulkanen, waarvan er 500 geologisch actief zijn.

Door zijn unieke noord-zuidligging over 39 breedtegraden kent Chili een enorme diversiteit aan landschappen: kale woestijnen met vulkanen en zoutmeren in het noorden; meren, wouden en zonovergoten dalen en een rijke flora en fauna in het midden van het land; en een fascinerende wereld van bergen, gletsjers, eilanden en fjorden in het zuiden. Op 755 776 km² wonen slechts achttien miljoen mensen. De afgeschermde ligging van Chili heeft ertoe geleid dat van de vijf- tot zesduizend plantensoorten in Chili ongeveer de helft uitsluitend in dit land groeien.

Arica y Parinacota

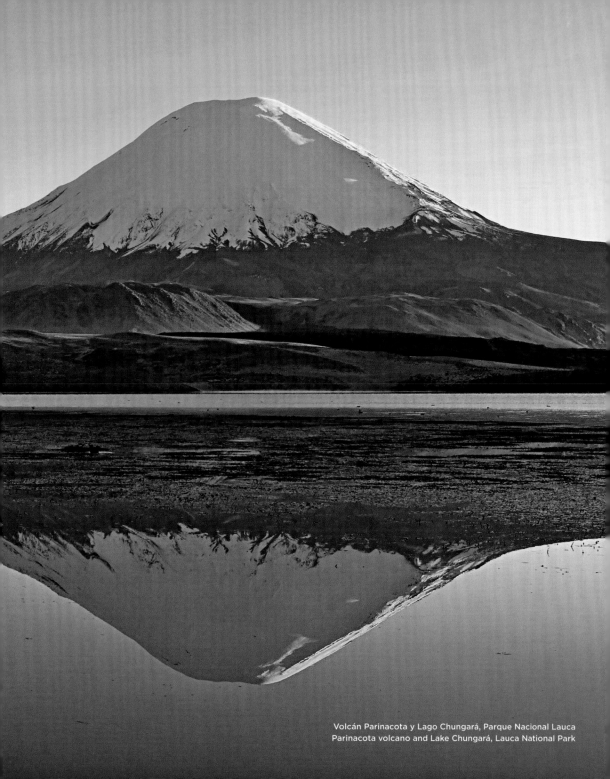

Volcán Parinacota y Lago Chungará, Parque Nacional Lauca
Parinacota volcano and Lake Chungará, Lauca National Park

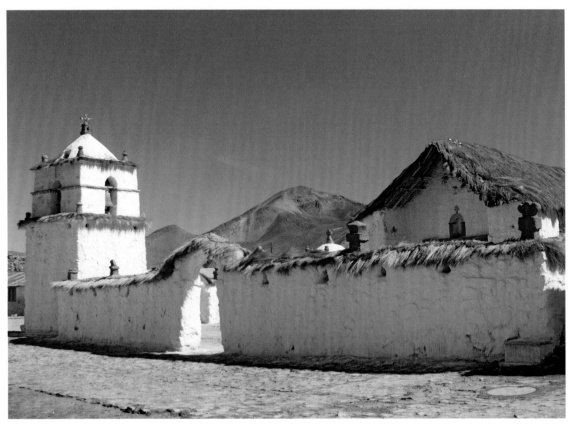

Iglesia en el pueblo de Parinacota, Parque Nacional Lauca
Church in Parinacota village, Lauca National Park

Arica and Parinacota Region

Dry, but with a beauty all its own: the northernmost region borders on Peru and Bolivia and is home to the barren Atacama desert, interrupted only by salt lakes and imposing volcanoes, all watched over by Parinacota, Pomerape, and Guallatiri, which rise more than 6000m (19,700 ft) into the almost perpetually cloudless skies.

Région d'Arica et Parinacota

Sous le charme du désert : la région la plus septentrionale du Chili, à la frontière du Pérou et de la Bolivie, offre une beauté très spécifique. L'étendue aride du désert d'Atacama n'est interrompue que par des lacs salés et d'imposants volcans. Les trois plus hauts, Parinacota, Pomerape et Guallatiri, s'élèvent à plus de 6000 m dans un ciel presque toujours pur.

Arica und Parinacota

Trockener Charme: Die nördlichste Region Chiles an der Grenze zu Peru und Bolivien besticht durch eine ganz eigene Schönheit. Die karge Weite der Atacama-Wüste wird nur unterbrochen durch Salzseen und imposante Vulkane – alles überragend Parinacota, Pomerape und Guallatiri, die bis über 6000 m in einen fast immer wolkenlosen Himmel ragen.

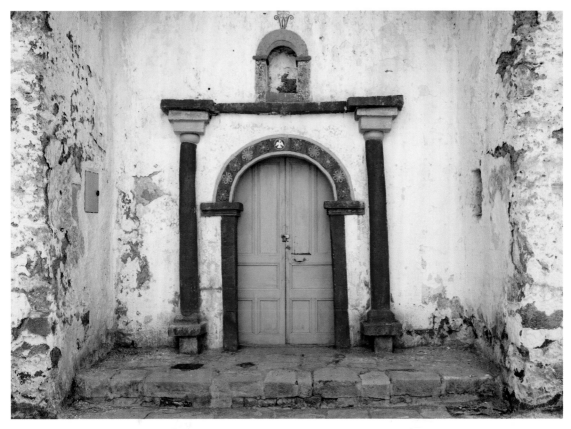

Iglesia en el pueblo de Parinacota, Parque Nacional Lauca
Church in Parinacota village, Lauca National Park

Arica y Parinacota

Encanto seco: La región más septentrional de Chile en la frontera con Perú y Bolivia ofrece una belleza única. La árida extensión del desierto de Atacama sólo es interrumpida por salinas e imponentes volcanes – excepcionales son los de Parinacota, Pomerape y Guallatiri que se proyectan en un cielo casi siempre sin nubes a más de 6000 m.

Arica e Parinacota

Il fascino del deserto: la regione più settentrionale del Cile, al confine con Perù e Bolivia affascina grazie alla sua particolare bellezza. La brulla vastità del deserto di Atacama è interrotta solo da laghi salati e imponenti vulcani, tra cui Parinacota, Pomerape e Guallatiri, che si innalzano in un cielo quasi sempre senza nuvole fino ad un'altezza di 6000 m.

Arica en Parinacota

Droge charme: de meest noordelijke regio van Chili, aan de grens met Peru en Bolivia, betovert door een eigen pracht. De kale wereld van de Atacamawoestijn wordt slechts onderbroken door zoutmeren en imposante vulkanen – verrijzend boven dat alles de Parinacota, de Pomerape en de Guallatiri, die met ruim 6000 m hoogte afsteken tegen de bijna altijd wolkeloze lucht.

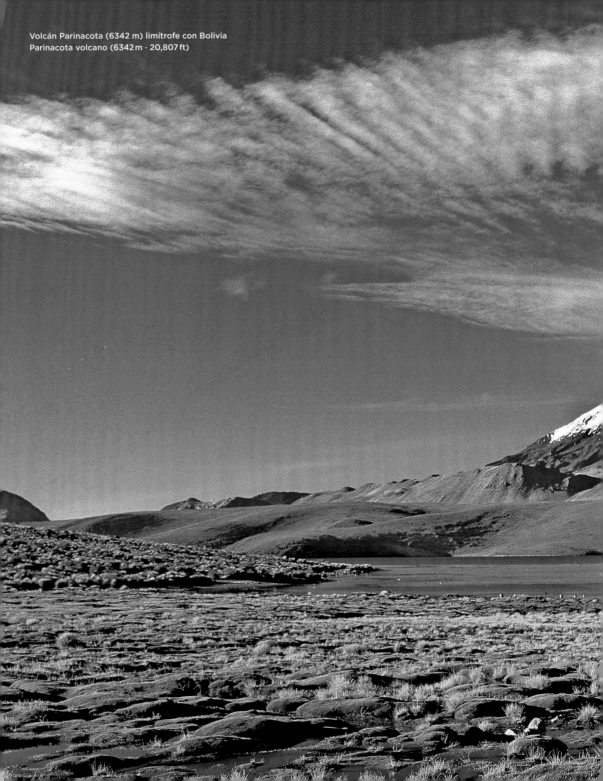

Volcán Parinacota (6342 m) limítrofe con Bolivia
Parinacota volcano (6342 m · 20,807 ft)

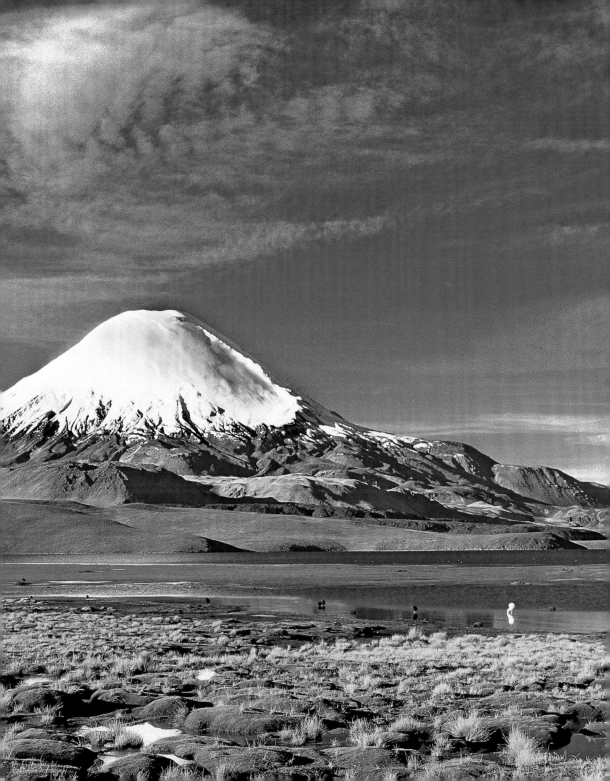

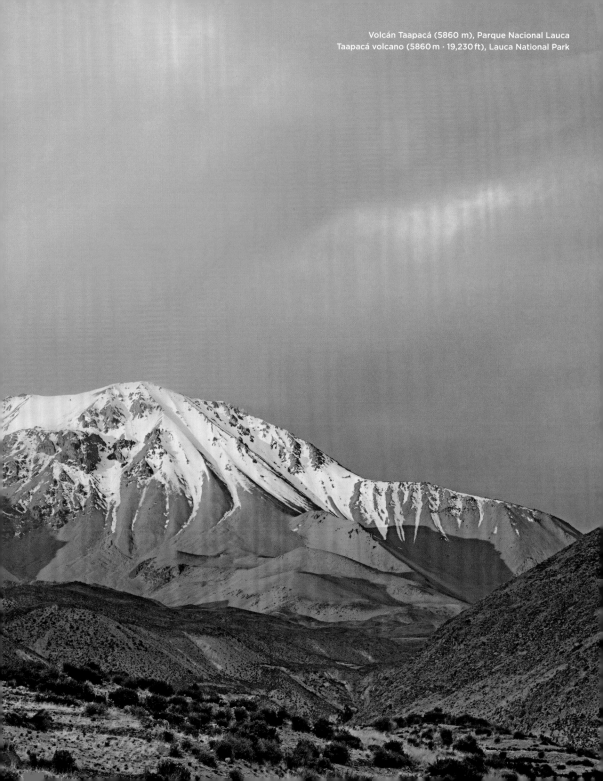

Volcán Taapacá (5860 m), Parque Nacional Lauca
Taapacá volcano (5860 m · 19,230 ft), Lauca National Park

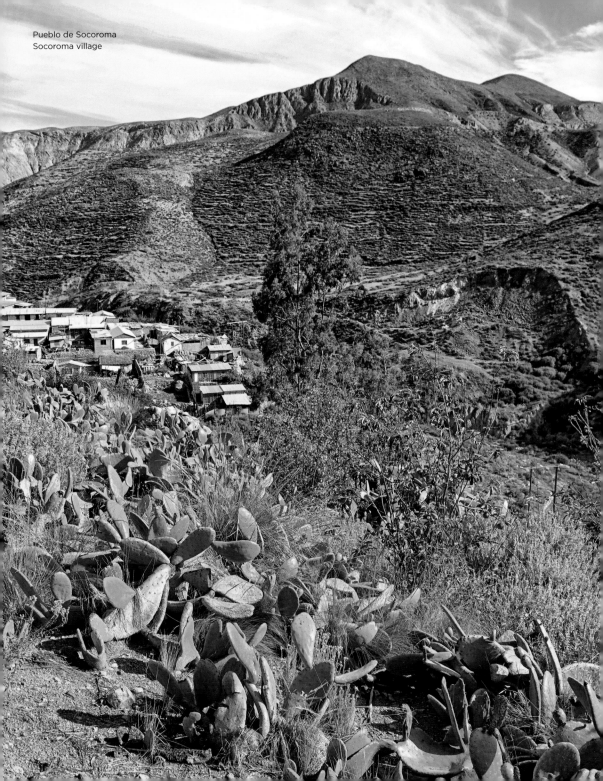
Pueblo de Socoroma
Socoroma village

Parque Nacional Lauca
Lauca National Park

Lauca National Park
Lauca National Park is located over 4000 m (13,000 ft) above sea level. In the middle of the impressive landscape, the paved Ruta 11 highway takes you past Lago Chungará, one of the highest lakes of the world.

Parc national Lauca
Le parc national Lauca est situé à une altitude de plus de 4000 m. Traversant de magnifiques paysages, la route 11 – asphaltée – mène à l'un des lacs les plus hauts du monde, le lac Chungara.

Lauca-Nationalpark
Auf einer Höhe von über 4000 m liegt der Lauca-Nationalpark. Mitten durch die beeindruckende Landschaft führt die asphaltierte Ruta 11 vorbei an einem der höchstgelegenen Seen der Welt, dem Lago Chungará.

Parque Nacional Lauca
El Parque Nacional Lauca se encuentra a una altitud de más de 4000 m. En medio del impresionante paisaje discurre la asfaltada Ruta 11 por uno de los lagos más altos del mundo, el Lago Chungará.

Parco nazionale Lauca
Il parco nazionale Lauca si trova a un'altitudine di oltre 4000 metri. La strada asfaltata Ruta CH-11, attraversando un paesaggio molto suggestivo, porta direttamente al Lago Chungará, uno dei laghi situati più in alto del mondo.

Nationale Park Lauca
Op een hoogte van ruim 4000 m ligt het Nationale Park Lauca. De geasfalteerde Ruta 11 loopt dwars door het indrukwekkende landschap, langs een van de hoogst gelegen meren op aarde, het Lago Chungará.

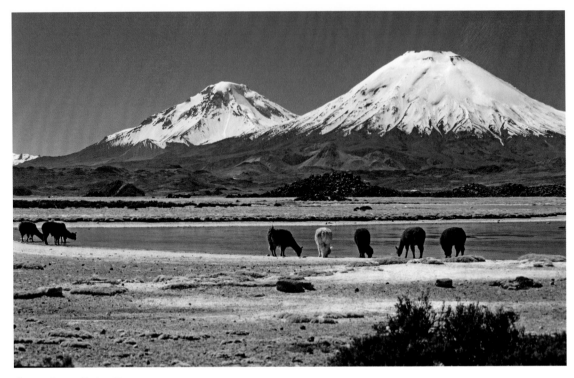

Alpacas, Parque Nacional Lauca
Alpacas, Lauca National Park

Vicuñas

Externally, vicuñas and guanacos differ mainly in terms of their size. The smaller and slimmer vicuñas also have a much finer coat. Their light brown wool is considered to be the finest in the world. After the vicuñas were nearly exterminated in the wild in the 1960s due to hunting for their fur, they are now only shaved and shorn every two years, with each animal only producing 150 g (5 oz) of wool each time. Clothes made from this luxurious wool are particularly soft and warm, but they also have their price.

Vigognes

Les vigognes et les guanacos se distinguent essentiellement par leur taille. Les vigognes, plus petites et plus minces, ont aussi une fourrure beaucoup plus fine. Leur laine marron clair est considérée comme la plus belle au monde. Après que les vigognes vivant en liberté ont frôlé l'extinction dans les années 1960 – en raison de la valeur marchande de leur fourrure –, à présent, elles ne sont rassemblées et tondues que tous les deux ans. Chaque animal ne donne que 150 g de laine par tonte. Les vêtements fabriqués avec ce fil de luxe sont particulièrement doux et chauds – mais leur prix est évidemment élevé.

Vikunjas

Vikunjas und Guanakos unterscheiden sich äußerlich vor allem durch ihre Größe. Die kleineren und schlankeren Vikunjas haben außerdem ein wesentlich feineres Fell. Ihre hellbraune Wolle gilt als die edelste der Welt. Nachdem die in freier Wildbahn lebenden Vikunjas in den 1960er-Jahren wegen ihres geldbringenden Fells fast ausgerottet waren, werden sie heute nur alle zwei Jahre zusammengetrieben und geschoren. Dabei kommen pro Tier gerade mal 150 g Wolle zusammen. Kleidungsstücke aus dem luxuriösen Garn sind besonders weich und wärmend – haben allerdings auch ihren Preis.

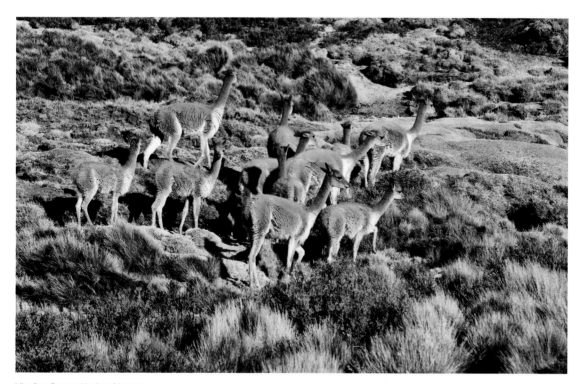

Vicuñas, Parque Nacional Lauca
Vicuñas, Lauca National Park

Vicuñas

Las vicuñas y los guanacos se diferencian externamente principalmente debido a su tamaño. Las vicuñas son más pequeñas y delgadas y también tienen la capa de pelo mucho más fina. Su lana marrón clara es considerada como la más noble del mundo. Después de que las vicuñas que vivían en la naturaleza casi fueran exterminadas en los años 1960 debido a su pelaje, ahora sólo se esquilan cada dos años. En este caso, sólo se emplean 150 g de lana de cada animal. Las lujosas prendas de hilo son particularmente suaves y cálidas, pero también caras.

Vigogna

Per l'aspetto, le vigogna e i guanaco si differenziano soprattutto per le dimensioni. Le vigogna, più piccole e slanciate, hanno inoltre un pelo molto più sottile. La lana color marrone chiaro è tra le più pregiate del mondo. Dopo che negli anni 1960 molte vigogna furono quasi sterminate nel loro habitat naturale per la lana preziosa, oggi vengono tosate soltanto una volta ogni due anni. Da ogni animale si ricavano circa 150 g di lana. I capi di abbigliamento in questo tessuto lussuoso sono particolarmente caldi e morbidi – e naturalmente molto costosi.

Vicuña's

Uiterlijk verschillen vicuña's en guanaco's vooral door hun grootte van elkaar. De kleinere en rankere vicuña's hebben bovendien een veel zachtere vacht. Hun lichtbruine wol wordt beschouwd als het fijnste ter wereld. Nadat de in het wild levende vicuña's in de jaren zestig van de vorige eeuw vanwege hun kostbare vacht bijna waren uitgeroeid, worden ze nu elke twee jaar samengedreven en geschoren. Daarbij levert elk dier amper 150 gram wol op. Kledingstukken van deze luxewol zijn bijzonder zacht en warm – en zeer prijzig.

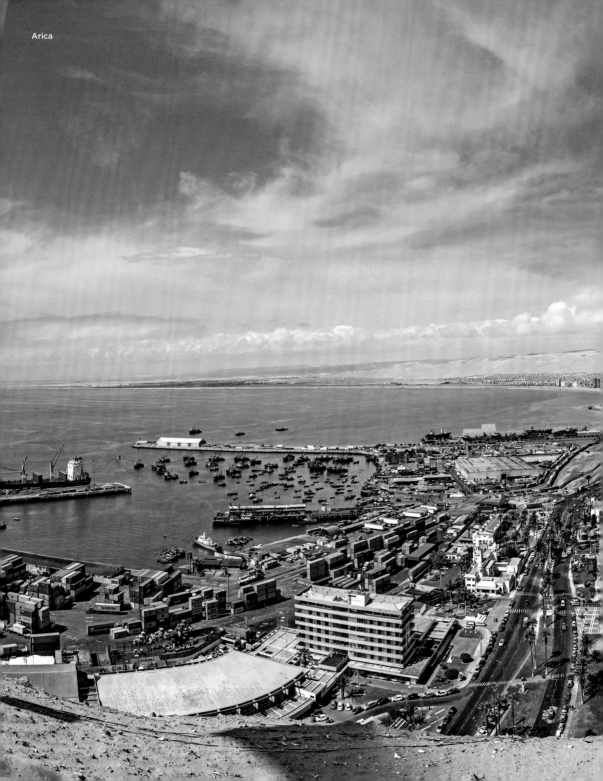
Arica

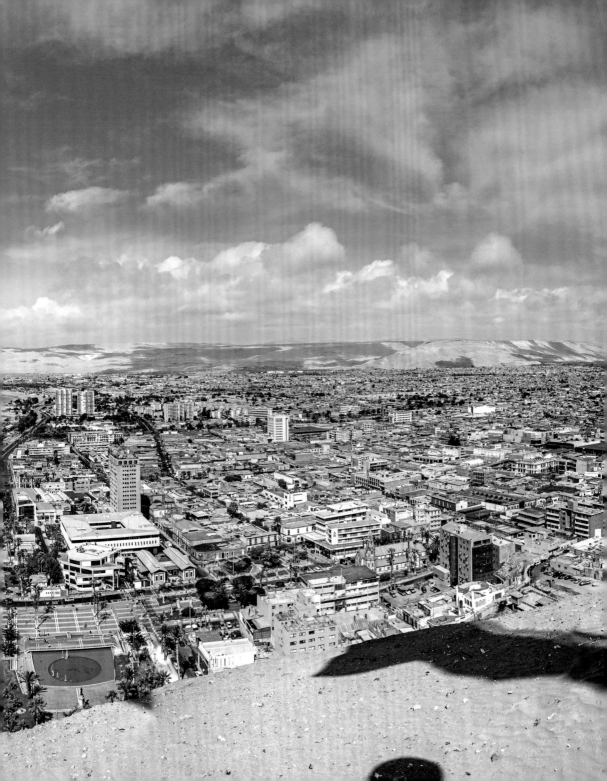

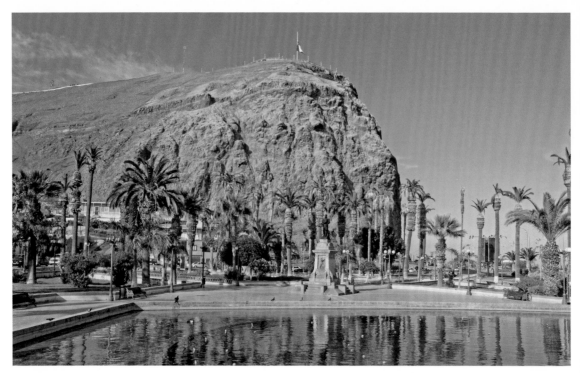

Morro de Arica, Arica

Arica

Towering high above Arica is the 206 m (675 ft) Morro de Arica, offering fantastic views of the city and the surrounding barren landscape. St. Mark's Cathedral in the town center was built in 1875 by a French architect who has since become world-famous: Alexandre Gustave Eiffel.

Arica

Por encima de Arica sobresalen los 206 m de alto Morro de Arica, que ofrece una fantástica vista de la ciudad y del árido entorno. La Catedral San Marcos, en el centro, fue construida en 1875 por un arquitecto francés, que llegaría a ser conocido mundialmente: Alexandre Gustave Eiffel.

Arica

Arica est dominée par les 206 m de la colline Morro de Arica qui offre une vue imprenable sur la ville et ses environs arides. Au centre, la cathédrale Saint-Marc a été construite en 1875 par un architecte français qui devint mondialement célèbre : Alexandre Gustave Eiffel.

Arica

Al di sopra di Arica si erge il Morro de Arica, alto 206 m, che offre una vista incredibile sull'intera città e sulla spoglia zona circostante. La cattedrale di San Marco nel centro è stata costruita nel 1875 da un architetto francese destinato a diventare famosissimo: Alexandre Gustave Eiffel.

Arica

Arica wird überragt vom 206 m hohen Morro de Arica, der eine fantastische Sicht auf die Stadt und das karge Umland bietet. Die Markuskathedrale im Zentrum wurde 1875 von einem französischen Architekten erbaut, der weltberühmt werden sollte: Alexandre Gustave Eiffel.

Arica

Boven Arica torent de 206 m hoge Morro de Arica uit, die een fantastisch uitzicht over deze stad en zijn schrale omgeving. De Sint-Marcuskathedraal in het centrum werd in 1875 door een nog onbekende Franse architect ontworpen: Alexandre Gustave Eiffel.

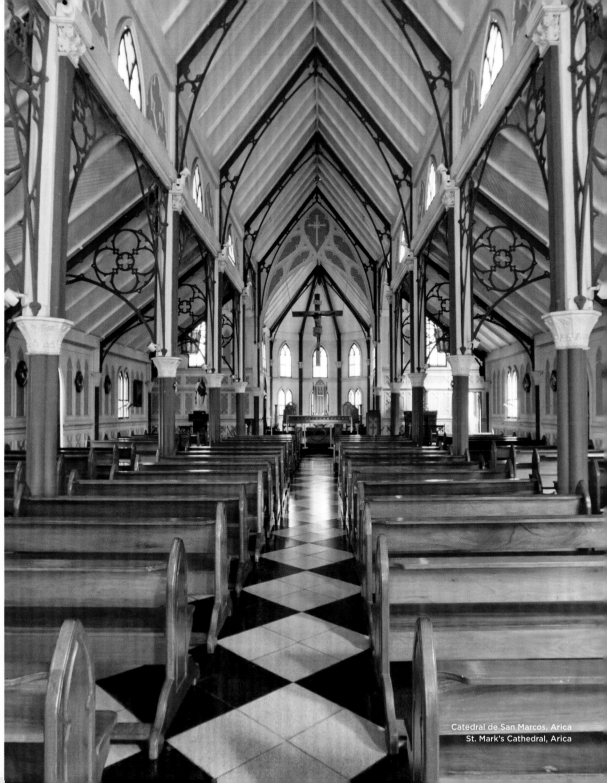

Catedral de San Marcos, Arica
St. Mark's Cathedral, Arica

Península del Alacrán, Arica
Scorpion Island, Arica

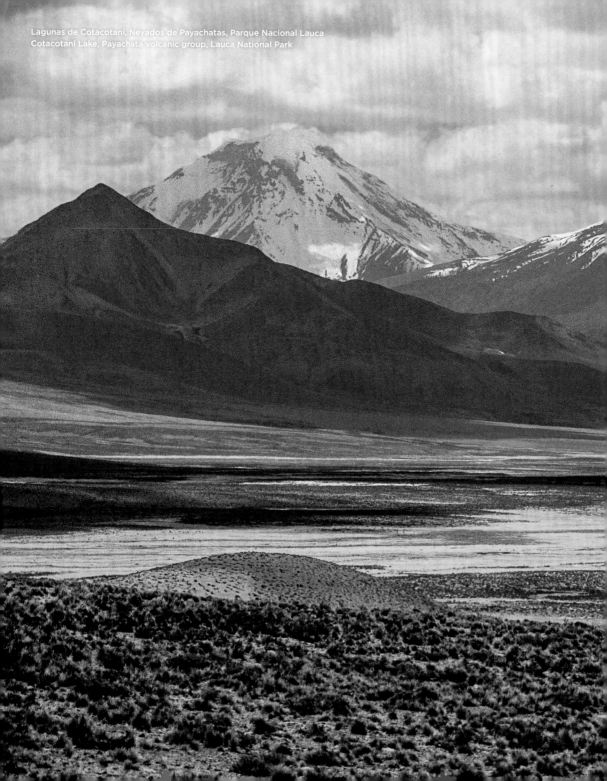

Lagunas de Cotacotani, Nevados de Payachatas, Parque Nacional Lauca
Cotacotani Lake, Payachata volcanic group, Lauca National Park

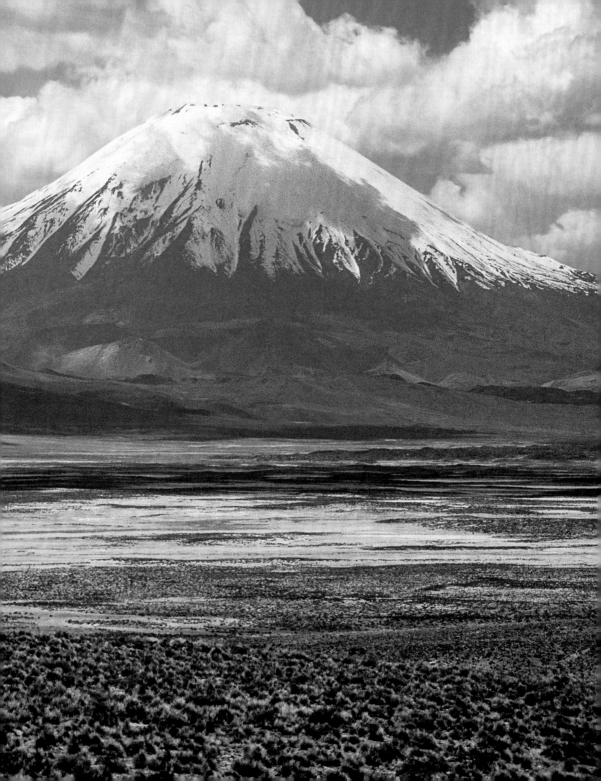

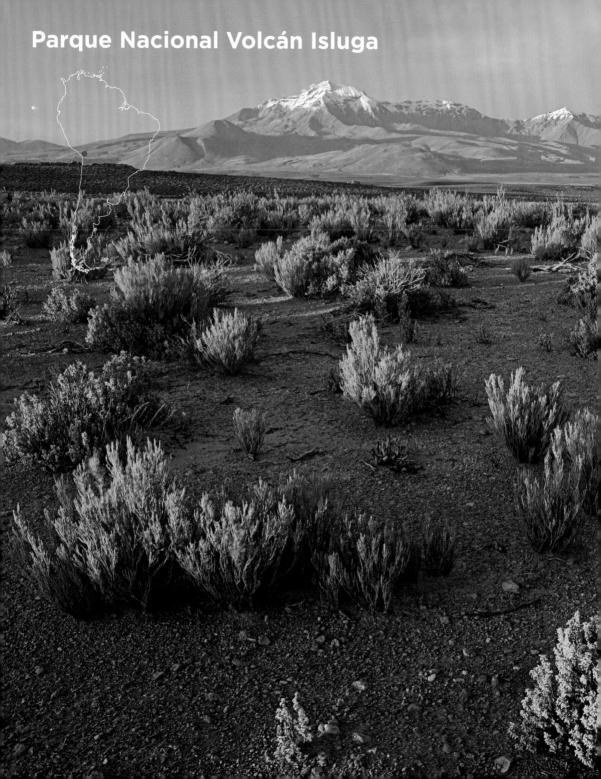

Parque Nacional Volcán Isluga

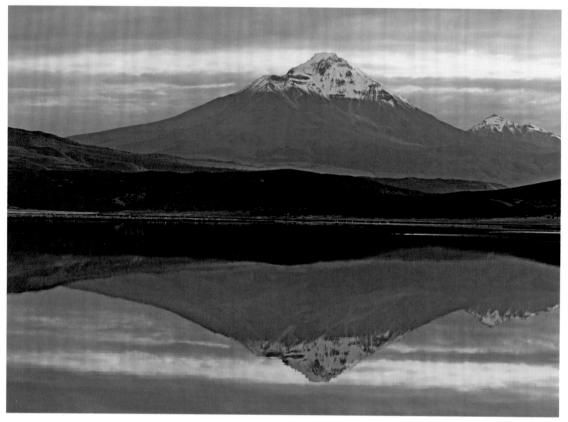

Volcán Isluga (5218 m)
Isluga volcano (5218 m · 16,959 ft)

Volcán Isluga National Park

The Volcán Isluga National Park covers more than 1747km² (675 mi²) on the high plateaus of the Tarapacá region. The park is named after the volcano Isluga, still considered active, although it has not erupted in more than 100 years. Guanacos, vicuñas, and pumas make their home here as do the flamingos und Andes condors on the salt lakes. Some of the mountains and hills are considered sacred by the Aymara people who live here.

Parc national Volcán Isluga

Le parc national Volcán Isluga s'étend sur 1747 km² sur le haut plateau de la région de Tarapacá. Il doit son nom au volcan Isluga, qui, bien que considéré comme actif, dort depuis plus d'un siècle. Guanacos, vigognes et pumas y vivent en compagnie des flamants roses, qui peuplent les lacs salés, et des condors des Andes. Pour le peuple Aymara habitant cette région, certaines montagnes et collines sont sacrées.

Nationalpark Volcán Isluga

Über 1747 km² erstreckt sich der Nationalpark Volcán Isluga auf der Hochebene der Region Tarapacá. Namensgeber ist der Vulkan Isluga. Er gilt als aktiv, hüllt sich aber seit mehr als 100 Jahren in Schweigen. Guanakos, Vikunjas und Pumas sind hier zu Hause, an den Salzseen Flamingos und Andenkondore. Einige der Berge und Hügel sind den hier lebenden Aymara heilig.

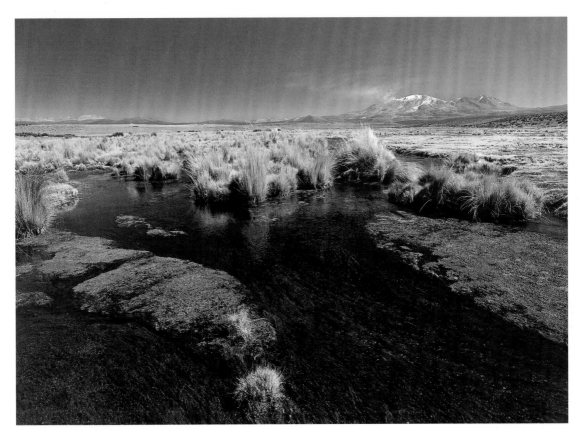

Parque Nacional Volcán Isluga
Volcán Isluga National Park

Parque Nacional Volcán Isluga

El Parque Nacional Volcán Isluga se extiende unos 1747 km² en la meseta de la región de Tarapacá. Se llama así por el volcán Isluga. Se le considera activo, pero lleva más de 100 años en silencio. Guanacos, vicuñas y pumas están aquí en su casa, en los lagos de sal flamencos y cóndores. Algunas de las montañas y colinas son sagradas para los aymaras que viven aquí.

Parco Nazionale del vulcano Isluga

Il Parco Nazionale del vulcano Isluga si estende su oltre 1747 km², nell'altipiano della regione di Tarapacá. Prende il nome dal vulcano Isluga, che si ritiene attivo anche se da più di cento anni è addormentato. Guanachi, vigogne e puma qui sono di casa, e sui laghi salati vivono fenicotteri e condor delle Ande. Alcune montagne e colline sono sacre alla popolazione degli Aymara che vive qui.

Nationaal Park Volcán Isluga

Het Nationale Park Volcán Isluga strekt zich uit over 1747 km², op de hoogvlakte van de regio Tarapacá. Het park dankt zijn naam aan de Isluga, een vulkaan die weliswaar actief is maar zich al meer dan honderd jaar koest houdt. Hier leven guanaco's, vicuña's en poema's, en rond de zoutmeren flamingo's en Andescondors. Enkele bergen en heuvels in deze streek zijn heilig voor het hier levende Aymaravolk.

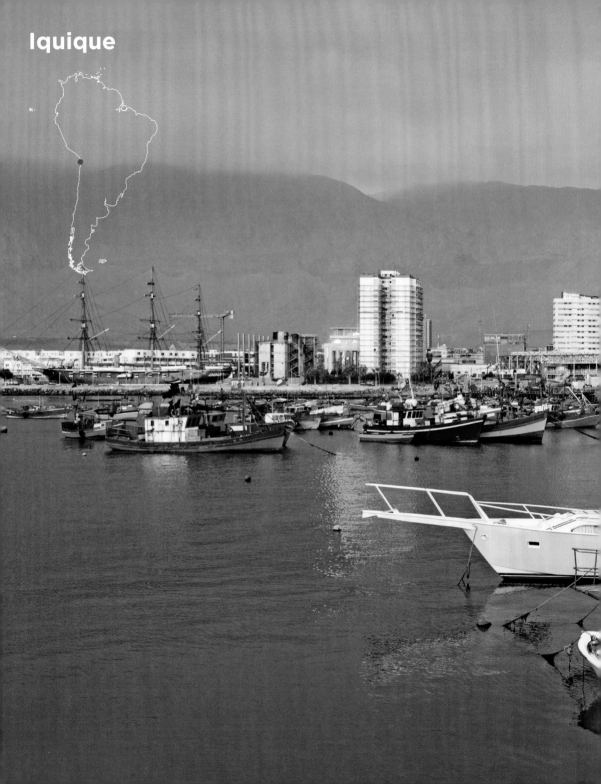

Iquique

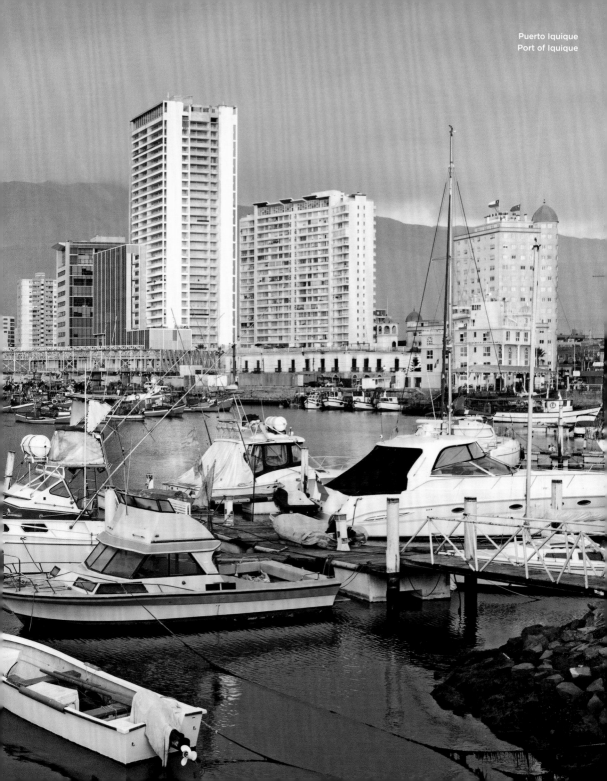

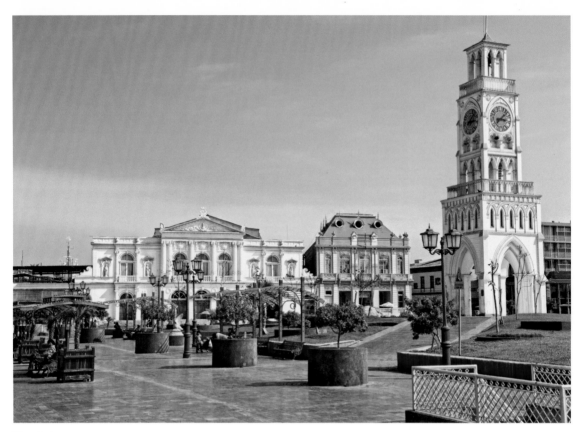

Plaza Prat

Iquique

Today known primarily for its extensive beaches and large duty-free zone with hundreds of shops, Iquique was the center for guano and saltpeter export in the 19th century. The renovated façades and wooden walkways in the historic city center testify to the splendor of this era. Plaza Prat has been home to the city's main landmark since 1877: the Clock Tower.

Iquique

Aujourd'hui essentiellement célèbre pour ses vastes plages et son immense zone franche comptant des centaines de commerces, Iquique était au XIXᵉ siècle un centre d'exportation de guano et de salpêtre. Les façades rénovées et les trottoirs en bois dans le centre historique témoignent de la splendeur de cette époque. La Tour de l'Horloge, symbole de la ville érigé en 1877, se dresse encore aujourd'hui sur la Plaza Prat.

Iquique

Heute vor allem für weitläufige Strände und eine große Freihandelszone mit hunderten Läden bekannt, war Iquique im 19. Jahrhundert Exportzentrum für Guano und Salpeter. Die renovierten Fassaden und hölzernen Gehwege im historischen Stadtkern zeugen vom Glanz dieser Epoche. Auf der Plaza Prat steht noch heute das 1877 aufgestellte Wahrzeichen der Stadt: der Uhrturm.

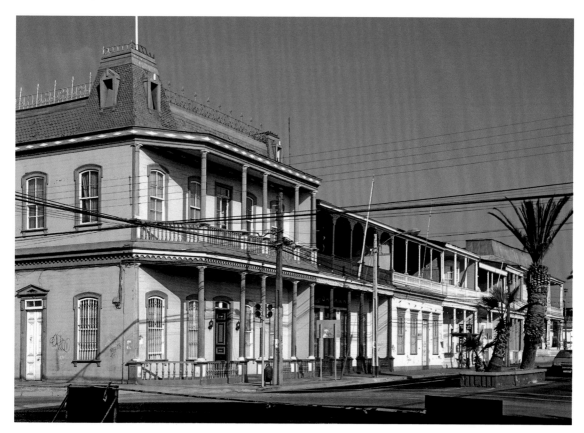

Casas de madera tradicionales
Traditional wooden houses

Iquique

Hoy conocida por sus extensas playas y una gran zona de libre comercio con cientos de tiendas, Iquique era el centro de exportación de guano y salitre en el siglo XIX. Las fachadas renovadas y las pasarelas de madera en el centro histórico de la ciudad testimonian el esplendor de esa época. En la Plaza Prat se encuentra el monumento emblema de la ciudad, levantado en 1877: la Torre del Reloj.

Iquique

Oggi Iquique è famosa soprattutto per le ampie spiagge e la grande zona franca con oltre cento negozi, mentre nel XIX secolo era centro per l'esportazione di nitro e guano. Nel centro storico, le facciate restaurate degli edifici e le passerelle di legno testimoniano lo splendore dell'epoca. Nella Plaza Prat si trova ancora il simbolo della città eretto nel 1877: la Torre dell'Orologio.

Iquique

Iquique is vooral bekend om zijn brede stranden en grote vrijhandelszone met honderden winkels, maar in de negentiende eeuw was het een uitvoerhaven van guano en salpeter. De opgeknapte façades en houten trottoirs in het oude centrum getuigen nog van de glans van deze tijd. Op de Plaza Prat staat het in 1877 opgerichte herkenningsteken van de stad: de Klokkentoren.

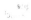

Playa Cavancha
Cavancha Beach

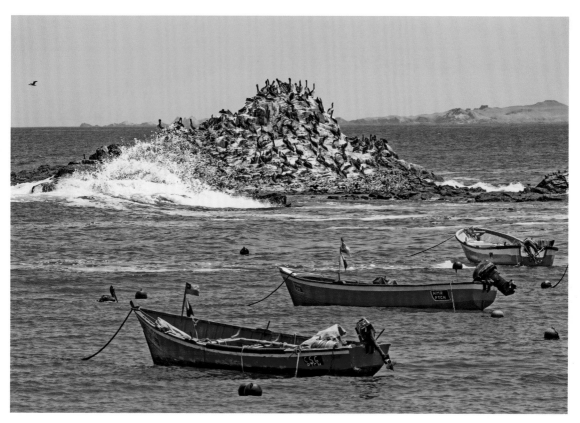

Barcos de pesca y pelícanos
Fishing boats and pelicans

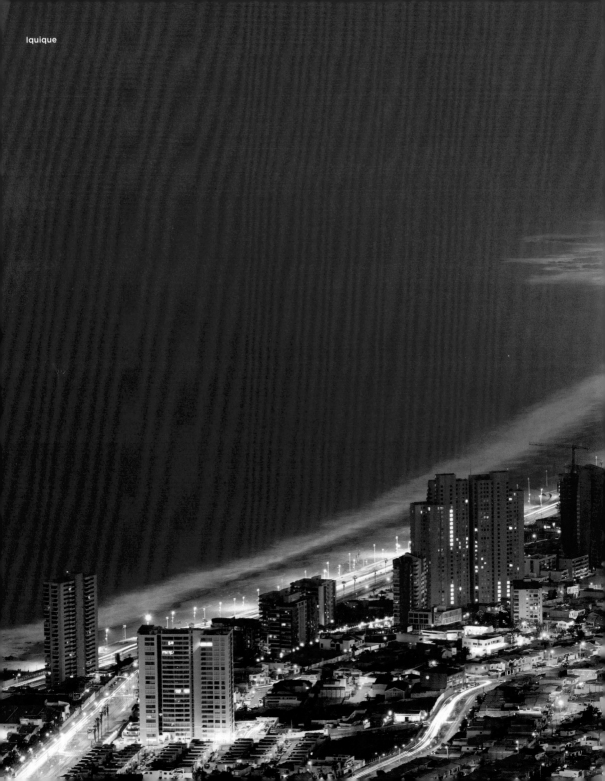

Iquique

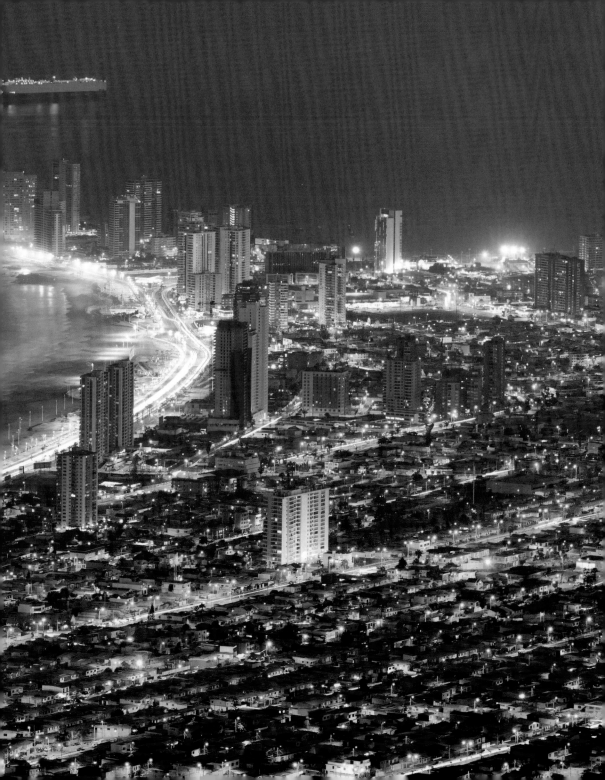

Géiseres de El Tatio

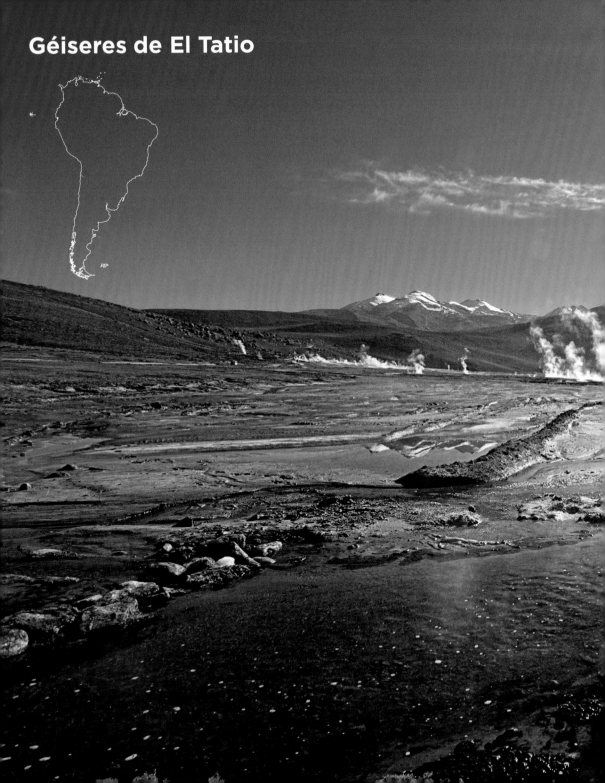

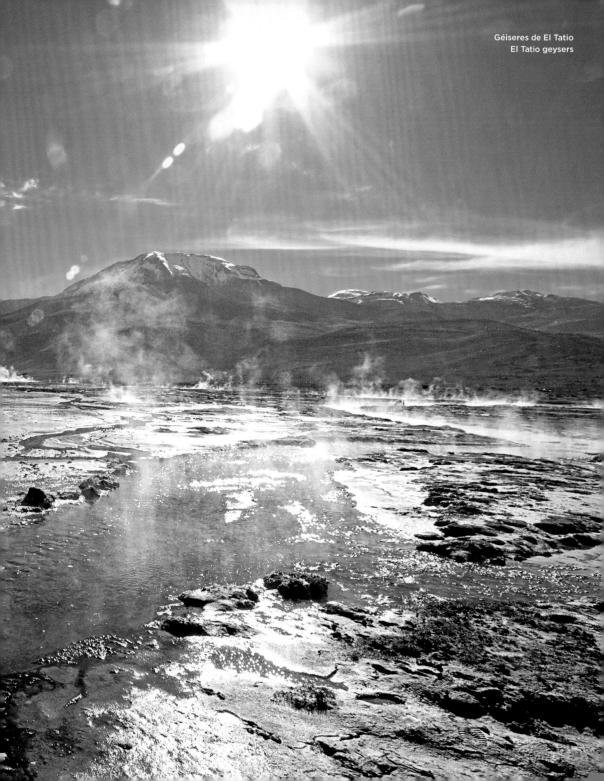

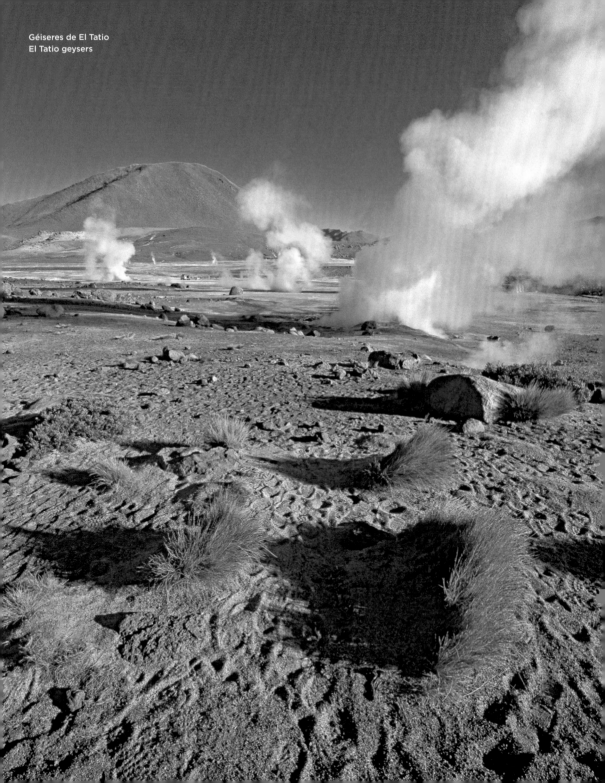

Géiseres de El Tatio
El Tatio geysers

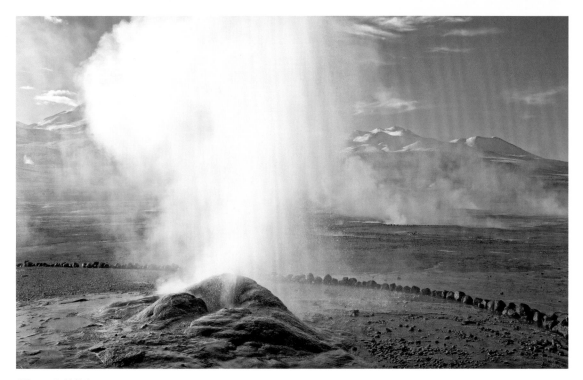

Géiseres de El Tatio
El Tatio geysers

El Tatio geysers

Almost 4300 m (14100 ft) above sea level, the geysers and hot springs at El Tatio bubble away in a massive volcanic crater. This is the largest geyser field in the southern hemisphere and has more than 80 geysers, 30 of which are always active. They shoot forth 86°C (187°F) water from below the surface of the earth and give some sense of the active volcanic activity under your feet. If you want to see the geysers in full action, come at sunrise.

Géiseres de El Tatio

Casi 4300 m sobre el nivel del mar los géiseres y aguas termales de El Tatio salen a borbotones en un enorme cráter volcánico. El campo de géiseres más grande en el hemisferio sur contiene más de 80 géiseres, 30 de ellos activos. A 86°C, las fuentes disparan fuera de la tierra y dan una idea de la actividad del ajetreo volcánico debajo de la superficie. Quien quiera experimentar los géiseres en acción, debe estar allí para ver el amanecer.

Geysers d'El Tatio

À pratiquement 4300 m d'altitude, les geysers et sources chaudes d'El Tatio jaillissent d'un immense cratère volcanique. Ce site, le plus vaste de l'hémisphère sud, compte plus de 80 geysers, dont 30 sont actifs en permanence. L'eau qui sort de terre à 86°C laisse entrevoir l'activité volcanique sous la surface de la Terre. Le lever du soleil est le meilleur moment de la journée pour profiter des geysers en pleine activité.

Geyser di El Tatio

A quasi 4300 m sul livello del mare, in un enorme cratere del vulcano spumeggiano i geyser chiamati sorgenti di El Tatio. La più grande area di geyser dell'emisfero meridionale comprende più di 80 geyser, di cui 30 sono sempre attivi. I getti d'acqua schizzano dal suolo ad una temperatura di 86°C e fanno intuire come l'attività vulcanica sia ancora presente sotto la superficie. Chi vuole vedere i geyser in azione, dovrebbe trovarsi sul posto all'alba.

Geysire von El Tatio

In fast 4300 m Meereshöhe sprudeln in einem riesigen Vulkankrater die Geysire und heißen Quellen von El Tatio. Das größte Geysirfeld der Südhalbkugel umfasst mehr als 80 Geysire, 30 davon sind ständig aktiv. Mit 86°C schießen die Fontänen aus der Erde und lassen erahnen, wie aktiv das vulkanische Treiben unter der Oberfläche noch ist. Wer die Geysire in voller Aktion erleben will, sollte zum Sonnenaufgang da sein.

El Tatio-geisers

Op bijna 4300 m hoogte borrelen in een reusachtige vulkaankrater de geisers en hete bronnen van El Tatio. Het grootste geiserveld van het zuidelijk halfrond omvat ruim tachtig geisers, waarvan er dertig voortdurend actief zijn. Met water van 86°C schieten de fonteinen uit de aarde en doen vermoeden hoe onrustig de vulkaan onder de oppervlakte nog is. Wie de geisers in volle actie wil zien, moet bij zonsopgang komen kijken.

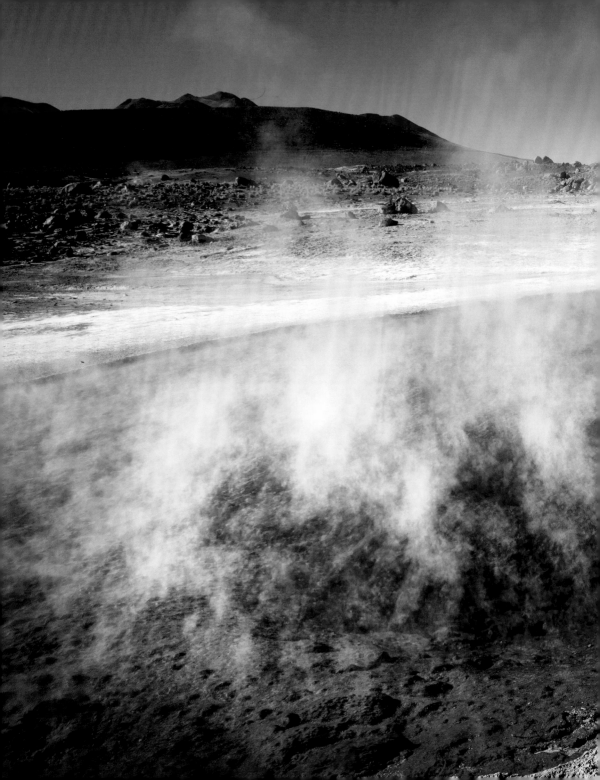

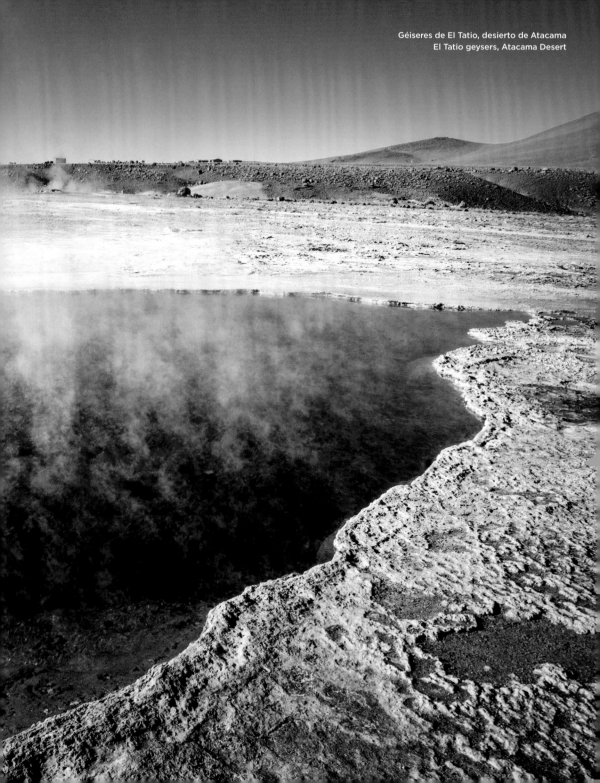

Géiseres de El Tatio, desierto de Atacama
El Tatio geysers, Atacama Desert

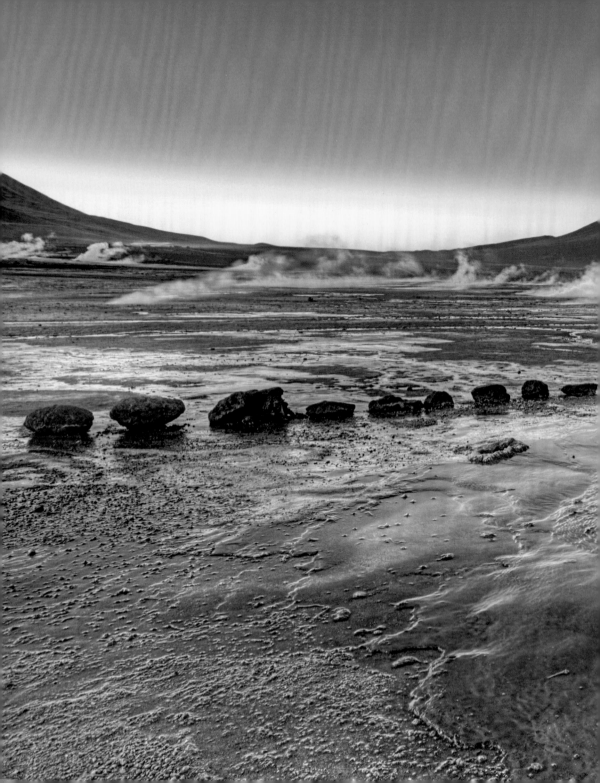

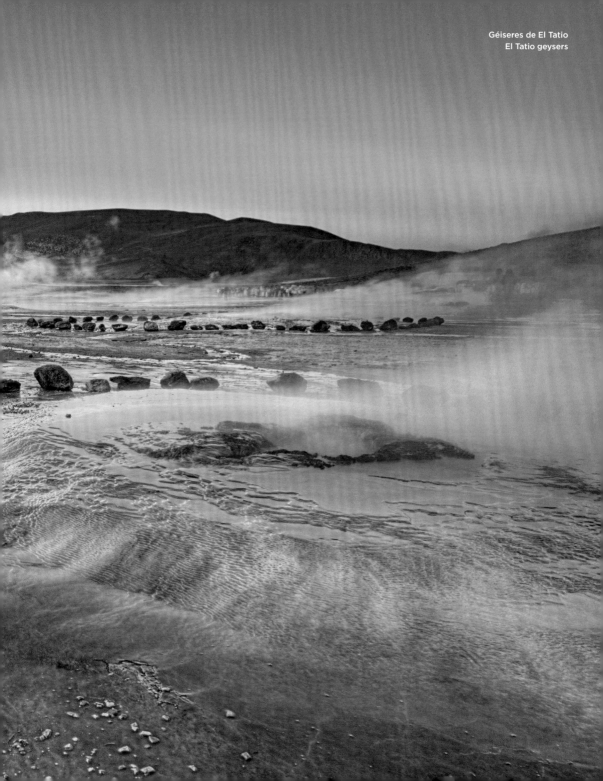

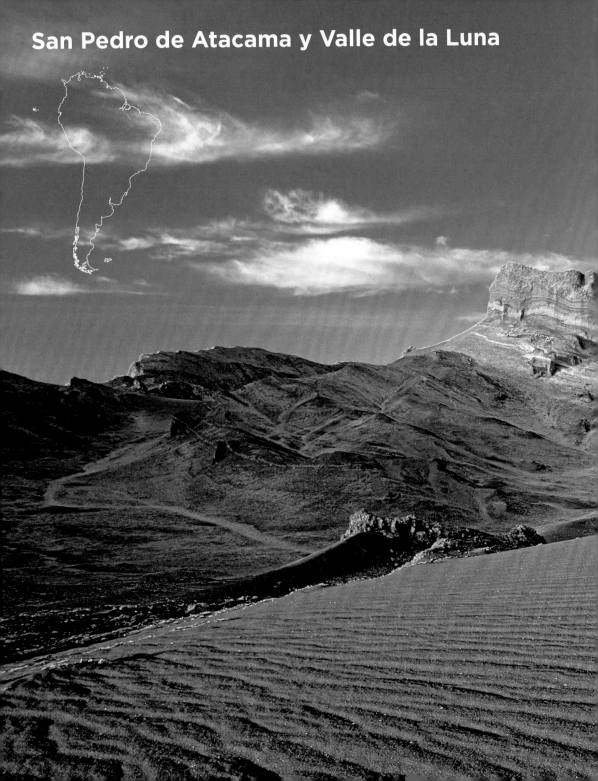

San Pedro de Atacama y Valle de la Luna

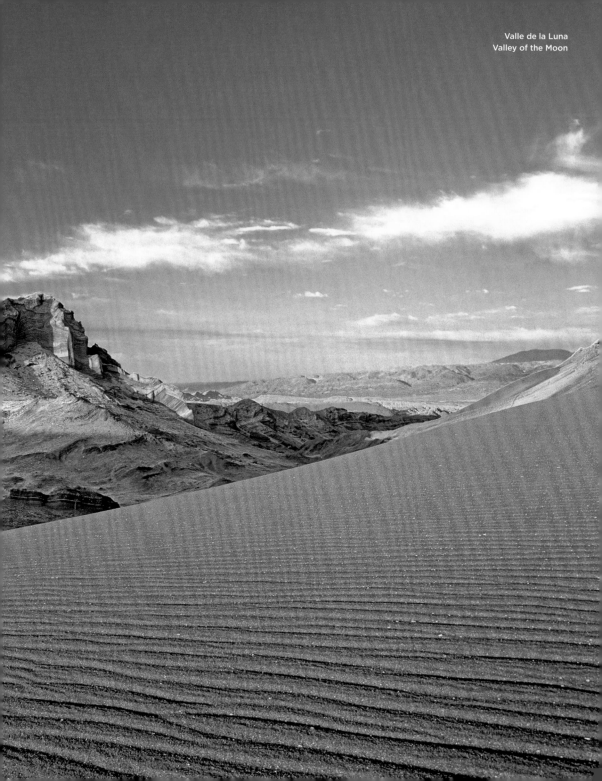

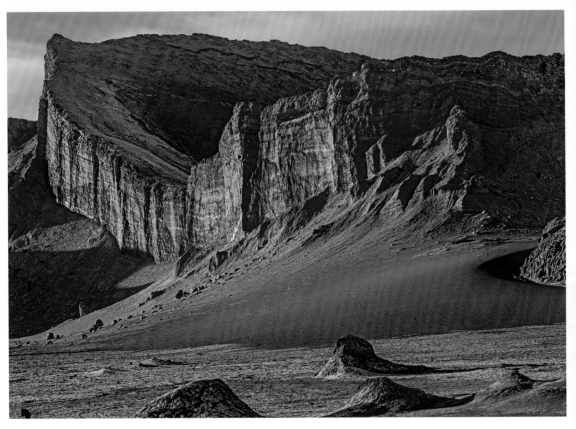

El Anfiteatro, Valle de la Luna
The Amphitheatre, Valley of the Moon

San Pedro de Atacama and the Valley of the Moon

The name says it all: "Valley of the Moon." The cratered landscape in the Atacama Desert seems to be from another planet. Steep cliff walls and bizarre rock formations, crystal-clear lagoons, and salt beds. The charming village of San Pedro de Atacama lies nearby and is a green oasis popular with tourists visiting the desert. As evening draws to a close, they head out to the Valley of the Moon in droves to see the cliffs in the reddish glow of the setting sun.

San Pedro de Atacama et la vallée de la Lune

Son nom est évocateur. Le paysage volcanique de la vallée de la Lune, dans le désert d'Atacama, fait songer à une autre planète : parois escarpées, formations rocheuses étranges, lagunes étincelantes et déserts de sel. Le charmant village-oasis de San Pedro de Atacama est implanté non loin. C'est une destination très prisée des touristes du désert qui s'aventurent nombreux dans la vallée, à la tombée du jour, à l'heure où le soleil couchant enflamme les rochers rouges.

San Pedro de Atacama und Valle de la Luna

Der Name sagt alles: „Tal des Mondes". Außerirdisch anmutende Kraterlandschaften in der Atacama-Wüste. Steile Felswände und bizarre Steinformationen, glänzende Lagunen und Salzpfannen. Ganz in der Nähe liegt der charmante Ort San Pedro de Atacama, begrünte Oase und beliebtes Ziel für Wüstentouristen. Gegen Abend ziehen diese in Scharen ins Valle de la Luna, wenn die untergehende Sonne die roten Felsen zum Leuchten bringt.

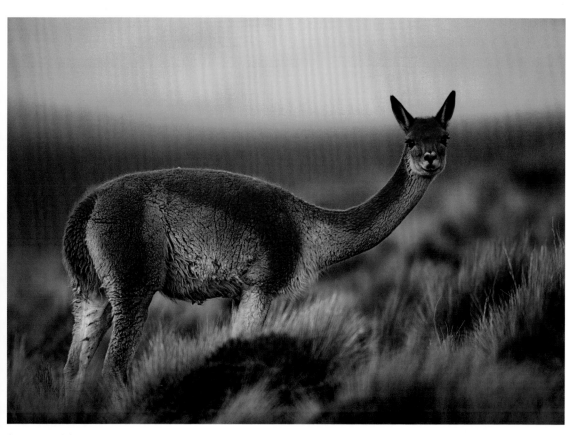

Guanaco en el desierto de Atacama
Guanaco in Atacama Desert

San Pedro de Atacama
y Valle de la Luna

El nombre lo dice todo: "Valle de la Luna". Cráteres en el desierto de Atacama de aspecto extraterrestre. Acantilados y extrañas formaciones rocosas, brillantes lagunas y salinas. Muy cerca se encuentra el encantador pueblo de San Pedro de Atacama, oasis frondoso y destino popular para los turistas del desierto. Por la noche se mueven en masa al Valle de la Luna, cuando el sol poniente saca a la luz el brillo de la roca roja.

San Pedro di Atacama
e Valle della Luna

Il nome dice tutto: la "Valle della Luna". Un paesaggio vulcanico dall'aspetto extraterrestre nel deserto di Atacama. Ripide pareti rocciose e bizzarre formazioni di pietra, lagune luminose e saline. Proprio nelle vicinanze si trova l'affascinante località di San Pedro di Atacama, oasi verde e meta amata dai turisti del deserto, che verso sera si dirigono a frotte nella Valle della Luna, quando il sole che tramonta illumina le rocce rosse.

San Pedro de Atacama
en de Valle de la Luna

De naam zegt het al: het 'Dal van de Maan', oftewel de buitenaards aandoende kraterlandschappen van de Atacamawoestijn, met steile rotswanden en bizarre steenformaties, glinsterende lagunes en zoutpannen. Vlakbij ligt het charmante plaatsje San Pedro de Atacama, een groene oase en een geliefde bestemming voor woestijntoeristen. Tegen de avond trekken bezoekers massaal naar de Valle de la Luna, wanneer de ondergaande zon de rotsen rood doet oplichten.

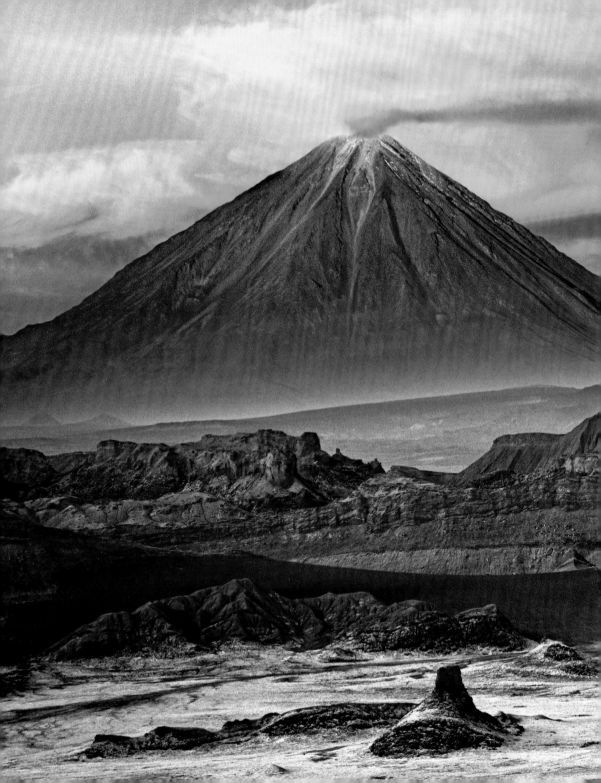

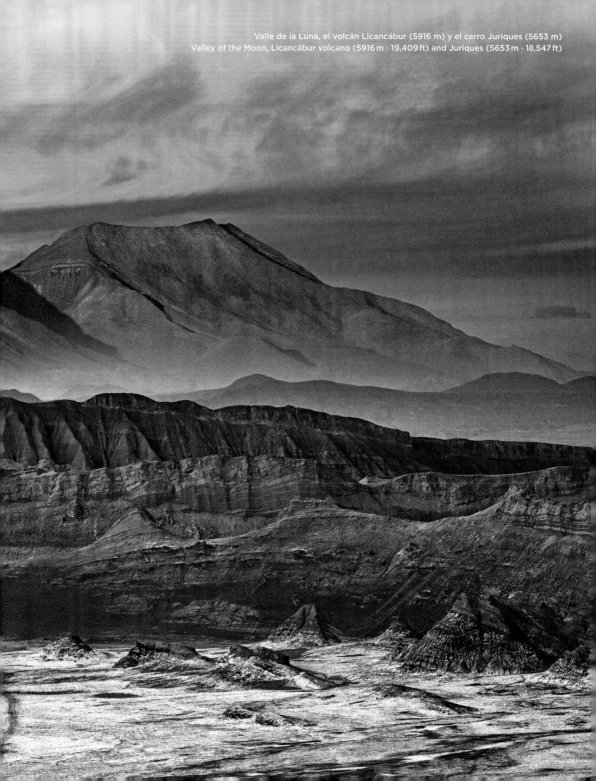

Valle de la Luna, el volcán Licancábur (5916 m) y el cerro Juriques (5653 m)
Valley of the Moon, Licancábur volcano (5916 m · 19,409 ft) and Juriques (5653 m · 18,547 ft)

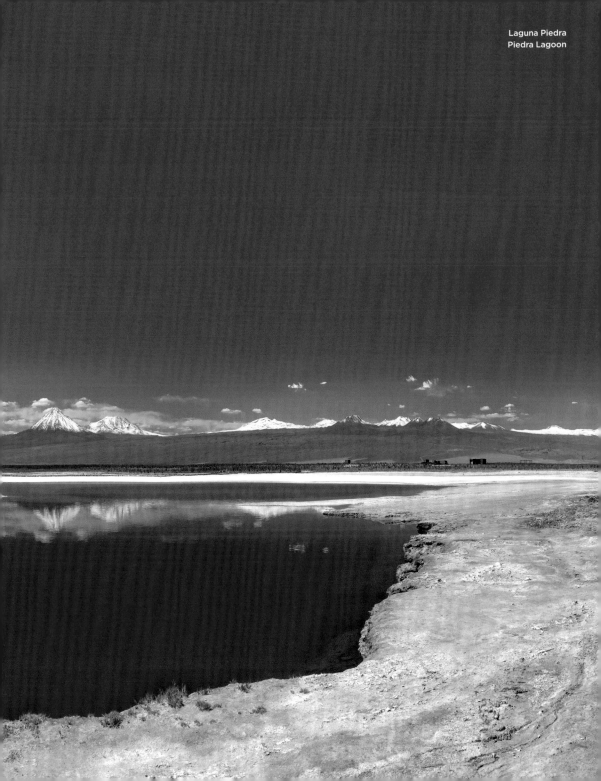

Laguna Piedra
Piedra Lagoon

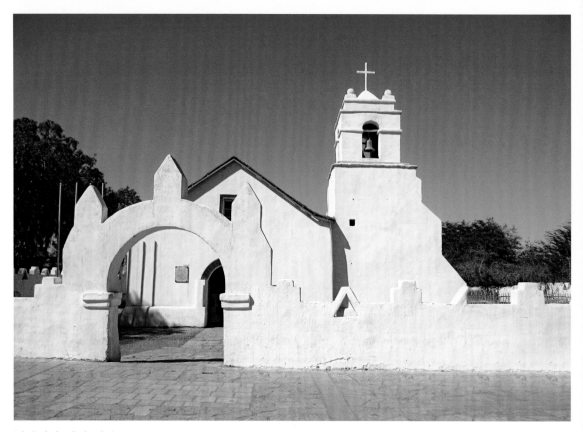

Iglesia de San Pedro de Atacama
Church of San Pedro de Atacama

Riches in the desert

The driest desert in the world: the Atacama only gets 0.1mm (0.004in) of precipitation in an average year. There are even places where a drop of rain hasn't fallen in more than 100 years. But the 105,000 km² (40,500 sq mi) region has its riches, such as copper and iron, gold, silver, and many other minerals. Chile is the world's leading supplier of copper and is home to the largest open-cast copper mine in the world at Chuquicamata. The turquoise-colored atacamite has even been named after this desert.

Un désert riche

Avec des précipitations moyennes annuelles limitées à 0,1 mm, le désert d'Atacama est le plus sec du monde. Certaines zones n'ont même reçu aucune goutte de pluie depuis plus d'un siècle. Cette immense région de 105 000 km² est en revanche riche en divers minéraux, dont le cuivre, le fer, l'or et l'argent. Le Chili est leader sur le marché mondial pour le cuivre et possède, avec la mine de Chuquicamata, la plus grande mine à ciel ouvert de cuivre au monde. L'atacamite, minéral de couleur turquoise, tire d'ailleurs son nom de ce désert.

Reiche Wüste

Die trockenste Wüste der Welt: Nur 0,1 mm Niederschlag fallen durchschnittlich pro Jahr in der Atacama-Wüste. Es gibt sogar Stellen, an denen seit über 100 Jahren kein Tropfen Regen mehr gefallen ist. Reich ist das 105 000 km² große Gebiet dennoch – an Kupfer und Eisen, Gold, Silber und vielen weiteren Mineralien. Chile ist Weltmarktführer für Kupfer und hat mit der Mine von Chuquicamata den größten Kupfertagebau der Welt. Das türkisfarbene Atacamit wurde sogar nach dieser Wüste benannt.

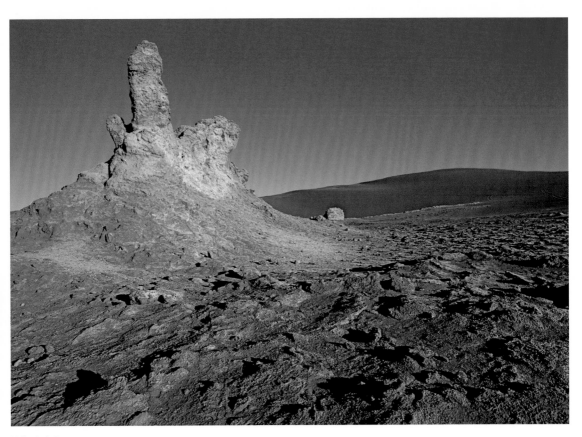

Valle de la Luna
Valley of the Moon

Ricos desiertos

El desierto más seco del mundo:
solamente cae en el desierto de Atacama
un promedio de 0,1 mm de precipitación
por año. Hay lugares donde incluso no ha
caído ni una gota de agua en 100 años. El
área de 105 000 km² es rica – en cobre y
hierro, oro, plata y muchos otros minerales.
Chile es líder mundial en cobre, siendo
la de Chuquicamata, la mina de cobre
a cielo abierto más grande del mundo.
La atacamita de color turquesa lleva el
nombre de este desierto.

Un ricco deserto

Il deserto più asciutto del mondo: solo
0,1 millimetri di precipitazioni cadono in
media all'anno nel deserto di Atacama. Ci
sono persino posti dove da oltre 100 anni
non è caduta una sola goccia di pioggia.
Tuttavia la zona vasta 105 000 km² è ricca
di rame e ferro, oro, argento e molti altri
minerali. Il Cile è famoso per il rame e
possiede la miniera di rame a cielo aperto
più grande del mondo: Chuquicamata.
L'atacamite dal colore turchese prende il
nome proprio da questo deserto.

Woestijn vol schatten

In de Atacamawoestijn, de droogste
woestijn ter wereld, valt gemiddeld
0,1 millimeter neerslag per jaar. Er
zijn zelfs gebieden waar al ruim een
eeuw geen druppel regen is gevallen.
Toch is dit 105 000 km² grote gebied
heel rijk: aan koper, ijzer, goud, zilver
en talloze andere mineralen. Chili is
's werelds grootste koperproducent
en de mijn van Chuquicamata is de
grootste open kopermijn ter wereld. Het
turkooisblauwe atacamiet is zelfs naar de
woestijn vernoemd.

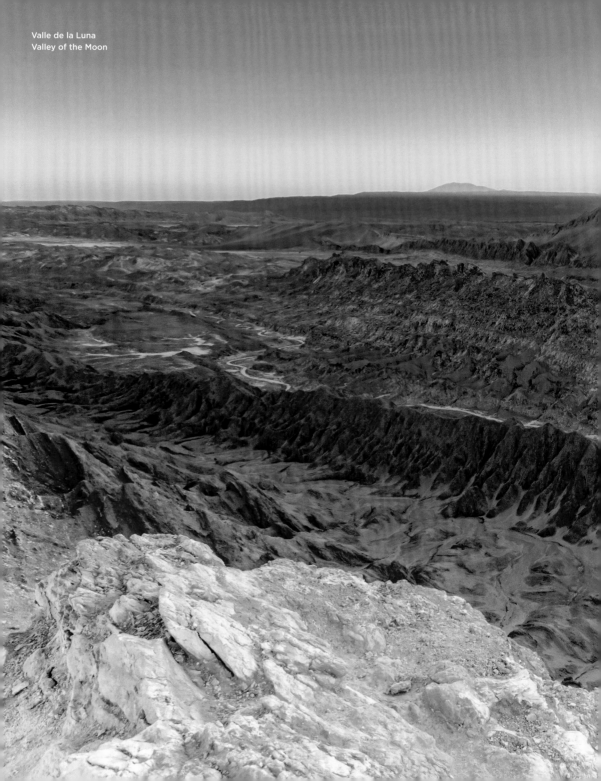

Valle de la Luna
Valley of the Moon

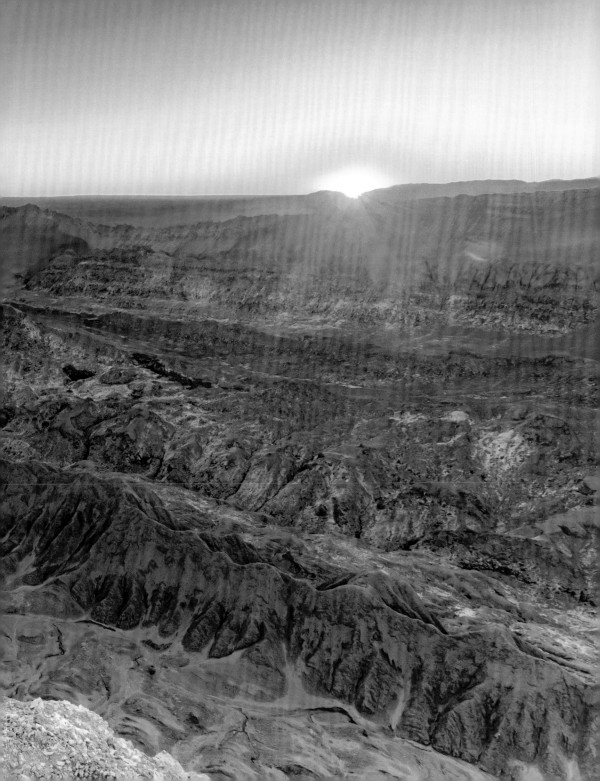

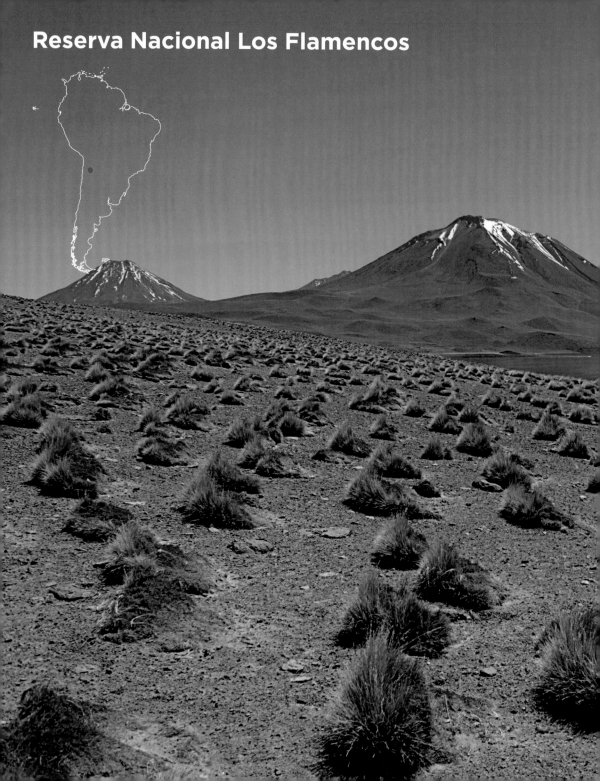

Reserva Nacional Los Flamencos

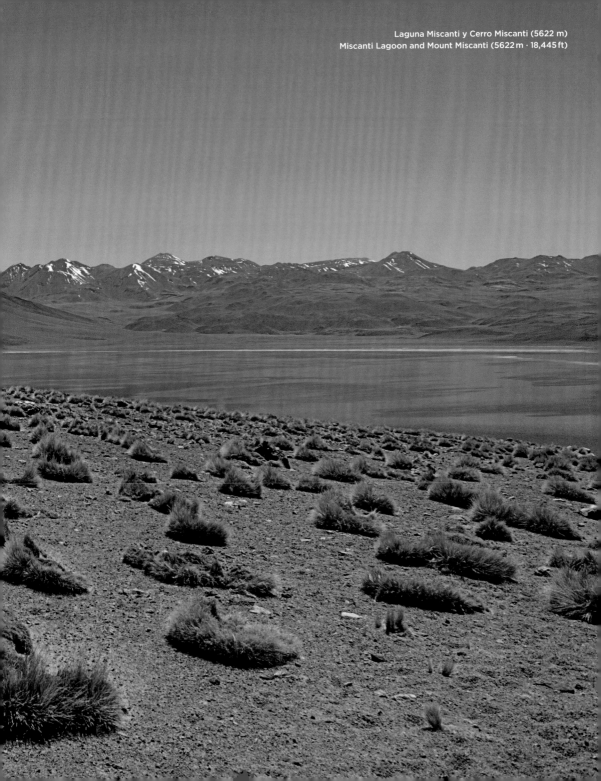

Laguna Miscanti y Cerro Miscanti (5622 m)
Miscanti Lagoon and Mount Miscanti (5622 m · 18,445 ft)

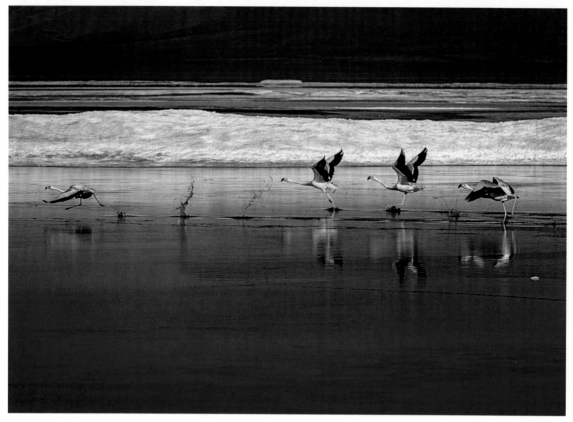

Flamencos de James, Reserva Nacional Los Flamencos
James's flamingos, Los Flamencos National Reserve

Los Flamencos National Reserve

Salt beds and lagoons, rocky landscapes and caves, dunes, and steppes. The Los Flamencos National Reserve covers more than 740 km² (285 sq mi) including several salt lakes and the Valle de la Luna. The massive region may appear hostile, but it is home to more than 100 animal species, including three of the world's seven flamingo species: the Andes, the Chilean, and the James's flamingo.

Réserve nationale Los Flamencos

Déserts de sel et lagunes, paysages minéraux et grottes, dunes et steppes: la réserve nationale Los Flamencos s'étend sur 740 km² et englobe plusieurs lacs salés et la vallée de la Lune. Cette immense région semble hostile à la vie mais compose pourtant l'habitat de plus de 100 espèces animales. Parmi elles, trois des sept espèces de flamants peuplant le monde: le flamant des Andes, le flamant du Chili et le flamant de James.

Nationalreservat Los Flamencos

Salzpfannen und Lagunen, Felslandschaften und Höhlen, Dünen und Steppe: Über 740 km² erstreckt sich das Nationalreservat Los Flamencos, zu dem mehrere Salzseen und auch das Valle de la Luna zählen. Das riesige, scheinbar lebensfeindliche Gebiet ist Lebensraum für mehr als 100 Tierarten. Allen voran drei der sieben weltweit vorkommenden Flamingoarten: der Anden-, der Chile- und der James-Flamingo.

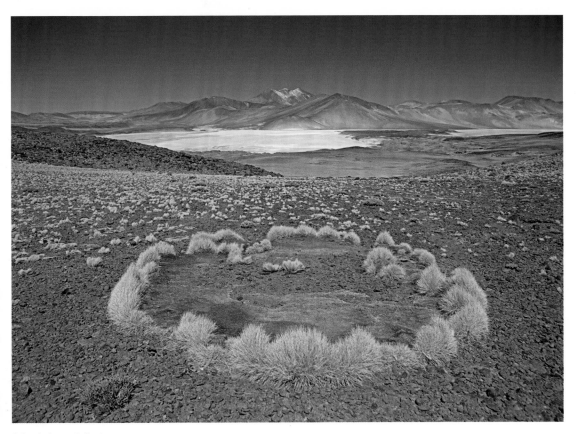

Salar de Aguas Calientes
Aguas Calientes Salt Flat

Reserva Nacional Los Flamencos

Salares y lagunas, formaciones rocosas
y cuevas, dunas y estepa: la reserva
nacional Los Flamencos abarca alrededor
de 740 km² y cuenta con varios salares y
con el Valle de la Luna. La enorme área,
aparentemente hostil es un hábitat para
más de 100 especies de animales. En
especial, tres de las siete especies de
Flamenco que existen en el mundo se
encuentran aquí: el andino, el chileno y el
flamenco de James.

Riserva Nazionale Los Flamencos

Saline e lagune, paesaggi rocciosi e grotte,
dune e steppa: la riserva nazionale di Los
Flamencos si estende su oltre 740 km², che
comprendono anche diversi laghi salati e la
Valle della Luna. L'enorme area dall'aspetto
piuttosto ostile è uno spazio vitale per
oltre 100 specie animali, prime fra tutte tre
delle sette varietà di fenicotteri esistenti al
mondo: il fenicottero delle Ande, quello del
Cile e il fenicottero di James.

Nationale Reservaat Los Flamencos

Met zijn zoutpannen, lagunes,
rotslandschappen, spelonken, duinen en
steppe strekt het Nationale Reservaat
Los Flamencos zich over ruim 740 km²
uit en omvat meerdere zoutmeren en
ook de Valle de la Luna. Het enorme en
schijnbaar onherbergzame gebied is
niettemin een toevluchtsoord voor ruim
honderd diersoorten, waaronder drie van
de zeven flamingosoorten in de wereld: de
Andesflamingo, de Chileense flamingo en
de James' flamingo.

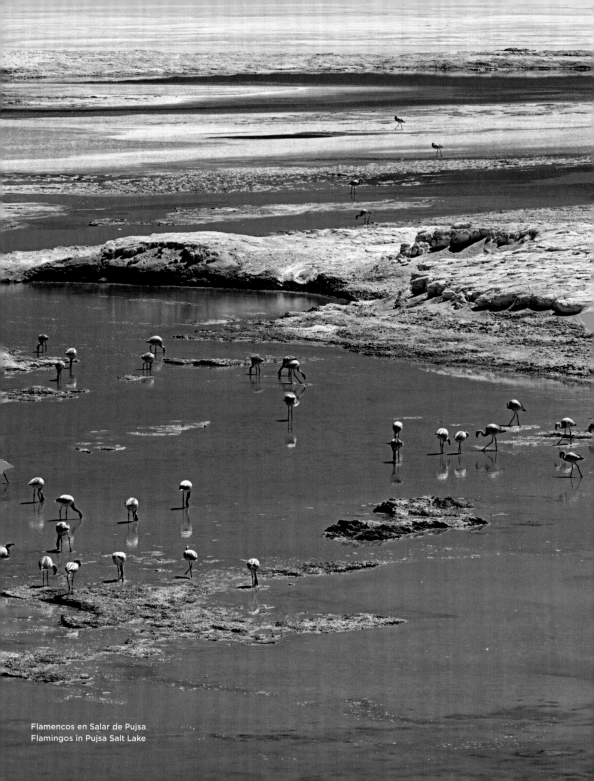

Flamencos en Salar de Pujsa
Flamingos in Pujsa Salt Lake

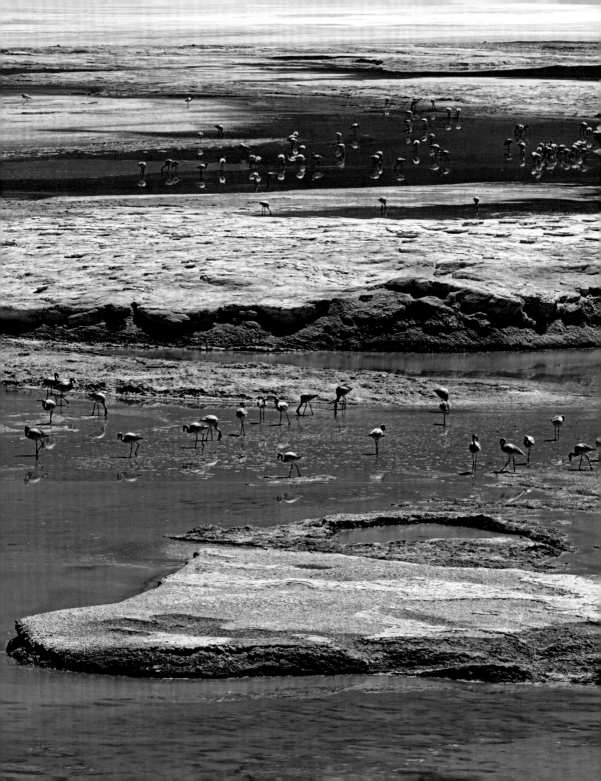

Moai de Tara, Reserva Nacional Los Flamencos
Moai de Tara, Los Flamencos National Reserve

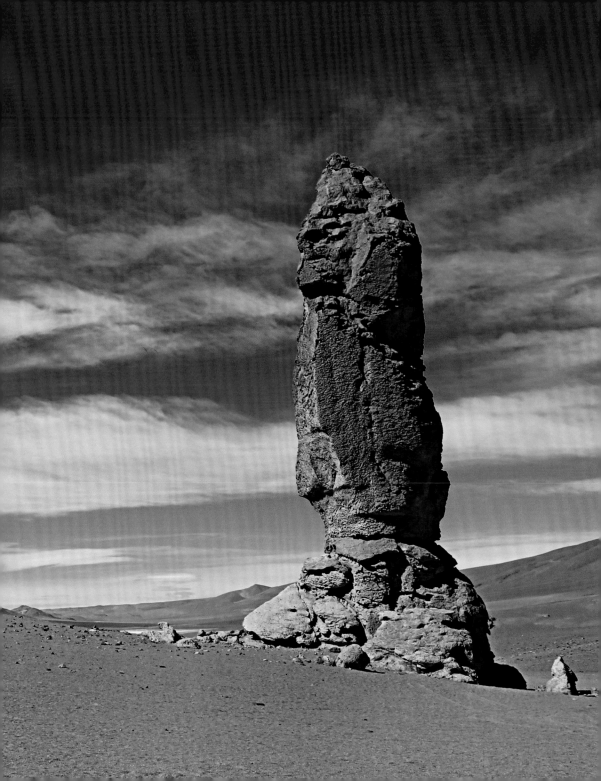

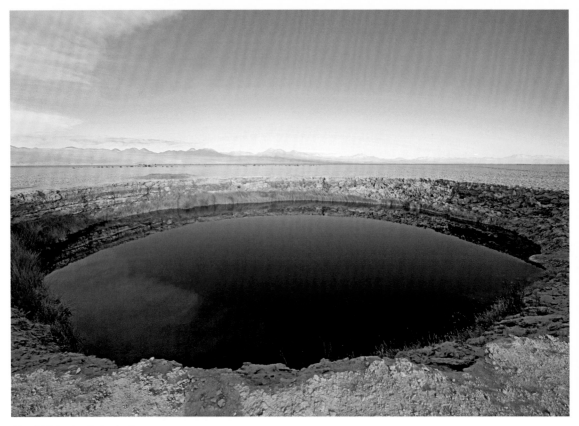

Ojos del Salar, San Pedro de Atacama
Eyes of the Salt Flat, San Pedro de Atacama

Salar de Atacama

The Salar de Atacama is some 3000 km²
(1200 sq mi) is by far the largest salt bed
in Chile and the third largest in the world.
Created millions of years ago by primordial
seas and surrounded by majestic
volcanoes, it has an almost surreal glimmer
in the pounding sun of the Atacama desert.
Less than 0.5 per cent of the massive salt
lake exists as lagoons or small ponds on
the plateau; the rest has long since dried
out, leaving behind all sorts of bizarre
salt formations.

Salar d'Atacama

Avec une superficie de 3000 km², le salar
d'Atacama est le plus grand dépôt de sel
du Chili et le troisième du monde. Il s'est
formé il y a plusieurs millions d'années à
partir d'étendues d'eaux préhistoriques.
Entouré de majestueux volcans, il jette
des reflets quasi surréalistes sous le soleil
aveuglant du désert d'Atacama. Les
lagunes et petits étangs des plateaux
constituent moins de 0,5 % de l'immense
salar. La plus grande partie est asséchée et
produit d'étranges formations de sel.

Salar de Atacama

Der Salar de Atacama ist mit gut 3000 km²
das größte Salzbecken in Chile und das
drittgrößte der Welt, entstanden vor
Jahrmillionen aus urzeitlichen Meeren.
Umgeben von majestätischen Vulkanen,
fast surreal schillernd in der gleißenden
Sonne der Atacama-Wüste. Weniger
als 0,5 Prozent des riesigen Salzsees
liegen als Lagunen oder kleine Teiche in
der Hochebene. Der allergrößte Teil ist
längst ausgetrocknet und gibt bizarre
Salzformationen preis.

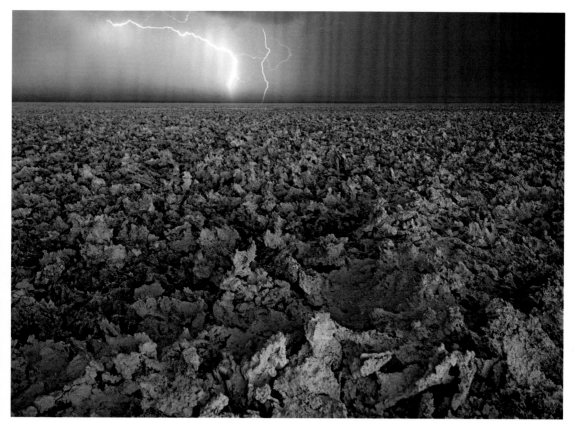

Laguna Chaxa
Chaxa Lagoon

Salar de Atacama

El Salar de Atacama es, con unos 3000 km², la mayor salina de Chile y la tercera más grande del mundo. Se originó hace millones de años a partir de los mares primitivos. Rodeado de majestuosos volcanes, deslumbra casi de forma surrealista en el sol abrasador del desierto de Atacama. Menos del 0,5 por ciento del enorme salar son pequeñas lagunas o estanques en la meseta. Hace tiempo que la gran mayoría se ha secado y se muestran como extrañas formaciones de sal.

Salar di Atacama

Il Salar di Atacama è il più grande bacino salato del Cile, con ben 3000 km², e il terzo al mondo. Nacque milioni di anni fa dai mari dei tempi più remoti. Circondato da vulcani maestosi, brilla in modo quasi surreale al sole splendente del deserto di Atacama. Meno dello 0,5% dell'enorme lago salato è formato da lagune o piccoli stagni nell'altipiano. La maggior parte è asciutta da molto tempo e rivela bizzarre formazioni saline.

Salar de Atacama

De Salar de Atacama is met zijn ruim 3000 km² het grootste zoutbekken van Chili en het op twee na grootste ter wereld. Het ontstond miljoenen jaren geleden uit oermeren en is nu omgeven door majestueuze vulkanen, die op bizarre wijze in de meedogenloze zon van de Atacamawoestijn glinsteren. Minder dan een half procent van het reusachtige zoutmeer op de hoogvlakte bestaat uit lagunes of kleine poelen, de rest is allang uitgedroogd en bestaat uit talloze bizarre zoutformaties.

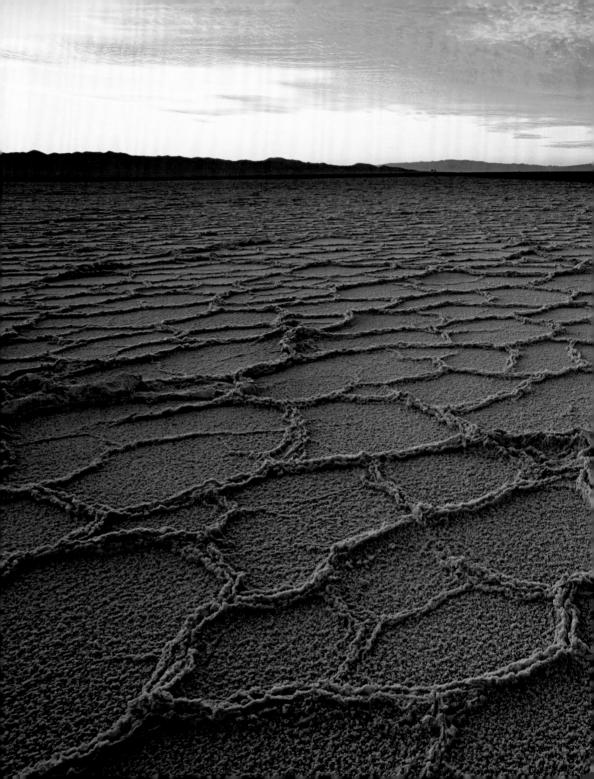

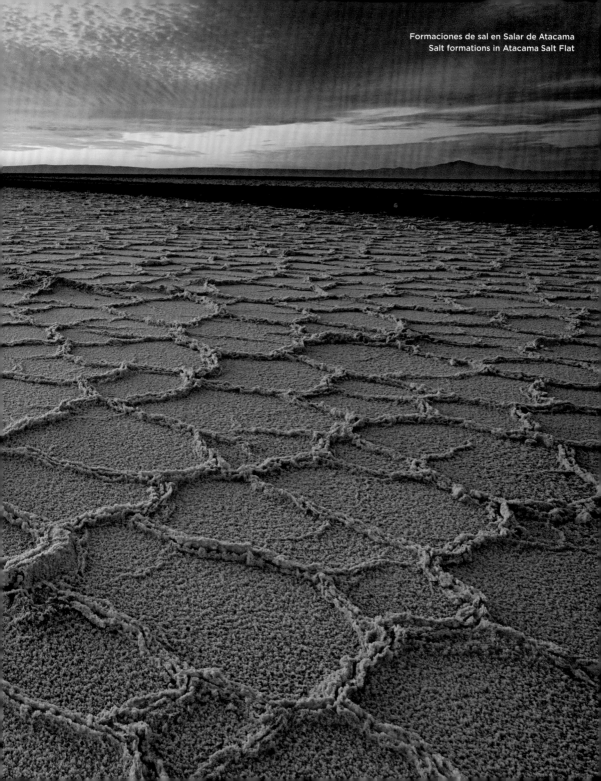

Formaciones de sal en Salar de Atacama
Salt formations in Atacama Salt Flat

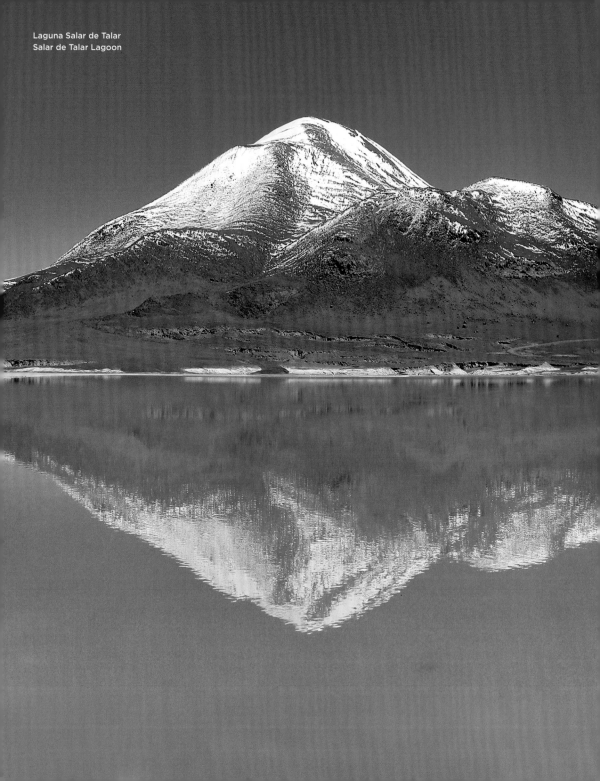

Laguna Salar de Talar
Salar de Talar Lagoon

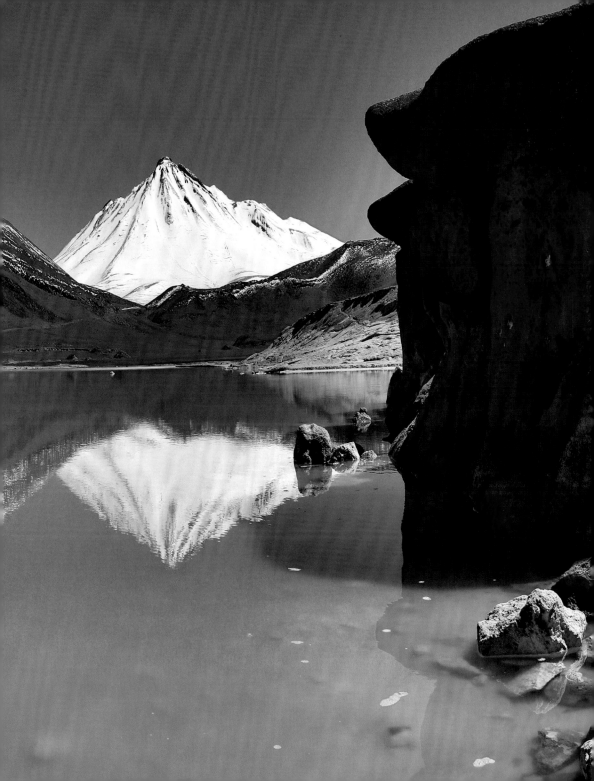

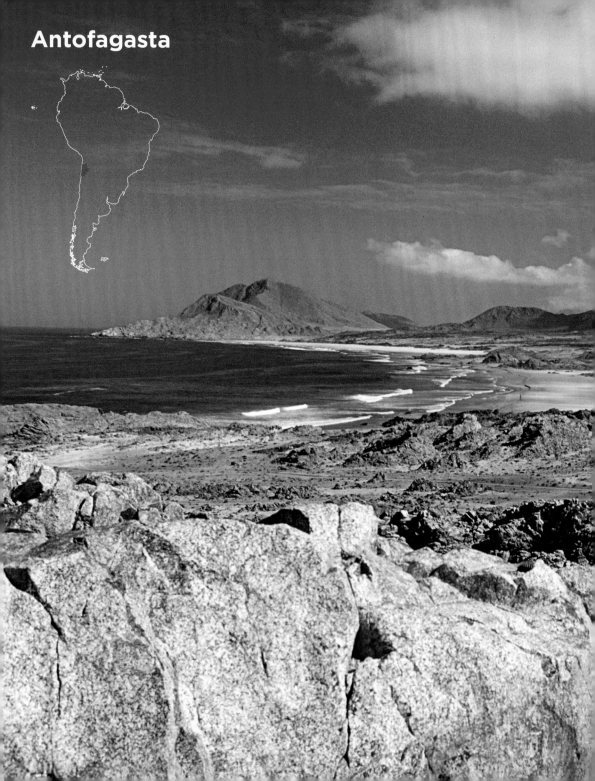

Antofagasta

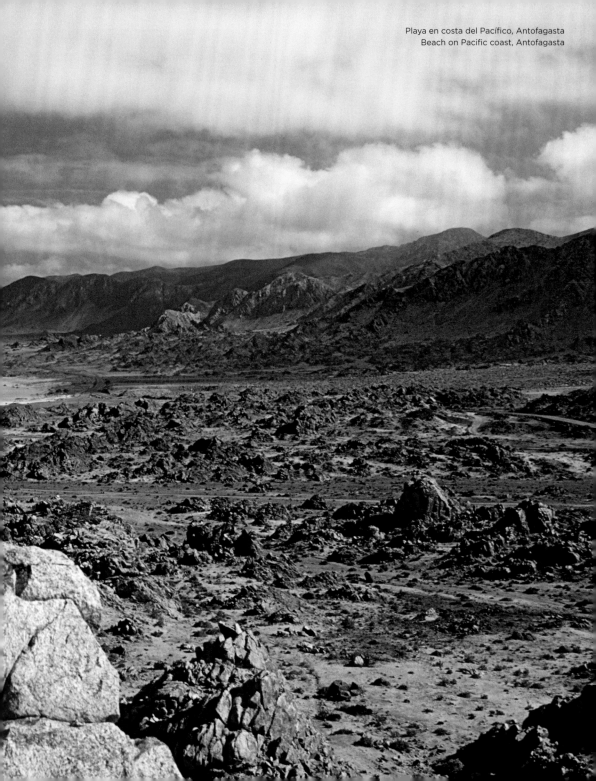

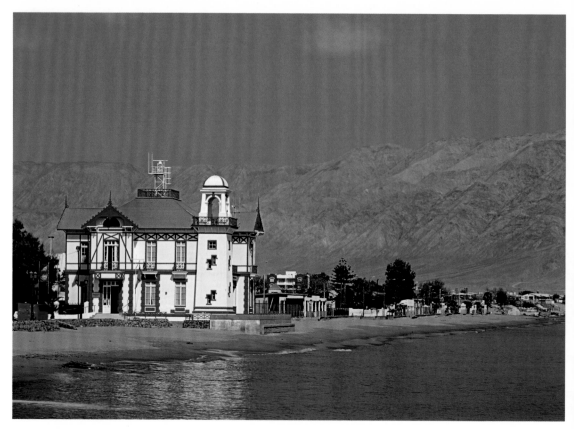

Playa de Mejillones
Beach in Mejillones

Antofagasta

Barren desert almost to the shores of
the Pacific. Volcanoes and hills, cliffs and
canyons. And almost never even a drop of
rain. The region around the harbor town
of Antofagasta may appear to be a hostile
no-man's land, but it is home to 90 species
of native wildflowers. A truly special
experience is on offer when it does actually
rain every year or two and the desert
explodes in a riot of color.

Antofagasta

Le désert aride s'étend jusqu'aux rivages
du Pacifique : volcans, collines, éperons
rocheux et canyons, sur lesquels ne
tombe pratiquement aucune goutte d'eau.
La région autour de la ville portuaire
d'Antofagasta tient vraiment du no man's
land. Pourtant, 90 variétés de fleurs
sauvages endémiques prospèrent dans
cette contrée désertique. Un spectacle
fantastique se produit parfois, lorsque
tombe la pluie et que le désert se pare de
milliers de fleurs.

Antofagasta

Karge Wüste bis an die Gestade des
Pazifiks. Vulkane und Hügel, Felsklippen
und Canyons. Und fast nie ein Tropfen
Regen. Die Region um die Hafenstadt
Antofagasta gilt als unwirtliches
Niemandsland. Dennoch gedeihen in
dieser kargen Einöde 90 verschiedene hier
heimische Wildblumenarten. Ein absolutes
Ereignis ist es, wenn es alle paar Jahre
einmal regnet und die Wüste in tausend
Farben erblüht.

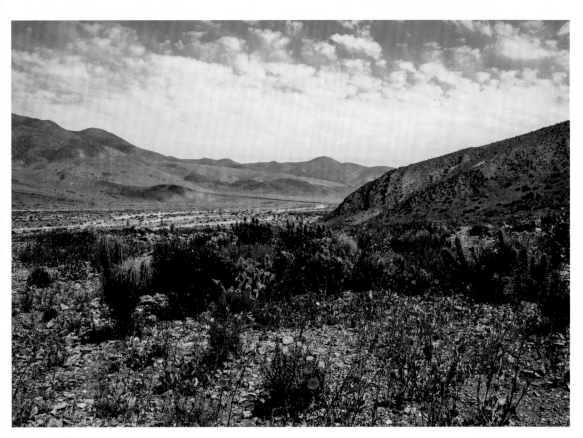

Desierto de Atacama
Atacama Desert

Antofagasta

Árido desierto a la orilla del Pacífico.
Volcanes y colinas, acantilados y cañones.
Y casi nunca una gota de lluvia. La región
alrededor de la ciudad portuaria de
Antofagasta está considerada como una
inhóspita tierra de nadie. Sin embargo,
prosperan en esta tierra árida 90 diferentes
especies nativas de flores silvestres. Un
evento increíble tiene lugar cuando llueve
una vez cada pocos años y el desierto
florece en mil colores.

Antofagasta

L'arido deserto fino alle coste del Pacifico.
Vulcani e colline, scogli rocciosi e canyon,
raramente una goccia di pioggia. La
regione intorno alla città portuale di
Antofagasta è considerata una terra di
nessuno inospitale. Tuttavia in questo
luogo desolato crescono 90 diverse varietà
locali di fiori selvatici. Quando piove una
volta ogni due anni e il deserto fiorisce di
mille colori è un vero avvenimento.

Antofagasta

Dit kale landschap strekt zich tot aan de
branding van de Grote Oceaan uit. De
vulkanen, heuvels, rotsklippen en ravijnen
ontvangen vrijwel geen druppel regen.
De regio rond de havenstad Antofagasta
geldt als een onwerkelijk niemandsland,
maar toch vormt de kurkdroge woestenij
het leefgebied van ruim negentig inheemse
soorten wilde bloemen. Dus áls het eens
in de zoveel jaar regent, komt de woestijn
in een spektakel van duizend kleuren
tot bloei.

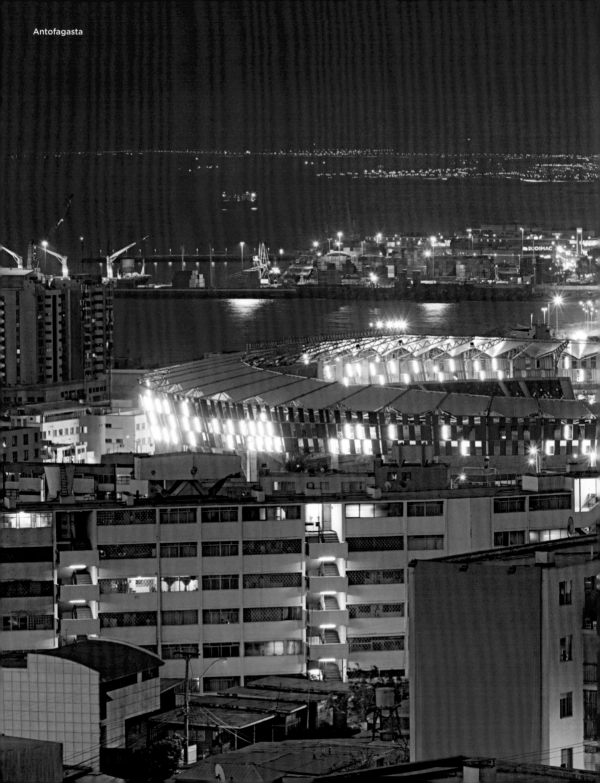

Antofagasta

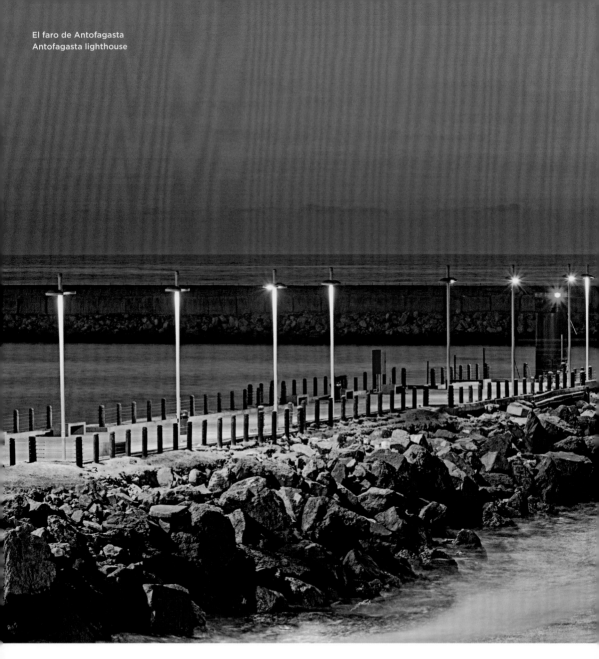

El faro de Antofagasta
Antofagasta lighthouse

Antofagasta

This capital of the province of the same name extends for more than 20 km (12 mi) along the Pacific coast. The port of the second-largest city of Chile is one of the most important in the country and not just for copper exports.

Antofagasta

La capitale de la région du même nom s'étend sur plus de 20 km le long du littoral Pacifique. Le port de la deuxième plus grande ville du Chili est l'un des plus importants du pays – pour l'exportation de cuivre, mais pas uniquement.

Antofagasta

Die Hauptstadt der gleichnamigen Region zieht sich über mehr als 20 km an der Pazifikküste entlang. Der Hafen der zweitgrößten Stadt Chiles zählt zu einem der wichtigsten des Landes – nicht nur für den Kupferexport.

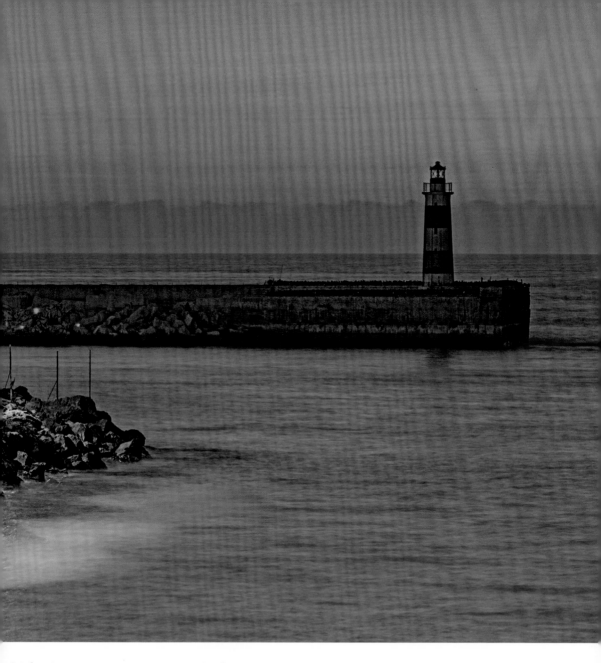

Antofagasta

La capital de la región con el mismo nombre tiene más de 20 km de costa a lo largo del Pacífico. El puerto de la segunda ciudad más grande de Chile es uno de los más importantes del país – no sólo para la exportación del cobre.

Antofagasta

Il capoluogo della regione omonimo si estende per più di 20 km lungo la costa pacifica. Il porto, il secondo del Cile, è uno dei più importanti del paese, non solo per l'esportazione di rame.

Antofagasta

De hoofdstad van de gelijknamige regio strekt zich ruim 20 km langs de Pacifische kust uit. De op één na grootste stad van Chili is een van de belangrijkste havens van het land, niet alleen voor de koperexport.

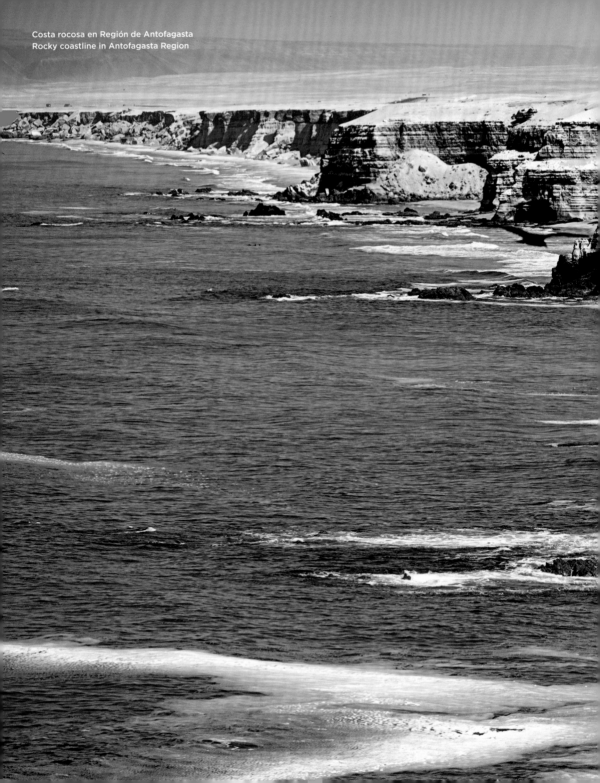
Costa rocosa en Región de Antofagasta
Rocky coastline in Antofagasta Region

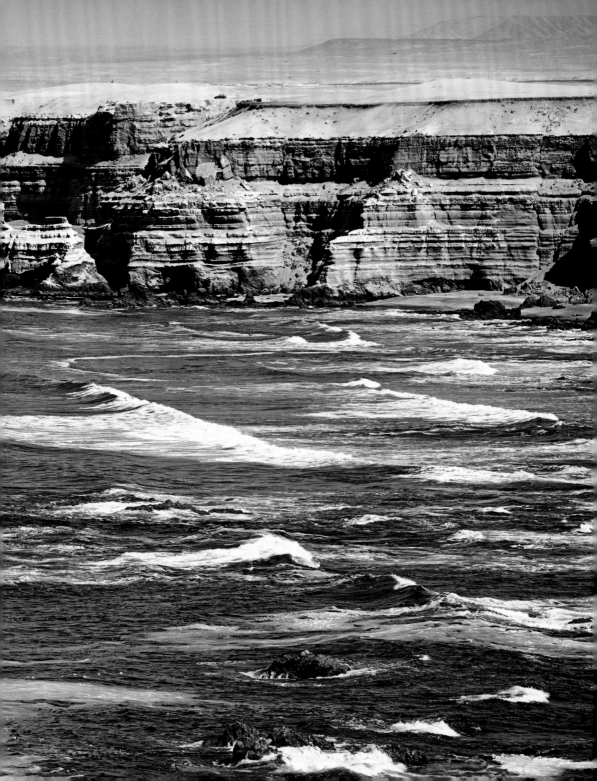

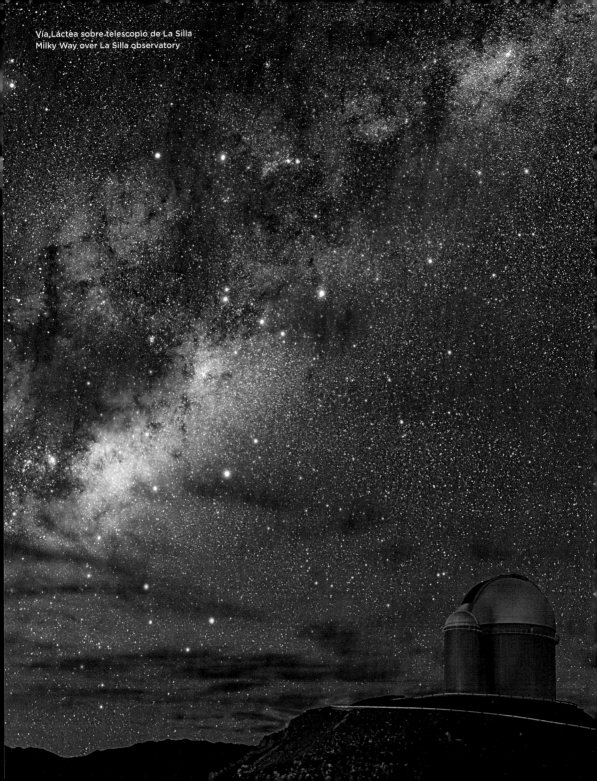

Vía Láctea sobre telescopio de La Silla
Milky Way over La Silla observatory

Cerro Paranal (2635 m) con Telescopio Muy Grande
Mount Paranal (2635 m · 8645 ft) with Very Large Telescope

Observatories

So close to the stars: Nowhere else in the world is the air so dry and so clear as in the Atacama Desert, which is why scientists have set up more than a dozen internationally prominent observatories in the Antofagasta region, including the European Paranal Observatory on Cerro Paranal with its "Very Large Telescope" and the telescopes of La Silla and Las Campanas.

Observatorios

Las estrellas tan cerca: casi en ninguna parte del mundo el aire es tan seco y tan claro como en el desierto de Atacama. Los científicos han construido en la región de Antofagasta más de una docena de observatorios de renombre internacional. Especialmente el Observatorio Paranal del Observatorio Europeo Austral en Cerro Paranal con el Very Large Telescope y los telescopios de La Silla y Las Campanas.

Observatoires

Si près des étoiles : aucune région du globe ne dispose d'un air aussi sec et aussi pur que le désert d'Atacama. Les scientifiques du monde entier ont érigé dans la région d'Antofagasta plus d'une dizaine d'observatoires renommés. Citons notamment l'observatoire européen de Paranal, installé sur le mont Cerro Paranal tout comme le Very Large Telescope, ainsi que les observatoires de La Silla et Las Campanas.

Osservatori astronomici

Così vicino alle stelle: in quasi nessun altro posto al mondo l'aria è così secca e limpida come nel deserto di Atacama. Nella regione di Antofagasta gli scienziati hanno fondato più di una dozzina di osservatori astronomici di fama internazionale. Tra tutti il Paranal dell'Osservatorio Europeo Australe sul Cerro Paranal, con il VLT (Very Large Telescope), oltre ai telescopi di La Silla e Las Campanas.

Sternwarten

Den Sternen so nah: Fast nirgendwo auf der Welt ist die Luft so trocken und so klar wie in der Atacama-Wüste. Wissenschaftler haben in der Region Antofagasta mehr als ein Dutzend international renommierter Sternwarten errichtet. Allen voran das Paranal-Observatorium der Europäischen Südsternwarte auf dem Cerro Paranal mit dem Very Large Telescope sowie die Teleskope von La Silla und Las Campanas.

Observatoria

Dichterbij de sterren: bijna nergens op aarde is de lucht zó droog en schoon als in de Atacamawoestijn. Wetenschappers hebben in de regio Antofagasta meer dan tien internationaal gerenommeerde observatoria gebouwd. Een van de belangrijkste is het Paranal-observatorium van de Europese Zuidelijke Sterrenwacht, met de Very Large Telescope op de Cerro Paranal en de telescopen van La Silla en Las Campanas.

La Portada, Antofagasta
La Portada, Antofagasta

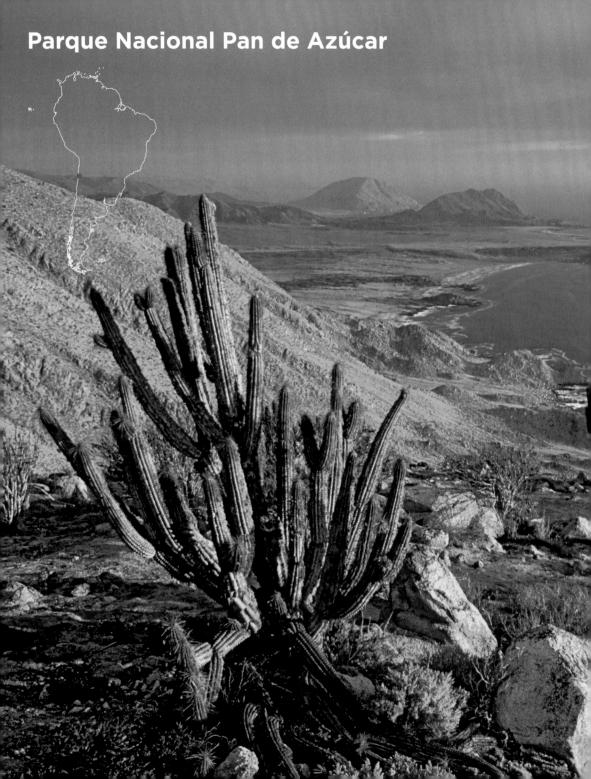

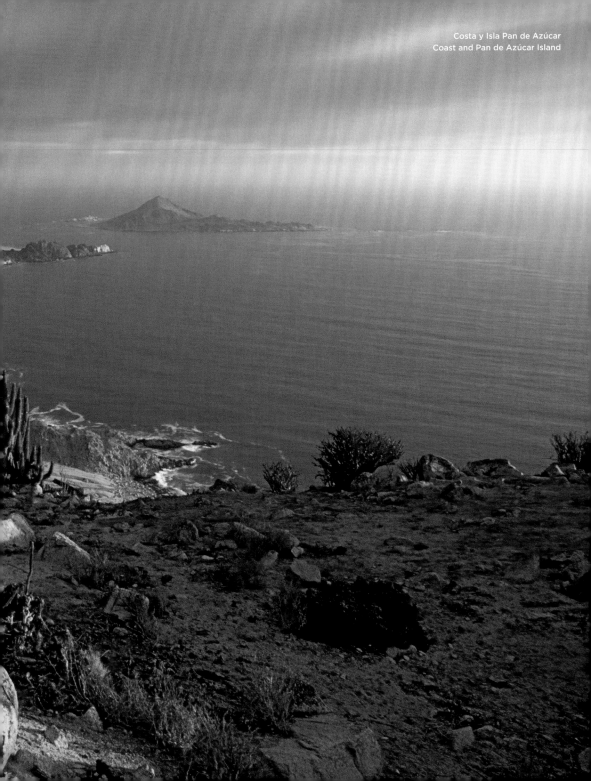

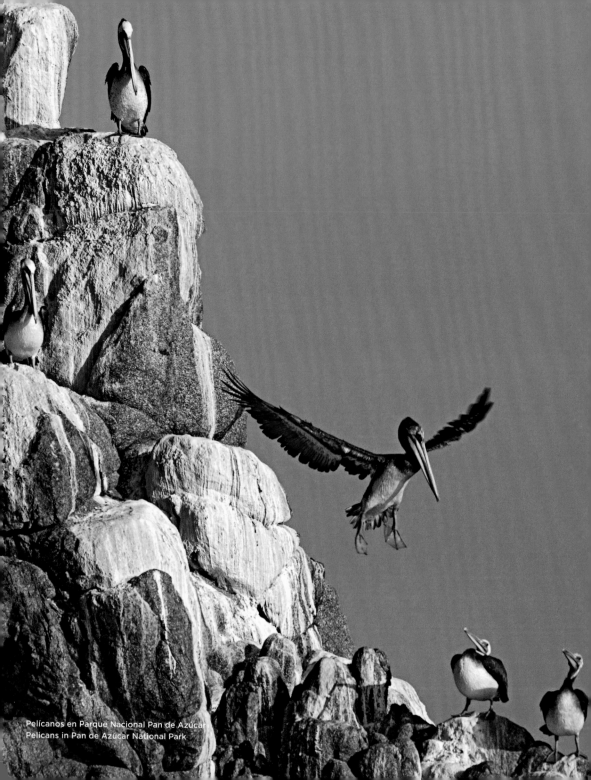

Pelícanos en Parque Nacional Pan de Azúcar
Pelicans in Pan de Azúcar National Park

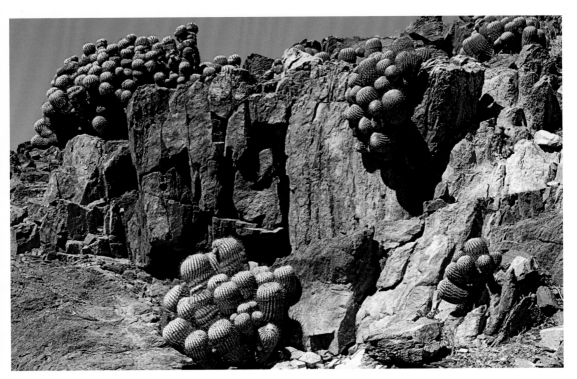

Cactus en Parque Nacional Pan de Azúcar
Cacti in Pan de Azúcar National Park

Pan de Azúcar National Park

This park named for "sugar bread" was established on the boundary between the Atacama und Antofagasta regions to protect native species. The bone-dry mountains along the sea are home to succulents, dwarf shrubs, and almost 30 species of cactus, of which 21 are found only here. They get their water from the fog rolling in off the coast.

Parque Nacional Pan de Azúcar

Pan de Azúcar. En la zona fronteriza entre las regiones de Atacama y Antofagasta, el Parque Nacional se consagra a proteger las especies nativas. En las increíblemente secas montañas del mar prosperan, gracias a la niebla costera, suculentas plantas, arbustos enanos y cerca de 30 especies de cactus, 21 de los cuales son endémicos de esta zona.

Parc national Pan de Azúcar

Le parc national Pan de Azúcar (pain de sucre), qui s'étend sur les régions d'Atacama et d'Antofagasta, est dédié à la protection des espèces endémiques. Sur les rives très sèches de l'océan, les embruns suffisent aux plantes succulentes, aux arbustes nains et à quelque 30 variétés de cactus, dont 21 ne poussent qu'à cet endroit du globe.

Parco Nazionale Pan de Azúcar

Pan de Azúcar, il Pan di Zucchero. Nell'area di confine tra le regioni di Atacama e Antofagasta, il Parco Nazionale è stato dedicato alla protezione delle specie indigene. Nelle montagne dal terreno secco come la polvere situate sul mare, attraverso la foschia sulla costa crescono piante succulente, subarbusti e quasi 30 tipi di cactus, dei quali 21 esistono solo qui.

Nationalpark Pan de Azúcar

Pan de Azúcar – „Zuckerbrot". Im Grenzbereich zwischen den Regionen Atacama und Antofagasta hat sich der Nationalpark dem Schutz einheimischer Arten verschrieben. In den staubtrockenen Bergen am Meer gedeihen durch den Küstennebel Sukkulenten, Zwergsträucher und fast 30 Kakteenarten, von denen 21 nur hier vorkommen.

Nationaal Park Pan de Azúcar

Het reservaat van 'Pan de Azúcar' – Spaans voor 'suikerbrood' – ligt op de grens tussen de regio's Atacama en Antofagasta en biedt bescherming aan talloze inheemse soorten. Door de kustnevel in de kurkdroge bergen bij de oceaan gedijen hier vetplanten, dwergstruiken en bijna dertig soorten cactus, waarvan 21 alleen hier groeien.

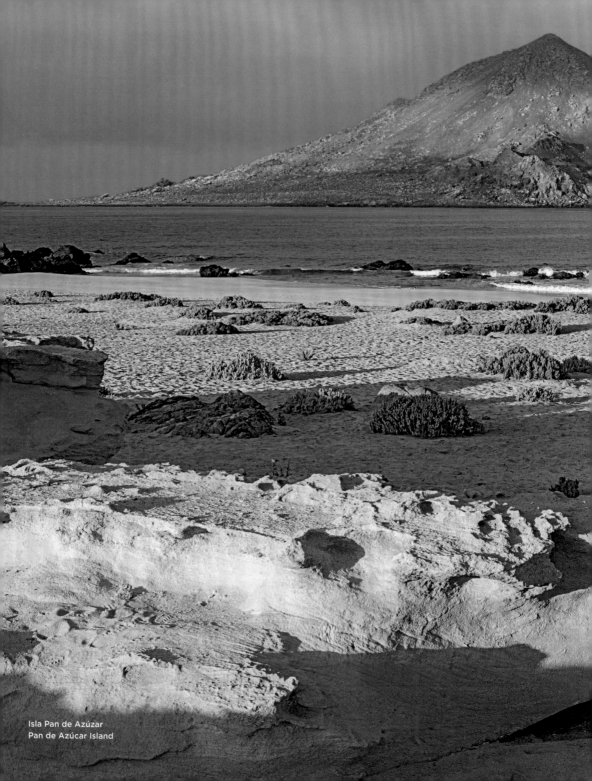

Isla Pan de Azúzar
Pan de Azúcar Island

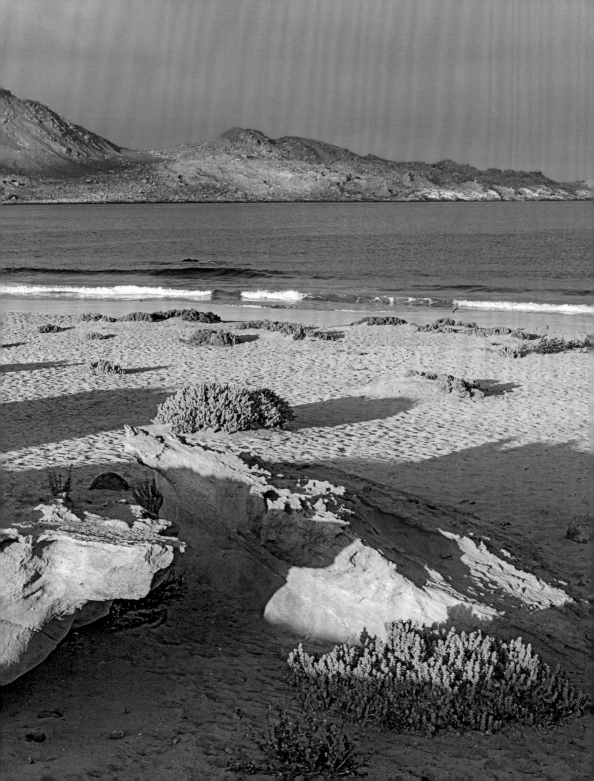

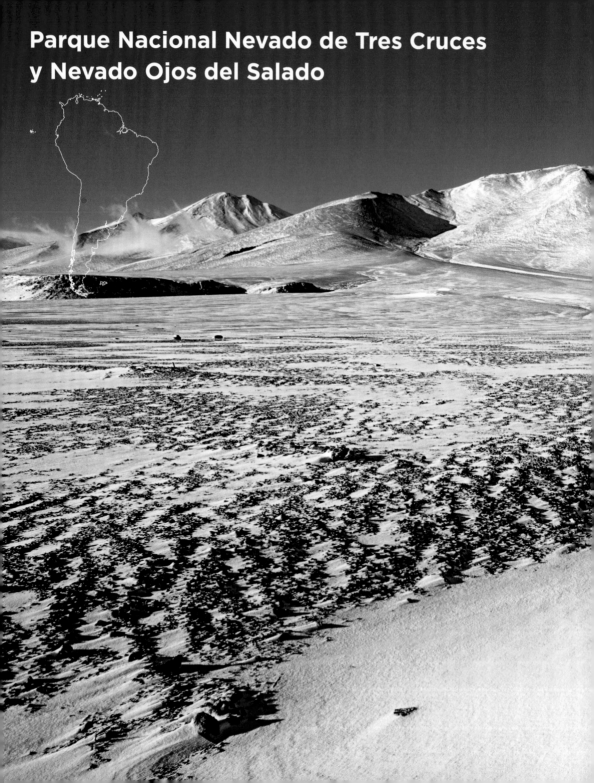

Parque Nacional Nevado de Tres Cruces y Nevado Ojos del Salado

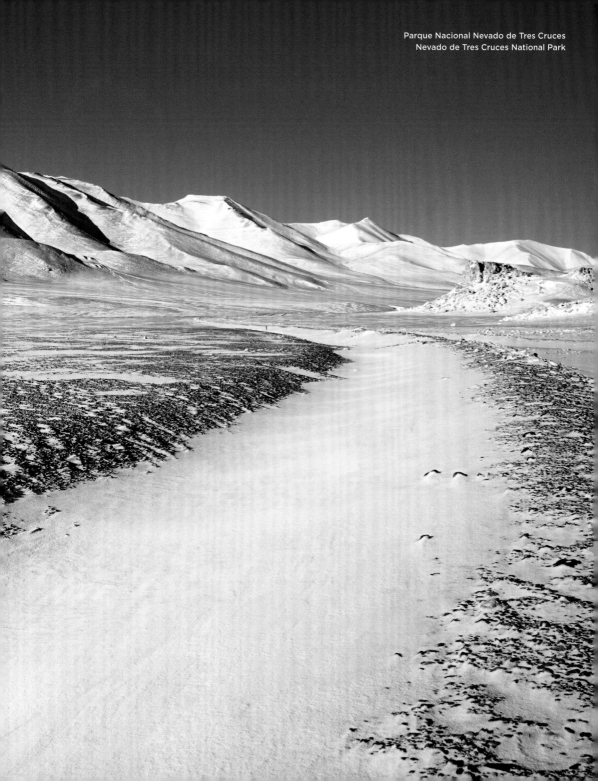

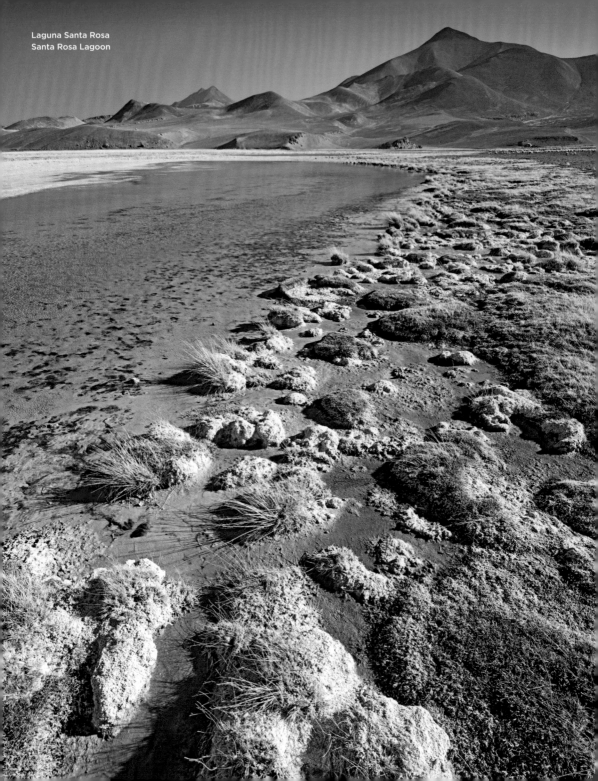

Laguna Santa Rosa
Santa Rosa Lagoon

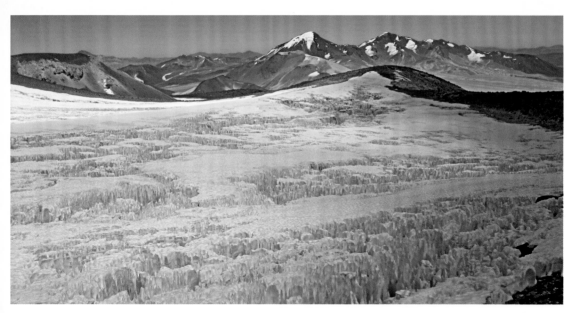

Glaciar del Nevado Ojos del Salado
Glacier at Nevado Ojos del Salado

Nevado de Tres Cruces National Park and Nevado Ojos del Salado

Snow-covered volcanic peaks, desert plains, glistening salt lakes: Nevado de Tres Cruces National Park is home to the volcano with the same name and offers an experience not unlike that of the Atacama, but on a smaller scale. Nature has created fascinating works of art on the volcano walls and it often takes more than one look to decide whether the bizarre formations are made of salt or ice. And above it all, the imposing peak of Nevado Ojos del Salado, just outside the park.

Parque Nacional Nevado de Tres Cruces y Ojos del Salado

Conos nevados de volcanes, llanuras desérticas, brillantes lagos de sal. El Parque Nacional Nevado de Tres Cruces, con el volcán del mismo nombre, mantiene la fascinación del desierto de Atacama en un espacio más pequeño. Centelleante arte natural se adhiere a las paredes volcánicas, y a menudo solo se puede saber en una segunda mirada si las estructuras cristalinas extrañas están formadas por sal o por hielo. Y sobresale por encima de todo – un poco fuera del parque – el cono imponente del Nevado Ojos del Salado, limítrofe con Argentina.

Parc national Nevado de Tres Cruces et Nevado Ojos del Salado

Volcans enneigés, plateaux désertiques et lac salés étincelants, le parc national Nevado de Tres Cruces, qui englobe le massif volcanique éponyme, concentre sur une petite superficie toute la fascination du désert d'Atacama. Sur les parois du volcan s'agrippent des structures cristallines, formations naturelles scintillantes, dont il est souvent difficile de déterminer au premier regard si elles sont constituées de glace ou de sel. Enfin, l'imposante silhouette volcanique du Nevado Ojos del Salado trône aux confins du parc.

Parco Nazionale Nevado de Tres Cruces e Nevado Ojos del Salado

Coni vulcanici innevati, pianure desertiche e splendidi laghi salati. Il Parco Nazionale Nevado de Tres Cruces, con il vulcano omonimo, riunisce in una piccola area tutto il fascino del deserto di Atacama. Le scintillanti opere d'arte della natura si aggrappano alle pareti vulcaniche, e spesso si può capire solo ad un secondo sguardo, se le bizzarre strutture di cristallo sono fatte di sale o ghiaccio. E sopra tutto questo, ma un po' fuori dal parco, troneggia l'imponente cono del Nevado Ojos del Salado.

Nationalpark Nevado de Tres Cruces und Nevado Ojos del Salado

Beschneite Vulkankegel, wüstenhafte Ebenen, gleißende Salzseen. Der Nationalpark Nevado de Tres Cruces mit dem gleichnamigen Vulkan fasst die ganze Faszination der Atacama-Wüste auf kleinem Raum zusammen. Glitzernde Kunstwerke der Natur krallen sich an Vulkanwände, und oft lässt sich erst auf den zweiten Blick erkennen, ob die bizarren Kristallstrukturen aus Salz oder aus Eis bestehen. Und über alledem thront, etwas außerhalb des Parks gelegen, der imposante Kegel des Nevado Ojos del Salado.

Nationaal Park Nevado de Tres Cruces en Nevado Ojos del Salado

Met zijn besneeuwde vulkaankegels, woestijnachtige plateaus en zinderende zoutmeren omvat het Nationale Park Nevado de Tres Cruces met de gelijknamige vulkaan bijna de volledige pracht van de Atacamawoestijn in één klein gebied. Glinsterende kunstwerken van de natuur bedekken de vulkaanhellingen, en vaak is pas bij nadere beschouwing te bepalen of deze bizarre kristalstructuren nu uit zout of ijs bestaan. Boven dit alles – en net buiten het park gelegen – torent de imposante kegel van de Nevado Ojos del Salado uit.

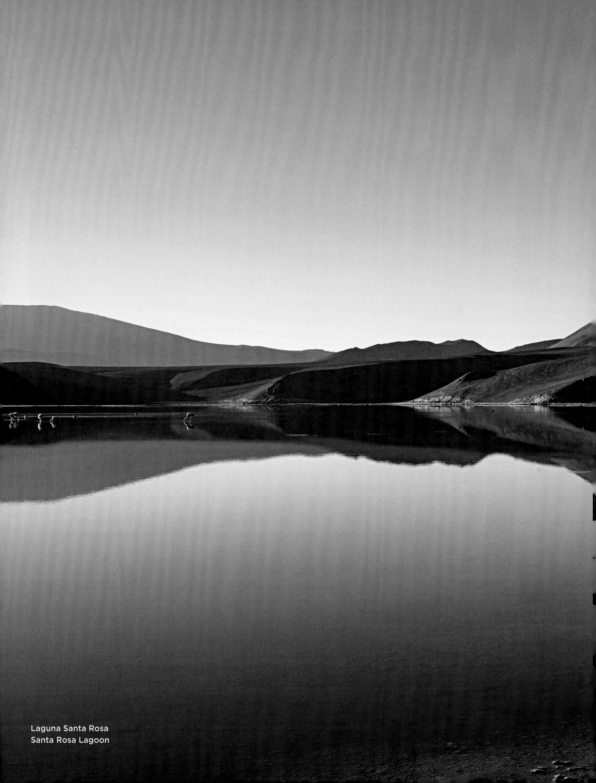

Laguna Santa Rosa
Santa Rosa Lagoon

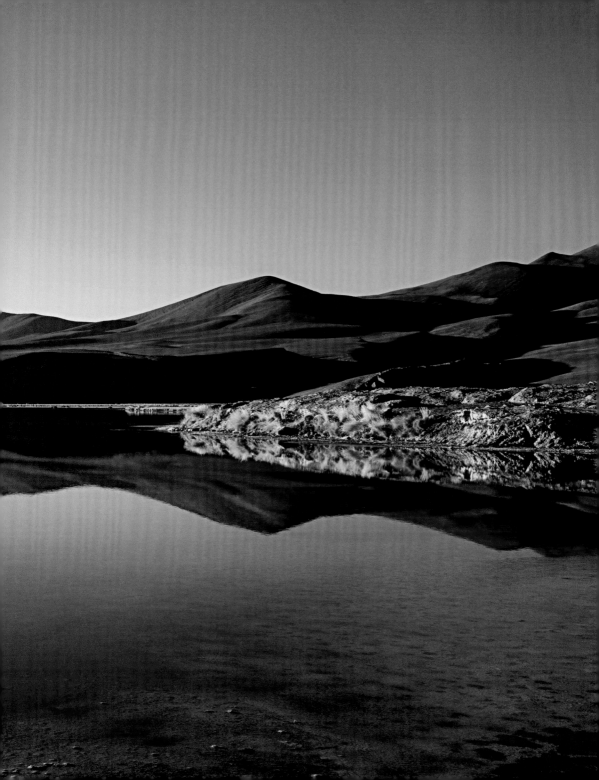

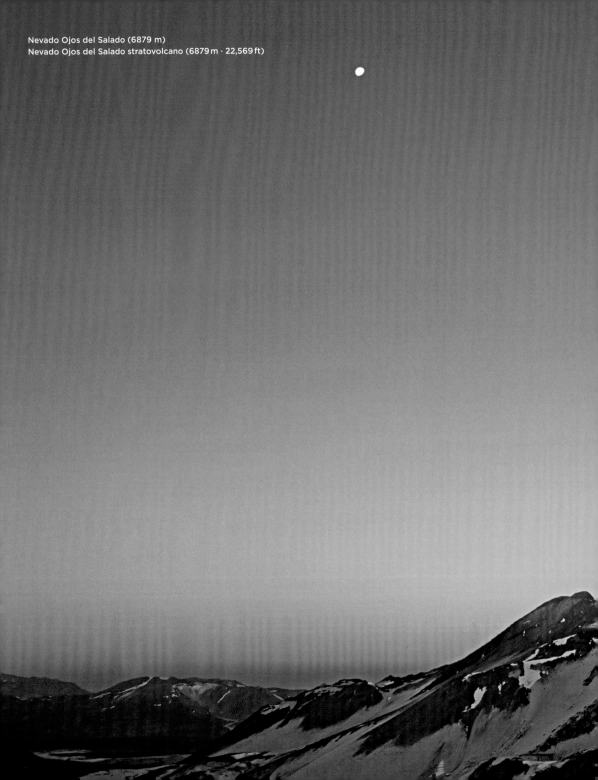

Nevado Ojos del Salado (6879 m)
Nevado Ojos del Salado stratovolcano (6879 m · 22,569 ft)

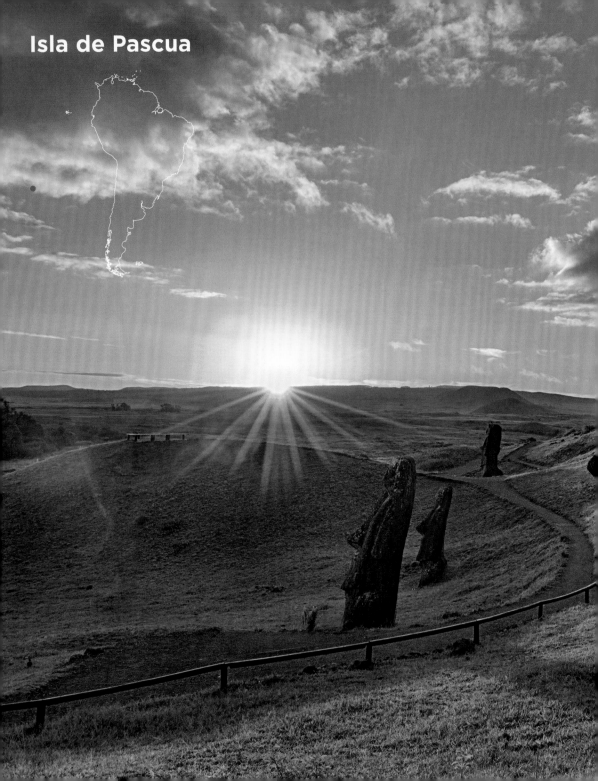

Isla de Pascua

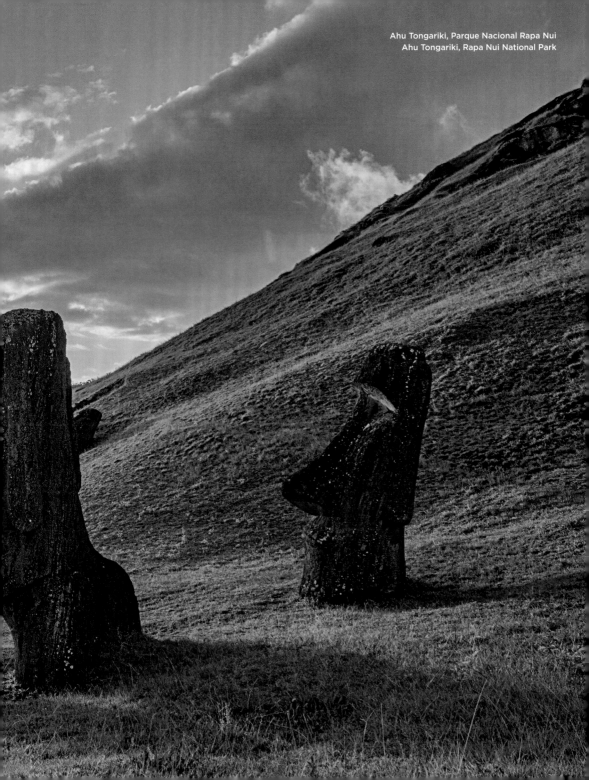

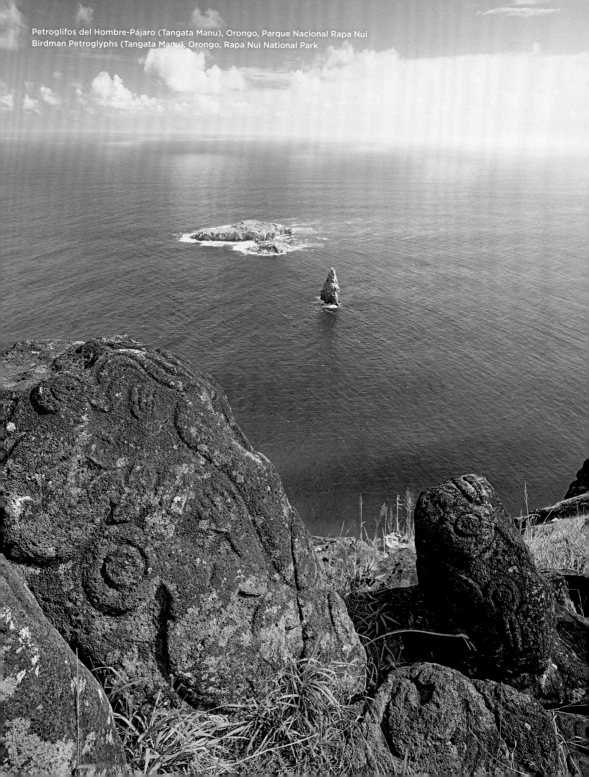

Petroglifos del Hombre-Pájaro (Tangata Manu), Orongo, Parque Nacional Rapa Nui
Birdman Petroglyphs (Tangata Manu), Orongo, Rapa Nui National Park

Campos volcánicos en costa sur, Parque Nacional Rapa Nui
Volcanic fields at southern coast, Rapa Nui National Park

Easter Island
Isolated. The stuff of legends. 3526 km (2191 mi) off the coast of Chile and geographically a part of Polynesia. It only measures 163.4 km² (63.1 sq mi) and is called Rapa Nui ("Big Island") by its inhabitants. Despite the warm, subtropical climate and adequate rain, the island is one of the least biodiverse on the planet. Rapanui is also the name of the Polynesian dialect that the island's natives speak. The language includes five vowels and only ten consonants. The official language, however, is Spanish and the younger generations and mainland Chileans who have moved here speak Spanish.

Isla de Pascua
Aislada. Legendaria. A 3526 km de la parte continental de Chile, cuenta geográficamente como Polinesia y mide solo 163,4 km² – aunque sus habitantes Rapa Nui la llamaran "Gran Isla". A pesar del clima subtropical cálido y de tener suficiente lluvia, la isla es uno de los tipos de isla más pobres del Pacífico Sur. Rapanui también se llama el dialecto polinesio, que hablan los habitantes de la isla de Ur. El lenguaje incluye cinco vocales y sólo diez consonantes. El idioma oficial, sin embargo, es el español y también cada vez más niños o chilenos provenientes del continente hablan español.

Île de Pâques
Isolée, légendaire, située à 3526 km de la côte chilienne, l'île fait géographiquement partie de la Polynésie. Sa superficie n'est que de 163,4 km², même si elle est appelée «grande île» par ses habitants, les Rapa Nui. Malgré un climat subtropical doux et des pluies suffisantes, l'île fait partie des régions du Pacifique sud les plus pauvres en espèces végétales. Le dialecte polynésien parlé par les Rapa Nui, insulaires d'origine, s'appelle aussi le rapanui. Il compte cinq voyelles et seulement dix consonnes. Mais la langue officielle est l'espagnol et de plus en plus d'enfants de Chiliens ayant immigré sur le continent parlent l'espagnol.

Isola di Pasqua
Isolata. Leggendaria. Distante 3526 km dalla terraferma cilena, geograficamente appartiene alla Polinesia e misura soltanto 163,4 km², anche se i suoi abitanti, i Rapa Nui, la chiamano "la grande isola". Nonostante il clima caldo subtropicale e le piogge sufficienti, l'isola è una delle più povere di specie del Sud Pacifico. Si chiama Rapa nui anche il dialetto polinesiano parlato dai primi abitanti dell'isola. La lingua comprende cinque vocali e solo dieci consonanti. La lingua ufficiale resta comunque lo spagnolo, e sono sempre di più i bambini o coloro cresciuti sulla terraferma a parlare spagnolo.

Osterinsel
Die Osterinsel. Abgelegen. Sagenumwoben. 3526 km vom chilenischen Festland entfernt, zählt sie geografisch zu Polynesien und misst nur 163,4 km² – auch wenn sie von ihren Einwohnern Rapa Nui, „große Insel", genannt wird. Trotz des warmen subtropischen Klimas und genügend Regen zählt das Eiland zu den artenärmsten Inseln im Südpazifik. Rapanui heißt auch der polynesische Dialekt, den die Ur-Insulaner sprechen. Die Sprache umfasst fünf Vokale und nur zehn Konsonanten. Die Amtssprache ist allerdings Spanisch und auch immer mehr Kinder oder zugezogene Festland-Chilenen sprechen Spanisch

Paaseiland
Het afgelegen en mythische eiland ligt 3526 km van het Chileens vasteland en behoort geografisch tot Polynesië. Paaseiland is slechts 163,4 km² groot maar wordt door de inheemse bewoners 'Rapa Nui' genoemd, het 'Grote Eiland'. Ondanks het warme subtropische klimaat en voldoende neerslag is Paaseiland een van de eilanden met de minste biodiversiteit in de Stille Zuidzee. 'Rapa Nui' wordt ook de Polynesische taal genoemd die door de inheemse bevolking wordt gesproken en die vijf klinkers en tien medeklinkers omvat. De officiële taal is het Spaans, dat steeds meer wordt gesproken – door de jeugd en door immigranten vanaf het vasteland

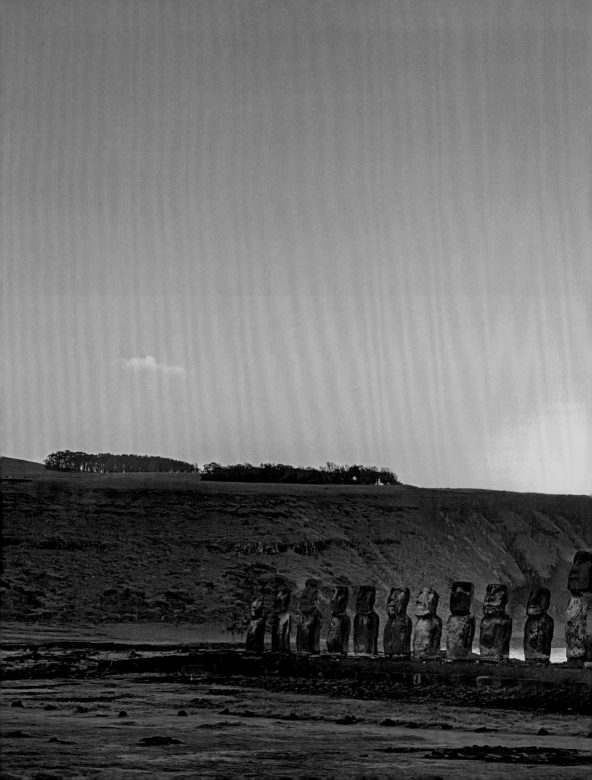

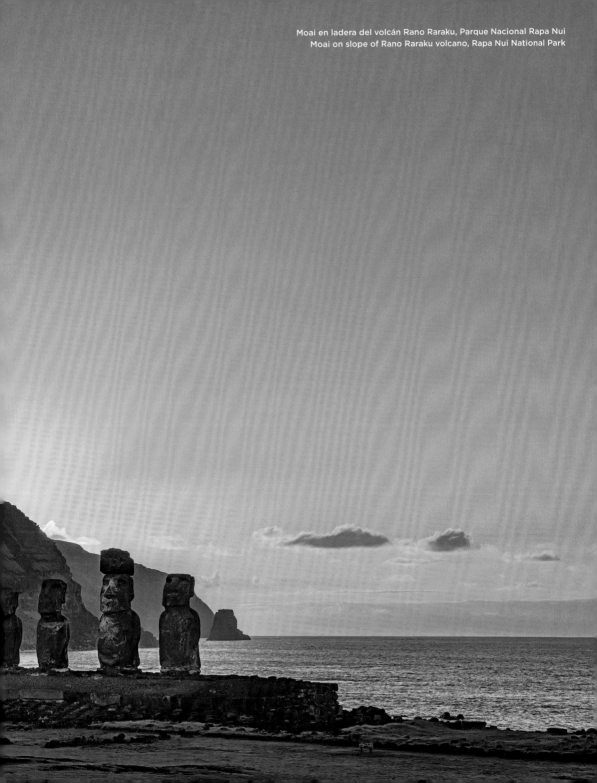

Moai en ladera del volcán Rano Raraku, Parque Nacional Rapa Nui
Moai on slope of Rano Raraku volcano, Rapa Nui National Park

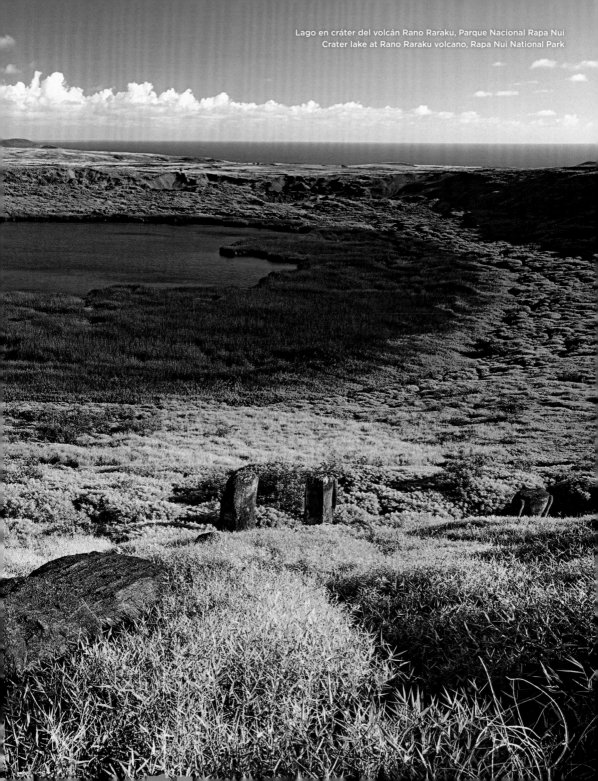

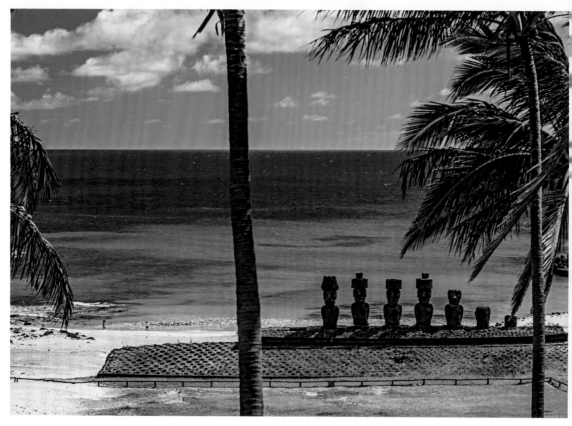

Moáis, Parque Nacional Rapa Nui
Moais, Rapa Nui National Park

Birdman cult

Drawings on the cliffs of Rapa Nui tell of an unusual prehistoric ritual for choosing the ruler of Easter Island, known as the birdman. Every year, warriors of different tribes came together. Their task was to be the first to find a sooty tern egg on the outlying island of Motu Nui, bring it back to the main island, and climb the cliffs to the village of Orongo.

Culte de l'homme-oiseau

Les légendes des Rapa Nui transmises par les peintures rupestres racontent un étonnant rituel pour désigner le souverain de l'île de Pâques – l'homme-oiseau. Chaque année, des guerriers de différentes tribus se livraient une compétition. Leur tâche : se saisir du premier œuf de sternes fuligineuses pondu sur l'îlot au large de Motu Nui, le rapporter à la nage sur l'île principale et gravir avec lui les falaises, jusqu'au village d'Orongo.

Vogelmann-Kult

In Felszeichnungen überlieferte Legenden der Rapa Nui erzählen von einem ungewöhnlichen Ritual zur Bestimmung des Herrschers über die Osterinsel – des Vogelmanns. Alljährlich traten Krieger verschiedener Stämme gegeneinander an. Ihre Aufgabe: das erste Rußseeschwalbenei auf der vorgelagerten Insel Motu Nui finden, es schwimmend zur Hauptinsel zurückbringen und damit die Klippen zum Dorf Orongo hinaufklettern.

Ahu Te Pito Kura, Parque Nacional Rapa Nui
Ahu Te Pito Kura, Rapa Nui National Park

Ritual del hombre pájaro

Los tradicionales dibujos en roca de las
leyendas rapanui hablan de un ritual
inusual para determinar al gobernante
de la Isla de Pascua – el ritual del hombre
pájaro. Cada año, los guerreros de
diferentes tribus competían entre sí. Su
misión: encontrar el primer huevo del
charrán sombrío en el islote de Motu Nui,
situado enfrente, traerlo de vuelta a la
isla principal y subir por los acantilados al
pueblo de Orongo.

Il culto dell'Uomo-uccello

Le leggende del Rapa Nui, ritrovate su
alcune incisioni rupestri, narrano di un
insolito rituale per eleggere il dominatore
dell'isola di Pasqua: l'uomo uccello. Ogni
anno vi prendevano parte diversi guerrieri
di varia origine. Il loro compito: trovare
il primo uovo depositato dalla sterna
fuliginosa nella vicina isola di Motu Nui,
riportarlo a nuoto fino all'isola principale
e risalire per gli scogli fino al villaggio
di Orongo.

Vogelmancultuur

De legenden van de Rapa Nui, die in
rotstekeningen zijn overgeleverd, vertellen
van de Vogelmancultus waarmee de
heerser over Paaseiland werd gekozen.
Elk jaar namen krijgers van de diverse
stammen het tegen elkaar op. Zij moesten
op het voor de kust gelegen eilandje Mou
Nui het eerste ei van de bonte stern vinden,
ermee naar het vasteland terugzwemmen
en het dan over de klippen naar het dorp
Orongo brengen.

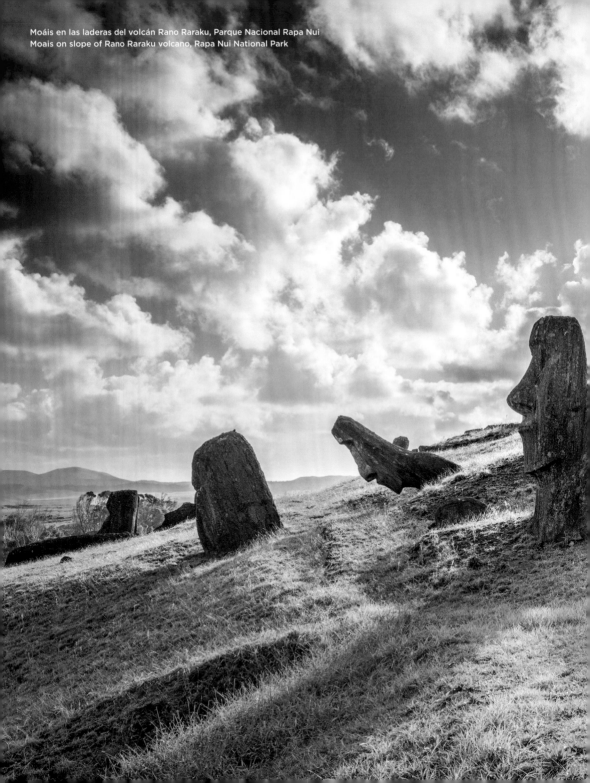

Moáis en las laderas del volcán Rano Raraku, Parque Nacional Rapa Nui
Moais on slope of Rano Raraku volcano, Rapa Nui National Park

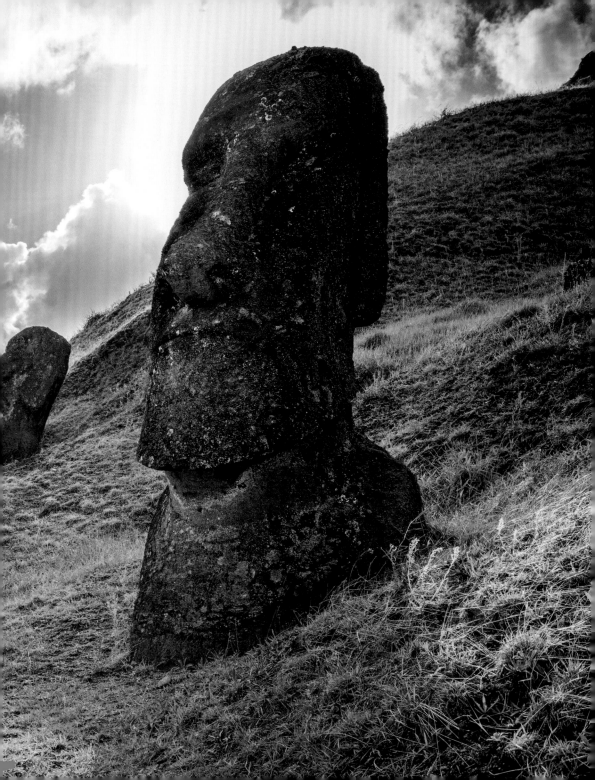

Playa Ananeka, Parque Nacional Rapa Nui
Ananeka Beach, Rapa Nui National Park

Stone sculptures

Across the entire island, the Rapa Nui people built more than 900 moai, monumental sculptures made from rock from the Rano Raraku quarry. No one still believes Erich von Däniken's theory that it was aliens stranded on the island who carved the stone figures and brought them to their present locations. The movement of these figures, some of which are up to ten meters (33 ft) tall, is probably responsible for the loss of the island's once-dense palm forest. One of the greatest human interventions to an ecological system ever experienced.

Sculptures de pierre

Les Rapa Nui érigèrent plus de 900 sculptures monumentales – ou moaï – réparties sur toute l'île. Plus personne aujourd'hui ne croit à la théorie d'Erich von Däniken, selon laquelle des extra-terrestres atterris sur l'île auraient sculpté les statues de pierre et les auraient placées à leur emplacement actuel. Les palmeraies de l'île, autrefois denses furent décimées pour le transport de ces statues pouvant atteindre dix mètres de haut. Cet épisode compte parmi les interventions les plus massives que l'homme ait imposées à un écosystème.

Steinskulpturen

Über die ganze Insel verteilt errichteten die Rapa Nui mehr als 900 Moai – monumentale Skulpturen aus dem Gestein des Steinbruchs Rano Raraku. An die Theorie Erich von Dänikens, Außerirdische seien auf der Insel gestrandet, hätten die Steinfiguren geschnitzt und zu ihren heutigen Standorten gebracht, glaubt heute keiner mehr. Dem Transport der bis zu zehn Meter hohen Figuren fielen wohl die einst dichten Palmwälder der Insel zum Opfer – einer der massivsten menschlichen Eingriffe, die je ein Ökosystem auf dem Planeten erlebt hat.

Esculturas de piedra

En toda la isla, los Rapanui construyeron más de 900 moáis – monumentales esculturas de la roca de la cantera del Rano Raraku. Según la teoría de Erich von Däniken, los alienígenas habrían naufragado en la isla, habrían tallado las figuras de piedra y las habrían llevado a sus lugares actuales, teoría que nadie cree hoy en día. El transporte de las figuras de hasta diez metros de altura recayó probablemente en los una vez densos palmerales de la isla que resultaron víctimas de una de la intervenciones humanas más masivas que nunca ha experimentado un ecosistema en el planeta.

Sculture in pietra

Su tutta l'isola i Rapa Nui hanno distribuito più di 900 moai: sculture monumentali realizzate con la cava di pietra del Rano Raraku. Ormai oggi nessuno dà più credito alla teoria di Erich von Däniken, secondo la quale gli extraterresti atterrarono sull'isola, plasmarono figure a loro somiglianza e le portarono dove si trovano adesso. Per il trasporto delle figure alte fino a dieci metri furono sacrificati i fitti palmeti dell'isola, uno degli interventi umani più massicci che sia mai avvenuto in un ecosistema sul pianeta.

De stenen moai

Verspreid over het eiland richtten de Rapa Nui ruim 900 moai op – enorme beelden van steenblokken uit de groeve van Rano Raraku. De theorie van Erich von Däniken, die meende dat de moai waren uitgehouwen en op hun plek waren gezet door buitenaardse wezens die op het eiland waren gestrand, wordt door niemand meer serieus genomen. Voor het transport van deze soms wel tien meter hoge beelden werden de ooit dichte palmbossen op het eiland geveld – een van de meest rampzalige ingrepen die de mens ooit in een ecosysteem op aarde heeft verricht.

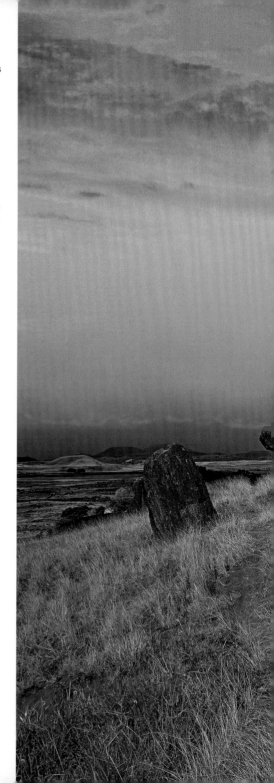

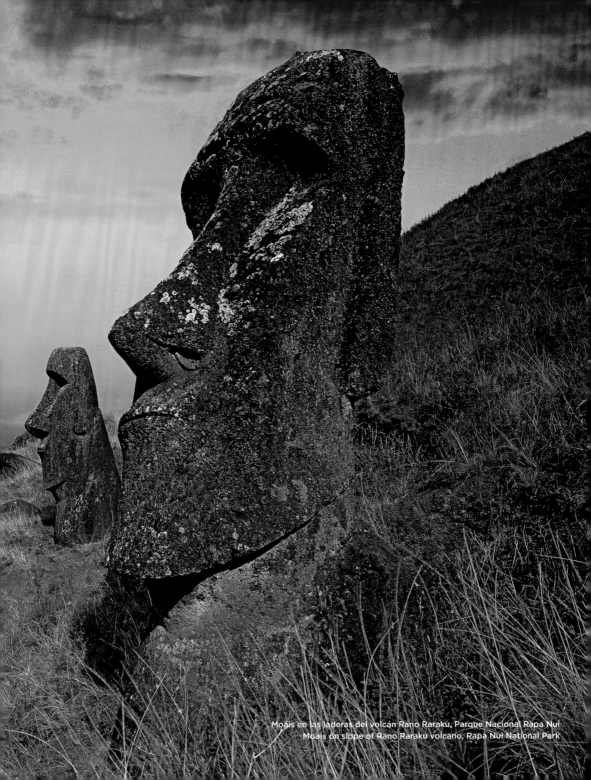

Moáis en las laderas del volcán Rano Raraku, Parque Nacional Rapa Nui
Moais on slope of Rano Raraku volcano, Rapa Nui National Park

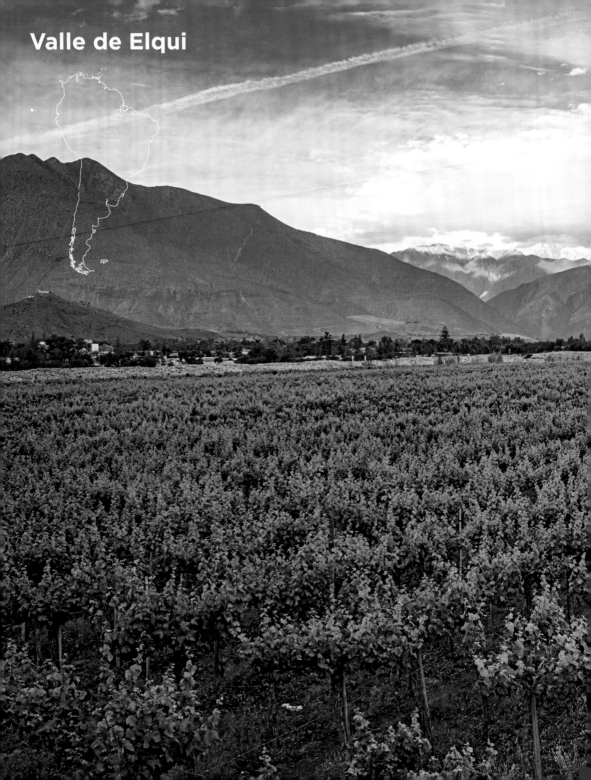

Valle de Elqui

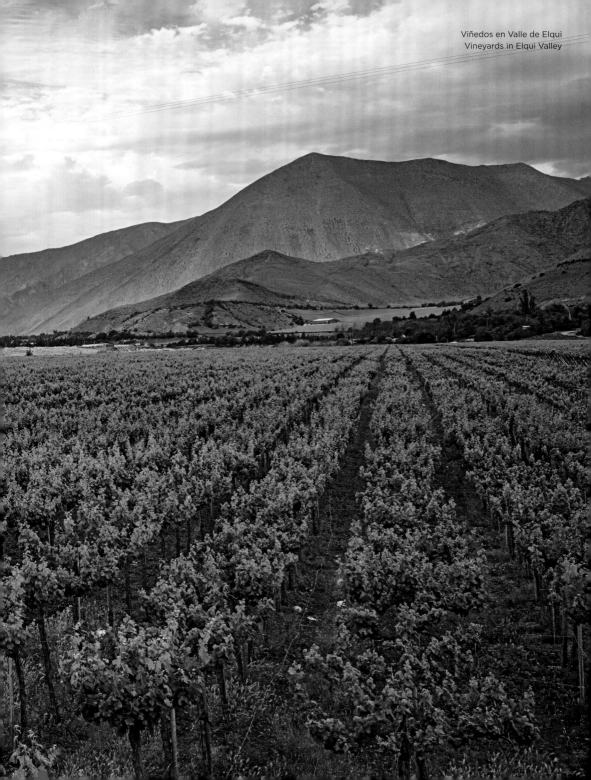

Viñedos en Valle de Elqui
Vineyards in Elqui Valley

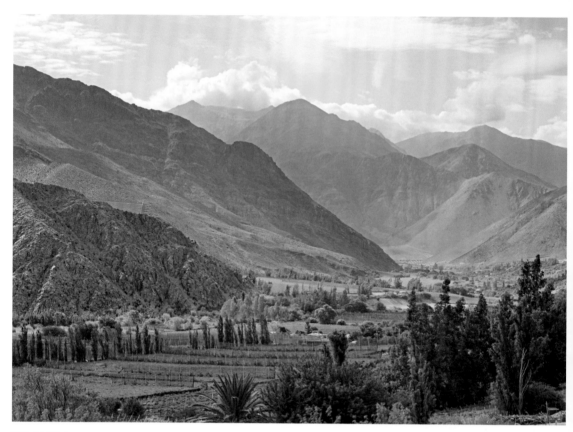

Valle de Elqui
Elqui Valley

Elqui Valley

The Elqui Valley serves as a large green oasis in the otherwise barren, desert-like Coquimbo region, full of thorny bushes and cacti. Much of the land in the valley has been converted to agricultural use, with many vineyards, orchards, and vegetable farms along the Río Elqui. Indeed, the Valle de Elqui is one of the biggest winegrowing regions in the country. Fertile deltas and the artificial Puclaro lake have created the basis for the excellent international reputation enjoyed by Chilean wines.

Vallée de l'Elqui

Telle une vaste oasis verte, la vallée de l'Elqui se loge au cœur de la région de Coquimbo, entre des chaînes montagneuses arides et désertiques où ne poussent qu'arbustes et cactus. Vignes, vergers et potagers dominent le paysage aux abords du fleuve Elqui. La vallée possède ainsi les cultures viticoles parmi les plus vastes du pays. Les terres fertiles des prairies en bordure de fleuve et le lac artificiel de Puclaro offrent les conditions idéales qui assurent aujourd'hui au vin chilien sa réputation mondiale.

Elqui-Tal

Wie eine große grüne Oase schmiegt sich das Elqui-Tal in der Region Coquimbo zwischen karge wüstenhafte Berge mit Dornsträuchern und Kakteen. Wein-, Obst- und Gemüsegärten dominieren das Landschaftsbild an vielen Stellen im Einzugsbereich des Río Elqui. Das Valle de Elqui zählt zu den größten Weinanbaugebieten des Landes. Fruchtbare Flussauen und der Puclaro-Stausee sind die Basis dafür, dass chilenischer Wein heute in aller Welt einen exzellenten Ruf genießt.

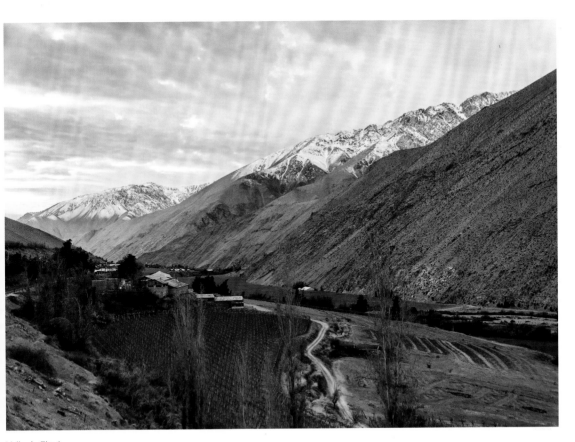

Valle de Elqui
Elqui Valley

Valle de Elqui

Como un gran oasis verde, el Valle del Elqui se encuentra en la región de Coquimbo entre áridas montañas desérticas con cardos y cactus. Huertas de viñas, frutas y verduras dominan el paisaje en muchos lugares del área de influencia del río Elqui. El Valle del Elqui es una de las regiones vinícolas más grandes del país. Una fértil llanura y el embalse Puclaro son la base para que el vino chileno tenga en la actualidad una excelente reputación a nivel mundial.

Valle di Elqui

La Valle di Elqui si stringe come una grande oasi verde nella regione di Coquimbo tra le aride montagne desertiche con arbusti spinosi e cactus. Vigneti, frutteti e orti dominano il paesaggio in molti luoghi del bacino idrografico del Rio Elqui. La Valle di Elqui è una delle maggiori zone di produzione vinicola del paese. Fertili pianure alluvionali e il lago artificiale Puclaro sono il motivo per cui oggi il vino cileno ha conquistato una fama eccellente in tutto il mondo.

Dal van de Elqui

Als een langgerekte groene oase slingert het dal van de Elqui in de regio Coquimbo zich tussen kale bergen door woestijnachtig gebied met doornstruiken en cactussen. Op veel plekken langs de Río Elqui wordt het landschap beheerst door wijngaarden, fruitboomgaarden en tuinbouwakkers. De Valle de Elqui behoort tot de belangrijkste wijnbouwregio's van het land. Dankzij vruchtbare ooipolders en het stuwmeer van Puclaro staan Chileense wijnen nu overal ter wereld in hoog aanzien.

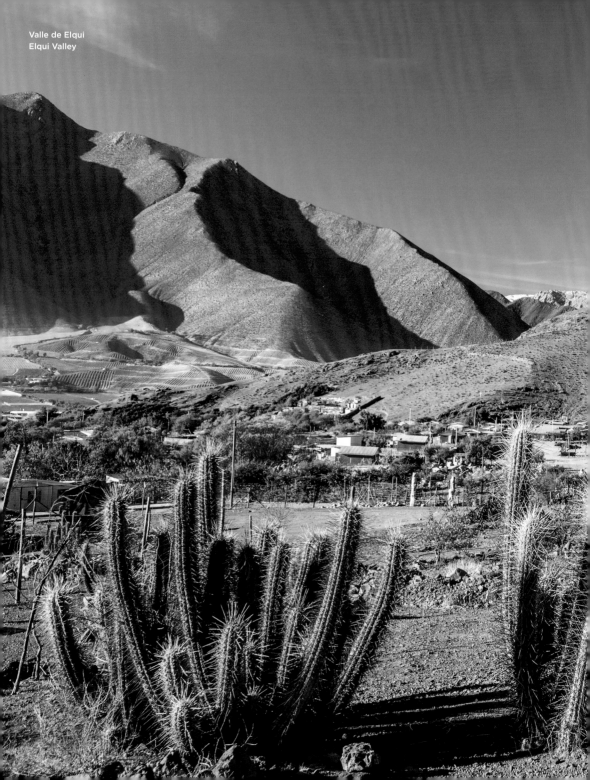

Valle de Elqui
Elqui Valley

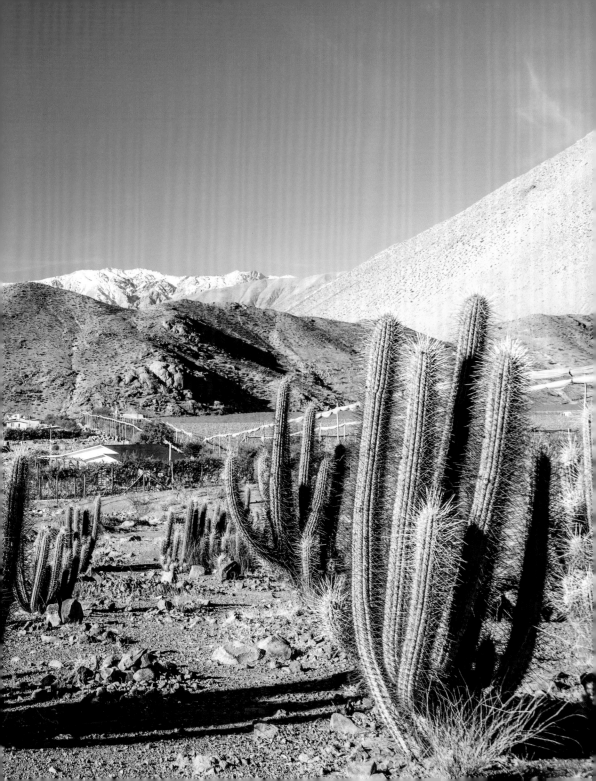

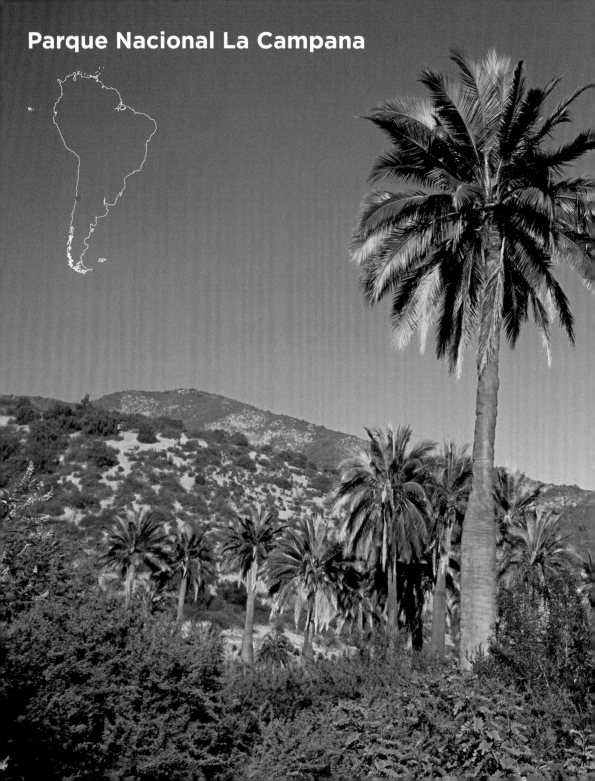

Parque Nacional La Campana

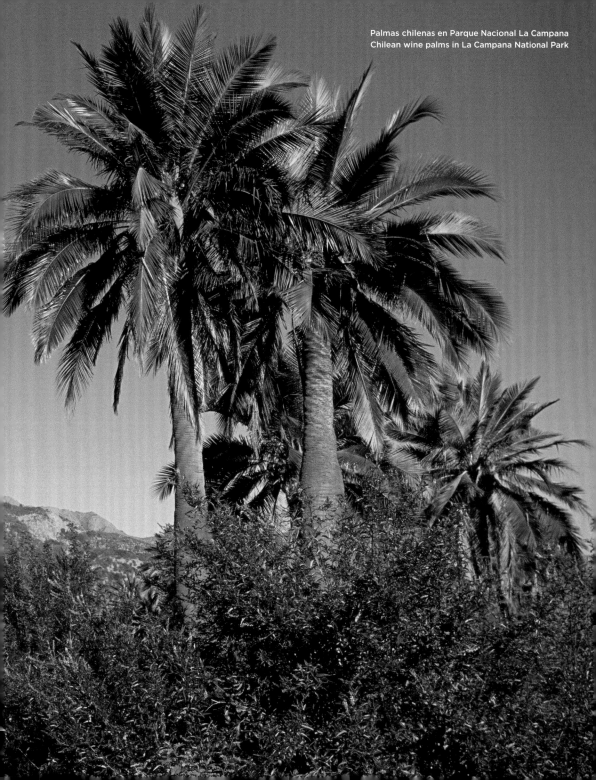

Palmas chilenas en Parque Nacional La Campana
Chilean wine palms in La Campana National Park

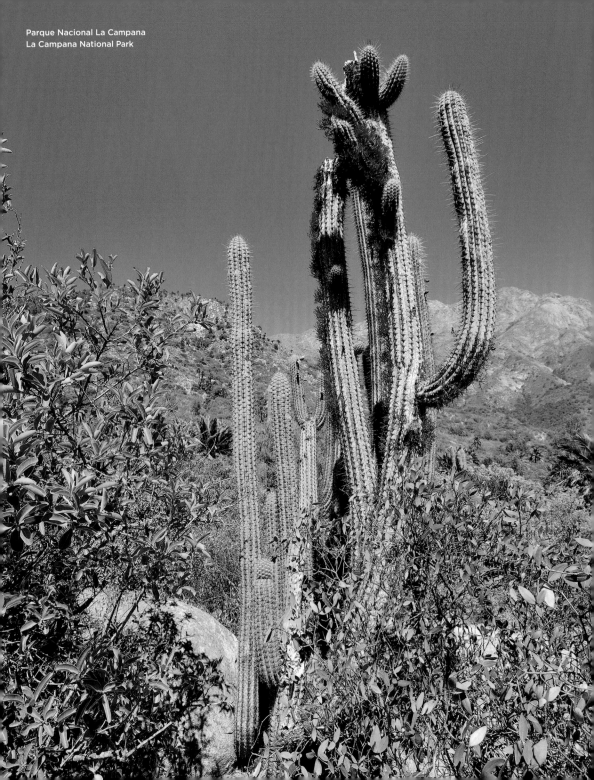

Puya azul, Parque Nacional La Campana
Blue puya, La Campana National Park

La Campana National Park

A tiny, botanical paradise. The key landmark in La Campana National Park around the mountain of the same name is the Palmar de Ocoa: one of the last surviving natural palm groves with more than 60,000 Chilean wine palms (Jubaea chilensis), an endangered species. More than 550 other plant species are at home in the Mediterranean climate of central Chile, including ferns and vines, orchids and alstroemeria, evergreen laurels, and the native soap bark tree.

Parque Nacional La Campana

Un paraíso botánico en el mínimo espacio. El elemento central del Parque Nacional La Campana, alrededor de la montaña del mismo nombre, es el Palmar de Ocoa: uno de los últimos palmares naturales con más de 60 000 ejemplares de la palma chilena en peligro (Jubaea chilensis). Por otra parte, prosperan en el clima mediterráneo de Chile Central más de 550 especies de plantas – helechos y plantas trepadoras, orquídeas y alstroemeria, familia del laurel de hoja perenne y también el quillay local.

Parc national La Campana

Un paradis botanique miniature. Emblème du parc national La Campana, la palmeraie d'Ocoa recouvre entièrement le mont La Campana. Elle est l'une des dernières palmeraies primaires et comprend plus de 60 000 spécimens de palmiers, ou cocotiers, du Chili (Jubaea chilensis), espèce de palmier en voie d'extinction. Le climat méditerranéen de la région profite en outre à plus de 550 autres espèces végétales : fougères et plantes grimpantes, orchidées et lys des Incas, lauracées persistantes, sans oublier le Quillaja saponaria endémique.

Parco Nazionale La Campana

Un paradiso botanico in uno spazio ridotto. Il fiore all'occhiello del Parco Nazionale La Campana, che si estende intorno al monte omonimo, è il Palmar de Ocoa: uno degli ultimi palmeti naturali con più di 60 000 esemplari della palma cilena minacciata dall'estinzione (Jubaea chilensis). Inoltre nel clima mediterraneo del Cile centrale crescono più di 550 varietà di piante: felci e piante rampicanti, orchidee e gigli dell'Inca, piante di alloro sempreverdi e anche la quillaja saponaria indigena.

Nationalpark La Campana

Ein botanisches Paradies auf kleinstem Raum. Aushängeschild des Nationalparks La Campana („Die Glocke") rund um den gleichnamigen Berg ist der Palmar de Ocoa: einer der letzten natürlichen Palmenhaine mit mehr als 60 000 Exemplaren der vom Aussterben bedrohten Chilenischen Palme oder Honigpalme (Jubaea chilensis). Außerdem gedeihen im mediterranen Klima Zentralchiles mehr als 550 weitere Pflanzenarten – Farne und Kletterpflanzen, Orchideen und Inkalilien, immergrüne Lorbeergewächse und auch der einheimische Seifenrindenbaum.

Nationaal Park La Campana

Het Nationale Park La Campana ('De Klok') is een botanisch paradijs op een zeer beperkte ruimte. Hét symbool van dit park rondom de gelijknamige berg is de Palmar de Ocoa: een van de laatste natuurlijke palmboomgaarden, met ruim zesduizend exemplaren van de met uitsterven bedreigde Chileense wijn- of kokospalm (ook wel 'honingpalm' – Jubaea chilensis). Daarnaast gedijen in het mediterrane klimaat ruim 550 andere plantensoorten, van varens tot klimplanten, van orchideeën tot de Incalelie, en van groenblijvende laurierbossen tot de inheemse Zuid-Amerikaanse zeepboom.

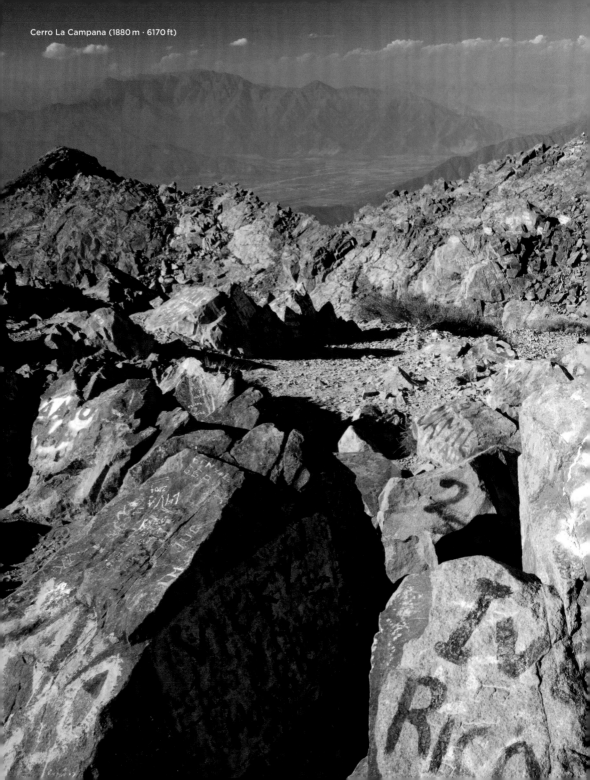

Cerro La Campana (1880 m · 6170 ft)

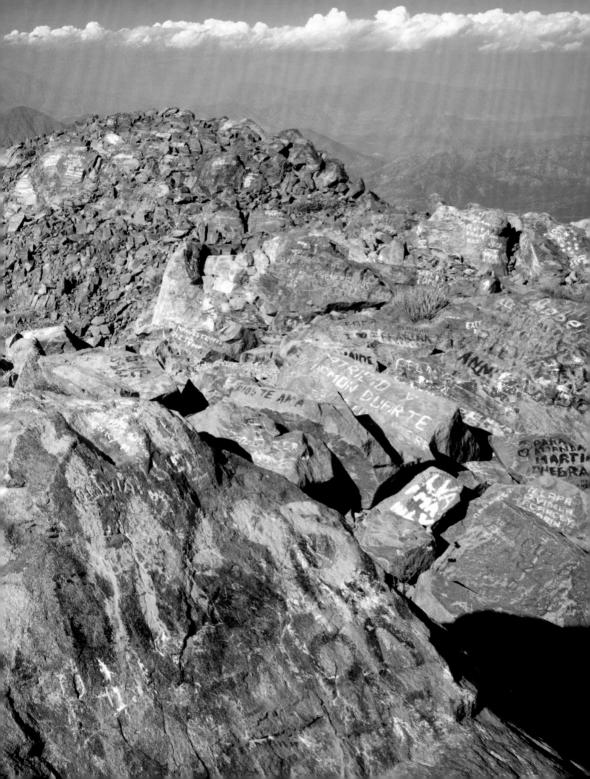

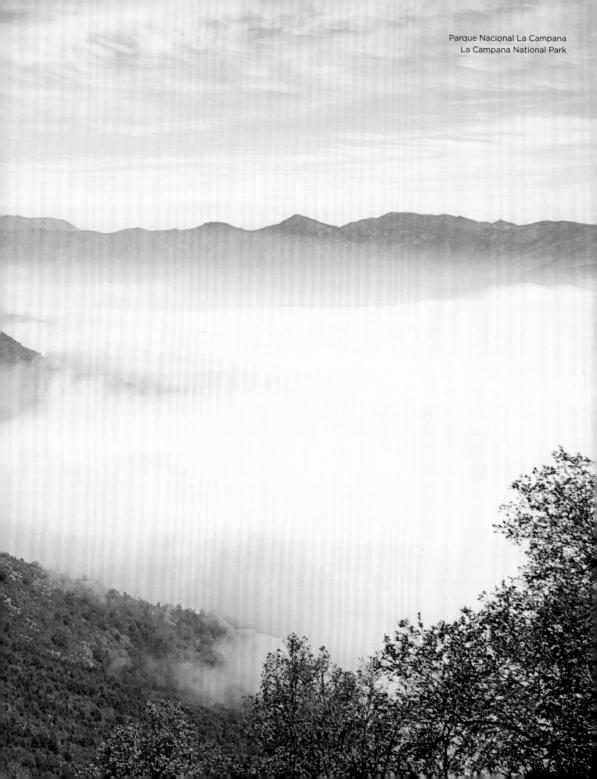

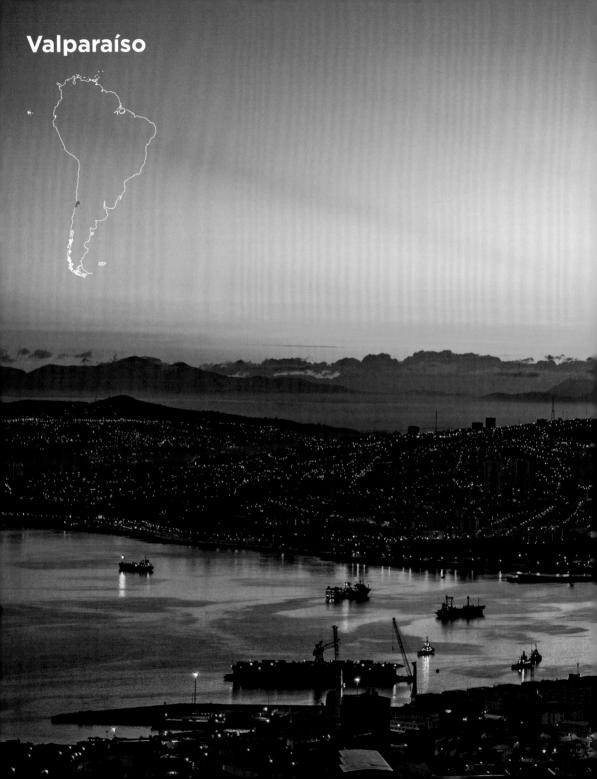

Valparaíso

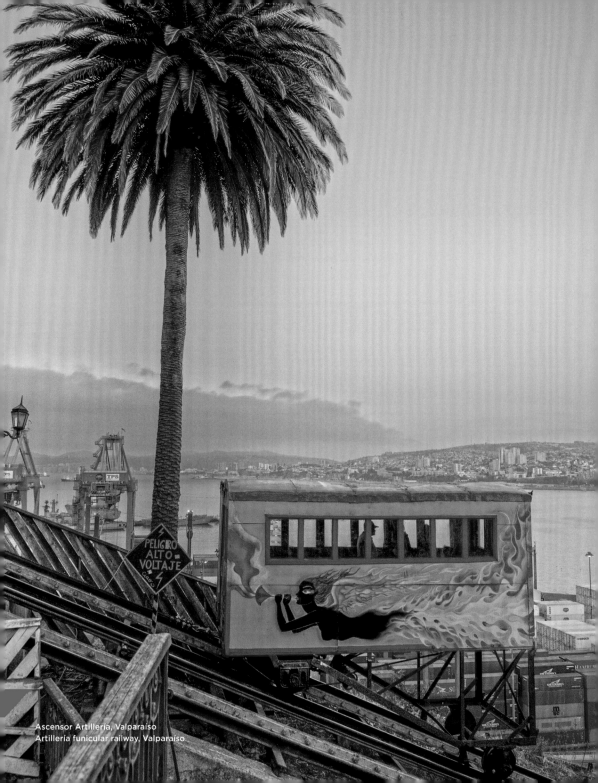

Ascensor Artillería, Valparaíso
Artillería funicular railway, Valparaíso

Centro histórico de Valparaíso
Historic quarter of Valparaíso

Valparaíso

Dreamy beaches in Pacific fjords, home to colonies of sea lions, penguins, and other birds. The port city of Valparaíso and the popular vacation spot Viña del Mar. Extensive vegetation inland with fertile valleys, dense forests, and many nature reserves. The Valparaíso region benefits from the Mediterranean climate of central Chile and the cool Humboldt current ensures pleasant temperatures and cool waters even in high summer.

Valparaíso

Des plages paradisiaques se lovent dans les baies rocheuses du Pacifique. Les colonies de lions de mer, de pingouins et d'oiseaux prospèrent sur la côte. La ville portuaire de Valparaíso et la cité balnéaire mondaine de Viña del Mar jouissent d'un arrière-pays à la végétation luxuriante, composé de vallées fertiles, de forêts denses et de nombreuses réserves naturelles. Au centre du Chili, la région de Valparaíso bénéficie d'un climat méditerranéen et le courant froid de Humboldt assure des températures agréables même en plein été, dans l'eau comme sur terre.

Valparaíso

Traumstrände in Felsenbuchten am Pazifik. Kolonien von Seelöwen, Pinguinen und Vögeln. Die Hafenstadt Valparaíso und der mondäne Ferienort Viña del Mar. Und im Hinterland eine üppige Vegetation mit fruchtbaren Tälern, dichten Wäldern und vielen Natur- reservaten. Die Region Valparaíso profitiert vom mediterranen Klima in der Mitte Chiles, und der kühle Humboldtstrom sorgt selbst im Hochsommer für angenehme Temperaturen und kühles Meerwasser.

Valparaíso

Calas rocosas en el Pacífico. Colonias de leones marinos, pingüinos y aves. La ciudad puerto de Valparaíso y el lugar de moda de vacaciones de Viña del Mar. Y en el interior una exuberante vegetación y valles fértiles, bosques densos y muchas reservas naturales. La Región de Valparaíso se beneficia del clima mediterráneo del centro de Chile, y la fría corriente de Humboldt asegura, incluso en verano, temperaturas agradables y agua fresca del océano.

Valparaíso

Spiagge da sogno nelle baie rocciose sul Pacifico. Colonie di leoni marini, pinguini e uccelli. La città portuale di Valparaíso e la località mondana di Viña del Mar. E nell'entroterra una rigogliosa vegetazione con fertili vallate, fitti boschi e tante riserve naturali. La regione di Valparaíso trae vantaggio dal clima mediterraneo del Cile centrale e la corrente fredda di Humboldt assicura in piena estate temperature gradevoli e la fresca acqua del mare.

Valparaíso

Droomstranden aan de Stille Oceaan, zeeleeuw-, pinguïn- en vogelkolonies, de mondaine badplaats Viña del Mar en in het achterland een weelderige vegetatie met vruchtbare dalen, dichte wouden en talloze natuurreservaten – dat alles biedt de regio Valparaíso, die in het centrum van Chili profiteert van een mediterraan klimaat en de koele Humboldtstroom, die ook in hartje zomer nog voor aangename temperaturen en fris zeewater zorgt.

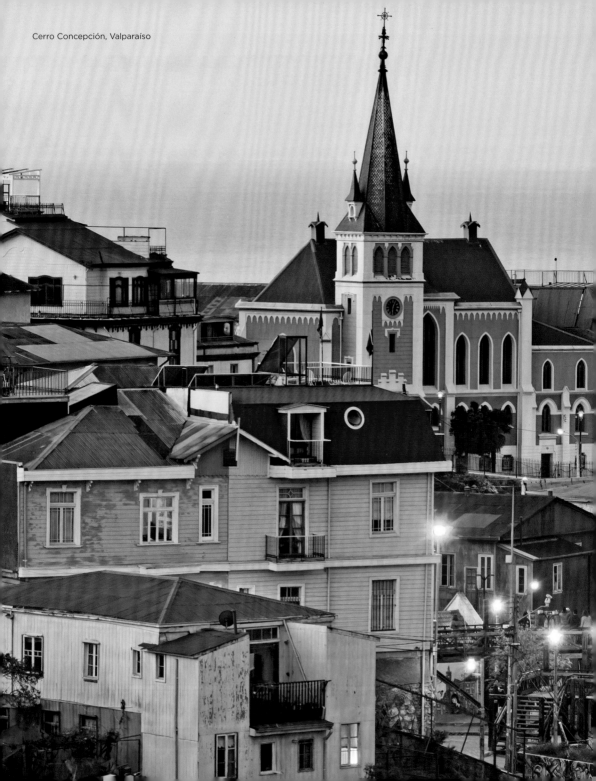
Cerro Concepción, Valparaíso

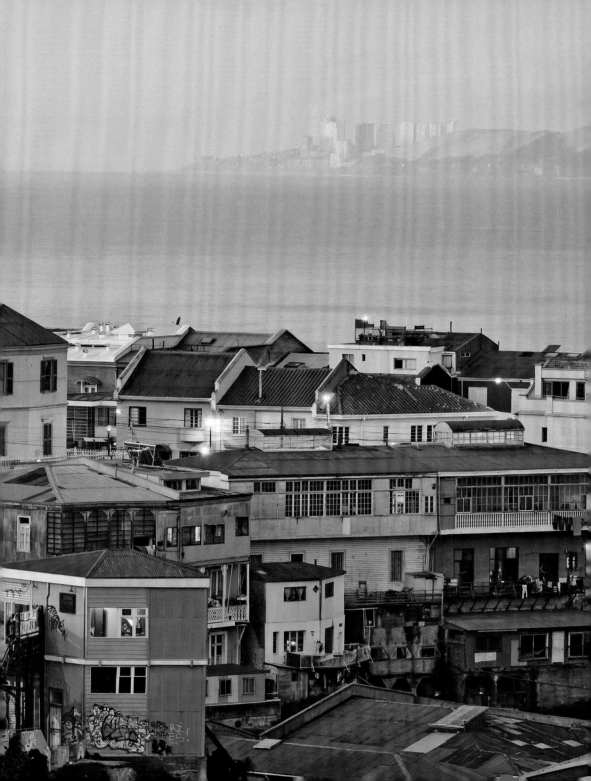

SOLDADOS

M.JAQUE	Z.TAPIA
A.VASQUEZ	F.GODOY
J.A. BARRERA	J.L. ESCOBAR
J.V. VALDIVIA	J.GOMEZ
F.ASCENCIO	M.MOLINA
J.PONCE	G.ALMAZABAL
C.ROSALES	J.D. DIAZ
V.CASTELLANO	E.RIQUELME

ARMADA DE CHILE

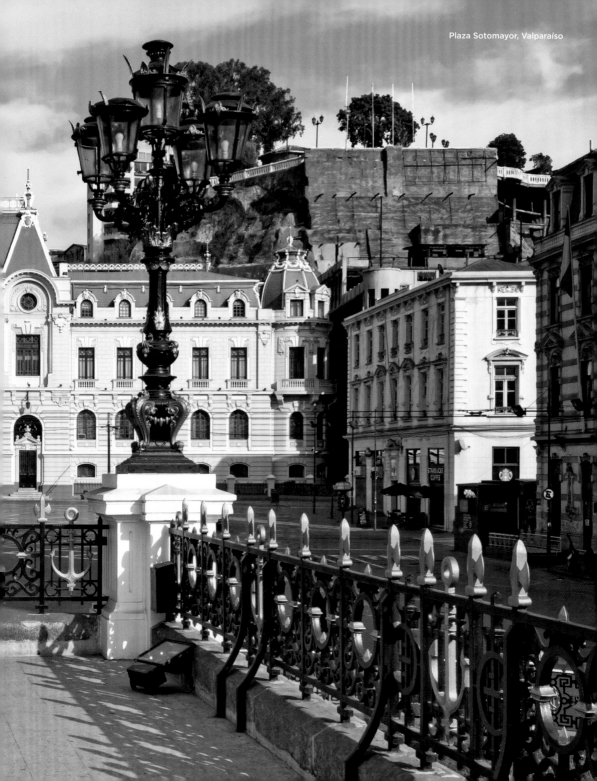

Plaza Sotomayor, Valparaíso

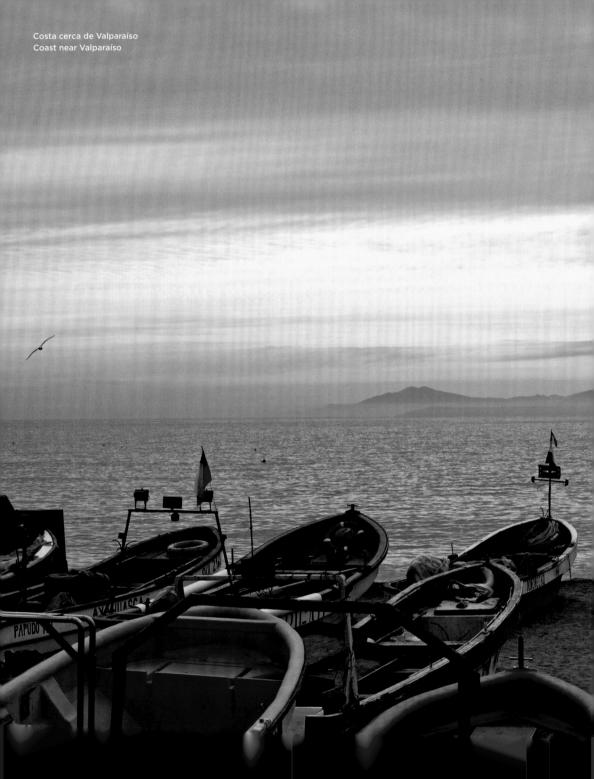

Costa cerca de Valparaíso
Coast near Valparaíso

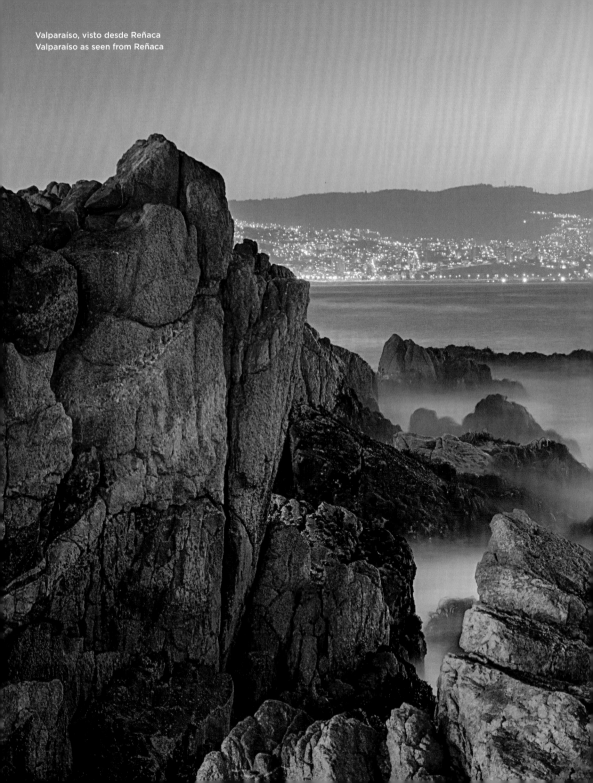

Valparaíso, visto desde Reñaca
Valparaíso as seen from Reñaca

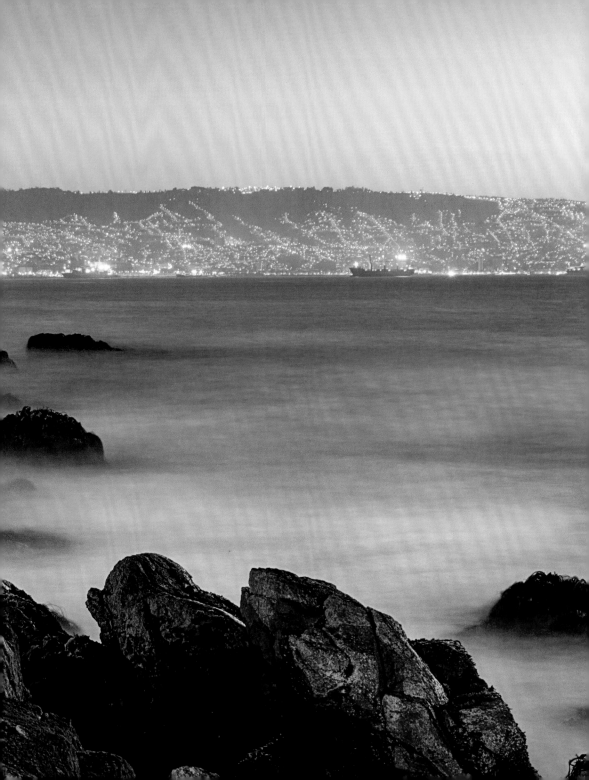

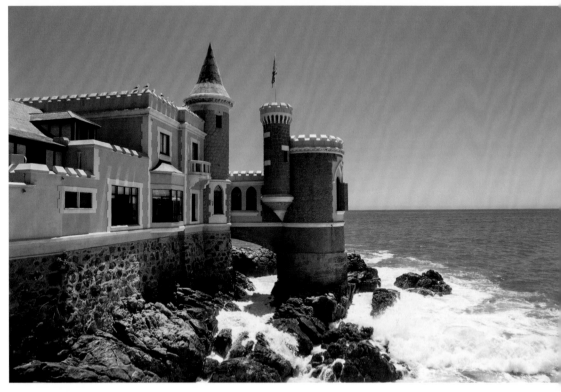

Castillo Wulff, Viña del Mar

Viña del Mar

With luxurious palaces, beautiful parks,
a casino, and long sandy beaches, the
garden city of Viña del Mar is one of the
most popular seaside resorts in Chile.
German-born saltpeter industrialist
Gustavo Adolfo Wulff built Castillo Wulff,
his castle-like villa, directly on the coast
in 1906.

Viña del Mar

Des palais résidentiels chics, de
magnifiques parcs, un casino et de
longues plages de sable – la « ville-jardin »
de Viña del Mar est l'une des stations
balnéaires les plus populaires du Chili. Le
magnat du salpêtre d'origine allemande,
Gustavo Adolfo Wulff, y construisit
en 1906 directement sur la côte une
villa ressemblant à un château fort, le
Castillo Wulff.

Viña del Mar

Mondäne Wohnpaläste, wunderschöne
Parkanlagen, ein Casino und lange
Sandstrände – die „Gartenstadt" Viña
del Mar ist eines der beliebtesten
Seebäder Chiles. Der deutschstämmige
Salpeterbaron Gustavo Adolfo Wulff
errichtete 1906 hier direkt an der Küste
eine burgähnliche Villa, das Castillo Wulff.

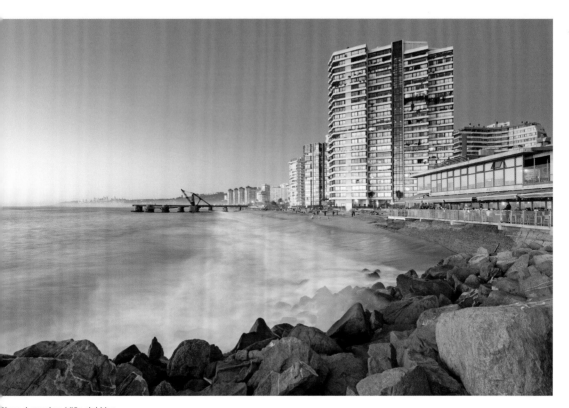

Playa Acapulco, Viña del Mar
Acapulco Beach, Viña del Mar

Viña del Mar

La "Ciudad Jardín" Viña del Mar – elegantes palacios, maravillosos parques y largas playas de arena – es uno de los complejos de playas más populares de Chile. Gustavo Adolfo Wulff, empresario salitrero de origen alemán, erigió en 1906 una villa parecida a un castillo, el Castillo Wulff, directamente en la costa.

Viña del Mar

Con le sue ville mondane, i meravigliosi parchi, un casinò e le lunghe spiagge sabbiose la "città giardino" Viña del Mar è una delle località balneari più amate del Cile. Gustavo Adolfo Wulff, commerciante di nitro di origine tedesca, fece costruire nel 1906 una villa stile castello direttamente sulla costa: il Castillo Wulff.

Viña del Mar

Met zijn mondaine stadspaleizen, fraaie parken, een casino en lange zandstranden is de 'tuinstad' Viña del Mar een van de populairste badplaatsen van Chili. De salpeterbaron van Duitse afkomst Gustavo Adolfo Wulff liet hier in 1906 aan de kust een kasteelachtige villa bouwen: het Castillo Wulff.

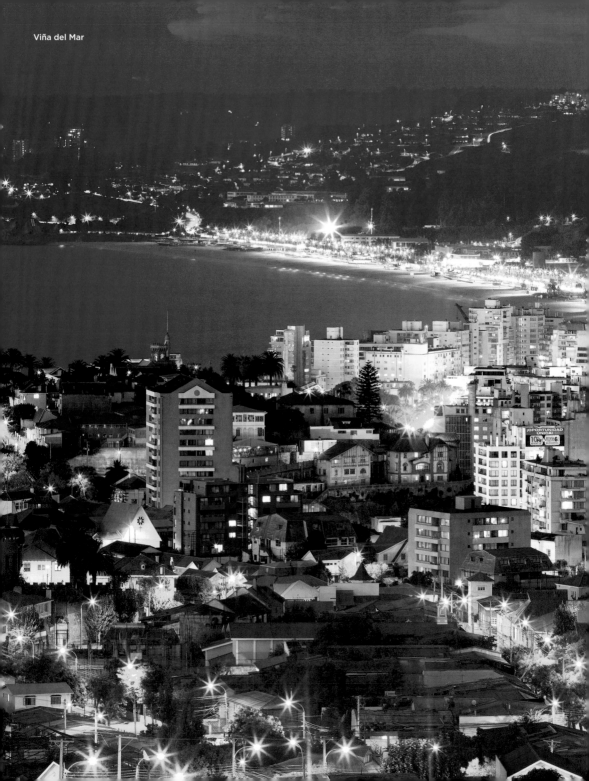

Viña del Mar

Playa en alrededores de Viña del Mar
Beach near Viña del Mar

Treasures of the sea

The coast of Chile stretches over 6000 km (3700 mi), so it should be no surprise that outstanding fish and seafood feature on many menus. Fish is usually prepared simply in a pan or on the grill. Another specialty is *ceviche,* fish which has been marinated with lemon and onions.

Trésors de la mer

La côte du Chili s'étend sur 6000 km – ce qui est synonyme de poissons et fruits de mer d'excellente qualité et d'une grande diversité. Le poisson est préparé de façon classique à la poêle ou sur le gril. L'une des spécialités est le *ceviche:* du poisson cru avec du citron et des oignons.

Schätze des Meeres

Über 6000 km erstreckt sich die Küste Chiles – das bedeutet Fisch und Meeresfrüchte in ausgezeichneter Qualität und immenser Vielfalt. Der Fisch wird klassisch in der Pfanne oder auf dem Grill zubereitet. Eine besondere Spezialität ist *ceviche:* roher Fisch mit Zitrone und Zwiebeln.

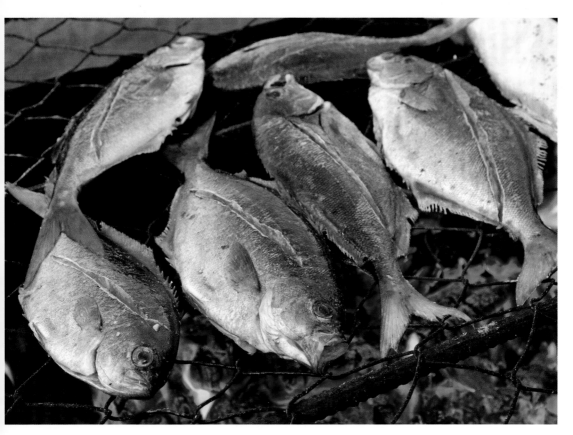

Pescado fresco a la parrilla
Fresh fish on the grill

Tesoros del mar

La costa de Chile se extiende a lo largo de más de 6000 km – lo que significa pescado y marisco de excelente calidad y una variedad inmensa. El pescado se cocina en la sartén o en la parrilla. Una especialidad especial es el ceviche: pescado crudo con limón y cebolla.

Tesori del mare

La costa del Cile si estende per oltre 6000 km: questo è sinonimo di pesce e frutti di mare di prima qualità e una ricca varietà culinaria. Il pesce viene preparato alla maniera classica in padella o sulla griglia. Una specialità locale è il *ceviche:* pesce crudo marinato con limone e cipolla.

Schatten uit de zee

Met een kust van meer dan 6000 km lang beschikt Chili over een ongekend rijke keuze aan verse vis en zeevruchten van uitzonderlijke kwaliteit. De vis wordt op klassieke wijze in de pan of op de grill bereid. Een bijzondere specialiteit is *ceviche:* rauwe vis met citroen en uien.

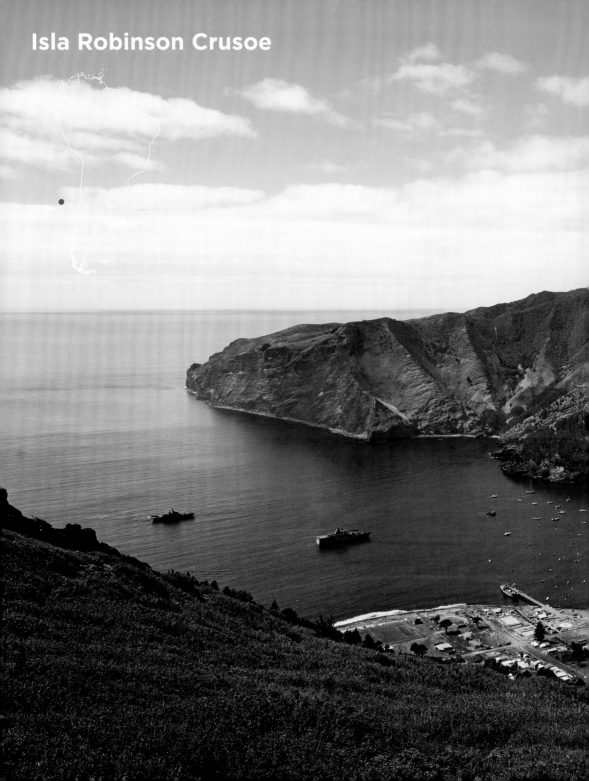

Isla Robinson Crusoe

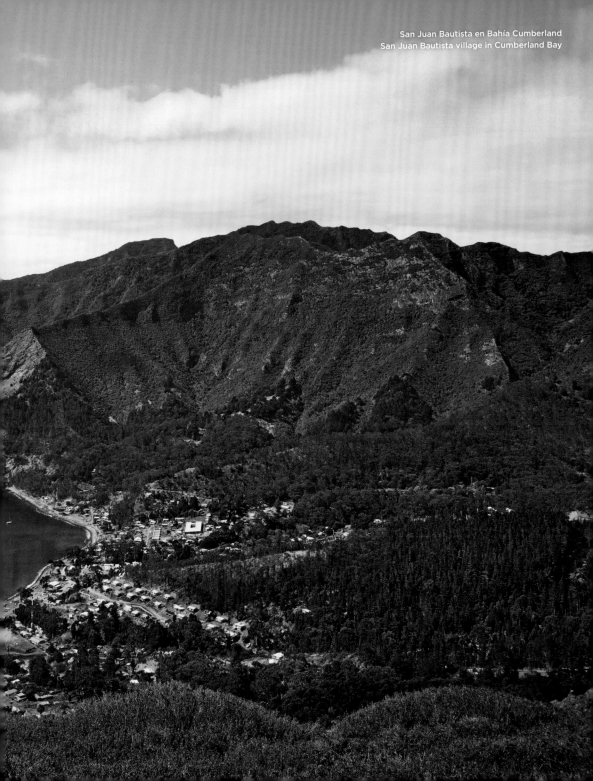

San Juan Bautista en Bahía Cumberland
San Juan Bautista village in Cumberland Bay

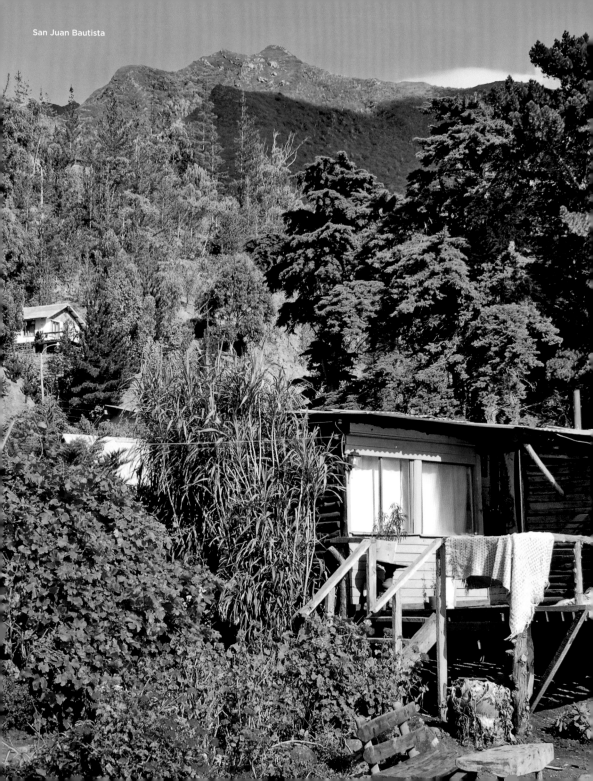

San Juan Bautista

Robinson Crusoe Island

The island is a part of the Archipiélago de Juan Fernández National Park, which also includes Isla Alejandro Selkirk, Isla Santa Clara, and several smaller islands. Only 900 people make their home in the 100 km² (38.5 sq mi) of the Juan Fernández archipelago, but the islands are home to many rare species such as the Chonta palm (*Juania australis*), the Juan Fernández fur seal (*Arctocephalus philippii*), and several native hummingbird species.

Isla Robinson Crusoe

La isla forma parte del Parque Nacional Archipiélago de Juan Fernández, que también incluye las islas de Alejandro Selkirk y Santa Clara y algunos islotes más pequeños. En un total de 100 km², viven en el Archipiélago Juan Fernández sólo alrededor de 900 personas, aunque muchas especies de animales y plantas raras, como la palma Chonta (*Juania australis*), el lobo marino de Juan Fernández (*Arctocephalus philippii*) y varias especies autóctonas de colibríes.

Île de Robinson Crusoé

L'île fait partie du parc national de l'archipel Juan Fernández, auquel appartiennent également les îles Alejandro Selkirk, Santa Clara et d'autres terres plus petites. Environ 900 personnes seulement vivent sur les 100 km² que couvre l'archipel Juan Fernández. Mais les îles sont peuplées de nombreuses espèces animales et végétales rares, telles que le palmier *Juania australis*, l'otarie des îles Juan Fernández (*Arctocephalus philippii*) et de nombreuses espèces endémiques de colibris.

Isola di Robinson Crusoe

L'isola fa parte del Parco Nazionale dell'Arcipelago di Juan Fernández, al quale appartengono anche le isole di Alejandro Selkirk, Santa Clara e alcune isole minori. Su un totale di 100 km², nell'arcipelago di Juan Fernández vivono solo circa 900 persone, ma anche molte specie animali e vegetali rare come la palma Chonta (*Juania australis*), l'otaria orsina Juan Fernández (*Arctocephalus philippii*) e diversi tipi di colibrì indigeni.

Robinson-Crusoe-Insel

Die Insel ist Teil des Nationalparks Archipiélago de Juan Fernández, zu dem auch die Inseln Alejandro Selkirk, Santa Clara und einige kleinere Eilande zählen. Auf insgesamt 100 km² leben im Juan-Fernández- Archipel nur rund 900 Menschen, dafür viele seltene Tier- und Pflanzenarten wie etwa die Chonta-Palme (*Juania australis*), der Juan-Fernández-Seebär (*Arctocephalus philippii*) und mehrere hier heimische Kolibriarten.

Robinson-Crusoe-eiland

Het eiland maakt deel uit van het Nationale Park Archipiélago de Juan Fernández, waartoe ook de eilanden Alejandro Selkirk en Santa Clara en enkele kleinere eilandjes behoren. Met in totaal 100 km² aan landoppervlak telt de Juan Fernández-archipel 900 inwoners, maar ook talloze zeldzame dier- en plantensoorten, waaronder de chontapalm (*Juania australis*), de juan fernández-zeebeer (*Arctocephalus philippii*) en meerdere inheemse kolibrisoorten.

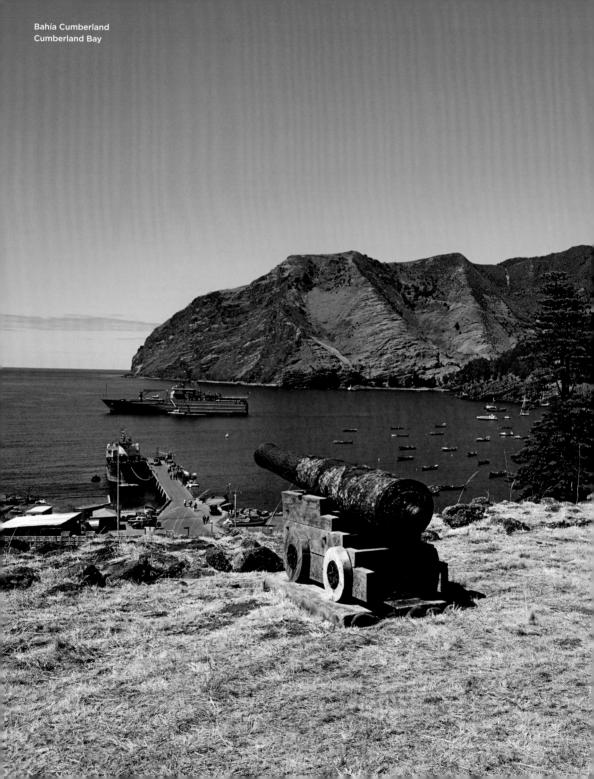

Bahía Cumberland
Cumberland Bay

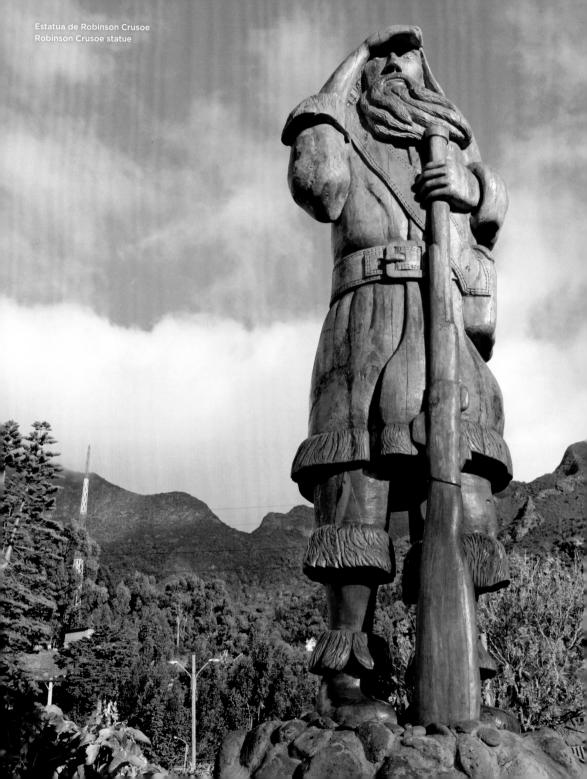

Cangrejos de río
Crayfish

Robinson Crusoe
This is where Scottish sailor Alexander
Selkirk survived for several years in the
early 18th century. He later serves as
the inspiration for Daniel Defoe's novel
Robinson Crusoe.

Robinson Crusoe
Aquí (sobre)vivió durante varios años
a principios del siglo XVIII, el marinero
escocés Alexander Selkirk, en el que Daniel
Defoe debió haberse inspirado para su
novela *Robinson Crusoe*.

Robinson Crusoé
C'est sur cette île que (sur)vécut seul,
pendant plusieurs années, le marin écossais
Alexander Selkirk, au début du XVIIIᵉ siècle.
Son histoire inspira par la suite à Daniel
Defoe son roman *Robinson Crusoé*.

Robinson Crusoe
L'isola di Robinson Crusoe. Qui all'inizio del
XVIII secolo (soprav)visse per diversi anni
il navigatore scozzese Alexander Selkirk,
che ispirò Daniel Defoe per il suo romanzo
Robinson Crusoe.

Robinson Crusoe
Hier (über)lebte während mehrerer Jahre
zu Anfang des 18. Jahrhunderts der
schottische Seefahrer Alexander Selkirk,
der Daniel Defoe zu seinem Roman
Robinson Crusoe inspiriert haben soll.

Robinson Crusoe
Op het Robinson-Crusoe-eiland wist begin
achttiende eeuw de Schotse zeeman
Alexander Selkirk vier jaar te overleven. Hij
was waarschijnlijk de inspiratie voor Daniel
Defoe's roman *Robinson Crusoe*.

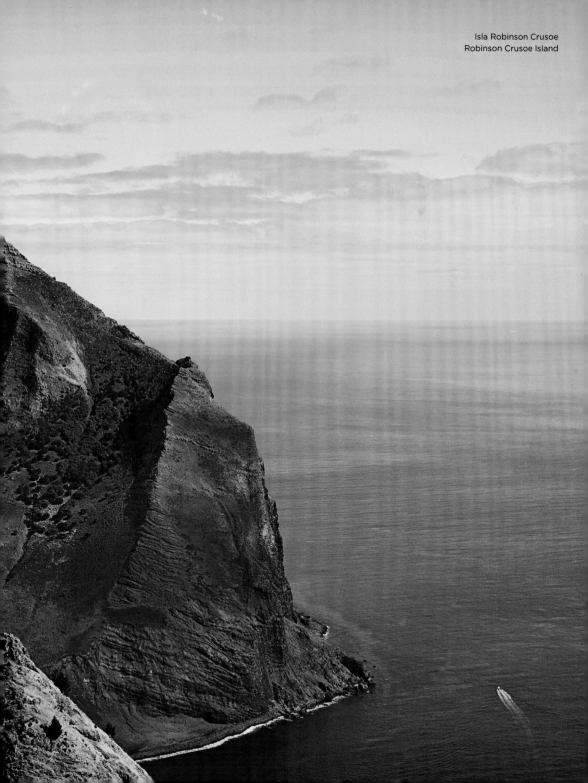

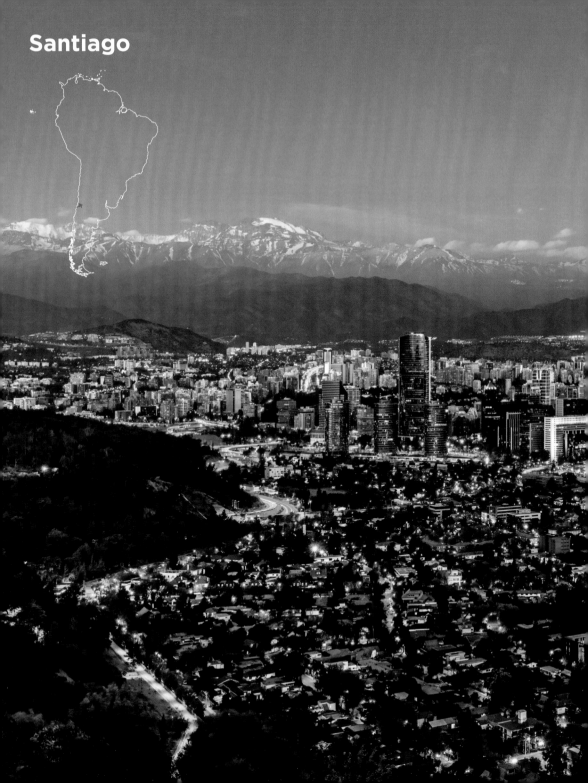

Santiago

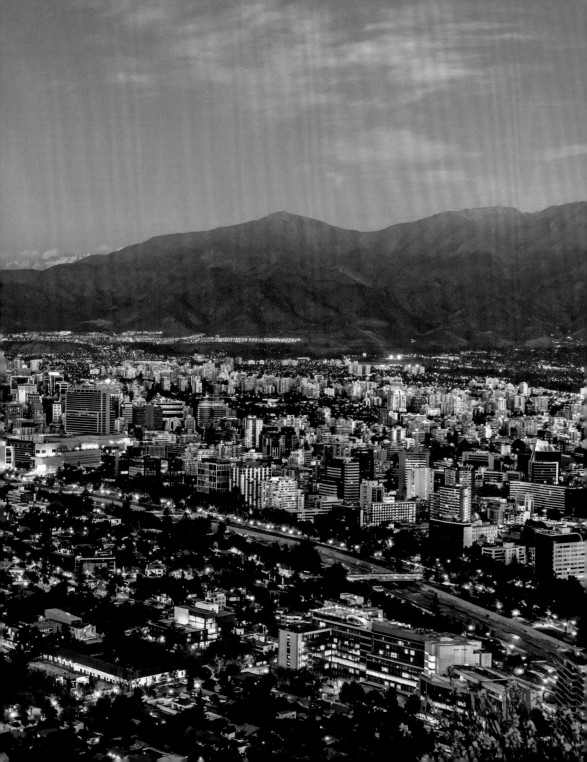

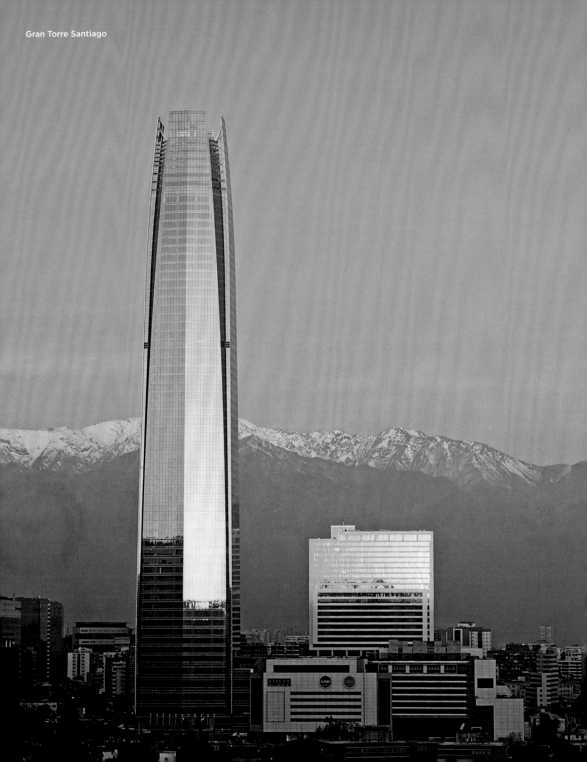

Gran Torre Santiago

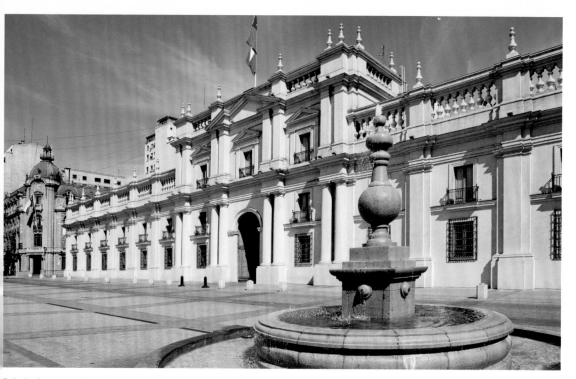

Palacio de La Moneda, Santiago
La Moneda Palace, Santiago

Santiago

More than five million people live in Santiago de Chile, the political, economic and cultural center of the country. Following a massive earthquake in 2010, high-rise buildings such as the Gran Torre Santiago are being built to absorb the vibrations of the earth directly. Chilean regulations for earthquake-resistant buildings are now among the most stringent in the world.

Santiago

Más de cinco millones de personas viven en Santiago de Chile, el centro político, económico y cultural del país. Tras un grave terremoto en el año 2010, edificios de gran altura como la Gran Torre Santiago serían construidos de manera que puedan absorber directamente las vibraciones de la Tierra. Las regulaciones chilenas para la resistencia a terremotos de edificios están ahora entre las más estrictas del mundo.

Santiago

Plus de cinq millions de personnes vivent à Santiago du Chili, le centre politique, économique et culturel du pays. Après un tremblement de terre important en 2010, les immeubles de grande hauteur comme la Gran Torre Santiago sont désormais construits de telle sorte que les vibrations de la terre sont directement absorbées. La réglementation chilienne sur la sécurité sismique des bâtiments est l'une des plus strictes au monde.

Santiago

Con i suoi oltre cinque milioni di abitanti, Santiago de Chile è il centro politico, economico e culturale del paese. Dopo un terremoto nel 2010 dalle conseguenze terribili, grattacieli come la Gran Torre Santiago sono stati costruiti in maniera da ammortizzare direttamente le oscillazioni della terra. I regolamenti cileni nel settore antisismico degli edifici sono tra i più all'avanguardia del mondo.

Santiago

Über fünf Millionen Menschen leben in Santiago de Chile, dem politischen, wirtschaftlichen und kulturellen Zentrum des Landes. Nach einem folgenschweren Erdbeben im Jahr 2010 werden Hochhäuser wie der Gran Torre Santiago so gebaut, dass Schwingungen der Erde direkt abgefedert werden. Die chilenischen Vorschriften für Erdbebensicherheit von Bauwerken gehören heute zu den strengsten der Welt.

Santiago

De hoofdstad Santiago de Chile telt ruim vijf miljoen mensen en is het politieke, economische en culturele centrum van het land. Na een zware aardbeving in 2010 worden wolkenkrabbers als de Gran Torre Santiago hier zo gebouwd dat ze de trillingen van de aarde direct afleiden. Vanwege het aardbevingsgevaar behoren de Chileense bouwvoorschriften tot de strengste ter wereld.

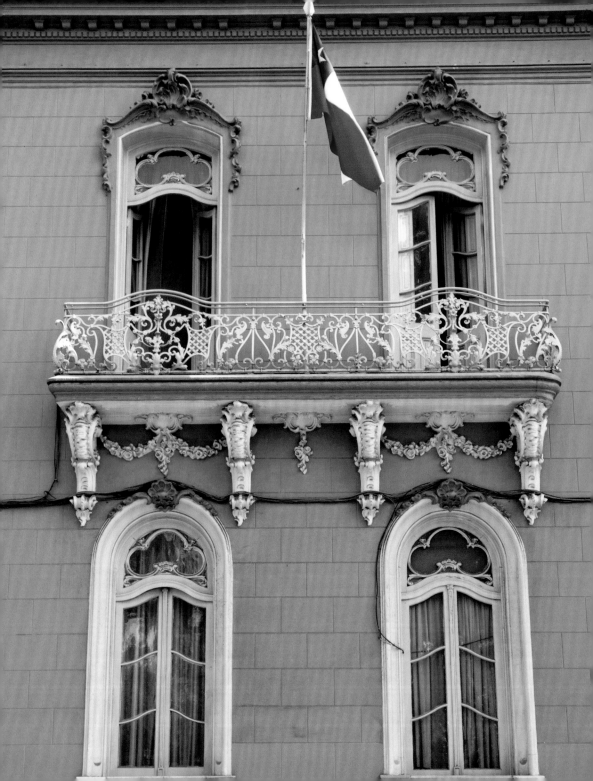

Edificio del ex Congreso Nacional de Chile, Santiago
Former National Congress Building, Santiago

Casa en Barrio Brasil, Santiago
House in Barrio Brasil, Santiago

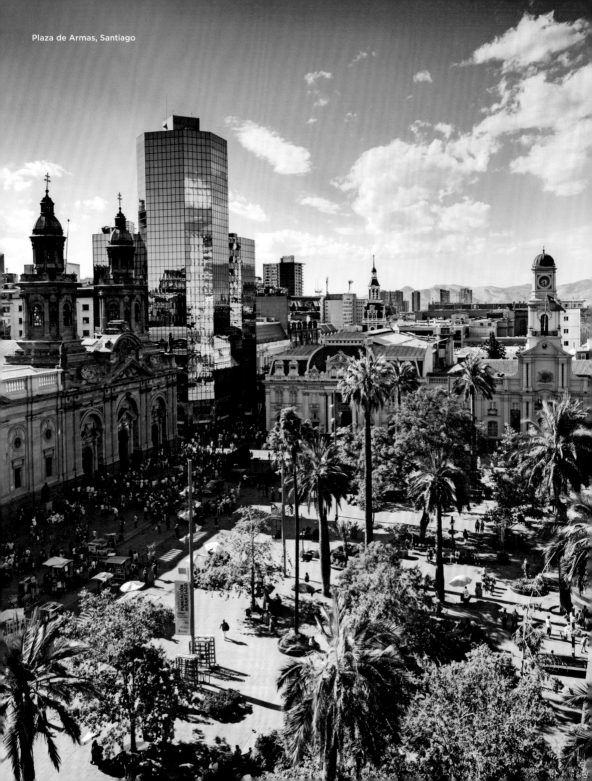

Plaza de Armas, Santiago

Centollas
King crabs

King crab
The king crab is considered a special delicacy from the Pacific. Weighing up to 2 kg (5 lbs) and with legs that can extend up to 1.80 m (5 ft), many of these creatures find their way from the aquarium to the kitchens of many restaurants.

Centolla
La centolla real está considerado como una delicatesen especial del Pacífico. Los animales, que pesan hasta 2 kg y pueden medir hasta 1,80 m con las patas extendidas, pasan en muchos restaurantes directamente desde el acuario a la cazuela.

Crabe royal
Le crabe royal est un met exceptionnel du Pacifique. Pesant jusqu'à 2 kg et d'une envergure allant jusqu'à 1,80 m, ces grands animaux passent, dans de nombreux restaurants, directement de l'aquarium à la casserole.

Granchio gigante
Una delicatezza unica del Pacifico è il granchio gigante. Questi animali possono raggiungere il peso di 2 kg e con le zampe distese una lunghezza di 1,80 m. In molti ristoranti vengono trasferiti direttamente dall'acquario alla pentola.

Königskrabbe
Als besondere Delikatesse aus dem Pazifik gilt die Königskrabbe. Die bis zu 2 kg schweren und mit ausgebreiteten Beinen bis zu 1,80 m großen Tiere wandern in vielen Restaurants direkt aus dem Aquarium in den Kochtopf.

Koningskrab
De rode koningskrab wordt als delicatesse uit de Stille Oceaan beschouwd. Met zijn lange poten kan de krab 2 kilo zwaar en 1,80 meter groot worden. In restaurants worden ze direct uit het aquarium in de kookpan gestopt.

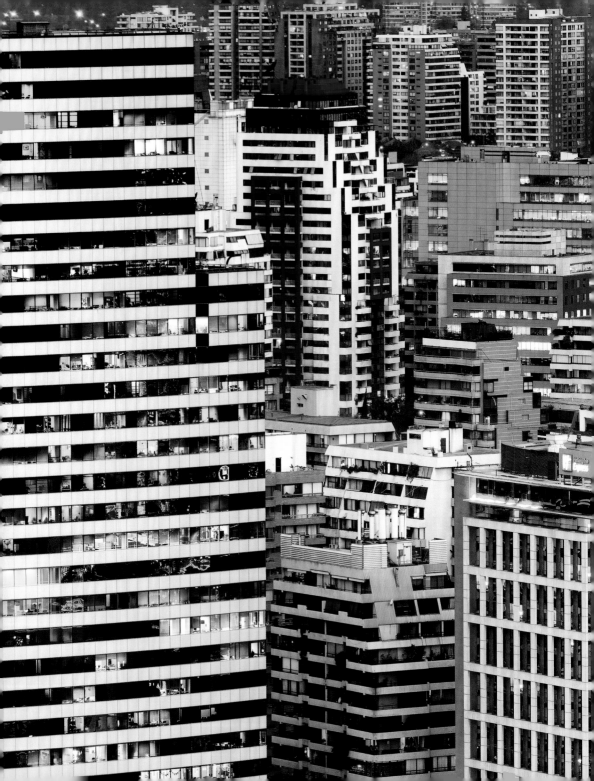

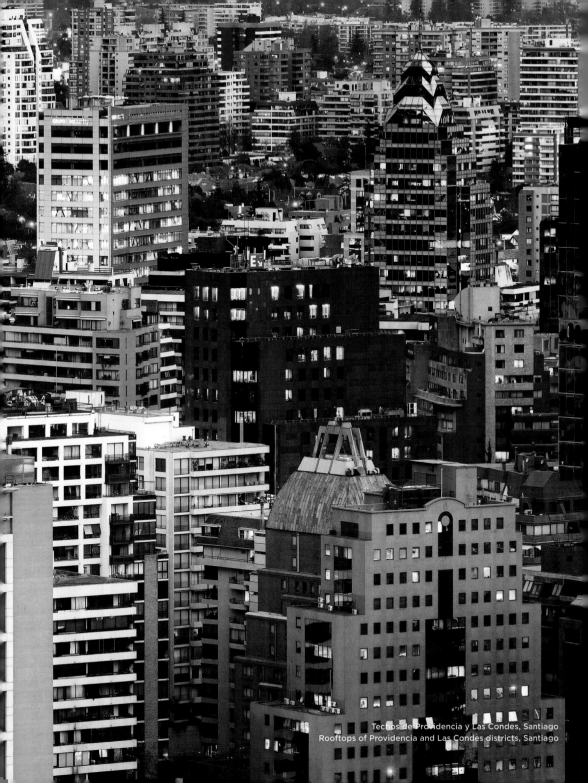

Techos de Providencia y Las Condes, Santiago
Rooftops of Providencia and Las Condes districts, Santiago

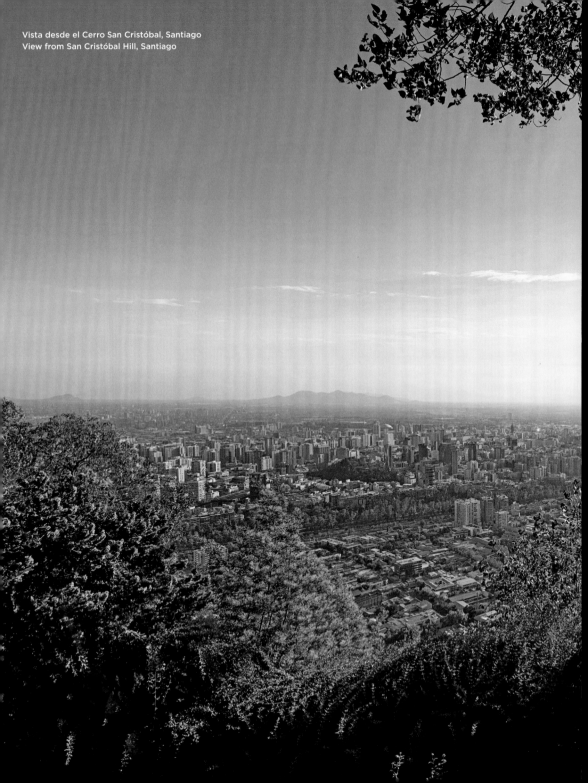

Vista desde el Cerro San Cristóbal, Santiago
View from San Cristóbal Hill, Santiago

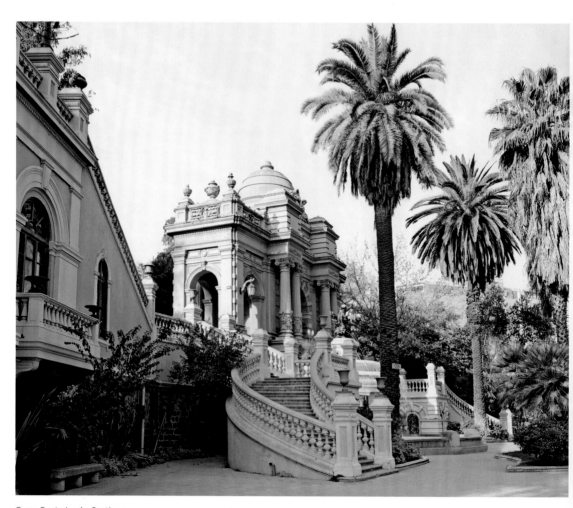

Cerro Santa Lucía, Santiago
Santa Lucía Hill, Santiago

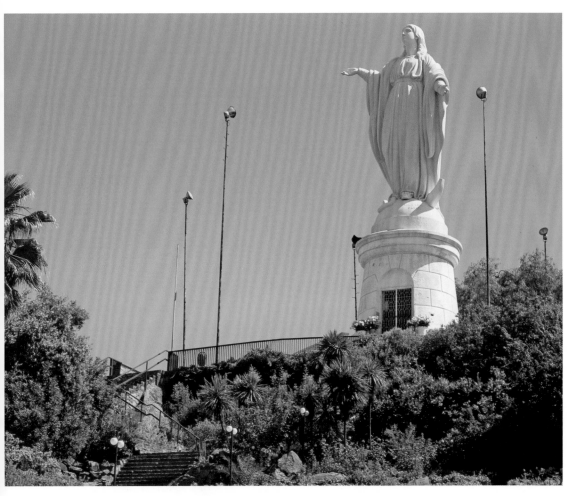

Cerro San Cristóbal, estatua de la Virgen María, Santiago
San Cristóbal Hill, statue of the Virgin Mary, Santiago

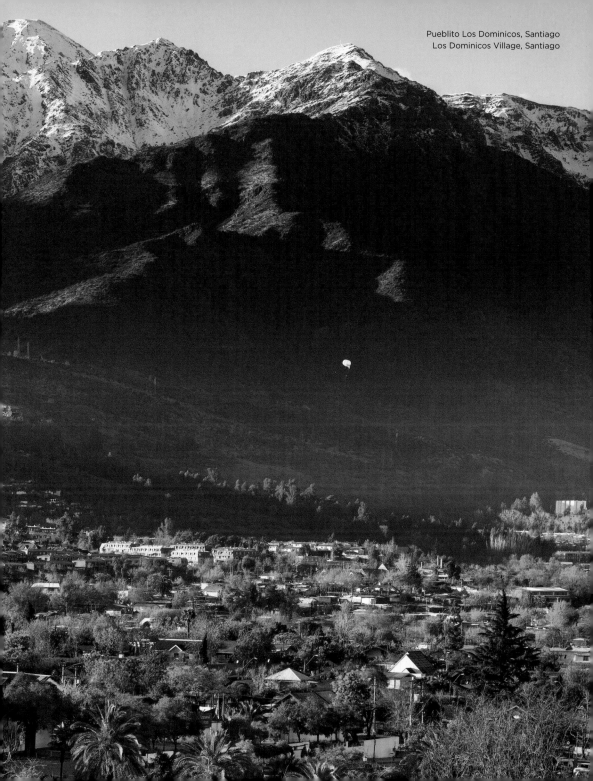

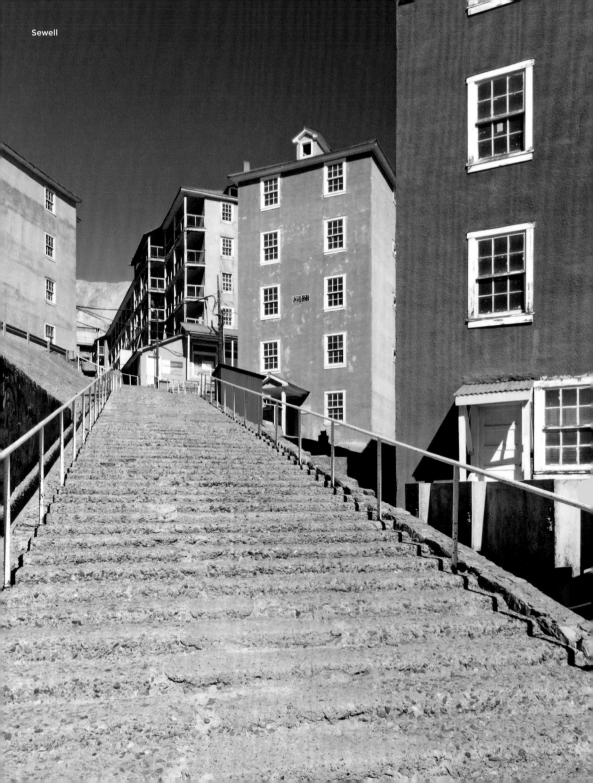

Sewell

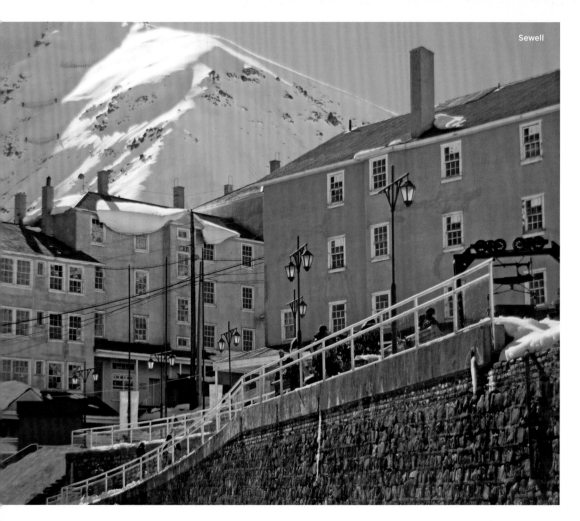

Sewell

Sewell

The former mining town of Sewell, 150 km (90 mi) south of Santiago, has been a UNESCO World Heritage Site since 2006. The colorful houses which once housed miners and their families are now abandoned and are protected as historical monuments.

Sewell

L'ancienne ville minière de Sewell, à 150 km au sud du Chili, appartient depuis 2006 au patrimoine mondial de l'UNESCO. Les maisons colorées, dans lesquelles les travailleurs des mines vivaient autrefois avec leurs familles, sont maintenant abandonnées et placées sous la protection des monuments historiques.

Sewell

Die ehemalige Bergarbeiterstadt Sewell, 150 km südlich von Chile, gehört seit 2006 zum UNESCO-Weltkulturerbe. Die bunten Häuser, in denen einst die Minenarbeiter mit ihren Familien lebten, sind heute verlassen und stehen unter Denkmalschutz.

Sewell

La antigua ciudad minera de Sewell, 150 km al sur de Chile, es Patrimonio de la Humanidad por la UNESCO desde 2006. Las coloridas casas, donde una vez los trabajadores mineros vivieron con sus familias, ahora están abandonadas y están protegidas como monumentos históricos.

Sewell

Sewell, città mineraria unica nel mondo a 150 km a sud del Cile, è stata inclusa nel 2006 nell'elenco dei patrimoni dell'umanità dell'UNESCO. Le case colorate, dove un tempo vivevano i minatori con le loro famiglie, oggi sono disabitate e divenute monumento protetto.

Sewell

Het voormalige mijnstadje Sewell ligt 150 km ten zuiden van Santiago en is sinds 2006 een UNESCO-Werelderfgoed. De bont geschilderde huizen, waarin ooit mijnwerkers met hun gezinnen woonden, staan nu leeg en worden als monumenten beschermd.

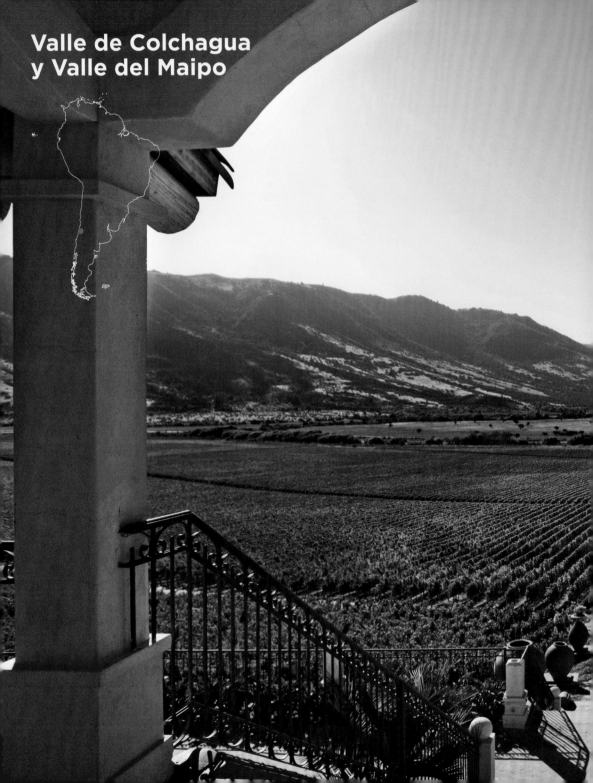

Valle de Colchagua
y Valle del Maipo

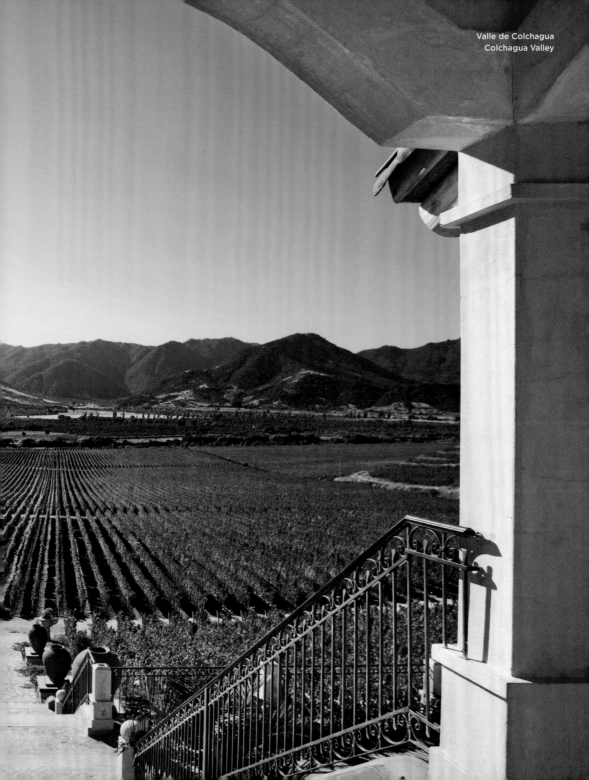

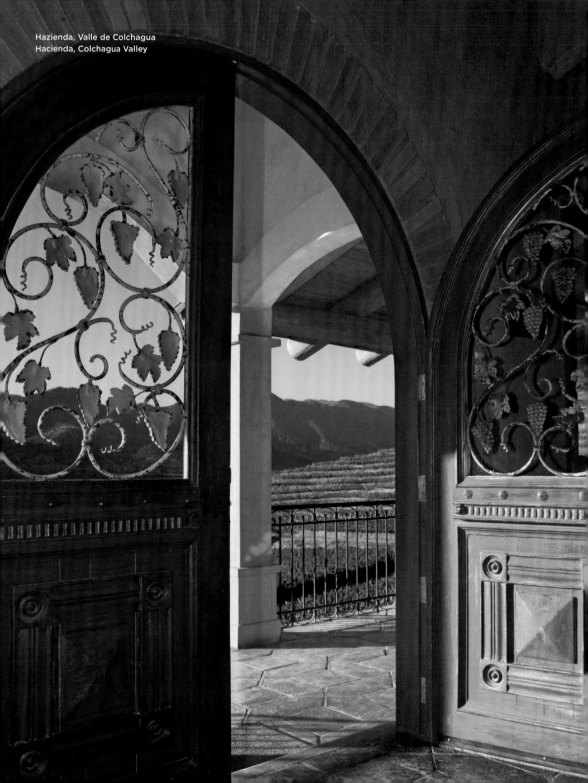

Hazienda, Valle de Colchagua
Hacienda, Colchagua Valley

Valle de Colchagua
Colchagua Valley

Colchagua and Maipo Valley
The metropolis of Santiago is surrounded by the famous vineyards of the Maipo Valley, dating back to the 16th century. A little further south is the sun-drenched Colchagua Valley. Grapes are able to grow in this otherwise dry region thanks to the Maipo, Mapocho and Tinguiriririca rivers. Many renowned vineyards are based here.

Valle de Colchagua y Valle del Maipo
Los famosos viñedos del Valle del Maipo se encuentran alrededor de la metrópoli de Santiago. Este fue el comienzo de la vitivinicultura chilena en el siglo XVI. Un poco más al sur está el soleado valle de Colchagua. Los ríos Maipo, Mapocho y Tinguiririria hacen posible la viticultura en esta región seca. Muchos viñedos de renombre tienen aquí su sede.

Vallée de Colchagua et vallée de Maipo
Les célèbres vignobles de la vallée de Maipo sont situés autour de la ville de Santiago. C'est ici que viticulture chilienne a fait ses débuts au XVIe siècle. La vallée de Colchagua, baignée de soleil, s'étend un peu plus au sud. La viticulture dans cette région aride est possible grâce aux fleuves Maipo, Mapocho et Tinguiririria. De nombreux établissements vinicoles de renom ont leur siège ici.

Valle di Colchagua e valle del Maipo
Nei dintorni della metropoli di Santiago si trovano i famosissimi vigneti della valle del Maipo. Qui nacque la viticoltura cilena nel XVI secolo. Un po' più a sud si estende la soleggiata valle di Colchagua. I fiumi Maipo, Mapocho e Tinguiririria rendono possibile la viticoltura in questa zona altrimenti arida. Qui si trovano inoltre molte importanti cantine vinicole.

Colchagua- und Maipo-Tal
Rund um die Metropole Santiago liegen die berühmten Weinberge des Maipo-Tals. Hier fand der chilenische Weinbau im 16. Jahrhundert seinen Anfang. Etwas weiter südlich erstreckt sich das sonnenverwöhnte Colchagua-Tal. Den Weinbau in der trockenen Region ermöglichen die Flüsse Maipo, Mapocho und Tinguiririria. Viele renommierte Weingüter haben hier ihren Sitz.

Colchaguavallei en de Maipovallei
Rondom de metropool Santiago liggen de beroemde wijnbergen van de Maipovallei. Hier begon in de zestiende eeuw de wijnbouw in Chili. Verder naar het zuiden strekt zich de zonovergoten Colchaguavallei uit. In deze droge regio is de wijnbouw mogelijk dankzij het water van de rivieren Maipo, Mapocho en Tinguiririria. Hier liggen veel beroemde wijngoederen.

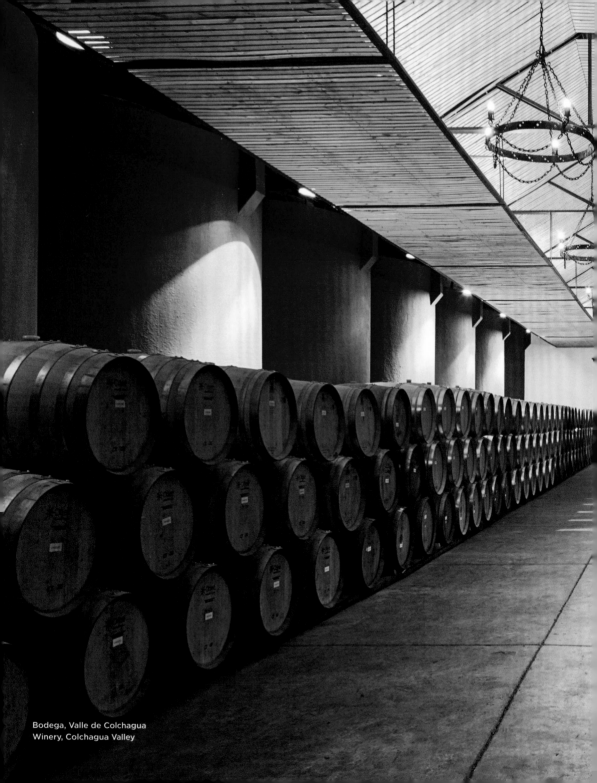

Bodega, Valle de Colchagua
Winery, Colchagua Valley

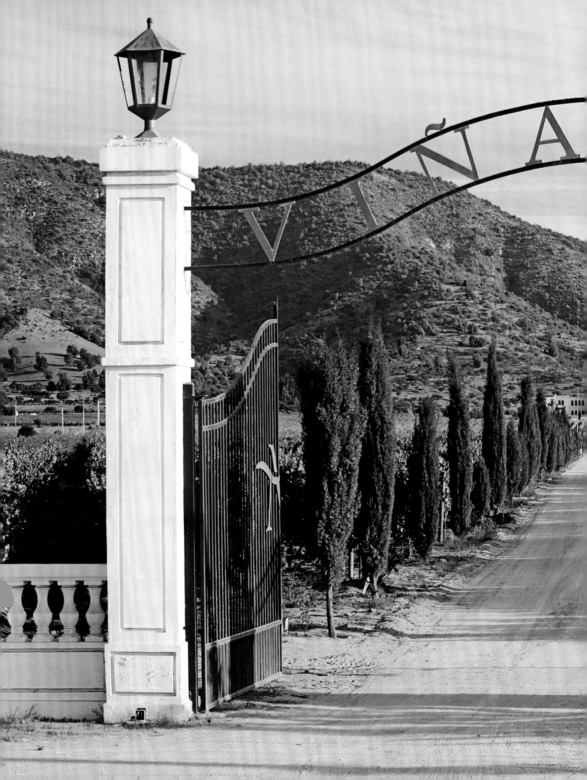

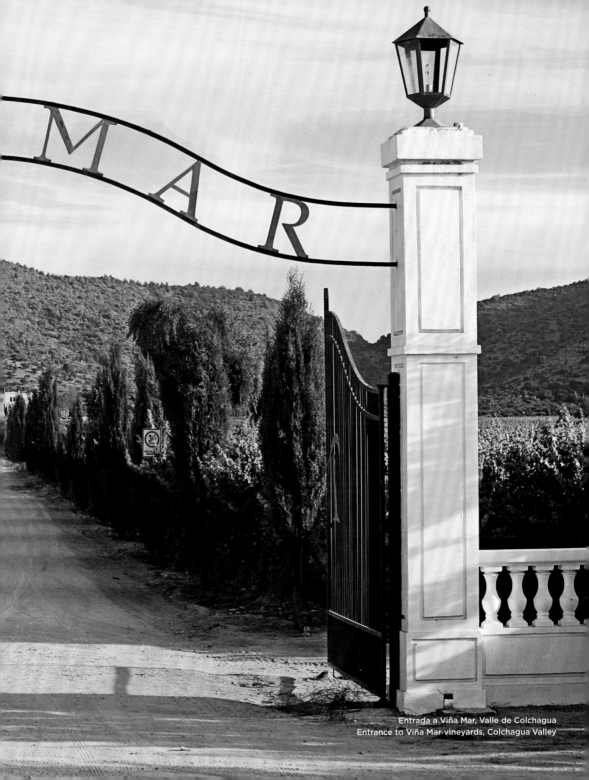

Entrada a Viña Mar, Valle de Colchagua
Entrance to Viña Mar vineyards, Colchagua Valley

Tren del vino, Valle de Colchagua
Wine train, Colchagua Valley

Vid, Valle de Colchagua
Grapevine, Colchagua Valley

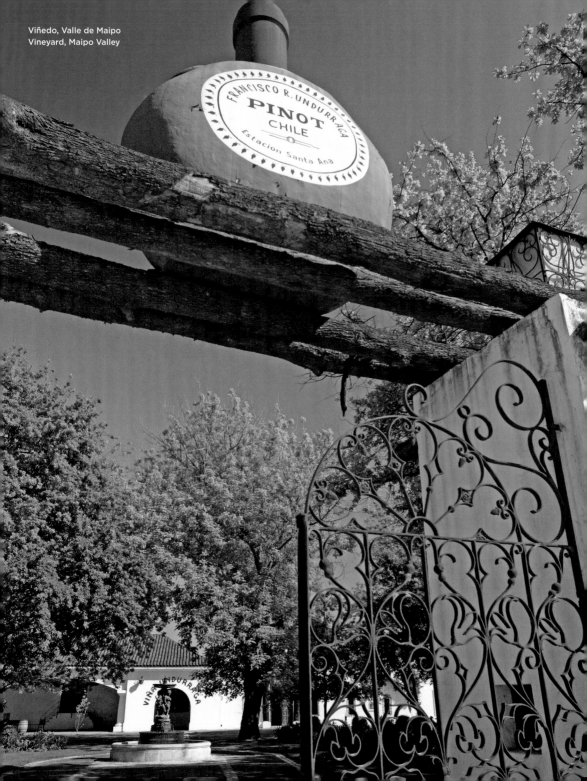

Viñedo, Valle de Maipo
Vineyard, Maipo Valley

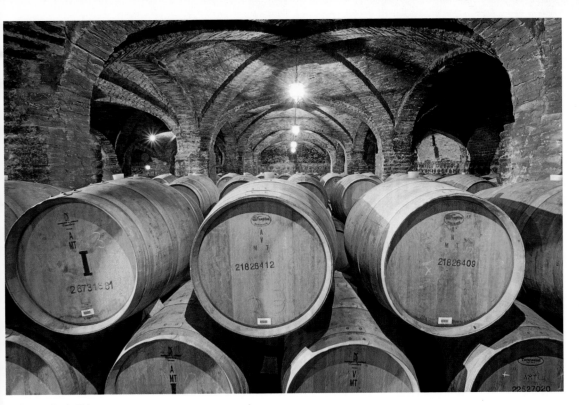

Bodega, Valle de Maipo
Winery, Maipo Valley

Wine

In the Maipo Valley, mostly red grape varieties are cultivated, with over half of the arable land dedicated to growing Cabernet Sauvignon. Only 2000 of the 10,000 hectares (5000 of 25,000 acres) of cultivated land are used for white varieties like Chardonnay, Sauvignon Blanc, and Semillón.

Vinos

En el valle del Maipo predominan las variedades de uva roja. Solo el Cabernet Sauvignon ocupa la mitad de la superficie de viñedo. Sólo en 2000 de las 10 000 hectáreas de tierra cultivada crecen variedades blancas como Chardonnay, Sauvignon Blanc y Semillón.

Vins

Dans la vallée du Maipo, on cultive essentiellement des cépages rouges. Le Cabernet Sauvignon occupe à lui seul plus de la moitié des vignobles de la vallée. Les blancs, comme le Chardonnay, le Sauvignon Blanc et le Sémillon, n'occupent que 2000 ha sur un total d'environ 10 000 ha cultivés.

Vini

Nella valle del Maipo vengono prodotti prevalentemente vini rossi. Già da solo, il Cabernet Sauvignon occupa più della metà delle superfici vinicole della valle. Solo 2000 dei circa 10 000 ettari vengono utilizzati per vitigni a bacche bianche come Chardonnay, Sauvignon Blanc e Semillón.

Weine

Im Maipo-Tal werden überwiegend rote Rebsorten angebaut. Allein der Cabernet Sauvignon nimmt über die Hälfte der Rebfläche des Tals ein. Nur auf 2000 der rund 10 000 Hektar Anbaufläche gedeihen weiße Sorten wie Chardonnay, Sauvignon Blanc und Semillón.

Wijnen

In de Maipovallei worden vooral rode druivensoorten verbouwd. Alleen al de Cabernet Sauvignon neemt de helft van de grond in beslag. Op 2000 van de 10 000 hectare aan wijngaarden groeien witte druivensoorten als Chardonnay, Sauvignon Blanc en Semillón.

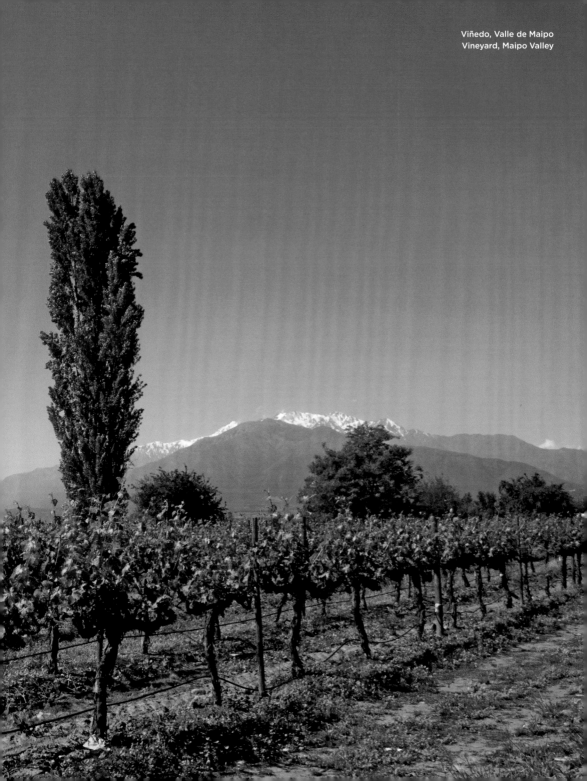

Viñedo, Valle de Maipo
Vineyard, Maipo Valley

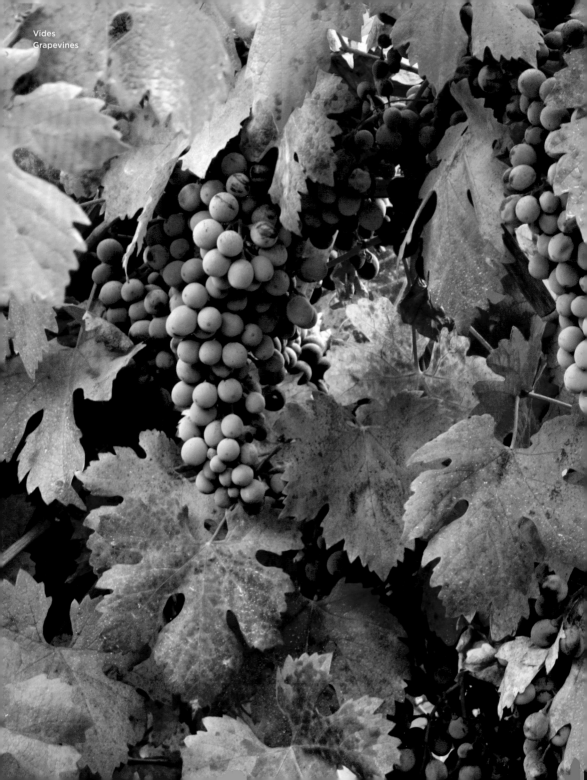

Vides
Grapevines

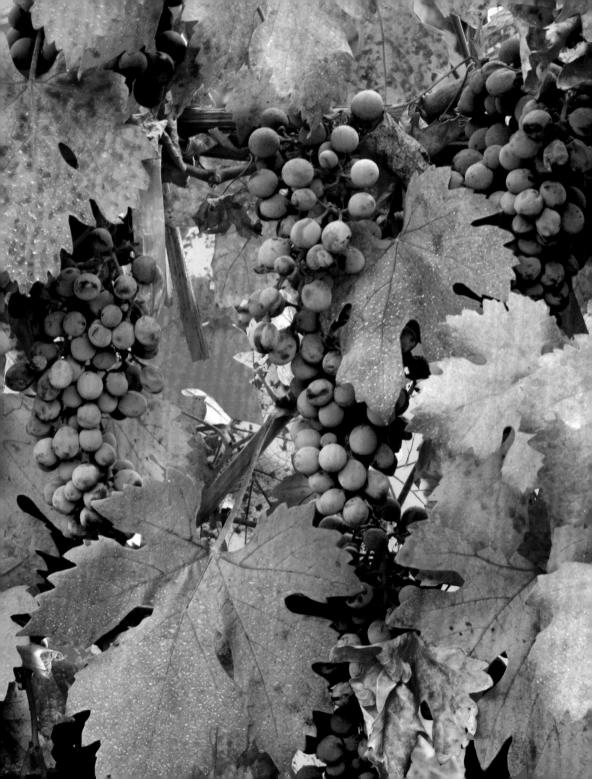

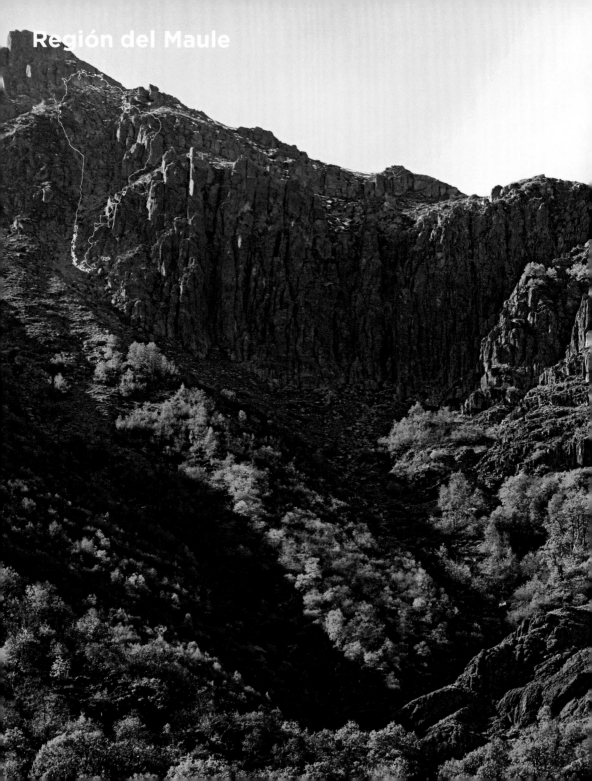

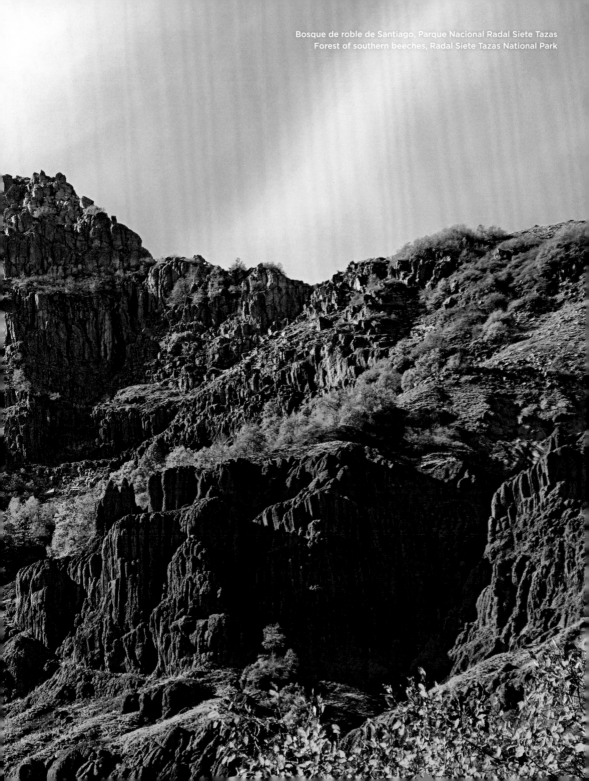

Bosque de roble de Santiago, Parque Nacional Radal Siete Tazas
Forest of southern beeches, Radal Siete Tazas National Park

Parque Nacional Radal Siete Tazas
Radal Siete Tazas National Park

Maule Region

From beach resorts to high mountains.
The Región del Maule is extremely diverse
with wide, sandy beaches on the ocean,
vineyards in the valley around Talca,
gurgling brooks, waterfalls, and lush
green valleys, all crowned high in the
Andes with the deceptively quiet volcano
Descabezado Grande ("Big Beheaded").
It last erupted in 1932 and has a crater
that measures more than a kilometer
(3300 ft) across.

Région du Maule

Entre plages estivales et haute montagne,
la région du Maule offre une diversité
de paysage extrême. De longues plages
de sable s'étirent le long du Pacifique et
les vignes s'épanouissent dans la vallée
de Talca. Les altitudes moyennes sont
ponctuées de ruisseaux gargouillant, de
chutes d'eau et de vallées exubérantes,
alors que le volcan Descabezado Grande
(le grand décapité) domine les hauteurs
des Andes. Il est apparemment endormi,
sa dernière éruption datant de 1932.
Son cratère mesure plus d'un kilomètre
de diamètre.

Region Maule

Vom Ferienstrand bis zum Hochgebirge.
Die Región del Maule präsentiert sich
extrem abwechslungsreich. Weite
Sandstrände am Pazifik. Weingärten
im Tal um Talca. Gurgelnde Bäche,
Wasserfälle und üppig grüne Täler in
den mittleren Lagen. Und oben in den
Höhen der Anden thront – nur scheinbar
schlafend – der Vulkan Descabezado
Grande: der „Große Geköpfte". 1932 ist
er zuletzt ausgebrochen. Sein Krater
hat einen Durchmesser von mehr als
einem Kilometer.

Cerca de San Clemente, Valle del Maule
Near San Clemente, Maule Valley

Región del Maule

De vacaciones en la playa a las altas montañas. La región del Maule se presenta muy variada. Amplias playas de arena en el Pacífico. Viñedos en el valle de Talca. Gorgoteantes arroyos, cascadas y valles verdes en las latitudes medias. Y encaramado en las alturas de los Andes – sólo aparentemente dormido – el volcán Descabezado Grande. En 1932 entró por última vez en erupción. Su cráter tiene un diámetro de más de un kilometro.

Regione del Maule

Dalla spiaggia fino all'alta montagna. La regione del Maule si presenta estremamente variegata. Spiagge di sabbia bianca sul Pacifico, vigneti nella valle di Talca, ruscelli gorgoglianti, cascate e lussureggianti e verdi vallate nel centro del paese. E lassù in cima alle Ande troneggia il vulcano Descabezado Grande: il "Gran Decapitato", solo in apparenza addormentato. Nel 1932 ha eruttato per l'ultima volta. Il suo cratere ha un diametro di più di un chilometro.

Regio Maule

Van vakantiestrand tot hooggebergte – in de regio Maule ontmoeten deze extremen elkaar, met brede zandstranden aan de Stille Oceaan, wijngaarden in het dal rond Talca en daartussenin bruisende beekjes, watervallen en weelderig groene dalen. Hoog in de Andes torent de (slechts schijnbaar slapende) vulkaan Descabezado Grande, de 'Grote Onthoofde', die in 1932 voor het laatst uitbarstte. De krater heeft een doorsnede van ruim een kilometer.

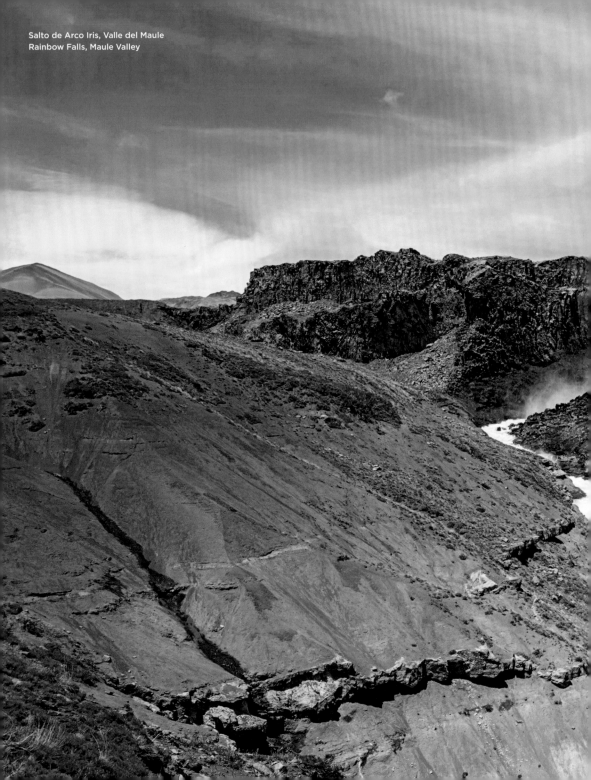

Salto de Arco Iris, Valle del Maule
Rainbow Falls, Maule Valley

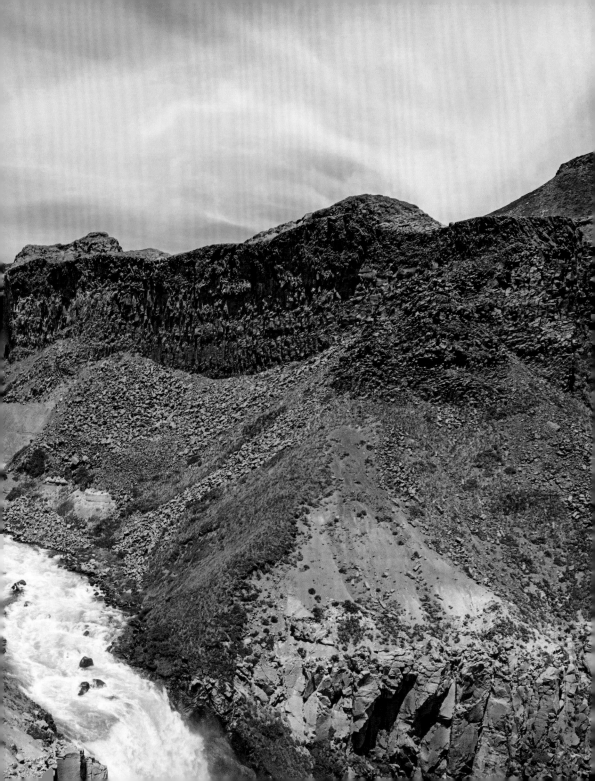

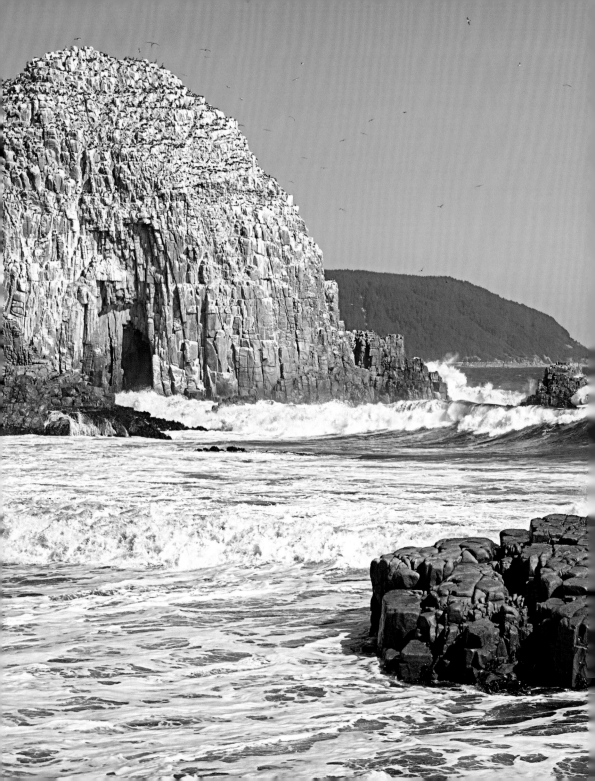

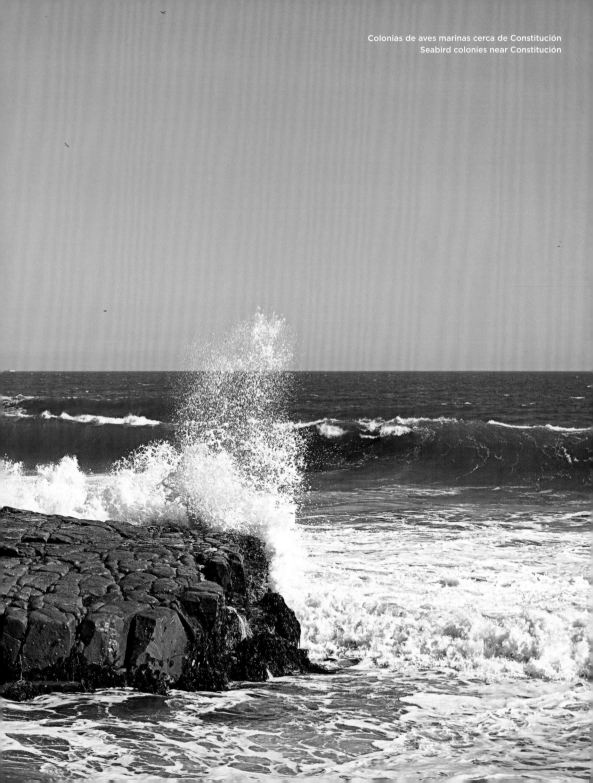

Salto Velo de la Novia, Parque Nacional Radal Siete Tazas
Waterfall Velo de la Novia (Bride's Veil), Radal Siete Tazas National Park

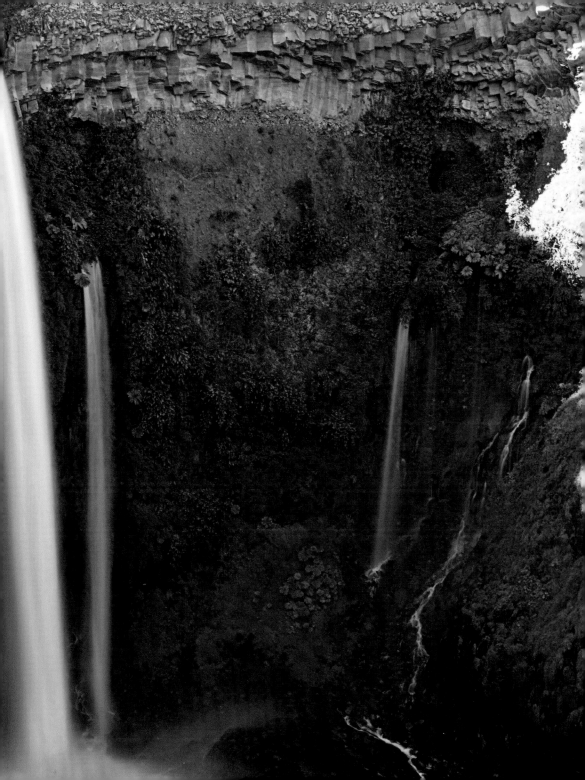

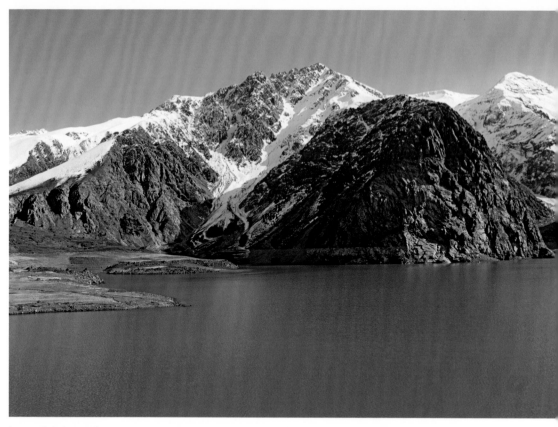

Laguna de la Invernada
La Invernada Lagoon

Radal Siete Tazas National Park

Radal Siete Tazas National Park owes
its name to the natural pools of water
(the "seven cups") of the Río Claro. The
river has also created some spectacular
waterfalls. Guemals, pumas, condors, and
parrots all make their home in the forests
of oak, beech, and bamboo.

Parc national Radal Siete Tazas

Le parc national Radal Siete Tazas doit
son nom aux bassins naturels (sept tasses)
formés dans le lit du Rio Claro. Le fleuve a
également forgé de spectaculaires chutes
d'eau. Dans les forêts denses de chênes, de
hêtres et de bambous vivent notamment
des cerfs des Andes, des pumas, des
condors et des perroquets.

Nationalpark Radal Siete Tazas

Der Nationalpark Radal Siete Tazas
verdankt seinen Namen den natürlichen
Wasserbecken („sieben Tassen") des Río
Claro. Auch spektakuläre Wasserfälle hat
der Fluss ausgebildet. Und in dichten
Eichen-, Buchen- und Bambuswäldern
leben unter anderem Andenhirsche und
Pumas, Kondore und Papageien.

Parque Nacional Radal Siete Tazas
Radal Siete Tazas National Park

Parque Nacional Radal Siete Tazas

El Parque Nacional Radal Siete Tazas toma su nombre de las piscinas naturales del Río Claro. El río también ha formado espectaculares cascadas. Y en los bosques densos de roble, haya y bambú, viven entre otros tarucas y pumas, cóndores y papagayos.

Parco nazionale Radal Siete Tazas

Il Parco nazionale Radal Siete Tazas deve il suo nome alle piscine naturali (le sette tazze) del Río Claro. Il fiume ha formato anche spettacolari cascate, e nei fitti boschi di querce, faggi e bambù vivono tra gli altri cervi delle Ande e puma, condor e pappagalli.

Nationaal Park Radal Siete Tazas

Het Nationaal Park Radal Siete Tazas dankt zijn naam aan het natuurlijke waterreservoir (de 'zeven mokken') van de Río Claro. De rivier heeft ook spectaculaire watervallen uitgesleten, en in de dichte eiken-, beuken- en bamboebossen leven onder andere huemuls, poema's, condors en papegaaien.

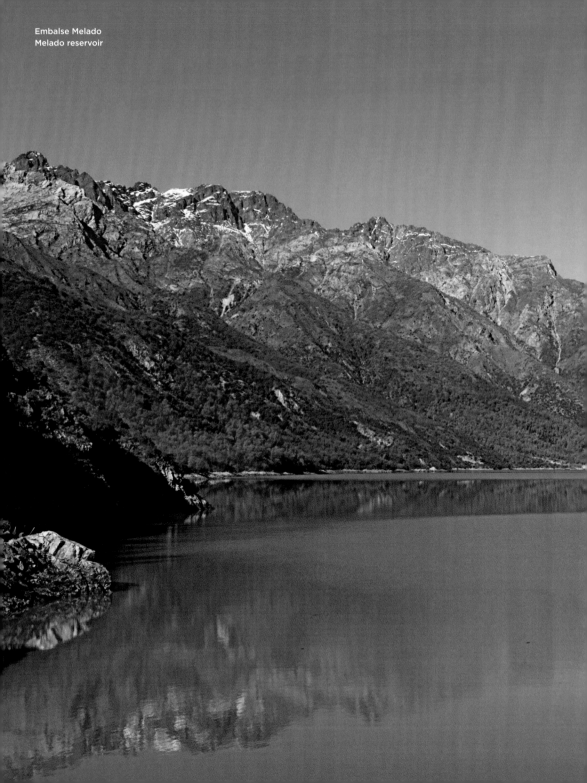

Embalse Melado
Melado reservoir

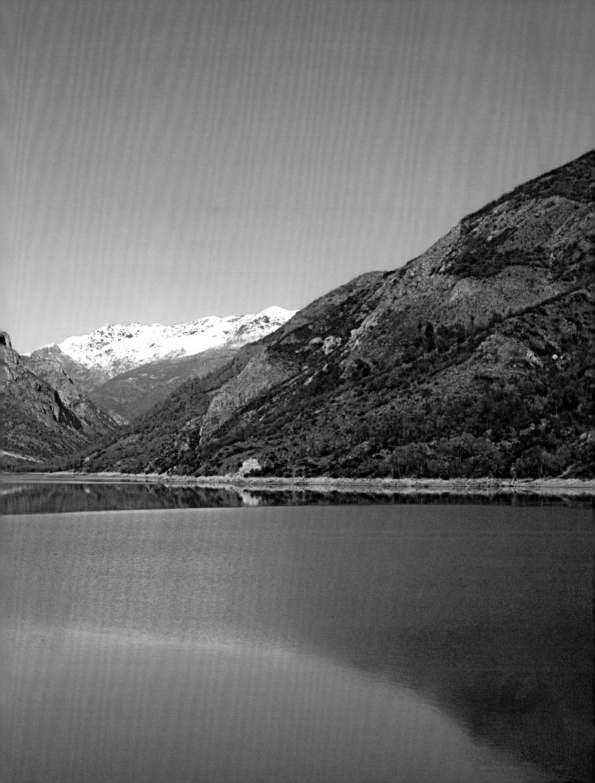

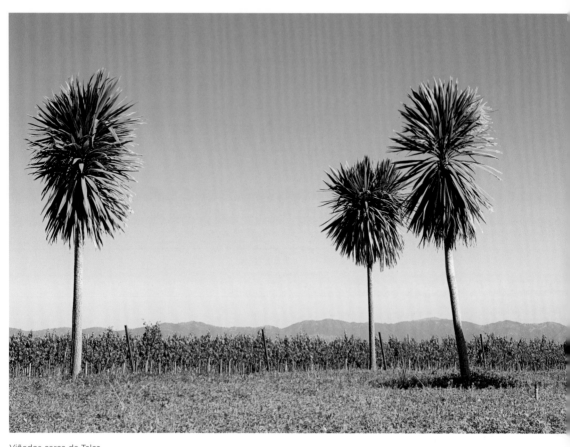

Viñedos cerca de Talca
Vineyards near Talca

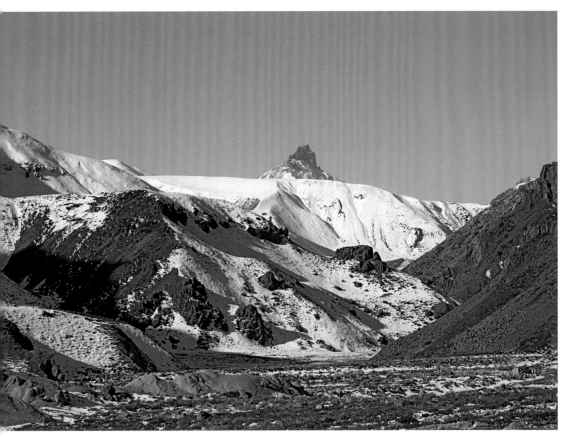

Cordillera de los Andes cerca de Talca
Andean Mountains near Talca

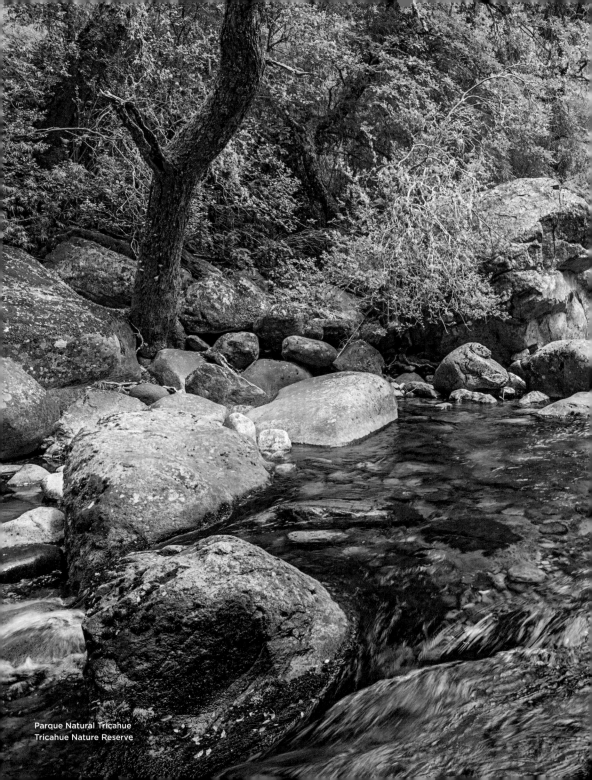

Parque Natural Tricahue
Tricahue Nature Reserve

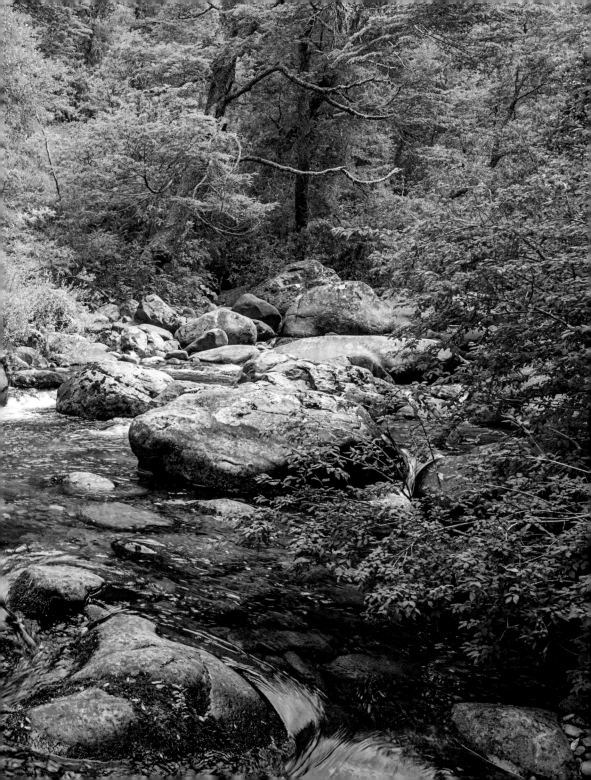

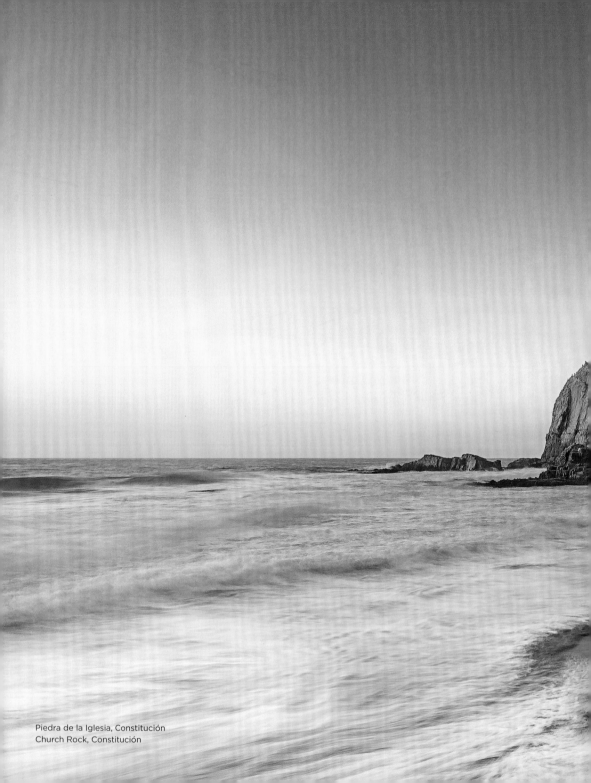

Piedra de la Iglesia, Constitución
Church Rock, Constitución

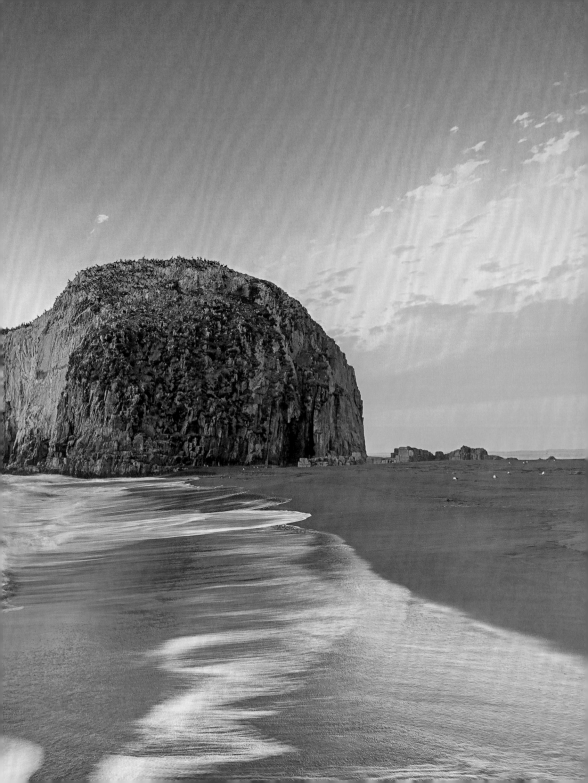

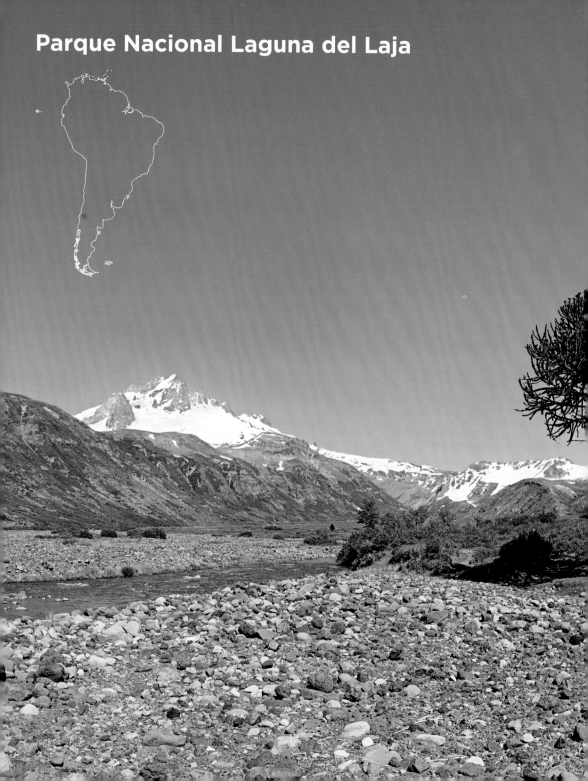

Parque Nacional Laguna del Laja

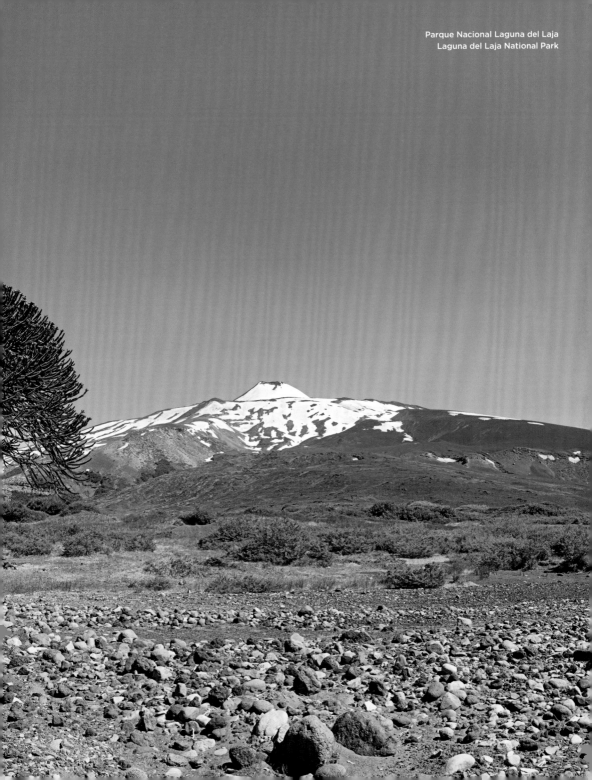

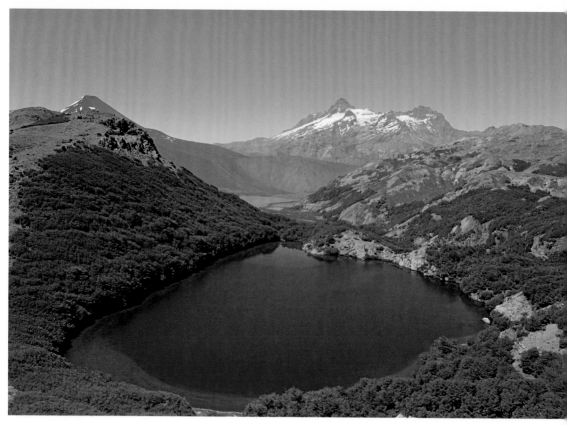

Laguna Los Cóndores
Los Cóndores Lagoon

Laguna del Laja National Park

Bizarre lava fields at the foot of Antuco Volcano, emerald-green volcanic lakes, waterfalls, and rugged fields of snow characterize the Laguna del Laja National Park. Lush green forests predominate whereever the lava has not managed to reach, such as the floodplains of the Río Laja. Mighty condors, eagles, and black-faced ibis rule the skies. And you can even ski the slopes of Antuco as you enjoy views of Laguna del Laja.

Parc national Laguna de Laja

Étranges champs de lave au pied du volcan Antuco, lacs de cratère émeraude et surfaces neigeuses craquelées constituent les paysages emblématiques du parc national Laguna del Laja. Dans les zones non atteintes par les coulées de lave, telles les prairies bordant le Rio Laja, s'épanouissent des forêts luxuriantes. Le fier condor, l'aigle et l'ibis à face noire planent dans le ciel du parc. Il est également possible de skier sur les flans de l'Antuco, en admirant la lagune de La Laja.

Nationalpark Laguna del Laja

Bizarre Lavafelder zu Füßen des Vulkans Antuco, smaragdgrüne Kraterseen, Wasserfälle und zerklüftete Schneefelder bestimmen das Bild im Nationalpark Laguna del Laja. Wo die Lavafinger der Vulkane nicht hinreichten, etwa in den Auen des Río Laja, gedeihen auch üppig grüne Wälder. In die Lüfte über dem Park erhebt sich der stolze Kondor ebenso wie der Adler und die Brillenibis. Und an den Flanken des Antuco kann man sogar Ski fahren – mit Blick auf die Laguna del Laja.

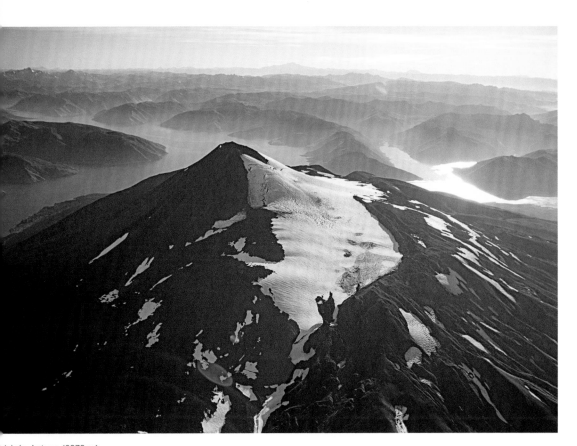

Volcán Antuco (2979 m)
Antuco volcano (2979 m · 9774 ft)

Parque Nacional Laguna del Laja

Extraños campos de lava al pie del volcán Antuco, lagos de color esmeralda en los cráteres, cascadas y escarpados campos de nieve.dominan el paisaje en el Parque Nacional Laguna del Laja. Donde no llegan los dedos de lava de los volcanes, por ejemplo, en la llanura de inundación del Río Laja, prosperan exuberantes bosques verdes. En los cielos sobre el parque se alza el cóndor orgulloso, así como el águila y las bandurrias australes. E incluso se puede ir a esquiar a los flancos del Antuco – con vistas a la Laguna del Laja.

Parco Nazionale Laguna del Laja

Bizzarre distese di lava ai piedi del vulcano Antuco, laghi vulcanici verde smeraldo, cascate e nevai ricchi di crepacci compongono il quadro del Parco Nazionale Laguna del Laja. Dove non arrivano le dita di lava del vulcano, nei prati lungo il Rio Laja crescono anche folte boscaglie verdi. Nel cielo al di sopra del parco si alza in volo il superbo condor, come anche l'aquila e l'ibis dalla faccia nera. E sui pendii dell'Antuco si può persino sciare, con vista sulla Laguna del Laja.

Nationaal Park Laguna del Laja

Bizarre lavavelden aan de voet van de vulkaan Antuco, smaragdgroene kratermeren, watervallen en sneeuwvelden met diepe scheuren bepalen het landschap van het Nationaal Park Laguna del Laja. Op plekken die buiten het bereik van de lavastromen zijn gebleven, zoals aan de oevers van de Río Laja, groeien weelderig groene bossen. In de lucht boven het park zweven majestueuze condors, adelaars en zwartmaskeribissen. Op de flanken van de Antuco kan worden geskied – met uitzicht op de Laguna del Laja.

Laja Falls

To the north of Los Ángeles, just off Ruta 5, the Río Laja rushes over cliffs to form four spectacular waterfalls. The Salto del Laja at 35 m (115 ft) is the largest waterfall in Chile.

Chutes de Laja

Au nord de Los Angeles, juste à côté de la route 5, le Río Laja se divise en quatre cascades spectaculaires et plonge par-dessus un plateau rocheux. Le Salto del Laja, d'environ 35 m de haut, est la plus grande chute d'eau du Chili.

Laja-Fälle

Nördlich von Los Ángeles, direkt an der Ruta 5, stürzt der Río Laja in vier spektakulären Wasserfällen über ein Felsplateau. Der Salto del Laja ist mit etwa 35 m der größte Wasserfall Chiles.

Salto del Laja

Al norte de Los Ángeles, justo en la Ruta 5, el río Laja cae en cuatro espectaculares cascadas sobre una meseta. El Salto del Laja, con unos 35 m, es la cascada más grande de Chile.

Salto del Laja

Al nord di Los Angeles, direttamente sulla Ruta CH-5, il Río Laja precipita sulle rocce formando quattro cascate spettacolari. Con i suoi 35 m di altezza, il Salto del Laja è la cascata più grande del Cile.

Laja-watervallen

Ten noorden van Los Ángeles, naast de Ruta 5, stort de Río Laja zich in vier spectaculaire watervallen van een rotsplateau. Met 35 meter hoogteverschil is de Salto del Laja de hoogste van Chili.

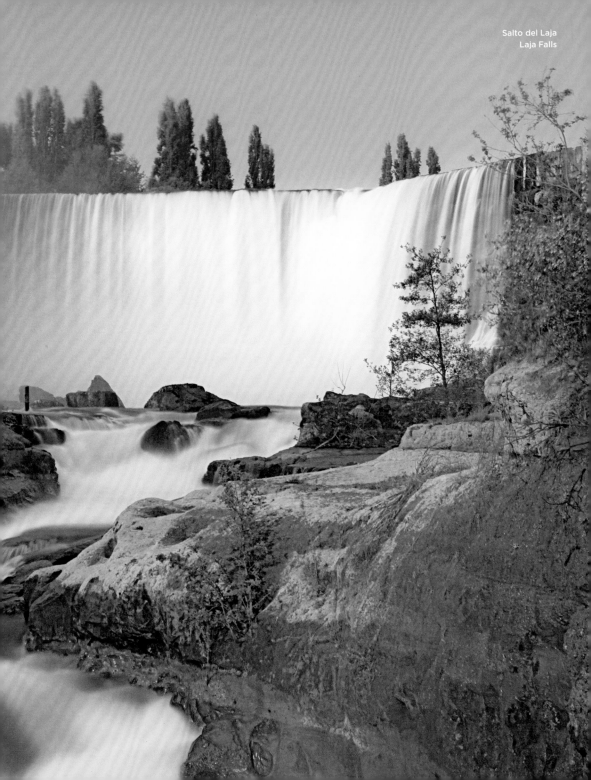

Salto del Laja
Laja Falls

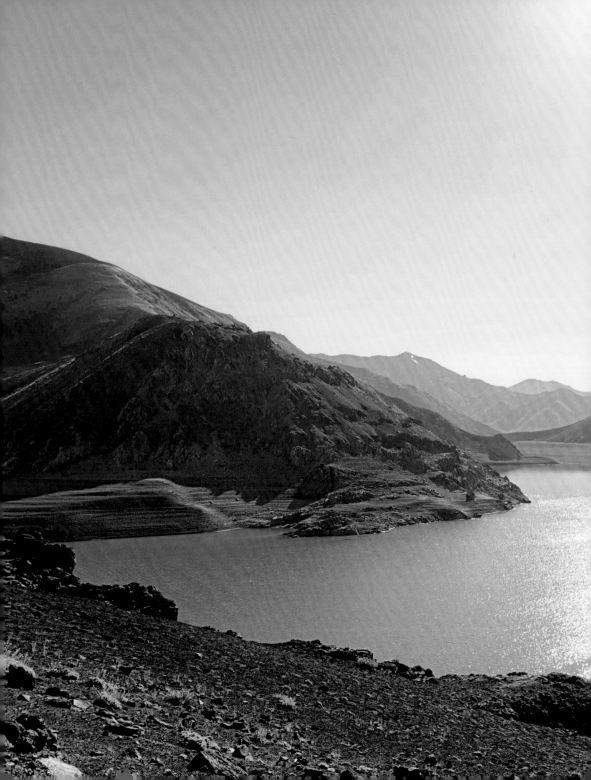

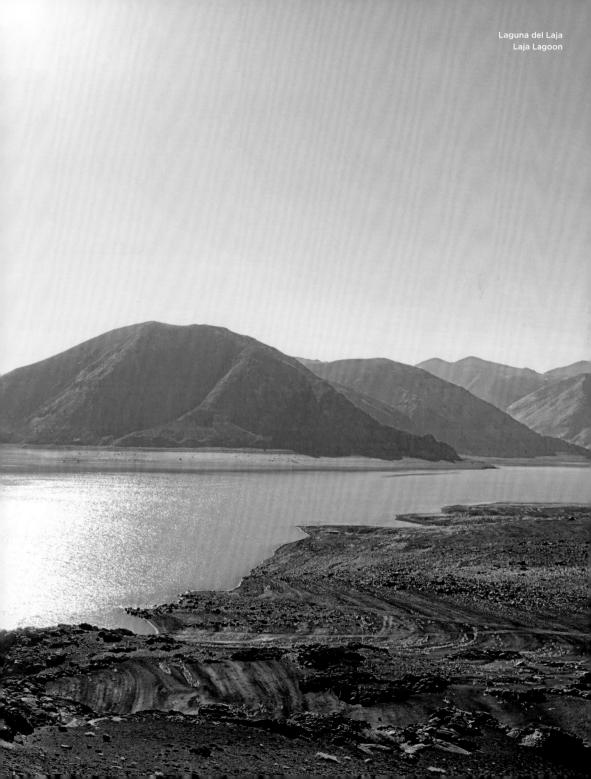

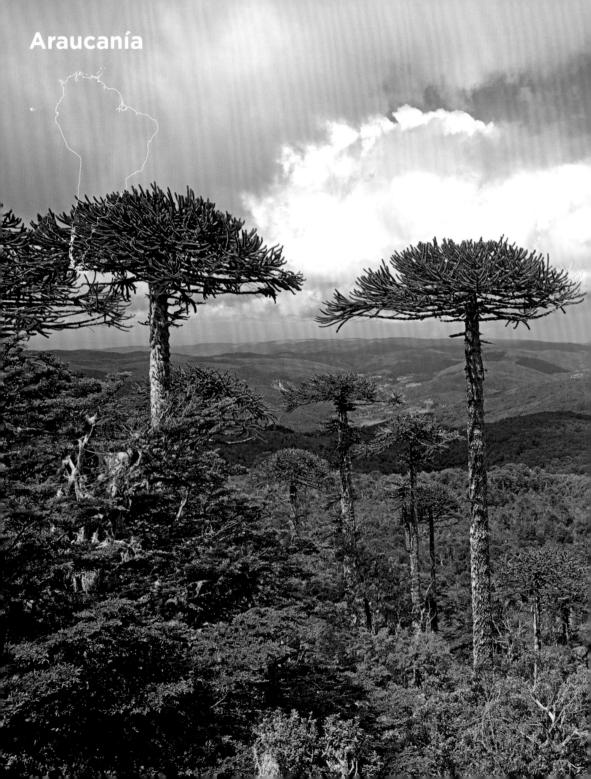

Araucanía

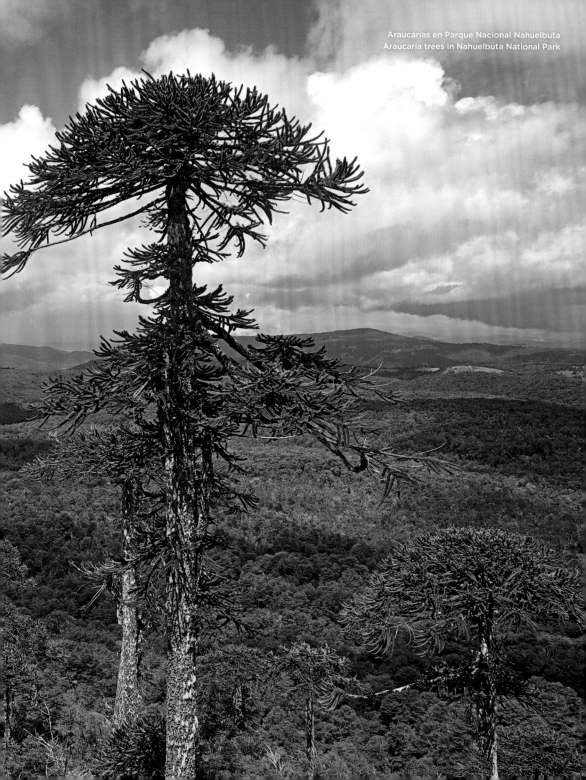

Araucarias en Parque Nacional Nahuelbuta
Araucaria trees in Nahuelbuta National Park

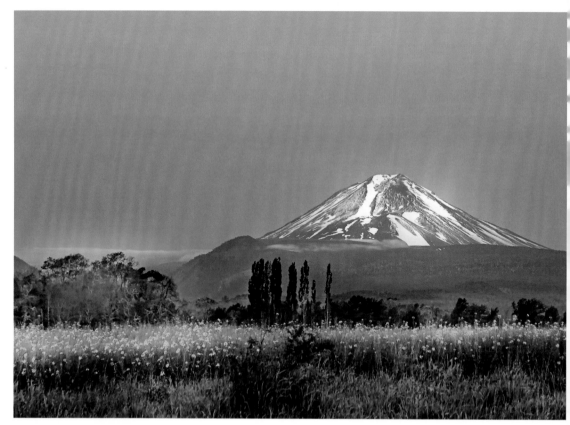

Volcán Lonquimay (2865 m)
Lonquimay volcano (2865 m · 9400 ft)

Araucanía

Dense green of the Valdivian rain forest.
Extensive fields and meadows here in
Chile's bread basket. Deep blue lakes and
foaming waterfalls. All crowned with the
imposing cones of volcanoes like Villarrica,
Llaima, Tolhuaca, and Lonquimay. The
Araucanía really shows Chile in all its
diversity and offers nature lovers almost
endless possibilities to explore on foot, by
horseback, or on the water.

Araucanie

Vert intense des forêts tempérées
valdiviennes, vastes champs du «grenier»
du Chili, lacs d'un bleu profond et chutes
d'eau écumantes. Ce paysage aux
multiples facettes est dominé par les
cônes imposants des volcans, notamment
Villarrica, Llaima, Tolhuaca et Lonquimay.
La région de l'Araucanie témoigne de la
diversité du Chili et offre aux amateurs de
nature des possibilités réellement illimitées
de la découvrir, à pied, à cheval ou par
voie d'eau.

Araukanien

Dichtes Grün des Valdivianischen
Regenwaldes. Weite Äcker und Felder
in der Kornkammer Chiles. Tiefblaue
Seen und schäumende Wasserfälle. Und
als Krönung die imposanten Kegel von
Vulkanen wie Villarrica, Llaima, Tolhuaca
und Lonquimay. In der Region Araukanien
zeigt Chile seine ganze Vielfalt auf und
bietet Naturliebhabern schier unendliche
Möglichkeiten, diese per pedes, auf dem
Pferderücken oder auf dem Wasser
zu erobern.

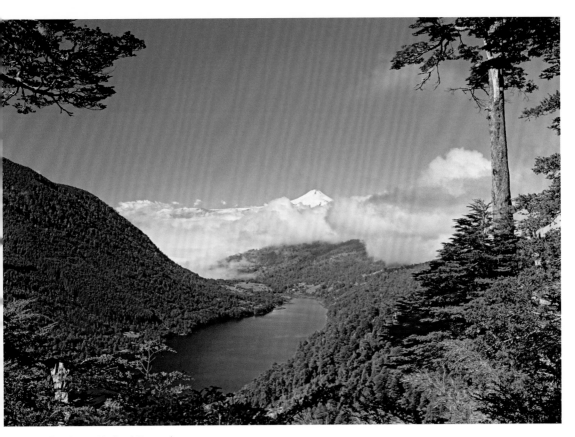

Lago Tinquilco, Parque Nacional Huerquehue
Lake Tinquilco, Huerquehue National Park

Araucanía

Densa y verde selva valdiviana.
Amplios campos y tierras en el granero
de Chile. Profundos lagos azules y
espumosas cascadas. Y para rematar, los
impresionantes conos de volcanes como
el Villarrica, Llaima, Tolhuaca y Lonquimay.
En la región de la Araucanía, Chile muestra
su diversidad y ofrece a los amantes de la
naturaleza infinitas formas de conquistarla
a pie, a caballo o en el agua.

Araucanía

Fitta vegetazione della foresta pluviale di
Valdivia. Vasti campi e prati nel granaio
del Cile. Laghi blu intenso e cascate
spumeggianti. E come coronamento gli
imponenti coni dei vulcani di Villarrica,
Llaima, Tolhuaca e Lonquimay. Nella
regione di Araucanía il Cile mostra tutta la
sua varietà e offre agli amanti della natura
possibilità quasi illimitate di conquistarlo a
piedi, in sella a un cavallo o sull'acqua.

Araucanië

De weidse akkers en velden van deze
graanschuur van Chili worden aangevuld
met het dichte groen van het gematigde
bos van Valdivia, naast diepblauwe meren
en ziedende watervallen. De bekroning
vormen de imposante kegels van vulkanen
als de Villarrica, de Llaima, de Tolhuaca en
de Lonquimay. In de regio Araucanië toont
Chili zijn meest veelzijdige pracht en biedt
natuurliefhebbers een welhaast oneindig
keuze om dit alles te voet, te paard of te
water te ontdekken.

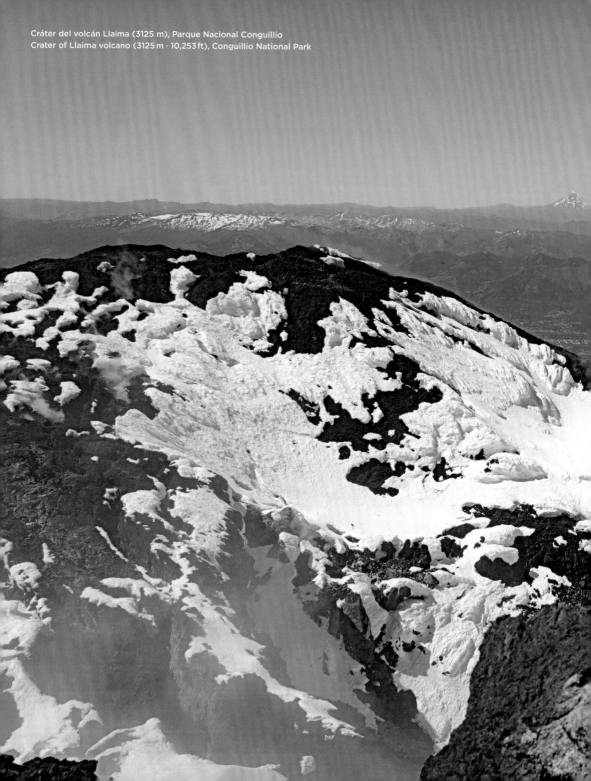

Cráter del volcán Llaima (3125 m), Parque Nacional Conguillío
Crater of Llaima volcano (3125 m · 10,253 ft), Conguillío National Park

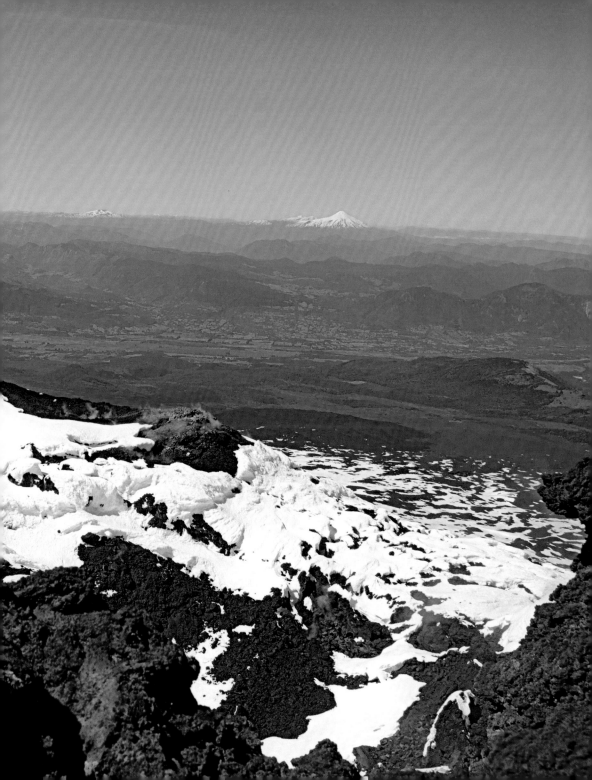

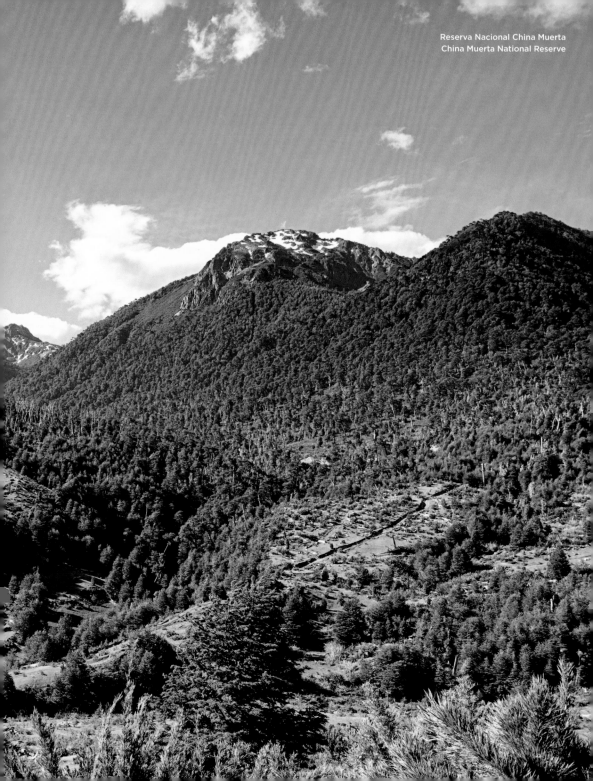

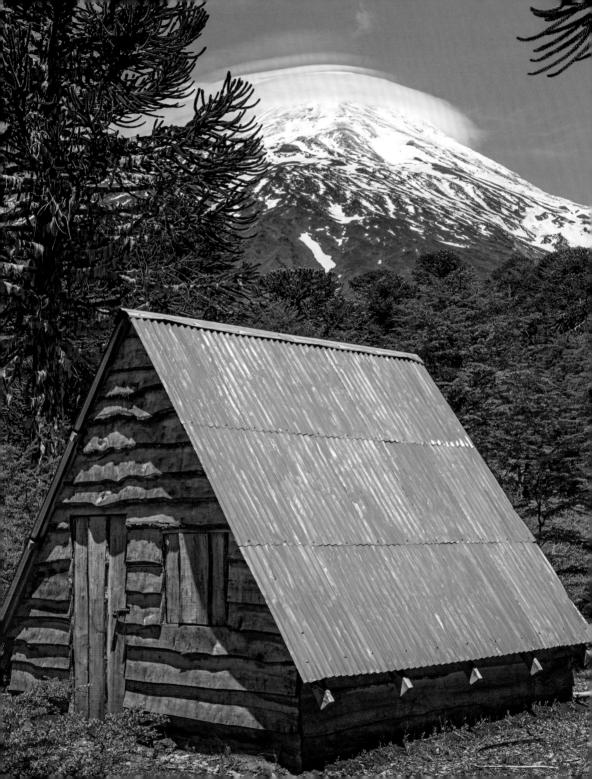

Río Trancura
Trancura River

Refugio y Volcán Lanín (3728 m)
Hut and Lanín volcano (3728 m · 12,231 ft)

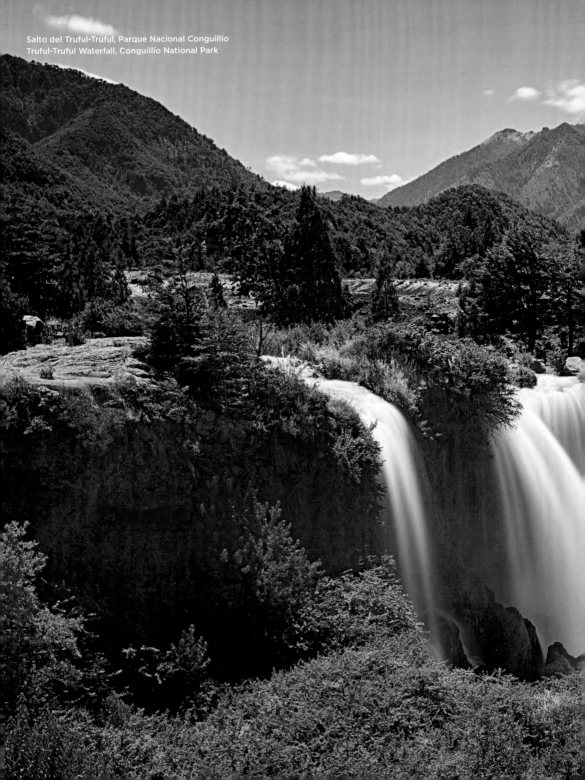

Salto del Truful-Truful, Parque Nacional Conguillío
Truful-Truful Waterfall, Conguillío National Park

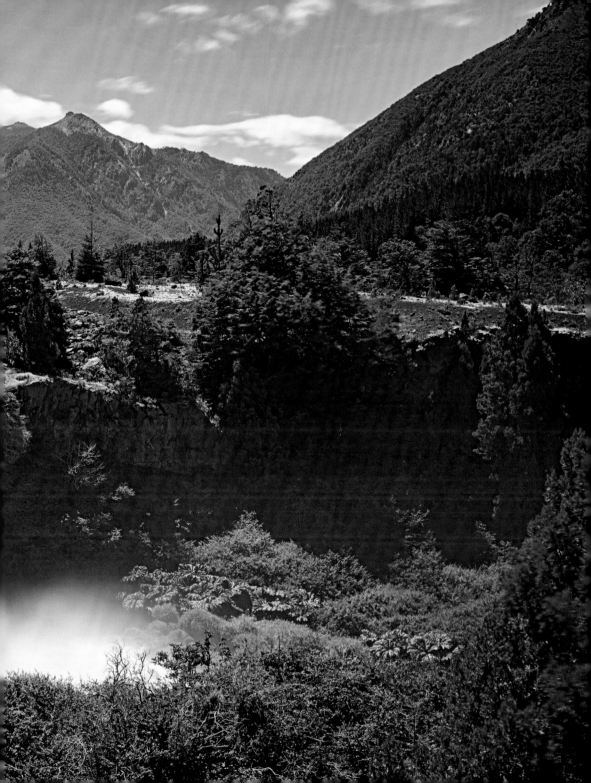

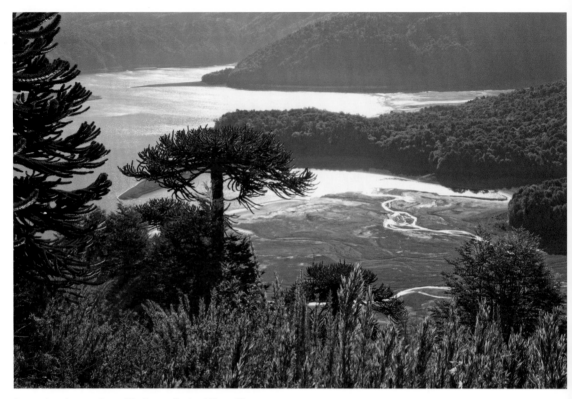

Araucarias y Laguna Conguillío, Parque Nacional Conguillío
Araucaria trees and Conguillío Lagoon, Conguillío National Park

Conguillío National Park

The Conguillío National Park is also called
Las Paraguas ("umbrellas") due to the
millions of monkey puzzle trees (Araucaria)
that act like natural umbrellas all around
the park. The tree with the sword-like
leaves is one of the oldest tree species
in the world and has given the Araucanía
region its name.

Parc national Conguillío

Le parc national Conguillío est surnommé
Los Paraguas (les parapluies). La raison :
les millions d'araucarias qui surplombent
le parc tels de majestueux parapluies
végétaux. Les araucarias, avec leurs feuilles
en forme de poignard, comptent parmi
les espèces d'arbres les plus anciennes
du globe et ont donné leur nom à la
région d'Araucanie.

Nationalpark Conguillío

Los Paraguas („Die Regenschirme") wird
der Nationalpark Conguillío auch genannt.
Der Grund: Millionen von Araukarien,
die wie natürliche Schirme den Park
überragen. Die Araukarie mit ihren
dolchartigen Blättern zählt zu den ältesten
Baumfamilien der Welt und hat der Region
Araukanien ihren Namen gegeben.

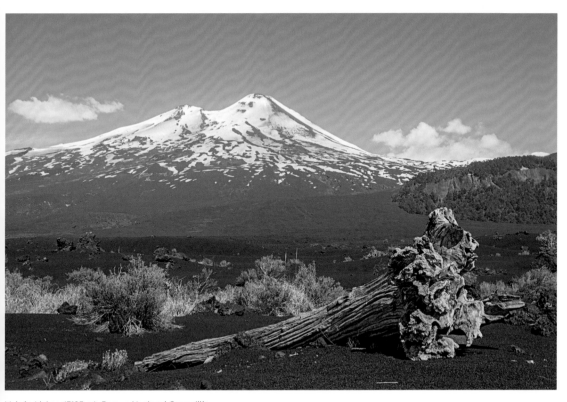

Volcán Llaima (3125 m), Parque Nacional Conguillío
Llaima volcano (3125 m · 10,253 ft), Conguillío National Park

Parque Nacional Conguillío

El Parque Nacional Conguillío también es conocido como Los Paraguas. La razón: millones de araucarias que se elevan en el parque a modo de escudos naturales. La araucaria, con sus hojas como dagas, es una de las familias de árboles más antigua del mundo y la región de Araucanía es la que le ha dado su nombre.

Parco Nazionale di Conguillío

Il Parco Nazionale di Conguillío viene chiamato anche Los Paraguas (gli ombrelli). Il motivo sono i milioni di araucarie che sovrastano il parco come ombrelli naturali. L'araucaria, con le sue foglie simili a pugnali, appartiene ad una delle più antiche famiglie di alberi del mondo e ha dato il suo nome alla regione di Araucanía.

Nationaal Park Conguillío

Los Paraguas ('de paraplu's') wordt het Nationaal Park Conguillío ook wel genoemd, omdat miljoenen slangendennen als natuurlijke regenschermen boven het park verrijzen. Met zijn dolkvormige bladeren behoort de slangenden (Araucaria araucana) tot de oudste bomenfamilies ter wereld; de regio is vernoemd naar de Latijnse naam van de boom.

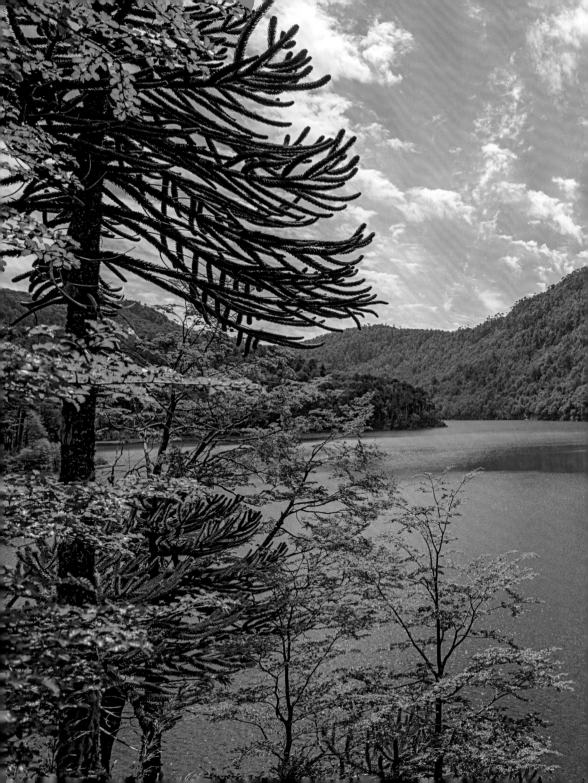

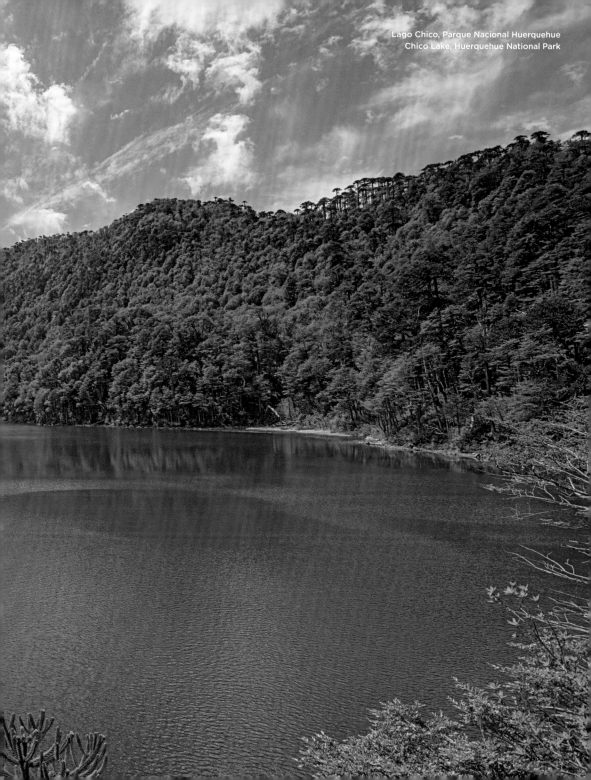

Lago Chico, Parque Nacional Huerquehue
Chico Lake, Huerquehue National Park

Montañas en Alto Biobío
Mountains in Alto Biobío

Lago Villarrica, Pucón
Lake Villarrica, Pucón

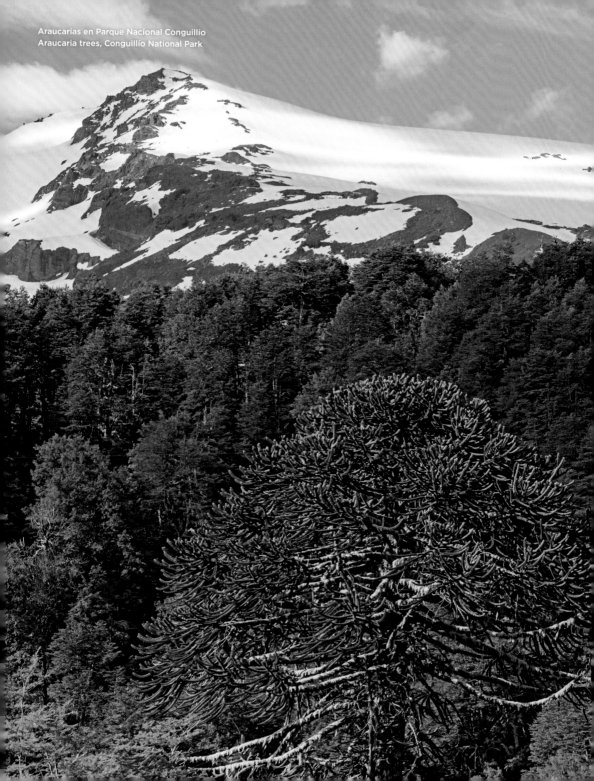
Araucarias en Parque Nacional Conguillío
Araucaria trees, Conguillío National Park

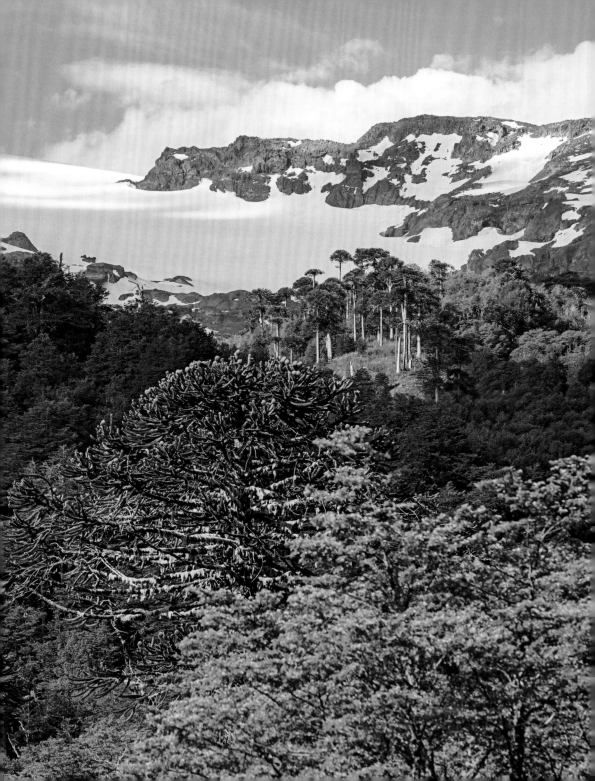

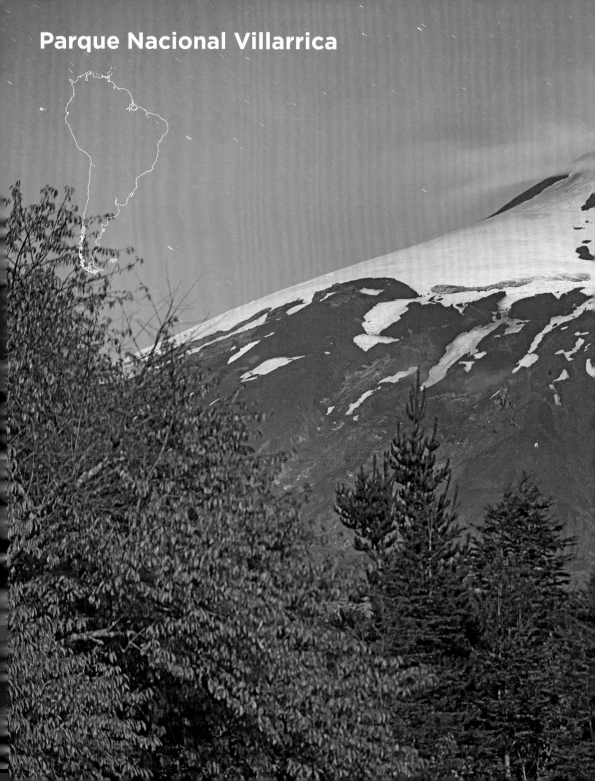

Parque Nacional Villarrica

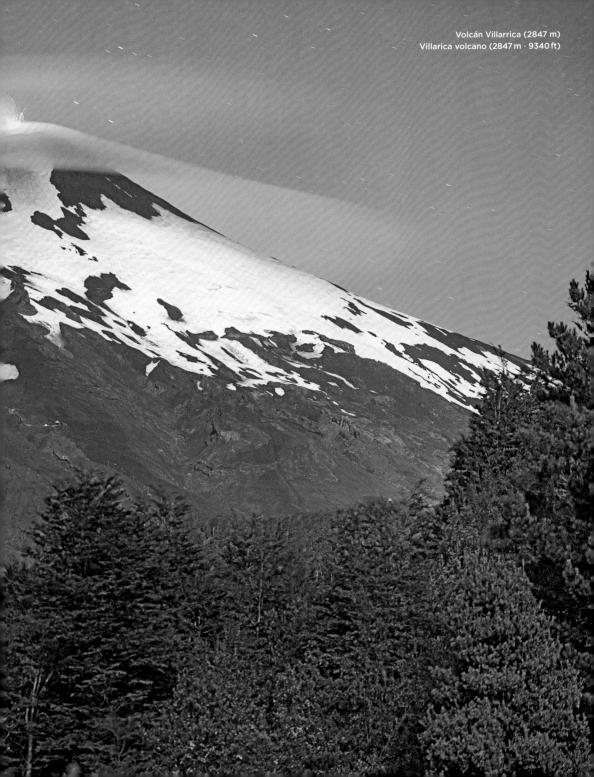

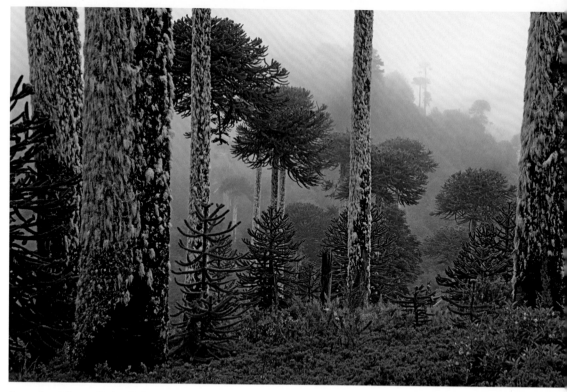

Araucarias en Parque Nacional Villarrica
Araucaria trees in Villarrica National Park

Villarrica National Park

Villarrica is one of most active volcanoes in the Americas and last erupted in March 2015. The national park named after it lies partly in Araucanía and partly in the Los Ríos region and is home not only to Villarrica, but also the volcanoes named Quetrupillán (2360 m · 7743 ft) and Lanín (3776 m · 12,388 ft). The park offers many trails and a ski area with seven lifts.

Parque Nacional Villarrica

El Villarrica es uno de los volcanes más activos de América – su última erupción fue en marzo de 2015. A este Parque Nacional que lleva su mismo nombre, situado en gran parte en la zona de la Araucanía y en parte en la Región de Los Ríos, pertenecen además del Villarrica, los volcanes Quetrupillán (2360 m) y Lanín (3776 m). Innumerables senderos cruzan el parque – además de una estación de esquí con siete remontes.

Parc national Villarrica

Le Villarrica est l'un des volcans les plus actifs d'Amérique, sa dernière éruption date de 2015. Le parc national portant son nom est situé en partie dans la région de Los Ríos et compte, outre le Villarrica, deux autres volcans, le Quetrupillán (2360 m) et le Lanín (3776 m). D'innombrables chemins de randonnée parcourent le parc et un domaine skiable y a été installé, offrant sept remontées.

Parco Nazionale Villarrica

Il Villarrica è uno dei vulcani più attivi d'America, ha eruttato per l'ultima volta nel marzo 2015. Al Parco Nazionale che prende il suo nome, situato in parte nella regione di Araucanía e in parte nella regione di Los Ríos, appartengono oltre al Villarrica anche i vulcani Quetrupillán (2360 m) e Lanín (3776 m). È possibile esplorare il parco grazie a innumerevoli sentieri per escursioni, oltre che in un comprensorio sciistico con sette seggiovie.

Nationalpark Villarrica

Der Villarrica zählt zu den aktivsten Vulkanen Amerikas – zuletzt ausgebrochen im März 2015. Zum nach ihm benannten Nationalpark, teils auf dem Gebiet von Araukanien, teils in der Región de Los Ríos gelegen, gehören neben dem Villarrica auch noch die Vulkane Quetrupillán (2360 m) und Lanín (3776 m). Unzählige Wanderwege erschließen den Park – und dazu ein Skigebiet mit sieben Lifts.

Nationaal Park Villarrica

De vulkaan Villarrica behoort tot de actiefste van Zuid-Amerika en is voor het laatst in maart 2015 uitgebarsten. Het naar de vulkaan genoemde park, dat deels in de regio Araucanía, deels in Los Ríos gelegen, omvat naast de Villarrica ook de vulkanen Quetrupillán (2360 m) en Lanín (3776 m). Vele wandelroutes ontsluiten het park, en er is een skigebied met zeven liften.

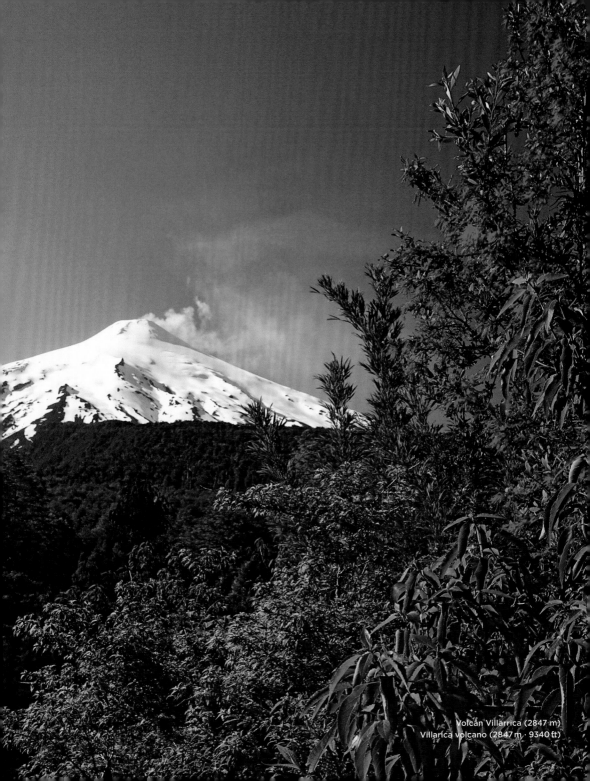

Volcán Villarrica (2847 m)
Villarica volcano (2847 m · 9340 ft)

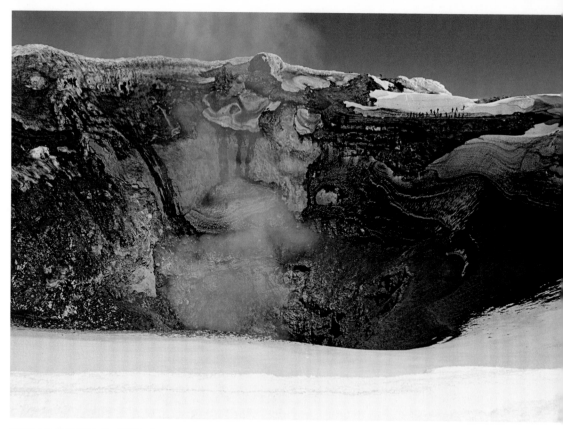

Cráter del volcán Villarrica (2847 m)
Crater of Villarica volcano (2847 m · 9340 ft)

Villarrica Volcano

A perfect now-covered volcanic cone with an almost permanent cloud of smoke, Villarrica is a dream destination for many climbers. After tackling the approx. five-hour climb, they are rewarded with unforgettable views of the glowing lava down in the crater.

Volcan Villarrica

Un cône parfait, avec un col enneigé dont sort presque toujours un nuage de fumée – le volcan Villarrica est une destination de rêve pour beaucoup de grimpeurs. Une ascension d'environ cinq heures offre une vue inoubliable sur le cratère et son magma incandescent.

Vulkan Villarrica

Ein perfekter Kegel mit Schneekragen, aus dem fast immer eine Rauchwolke emporsteigt – der Vulkan Villarrica ist für viele Bergsteiger ein Traumziel. Nach etwa fünfstündigem Aufstieg eröffnet sich ein unvergesslicher Blick in den glühenden Krater.

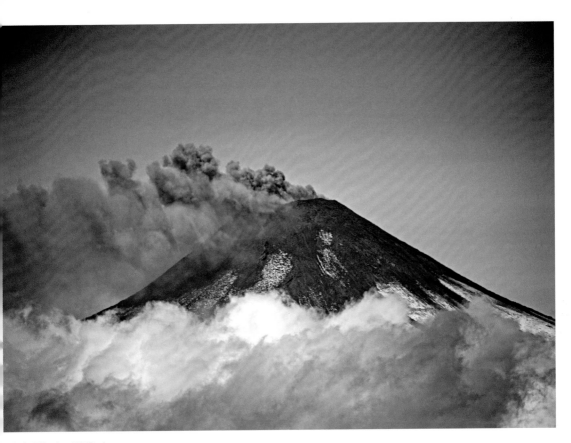

Volcán Villarrica (2847 m)
Villarica volcano (2847 m · 9340 ft)

Volcán Villarrica

Un cono perfecto con un cuello de nieve, de donde casi siempre surge una nube de humo – el volcán Villarrica es un destino de ensueño para muchos escaladores. Después de unas cinco horas de ascenso, se tendrá una vista inolvidable del resplandeciente cráter.

Vulcano Villarrica

Un cono dalla forma perfetta ricoperto di neve, quasi sempre sovrastato da una nuvola di fumo: il vulcano Villaricca è un sogno per molti arrampicatori. Dopo una salita di circa cinque ore si viene premiati da una vista indimenticabile all'interno del cratere ardente.

De vulkaan Villarrica

Een perfecte en besneeuwde kegel waaruit bijna altijd een rookwolk opstijgt – dat is de vulkaan Villarrica, voor veel bergwandelaars een topbestemming. Een beklimming van zo'n vijf uur wordt beloond met een prachtig uitzicht over de gloeiende krater.

Lago Villarica
Lake Villarica

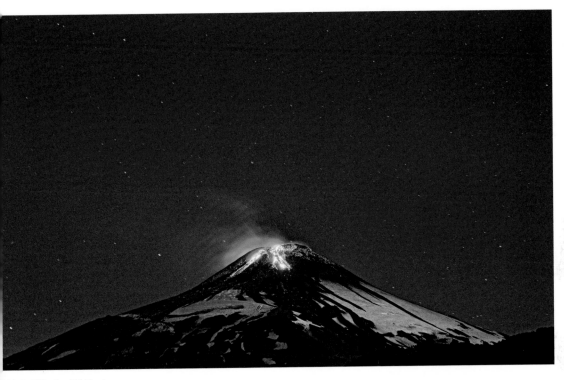

Volcán Villarrica (2847 m)
Villarica volcano (2847 m · 9340 ft)

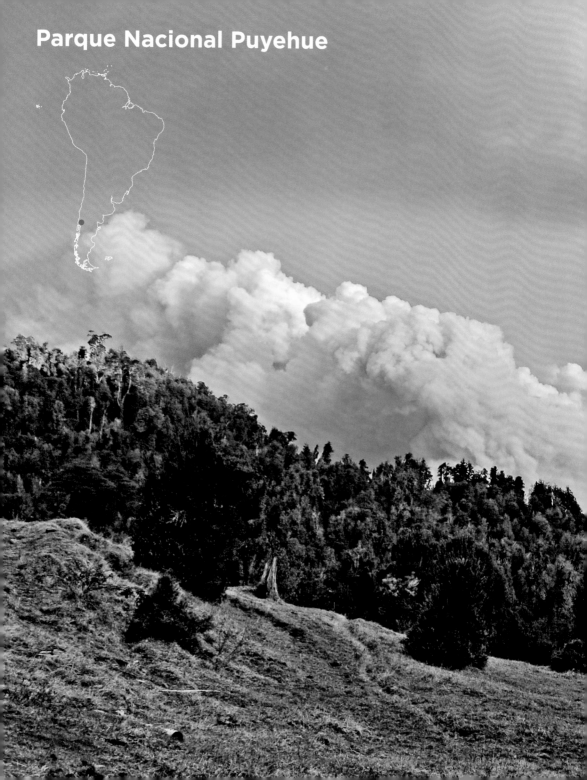

Parque Nacional Puyehue

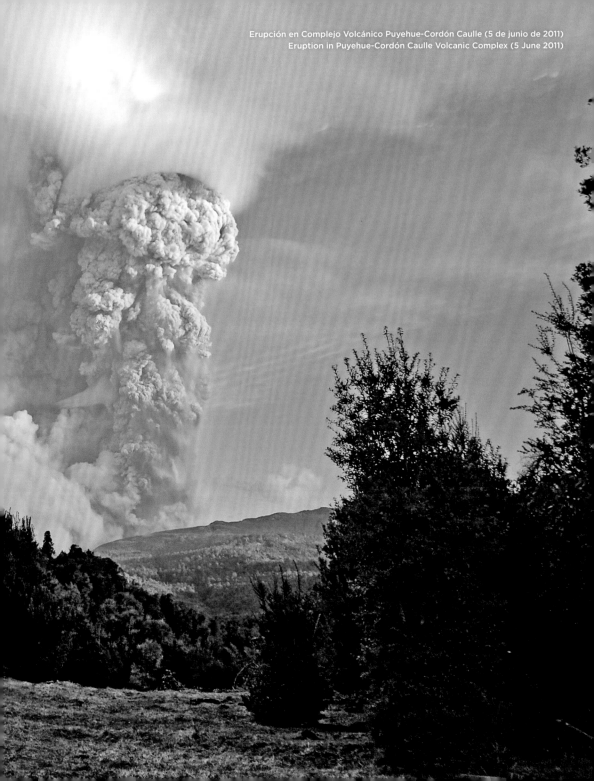

Erupción en Complejo Volcánico Puyehue-Cordón Caulle (5 de junio de 2011)
Eruption in Puyehue-Cordón Caulle Volcanic Complex (5 June 2011)

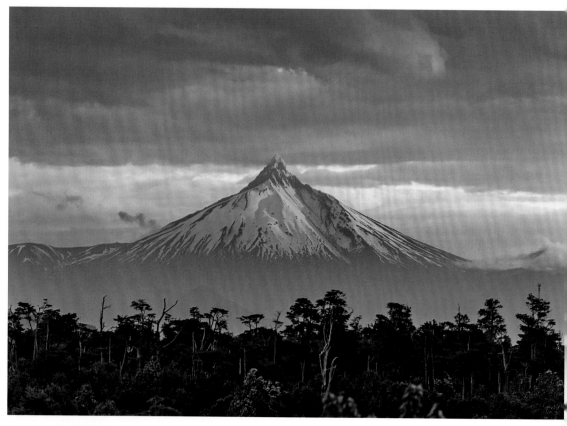

Volcán Puyehue (2236 m)
Puyehue volcano (2236 m · 7736 ft)

Puyehue National Park

Puyehue was the cause of much excitement back in June 2011 when the volcano complex Puyehue-Cordón Caulle shook the earth with eruptions and explosions that spewed lava and ash for miles around for several days. The national park includes Puyehue with its 2.5 km (1.5 mi) crater, the Cordón Caulle mountain range, and the Carrán-Los-Venados group with about 70 craters.

Parc national Puyehue

Le nom Puyehue évoque les journées rocambolesques du mois de juin 2011 qui ont suivi le réveil tonitruant du complexe volcanique Puyehue-Cordón Caulle. Éruptions, explosions, coulées de lave et nuages de cendre de plusieurs kilomètres de hauteur avaient duré plusieurs jours. Le parc national inclut le volcan Puyehue et son cratère de 2,5 km, le sommet arrondi du Cordón Caulle et le massif volcanique Carrán-Los Venados et ses 70 cratères.

Nationalpark Puyehue

Der Name Puyehue steht für abenteuerliche Tage im Juni 2011. Damals brach der Vulkankomplex Puyehue-Cordón Caulle mit großem Getöse aus. Eruptionen und Explosionen, Lavaströme und kilometerhohe Aschewolken über mehrere Tage. Zum Nationalpark zählen der Puyehue mit seinem 2,5 km großen Krater, der Bergrücken Cordón Caulle und die Carrán-Los- Venados-Gruppe mit rund 70 Kratern.

Roble de Santiago, Parque Nacional Puyehue
Southern beech, Puyehue National Park

Parque Nacional Puyehue

El nombre Puyehue tuvo unos días de aventura en junio de 2011. En ese momento, estalló el complejo volcánico Puyehue-Cordón Caulle con gran estrépito. Las erupciones y explosiones, ríos de lava y nubes de ceniza de kilómetros de altura duraron varios días. El Parque Nacional incluye el Puyehue con su enorme cráter de 2,5 km de ancho, la cresta de la montaña Cordón Caulle y el grupo Carrán-Los Venados con alrededor de 70 cráteres.

Parco Nazionale Puyehue

Il nome Puyehue porta alla mente i giorni avventurosi del giugno 2011. In quel periodo il complesso vulcanico Puyehue-Cordón Caulle eruttò con grande fragore. Eruzioni ed esplosioni, fiumi di lava e nuvole di cenere alte chilometri si susseguirono per diversi giorni. Al Parco Nazionale appartengono il Puyehue, con il suo cratere grande 2,5 km, la dorsale di Cordón Caulle e il gruppo di Carrán-Los-Venados con circa 70 crateri.

Nationaal Park Puyehue

De naam 'Puyehue' herinnert aan de spectaculaire gebeurtenissen van juni 2011 toen het vulkaancomplex Puyehue-Cordón Caulle met donderend geweld uitbarstte: erupties, lavastromen en kilometers hoge aswolken bedreigden het gebied meerdere dagen. Het park omvat naast de Puyehue met zijn 2,5 km brede krater ook de bergruggen Cordón Caulle en de Carrán-Los-Venados-groep, met zo'n 70 kraters.

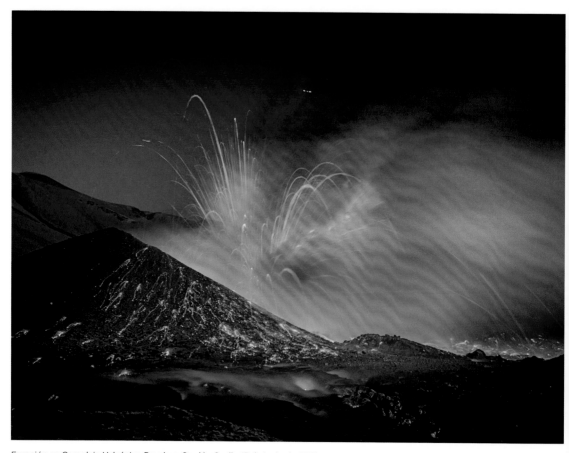

Erupción en Complejo Volcánico Puyehue-Cordón Caulle (5 de junio de 2011)
Eruption in Puyehue-Cordón Caulle Volcanic Complex (5 June 2011)

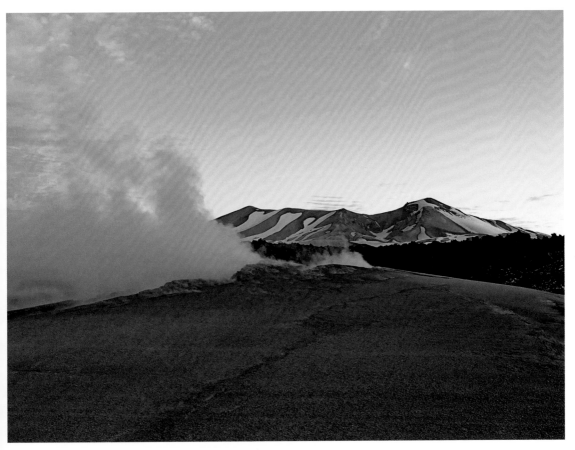

Fumarolas y lava en Complejo Volcánico Puyehue-Cordón Caulle
Fumaroles and lava in Puyehue-Cordón Caulle Volcanic Complex

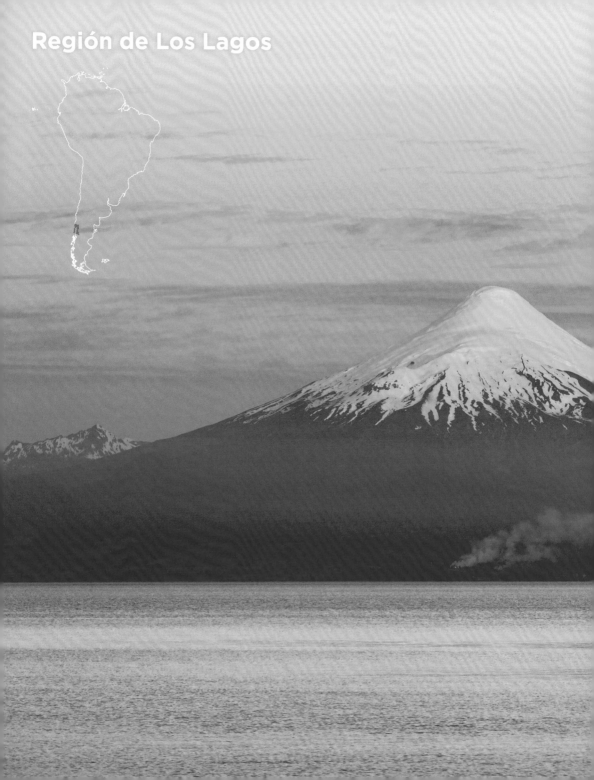

Región de Los Lagos

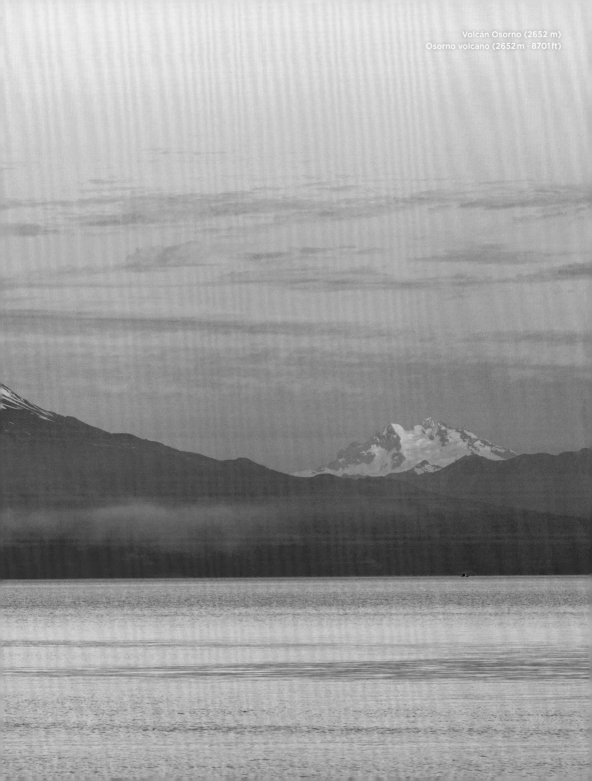

Volcán Osorno (2652 m)
Osorno volcano (2652 m · 8701 ft)

Puerto Varas

Los Lagos Region

Los Lagos Region is Chile's fresh water paradise with hundreds of lakes, waterfalls, and crystal-clear streams. The coastline enchants visitors with its isolated bays and beaches, while the higher regions are home to active volcanoes, glaciers, and the snow-capped Andes. It's no wonder that six of Chile's 36 national parks are found in this region. Provincial capital Puerto Montt is the starting point for many boat tours through the fjords of Chile and to Chiloé.

Région des Lacs

La région des Lacs est un véritable paradis d'eau douce qui recèle plusieurs centaines de lacs, chutes d'eau écumantes et rivières transparentes. Criques et plages composent les magnifiques paysages de la côte pacifique, alors que les régions en altitude sont tout aussi attrayantes, avec leurs volcans actifs, leurs glaciers et leurs sommets andins enneigés. Ainsi, on ne s'étonnera pas que la région des Lacs possède six des 36 parcs nationaux du pays. Des excursions en bateau à travers les fjords et en direction de Chiloé partent du port de la capitale provinciale, Puerto Montt.

Region Los Lagos

Die Region Los Lagos ist das Süßwasserparadies Chiles. Mit Hunderten Seen, schäumenden Wasserfällen und kristallklaren Flüssen. Die Küstenlandschaften am Pazifik bezaubern mit einsamen Buchten und Stränden. In den höheren Regionen locken aktive Vulkane, Gletscher und schneebedeckte Andengipfel. Kein Wunder also, dass sich sechs der 36 chilenischen Nationalparks in der Region Los Lagos befinden. Im Hafen der Hauptstadt Puerto Montt starten Schiffstouren durch die Fjorde und nach Chiloé.

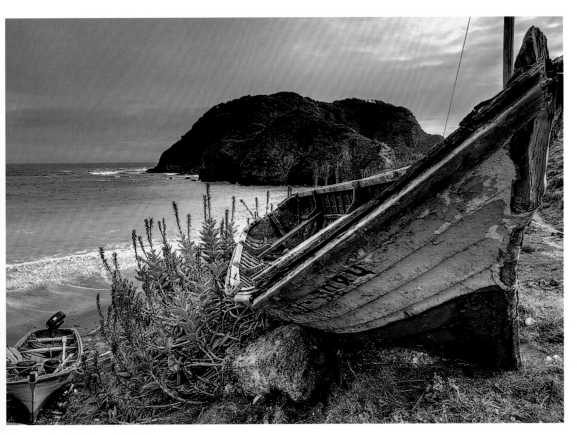

Barcos en la orilla del mar, Estaquilla
Boats on the seashore, Estaquilla

Región de Los Lagos

La región de Los Lagos es el paraíso de agua dulce de Chile. Con cientos de lagos, cascadas y ríos cristalinos. Los paisajes de la costa del Pacífico fascinan por el encanto de sus calas y playas. En las regiones más altas llaman la atención los volcanes activos, glaciares y los nevados picos de los Andes. No es de extrañar que seis de los 36 parques nacionales de Chile se encuentren en la región de Los Lagos. En el puerto de la capital Puerto Montt comienzan los viajes en barco a través de los fiordos hacia Chiloé.

Regione di Los Lagos

La regione di Los Lagos è il paradiso di acqua dolce del Cile, con centinaia di laghi, cascate spumeggianti e fiumi dalle acque cristalline. Il paesaggio costiero sul Pacifico affascina con baie e spiagge isolate. Nelle regioni montane attirano vulcani attivi, ghiacciai e le vette delle Ande coperte di neve. Non stupisce perciò che sei dei 36 parchi nazionali cileni si trovino nella regione di Los Lagos. Dal porto della capitale Puerto Montt partono escursioni in barca attraverso i fiordi e a Chiloé.

Regio Los Lagos

De regio Los Lagos is het zoetwaterparadijs van Chili. Dit kustlandschap aan de Stille Oceaan betovert niet alleen door zijn honderden meren, bruisende watervallen en kristalheldere rivieren, maar ook door zijn eenzame baaien en stranden. In hoger gelegen gebieden lonken actieve vulkanen, gletsjers en de besneeuwde pieken van de Andes. Geen wonder dat zes van de 36 nationale parken van Chili in de regio Los Lagos liggen. De haven van de regiohoofdstad Puerto Montt is het vertrekpunt voor cruises door de fjorden en naar Chiloé.

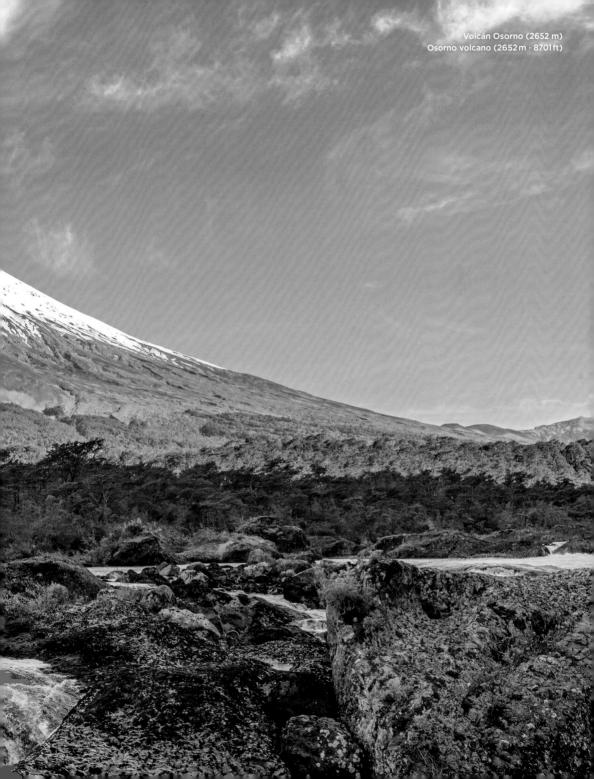

Volcán Osorno (2652 m)
Osorno volcano (2652 m · 8701 ft)

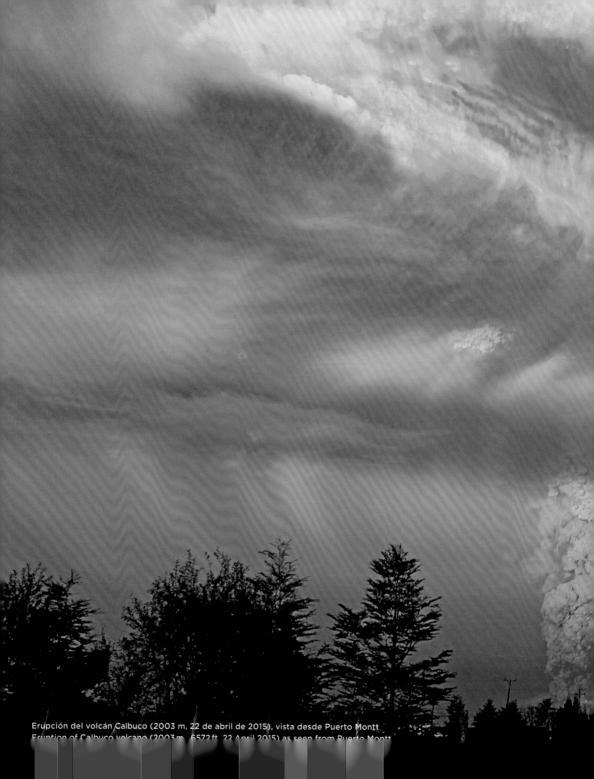

Erupción del volcán Calbuco (2003 m, 22 de abril de 2015), vista desde Puerto Montt.
Eruption of Calbuco volcano (2003 m - 6572 ft, 22 April 2015) as seen from Puerto Montt.

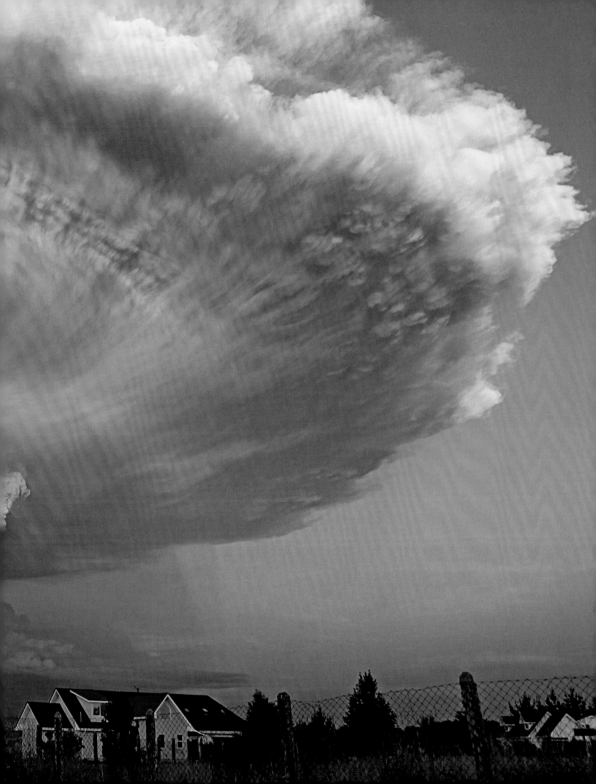

Puerto Montt

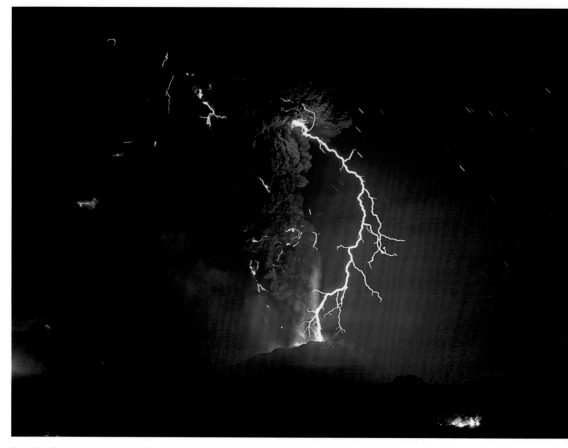

Erupción del volcán Calbuco (2003 m, 23 de abril de 2015), vista desde Puerto Montt
Eruption of Calbuco volcano (2003 m · 6572 ft, 23 April 2015) as seen from Puerto Montt

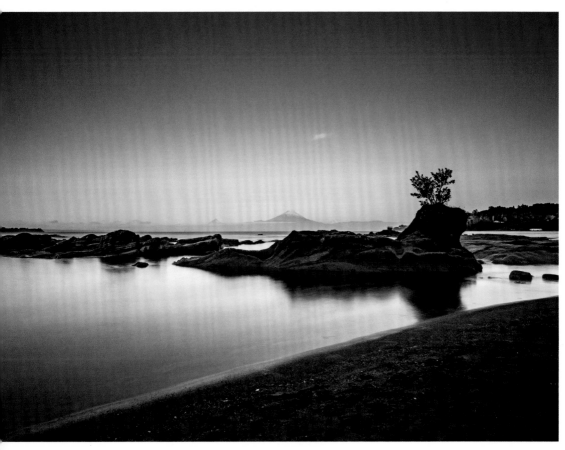

Lago Llanquihue
Lake Llanquihue

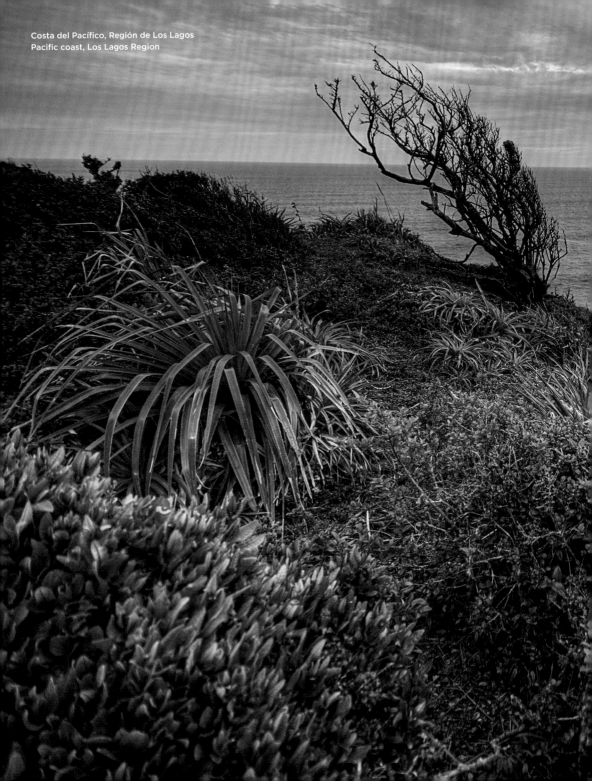

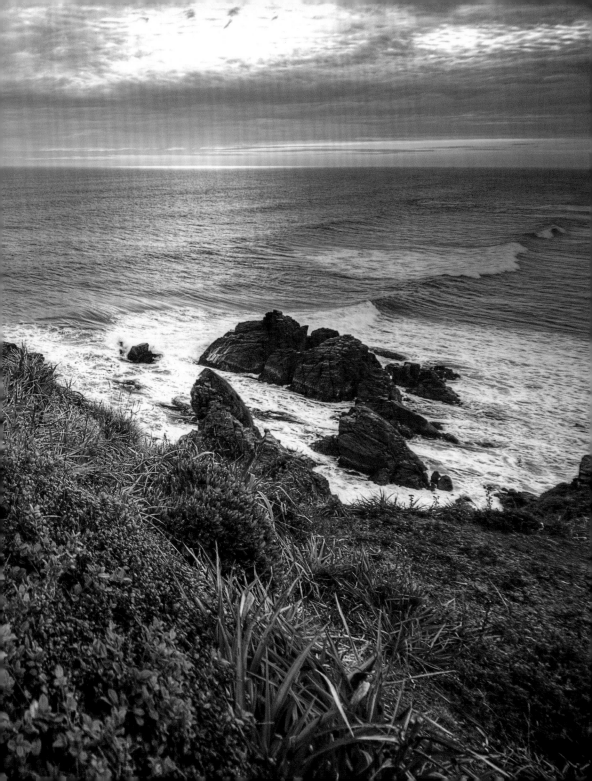

Lago Rupanco
Lake Rupanco

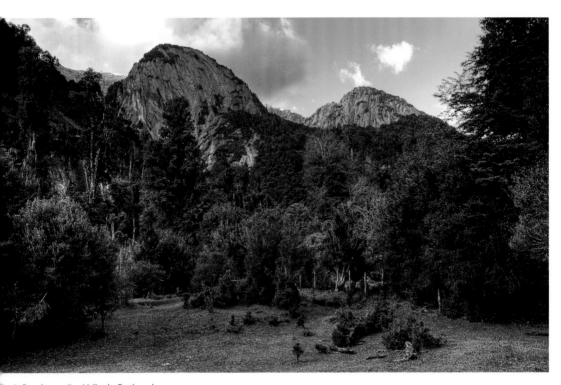

Montañas de granito, Valle de Cochamó
Mountains of granite, Cochamó Valley

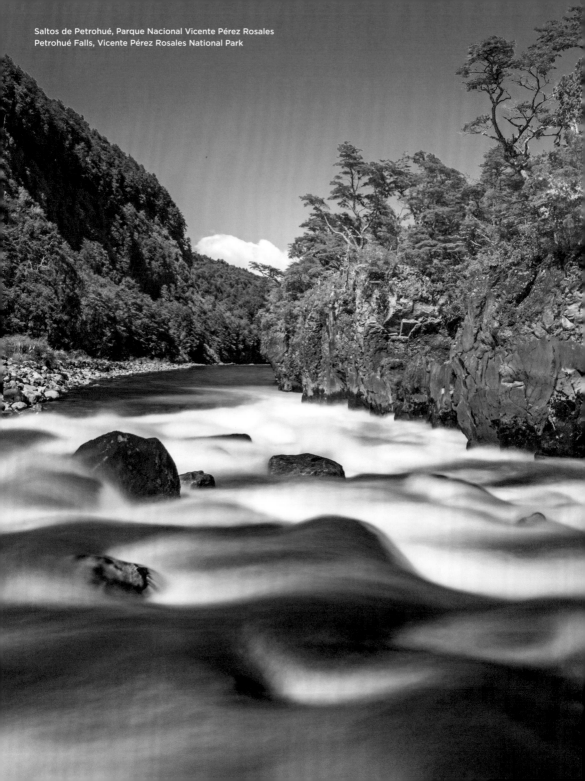

Saltos de Petrohué, Parque Nacional Vicente Pérez Rosales
Petrohué Falls, Vicente Pérez Rosales National Park

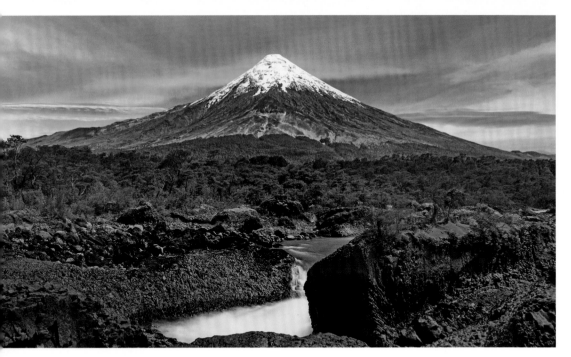

Saltos de Petrohué y volcán Osorno (2652 m), Parque Nacional Vicente Pérez Rosales
Petrohué Falls and Osorno volcano (2652 m · 8701 ft), Vicente Pérez Rosales National Park

Rain Forests

Although the average temperature is only 12 °C (54 °F), south-central Chile is home to lush rain forests in the regions up to 500 m (1640 ft) above sea level. The evergreen Valdivian Rain Forest is home to trees as tall as 40 m (130 ft) and has almost as many species as tropical rain forests. Typical species here include the lenga beech, Patagonian cypress, plum pines, laurel, Chilean hazelnut, and various epiphyte species.

Forêts humides

Bien que la température moyenne ne soit que de 12 °C dans la région sud-centrale du pays, la forêt humide luxuriante domine, jusqu'à une altitude de 500 m. La forêt valdivienne tempérée à feuillage persistant est composée de grands arbres (jusqu'à 40 m de haut) et compte pratiquement autant d'espèces que la forêt tropicale humide. Le hêtre blanc, le cyprès de Patagonie et le podocarpus, tout comme le laurier, le noisetier chilien et diverses espèces d'épiphytes sont caractéristiques de la région.

Regenwälder

Obwohl die Durchschnittstemperatur hier nur um die 12 °C liegt, überzieht im südlichen Zentralchile üppiger Regenwald die Regionen bis zu einer Höhe von 500 m. Der immergrüne Valdivianische Regenwald besteht aus bis zu 40 m hohen Bäumen und ist fast so artenreich wie tropische Regenwälder. Charakteristisch sind Lenga-Südbuchen, Patagonische Zypressen und Steineiben sowie Lorbeer, Chilenische Hasel und die verschiedensten Epiphyten (Aufsitzerpflanzen).

Bosque valdiviano

Aunque la temperatura media es de sólo 12 °C, la exuberante selva cubre las regiones del centro sur de Chile hasta una altura de 500 m. La selva valdiviana de hoja perenne se compone de árboles de hasta 40 m de altura y es casi tan rica en species como las selvas tropicales. Son característicos de aquí las lengas, el alerce patagónico, y mañíos como el laurel, el tevuín y varias epifitas.

Foreste pluviali

Sebbene la temperatura media qui si attesti solo su 12 °C, nella zona meridionale del Cile centrale la rigogliosa foresta pluviale ricopre la regione fino ad un altezza di 500 m. La foresta pluviale sempreverde di Valdivia è formata da alberi alti fino a 40 m ed è tanto ricca di specie quasi come le foreste tropicali. Tipici sono i faggi di Lenga, i cipressi della Patagonia e i podocarpi, oltre a piante di alloro, noccioli e le più diverse piante epifite (piante che vivono su altre piante).

Regenwouden

Hoewel de gemiddelde temperatuur hier slechts 12 °C bedraagt, is het zuiden van Centraal-Chili tot een hoogte van 500 m bedekt door dicht regenwoud. Het groenblijvende gematigde regenbos van Valdivia bestaat hier uit bomen van tot wel 40 m hoog en is even soortenrijk als tropische regenwouden. Kenmerkend zijn lenga-schijnbeuken, Patagonische cipressen en Chileense totara's, alsook laurierbomen, Chileense hazelaars en verschillende epifyten (planten die op andere planten groeien).

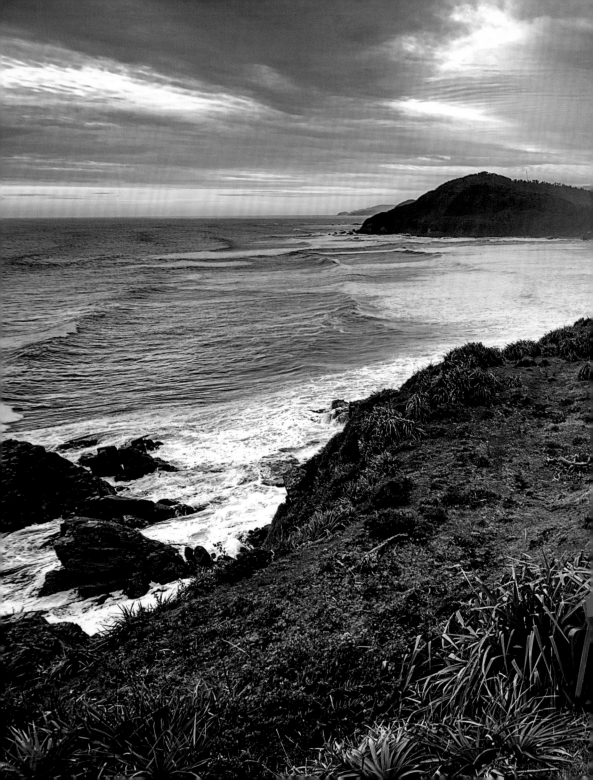

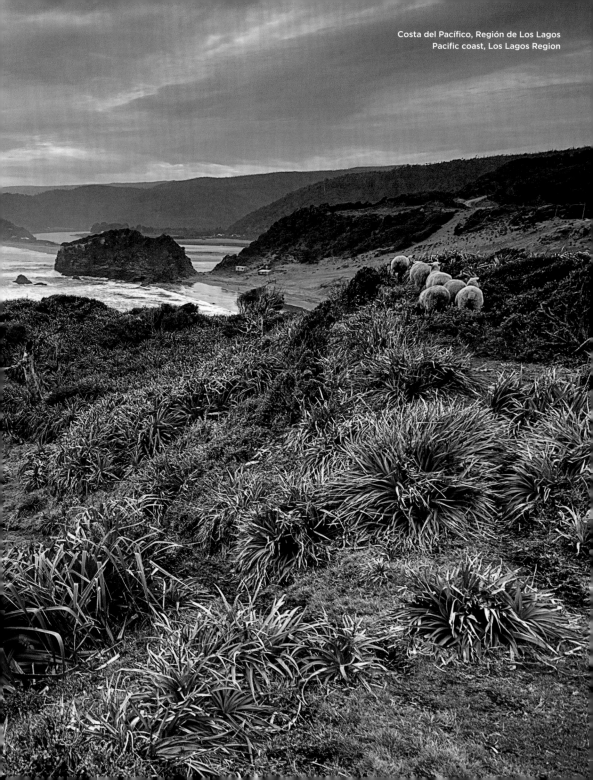

Costa del Pacífico, Región de Los Lagos
Pacific coast, Los Lagos Region

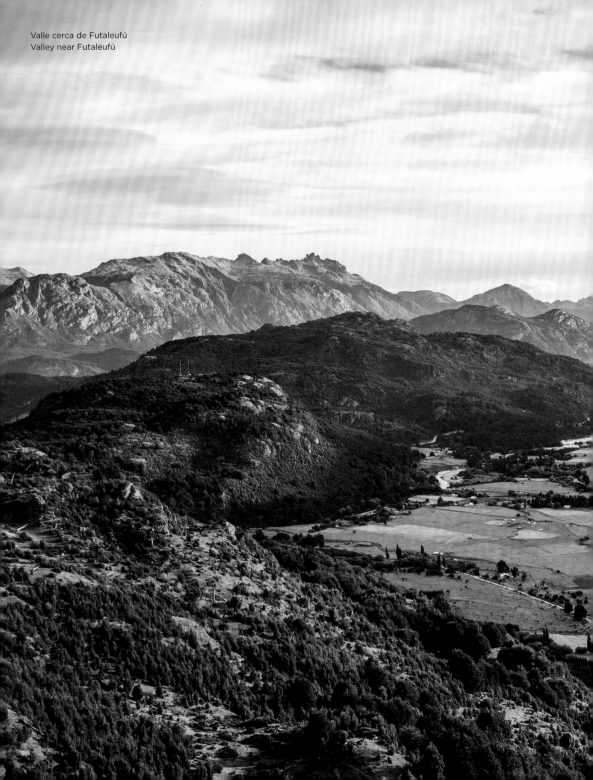

Valle cerca de Futaleufú
Valley near Futaleufú

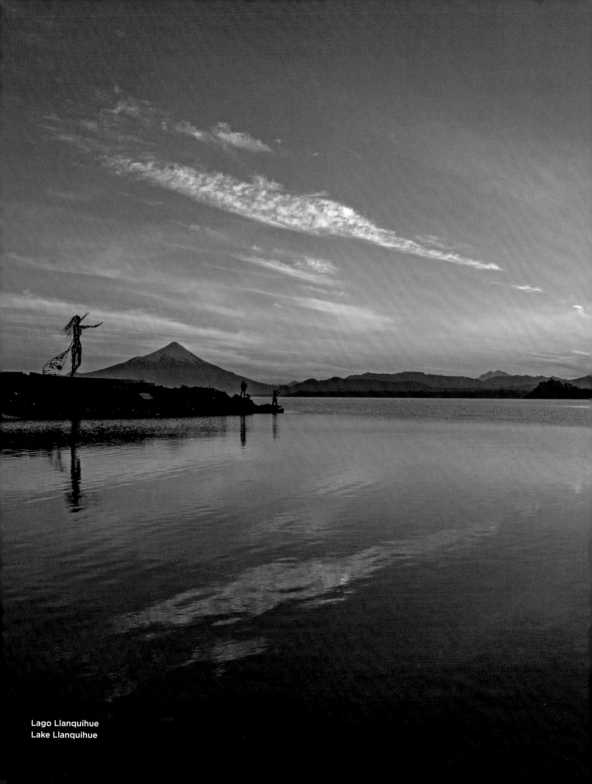

Lago Llanquihue
Lake Llanquihue

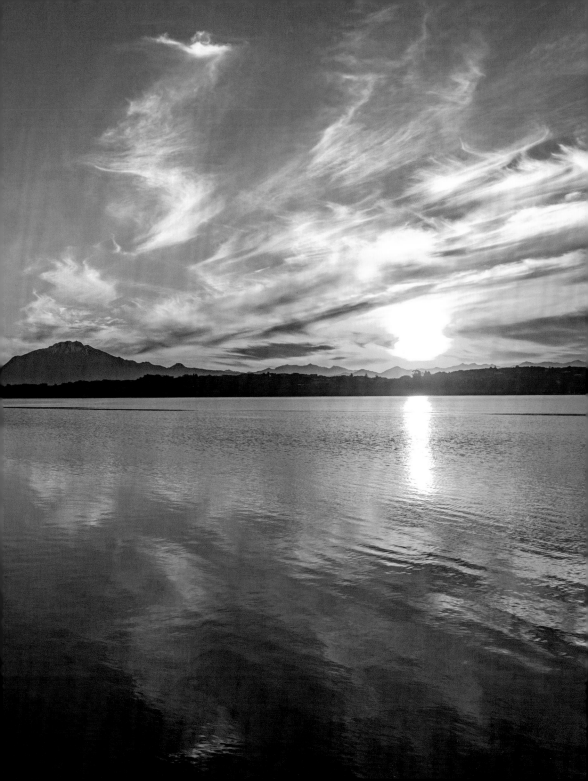

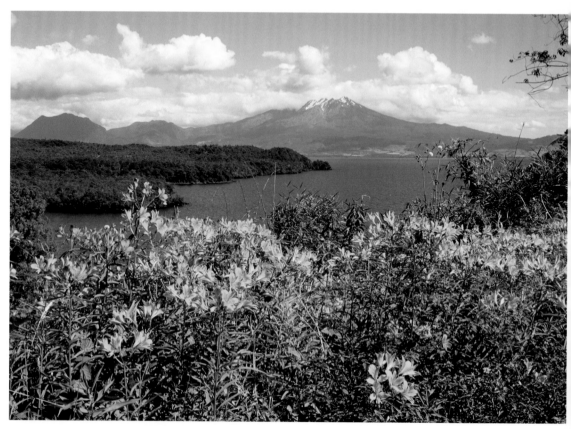

Azucenas peruanas frente al Lago Llanquihue
Peruvian lilies with Lake Llanquihue

Vicente Pérez Rosales National Park

Vicente Pérez Rosales National Park is
home to the Tronador mountain, the
Osorno volcano, and Lago Todos los
Santos. It is a true hikers' paradise. Many
signed paths take visitors through the
wild landscape, such as the Sendero
Los Enamorados (Lovers' Stroll) and
side trips to Cascada de los Novios
(Fiancés' Waterfall).

Parc national Vicente Pérez Rosales

Le parc national Vicente Pérez Rosales,
avec le Tronador, le volcan Osorno et le
lac d'altitude Lago Todos los Santos, est
un véritable paradis pour les randonneurs.
Il est sillonné par de nombreux sentiers
balisés. Une promenade sur le Sendero
Los Enamorados (sentier des amoureux)
ou un crochet par la Cascada de los
Novios (cascades des fiancés) illustre le
romantisme sauvage du paysage.

Nationalpark Vicente Pérez Rosales

Der Nationalpark Vicente Pérez Rosales
mit dem Tronador, dem Vulkan Osorno und
dem Gebirgssee Lago Todos los Santos
ist ein wahres Wanderparadies. Viele
ausgeschilderte Wege erschließen den
Park. Wie wildromantisch diese Gegend
ist, zeigt ein Spaziergang auf dem „Weg
der Verliebten" (sendero Los Enamorados)
oder ein Abstecher zum „Wasserfall der
Verlobten" (Cascada de los Novios).

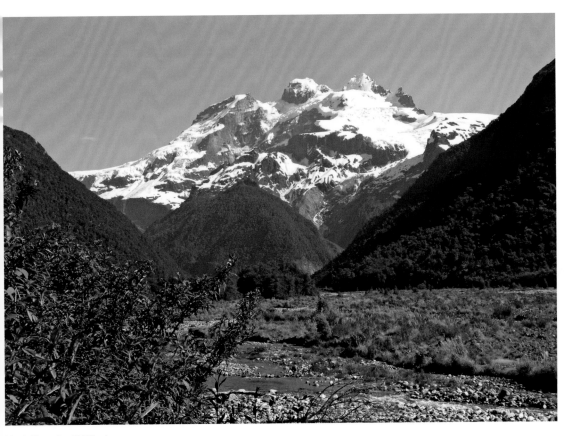

Monte Tronador (3478 m)
Tronador mountain (3478 m · 11,411 ft)

Parque Nacional Vicente Pérez Rosales

El Parque Nacional Vicente Pérez Rosales con el monte Tronador, el volcán Osorno y el lago de montaña Todos los Santos son un verdadero paraíso para hacer senderismo. Cruzan el parque muchos senderos marcados. Como zona salvaje y romántica que es, se puede ir por el sendero "Los Enamorados" así como hacer una excursión a la "Cascada de los novios".

Parco nazionale Vicente Pérez Rosales

Il parco nazionale Vicente Pérez Rosales è un vero paradiso per gli escursionisti grazie alla presenza del monte Tronador, del vulcano Osorno e del Lago Todos los Santos. Molti sentieri con segnaletica percorrono il parco. Quanto questa regione sia romantica e selvaggia lo dimostra una passeggiata sul "sentiero degli innamorati" (sendero Los Enamorados) o una gita alla "cascata dei fidanzati" (Cascada de los Novios).

Nationale Park Vicente Pérez Rosales

Met de Tronador, de vulkaan Osorno en het bergmeer Lago Todos los Santos is het Nationale Park Vicente Pérez Rosales een paradijs voor bergwandelaars, dat wordt ontsloten door middel van vele routes die met bordjes zijn aangeduid. Hoe woest en romantisch deze omgeving is, blijkt uit een wandeling over de 'Weg der verliefden' (sendero Los Enamorados) of een uitstapje naar de 'Waterval van de verloofden' (Cascada de los novios).

Playa Pangal, Maullín
Pangal Beach, Maullín

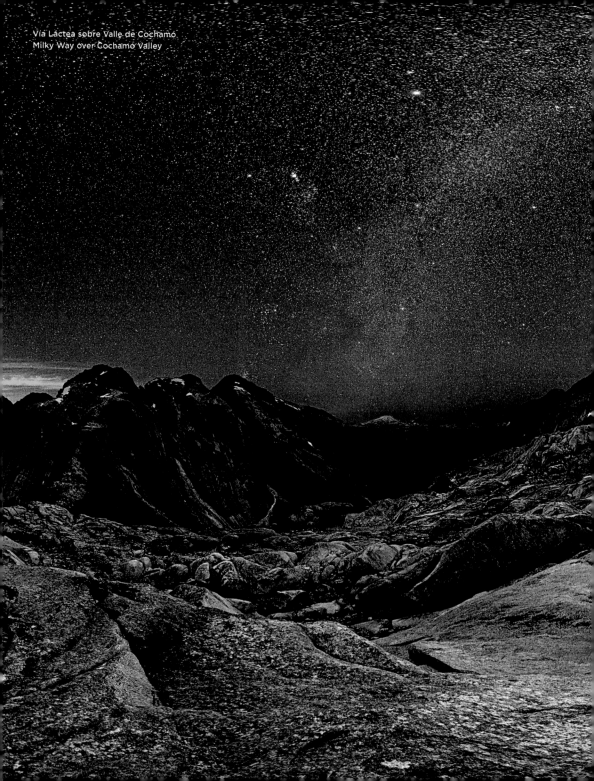

Vía Láctea sobre Valle de Cochamó
Milky Way over Cochamó Valley

Isla Grande de Chiloé

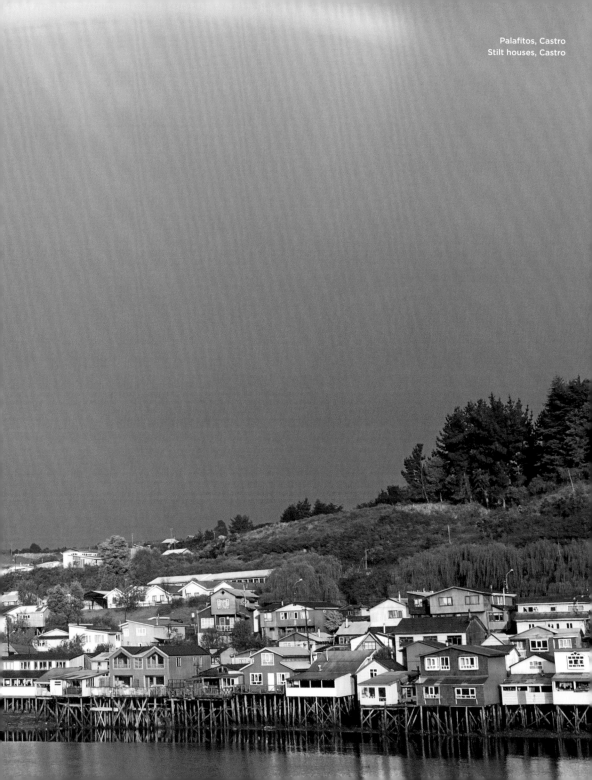

Palafitos, Castro
Stilt houses, Castro

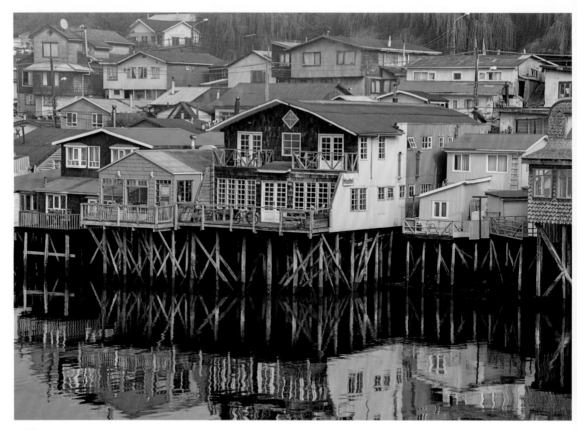

Palafitos, Castro
Stilt houses, Castro

Greater Island of Chiloé

The second largest island in Chile lies
about 50 km (30 mi) off the Chilean
mainland. With steep cliffs and wild fjords,
green meadows and hills up to 893 m
(2930 ft). The mild, rainy weather results in
lush vegetation.

Île de Chiloé

La Grande Chiloé, deuxième plus grande île
du pays, se situe à environ 50 km au large
du continent. Son paysage est dessiné
par des éperons abrupts et des criques
sauvages, de vertes prairies et des collines
d'une hauteur maximale de 893 mètres.
Son climat doux et très humide favorise
une végétation luxuriante.

Chiloé

Die „Große Insel von Chiloé", zweitgrößte
Insel des Landes, liegt etwa 50 km westlich
vom chilenischen Festland. Mit steilen
Klippen und wilden Buchten, grünen
Wiesen und Hügeln bis 893 m. Das milde
und sehr regenreiche Klima lässt eine
üppige Vegetation sprießen.

Alrededores de Tenaún, Chiloé
Near Tenaún, Chiloé

Isla Grande de Chiloé

La Isla Grande de Chiloé, segunda isla más grande del país, está situada a unos 50 km al oeste de la parte continental de Chile. Con acantilados y calas salvajes, verdes prados y colinas a 893 m. Debido a su clima templado y muy lluvioso brota una exuberante vegetación.

Isola di Chiloé

La "Grande isola di Chiloé", la seconda isola più grande del paese, si trova a circa 50 km ad ovest dalla terraferma cilena. Vanta ripide scogliere e baie selvagge, prati verdi e colline fino a 893 m di altitudine. Il clima mite e molto piovoso fa crescere una vegetazione lussureggiante.

Grote Eiland van Chiloé

Het 'Grote Eiland van Chiloé' is het op één na grootste van het land en ligt circa 50 km ten westen van het Chileense vasteland. Het eiland biedt steile klippen en woeste baaien, groene weiden en heuvels tot een hoogte van 893 m; het milde en zeer regenachtige klimaat zorgt voor een weelderige vegetatie.

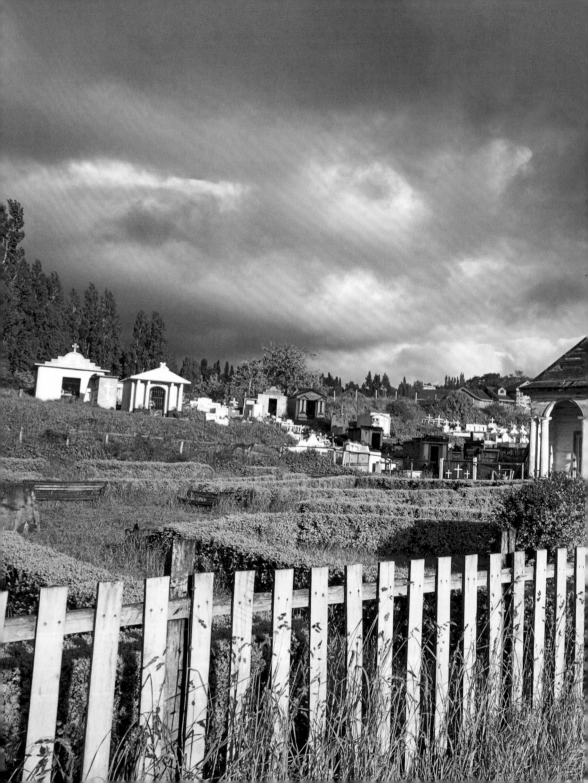

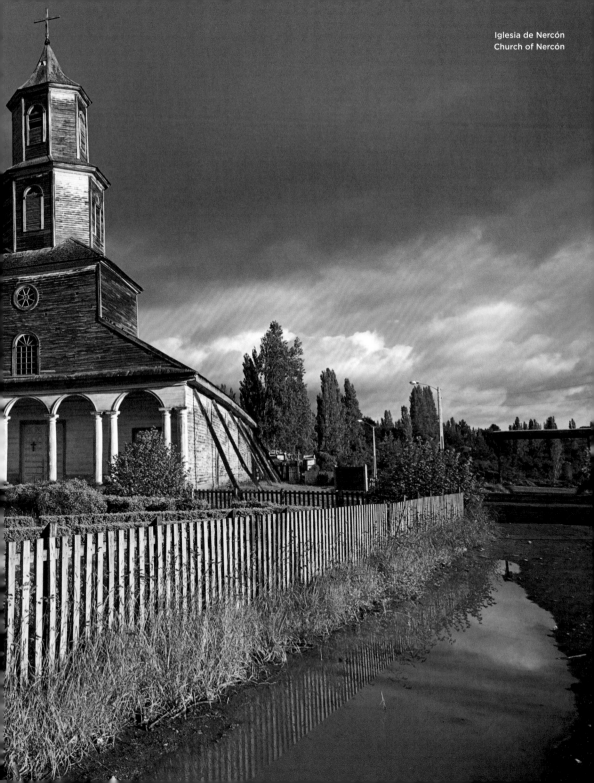

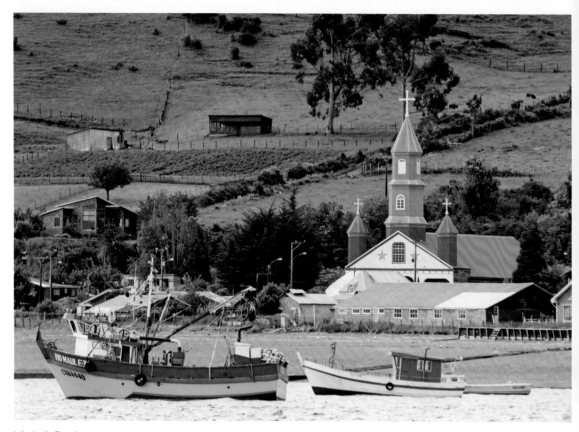

Iglesia de Tenaún
Church of Tenaún

Wooden churches

To assist with their mission to convert the inhabitants of the islands, Jesuits built numerous churches out of cypress wood in the early 17th century. Today, over 150 of these survive and some are designated UNESCO World Cultural Heritage Sites. These unique buildings combine European and local construction methods.

Iglesias de madera

Los jesuitas construyeron numerosas iglesias con madera de ciprés a principios del siglo XVII para la difusión de la fe católica entre los aborígenes de la isla. Hoy en día, más de 150 de ellas siguen formando parte del patrimonio cultural de la UNESCO. Los edificios únicos combinan la arquitectura europea con la arquitectura local.

Églises en bois

Pour propager la foi catholique parmi les autochtones, des jésuites insulaires construisirent de nombreuses églises en bois de cyprès au début du XVIIe siècle. On en compte encore plus de 150 aujourd'hui, dont certaines font partie du patrimoine mondial de l'UNESCO. Dans ces édifices singuliers, l'architecture européenne et l'architecture locale sont combinées.

Chiese lignee

Per diffondere la fede cattolica tra gli autoctoni, all'inizio del XVII secolo i gesuiti costruirono numerose chiesette in legno di cipresso. Oggi ne sono rimaste più di 150, che in parte sono inserite nel patrimonio mondiale protetto dall'UNESCO. Si tratta di edifici unici, che riuniscono l'architettura europea e la cultura urbanistica degli abitanti del posto.

Holzkirchen

Zur Verbreitung des katholischen Glaubens unter den Ureinwohnern der Insel bauten Jesuiten Anfang des 17. Jahrhunderts zahlreiche Kirchen aus Zypressenholz. Heute sind davon noch über 150 erhalten, die teilweise zum UNESCO-Weltkulturerbe zählen. In den einzigartigen Gebäuden vereinen sich europäische Architektur und die Baukunst der Einheimischen.

Houten kerken

Om het katholieke geloof onder de inheemse bevolking van de eilanden te verbreiden, bouwden jezuïeten begin zeventiende eeuw veel kerken van cipressenhout. Nu staan er nog ruim 150 van deze kerken, die deels als UNESCO-Werelderfgoed zijn erkend. De unieke bouwwerken verenigen Europese architectuur en inheemse bouwtechniek.

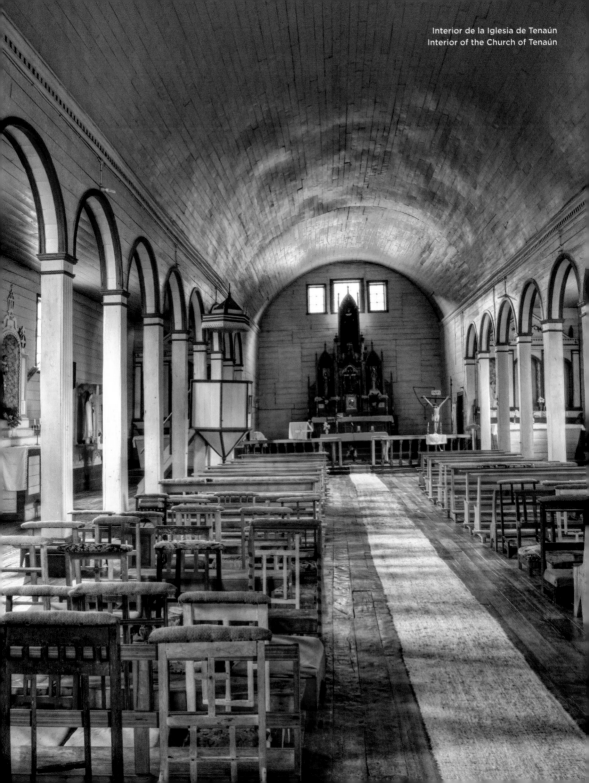

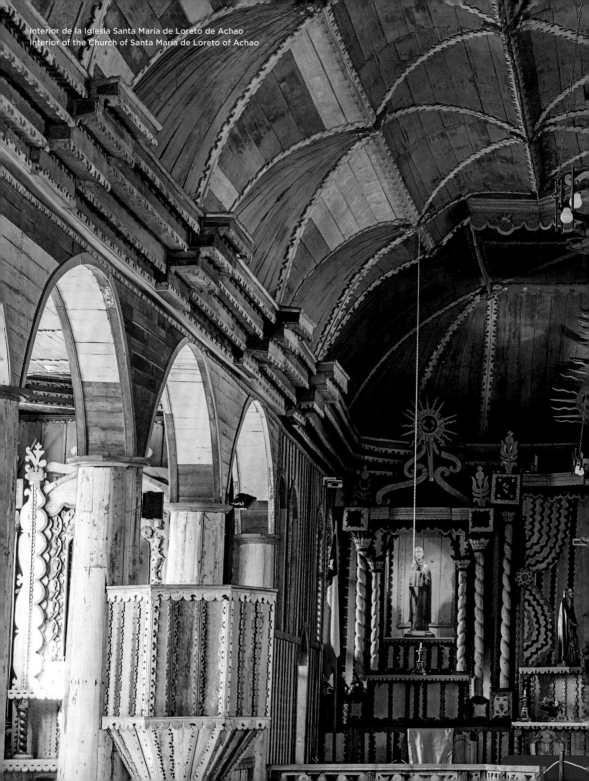

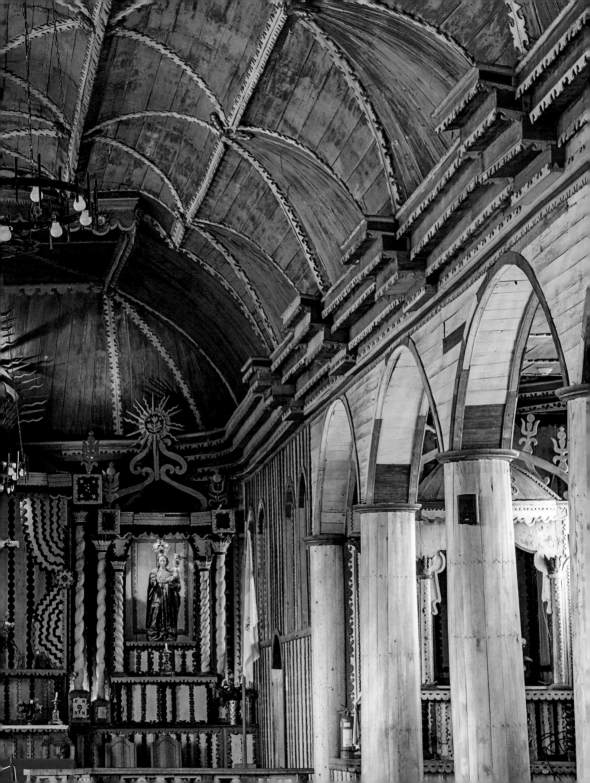

Iglesia de Puchilco
Church of Puchilco

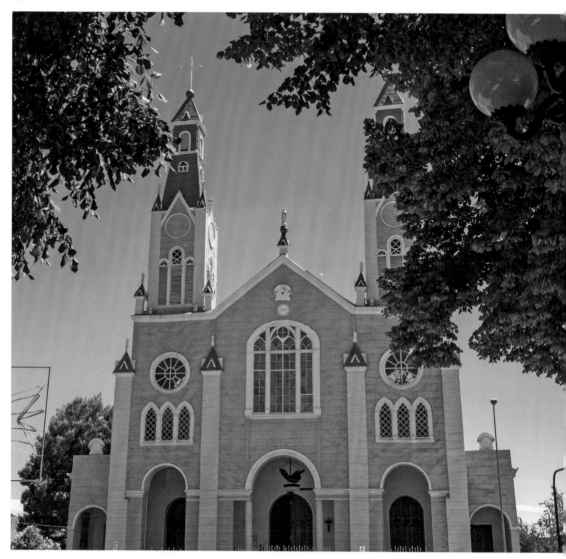

Iglesia de San Francisco, Castro
Church of San Francisco, Castro

Arte en el techo de una iglesia
Art on the roof of a church

Isla Grande de Chiloé, Parque Nacional Chiloé
Greater Island of Chiloé, Chiloé National Park

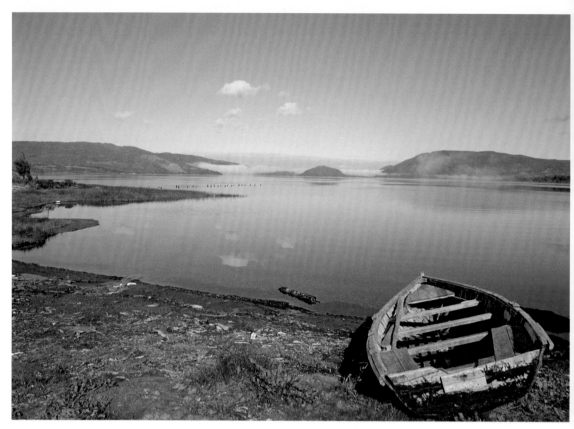

La Bahía de Castro, Chiloé
Castro Bay, Chiloé

Chiloé National Park
In the hills on Chiloés west coast, Chiloé
National Park is home to dunes, Valdivian
rain forest, cypress forests, and wetlands.
The potato allegedly also came from the
island and was cultivated here as early as
13,000 years ago.

Parc national de Chiloé
Sur les collines de la côte ouest de Chiloé,
le parc national de Chiloé assure la
protection des dunes, de la forêt humide
valdivienne, des forêts de cyprès et des
zones humides. L'île serait par ailleurs la
région d'origine de la pomme de terre qui y
serait cultivée depuis 13 000 ans.

Nationalpark Chiloé
In den Hügeln von Chiloés Westküste
bewahrt der Nationalpark Chiloé
Dünen, Valdivianischen Regenwald,
Zypressenwälder und Feuchtgebiete.
Übrigens soll auch die Kartoffel von der
Insel Chiloé stammen und dort bereits vor
rund 13 000 Jahren angebaut worden sein.

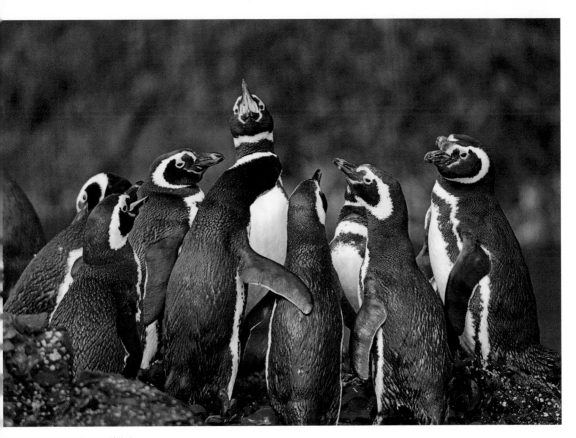

Pingüinos de Magallanes, Chiloé
Magellanic penguins, Chiloé

Parque Nacional Chiloé

En las colinas de la costa oeste de Chiloé preserva el Parque Nacional Chiloé dunas, selva valdiviana, bosques de alerces y humedales. Por cierto, la patata es originaria de la isla Chiloé y ya se cultivaba allí hace unos 13 000 años.

Parco nazionale di Chiloé

Nelle colline della costa occidentale di Chiloé, il parco nazionale preserva le dune, la foresta temperata valdiviana, boschi di cipressi e zone umide. Del resto li cresce anche la patata dell'isola di Chiloé, che era coltivata già circa 13 000 anni fa.

Nationale Park van Chiloé

In de heuvels aan de westkust van Chiloé worden in het Nationale Park van Chiloé duinlandschappen, Valdiviaans regenbos, cipressenwouden en drasland beschermd. Overigens zou ook de aardappel van dit eiland stammen, die hier al zo'n 13 000 jaar geleden moet zijn verbouwd.

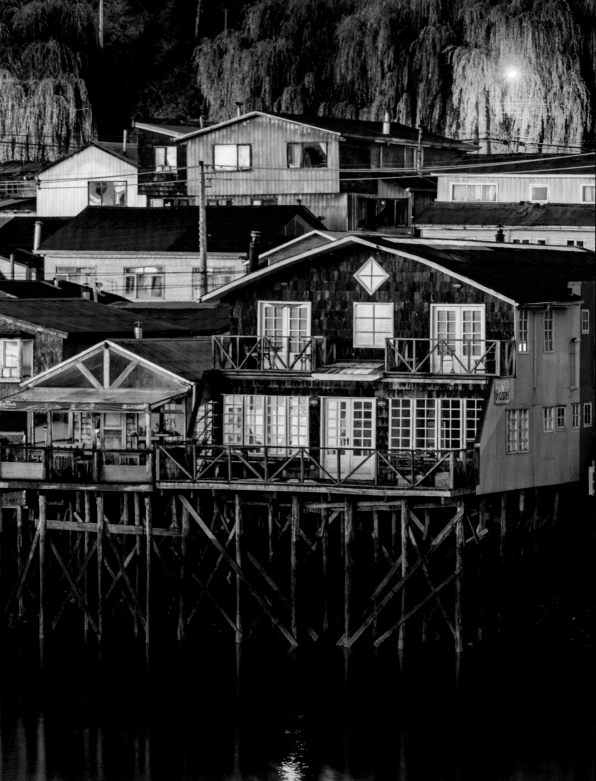

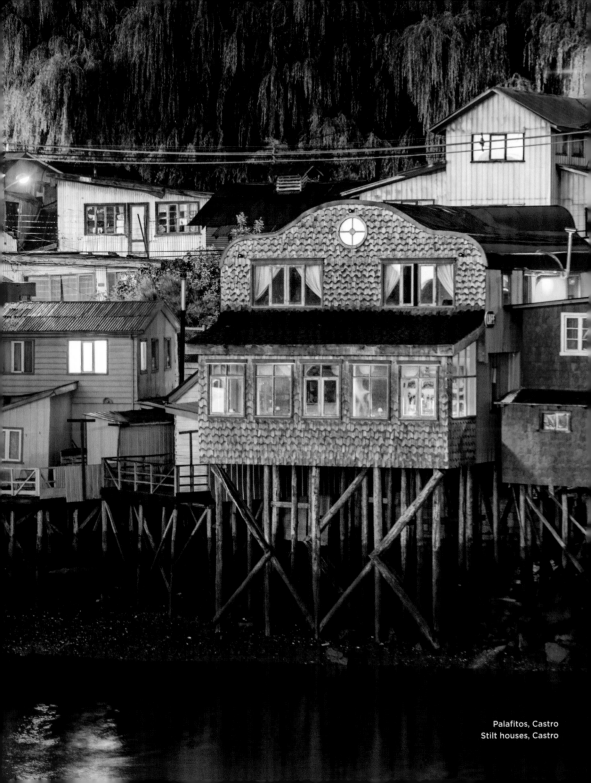

Palafitos, Castro
Stilt houses, Castro

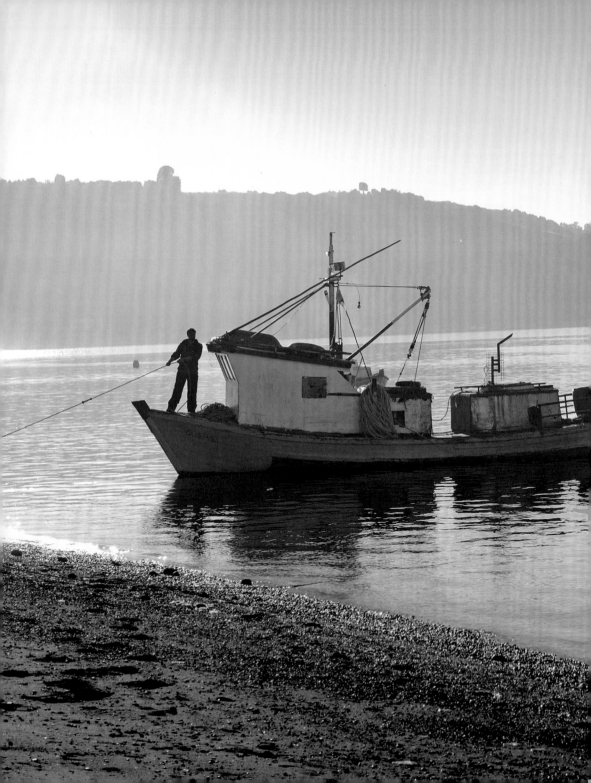

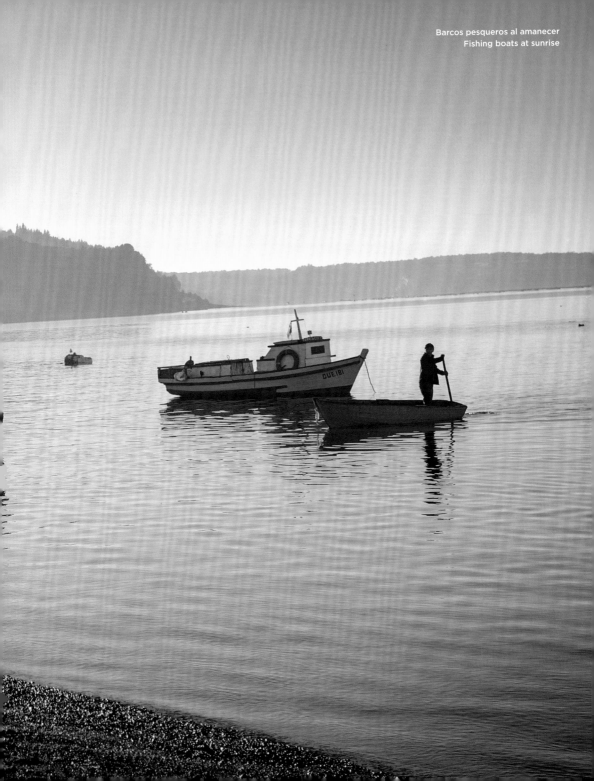

Arroyo en la isla de Chiloé
Creek on Chiloé Island

Familia porcina cruzando la calle
Pig family crossing the street

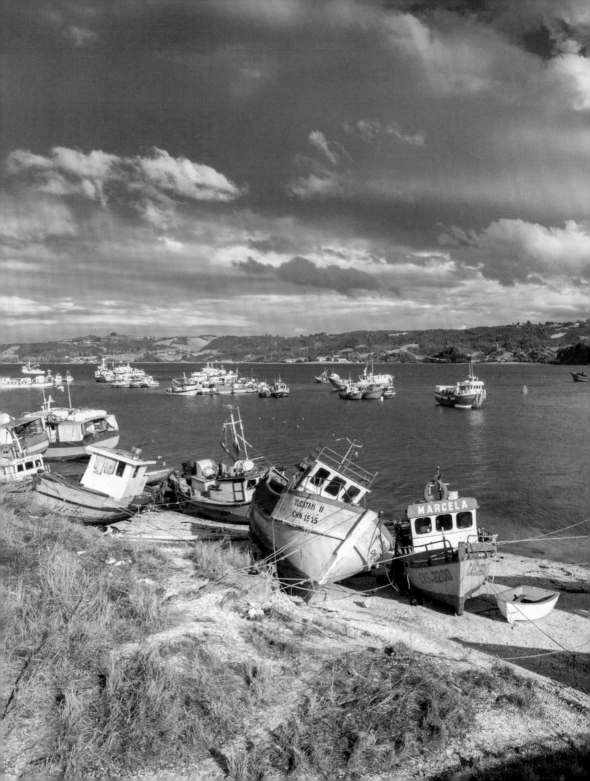

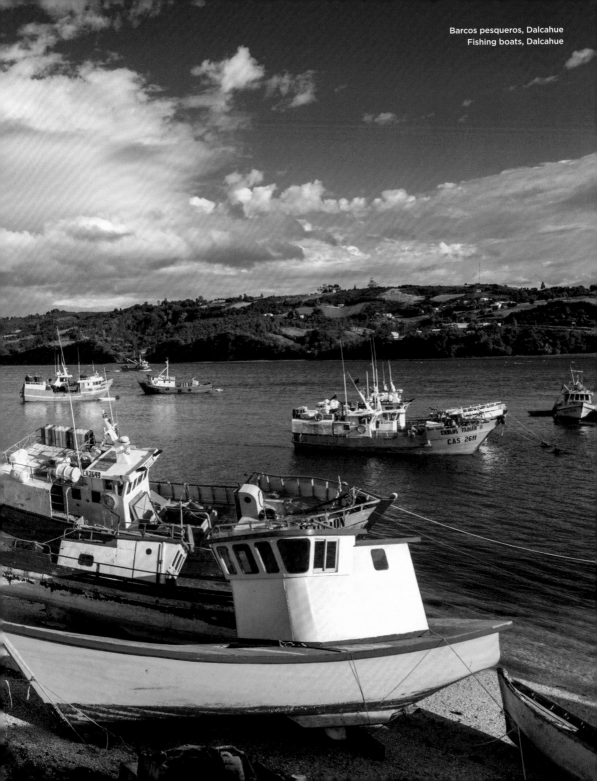

Carretera Austral

Puerto Montt

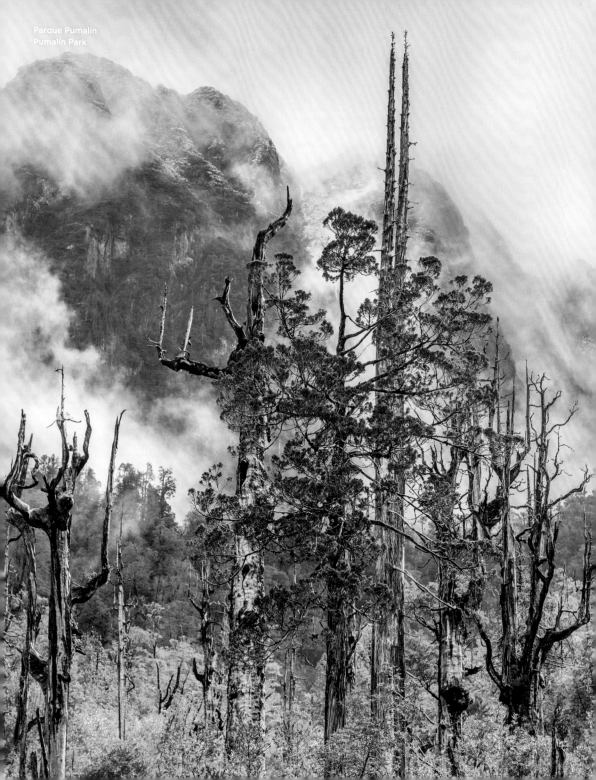

Notro cerca de Coyhaique
Chilean firebush near Coyhaique

Carretera Austral

This 1200 km (770 mi) designated Ruta 7 runs from Puerto Montt to Villa O'Higgins. For many, it is considered the most beautiful highway in Chile and possibly one of the most beautiful in the world. It passes through grand landscapes, several national parks, and nature reserves. Pumalín Park north of Chaitén is privately owned. American Douglas Tompkins bought the vast area to preserve the unique landscape from development.

Carretera Austral

Este trayecto de 1200 km, la Ruta 7 desde Puerto Montt a Villa O'Higgins, es para muchos la ruta más hermosa de Chile – para algunos incluso uno de los más bellos del mundo. Pasa a través de paisajes grandiosos, varios parques nacionales y reservas naturales. El Parque Pumalín al norte de Chaitén es de propiedad privada. El americano Douglas Tompkins compró la enorme área para preservar la naturaleza única.

Carretera Austral

Nombreux sont ceux qui considèrent que les 1200 km de la route 7 allant de Puerto Montt à Villa O'Higgins sont la plus belle route du Chili – pour certains, c'est même l'une des plus belles du monde. Elle traverse des paysages magnifiques, plusieurs parcs nationaux et des réserves naturelles. Le parc de Pumalín, au nord de Chaitén, est une propriété privée. L'américain Douglas Tompkins a acheté le vaste domaine afin de préserver la nature unique.

Carretera Austral

Il tragitto di ben 1200 km, la Ruta CH-7 di Puerto Montt fino a Villa O'Higgins, è per molti il più bello del Cile; per altri uno dei più belli del mondo. Attraversa paesaggi meravigliosi, numerosi parchi nazionali e aree naturali protette. Il Parco Pumalín, situato a nord di Chaitén, è di proprietà privata. L'americano Douglas Tompkins acquistò l'enorme riserva naturale, per preservarne il patrimonio naturale unico.

Carretera Austral

Die 1200 km lange Ruta 7 von Puerto Montt nach Villa O'Higgins ist für viele die schönste Route Chiles – für manche sogar eine der schönsten der Welt. Sie führt durch grandiose Landschaften, mehrere Nationalparks und Naturschutzgebiete. Der Pumalín-Park nördlich von Chaitén ist in Privatbesitz. Der Amerikaner Douglas Tompkins kaufte das riesige Gebiet, um die einzigartige Natur zu bewahren.

Carretera Austral

De 1200 km lange snelweg, Ruta 7, van Puerto Montt naar Villa O'Higgins, is volgens velen de mooiste weg van Chili – en voor sommigen zelfs van de wereld. De route loopt door grandioze landschappen en meerdere nationale parken en natuurreservaten. Ten noorden van Chaitén is het Pumalín Park in privébezit. De Amerikaan Douglas Tompkins kocht het reusachtige gebied om er de unieke natuur te kunnen behouden.

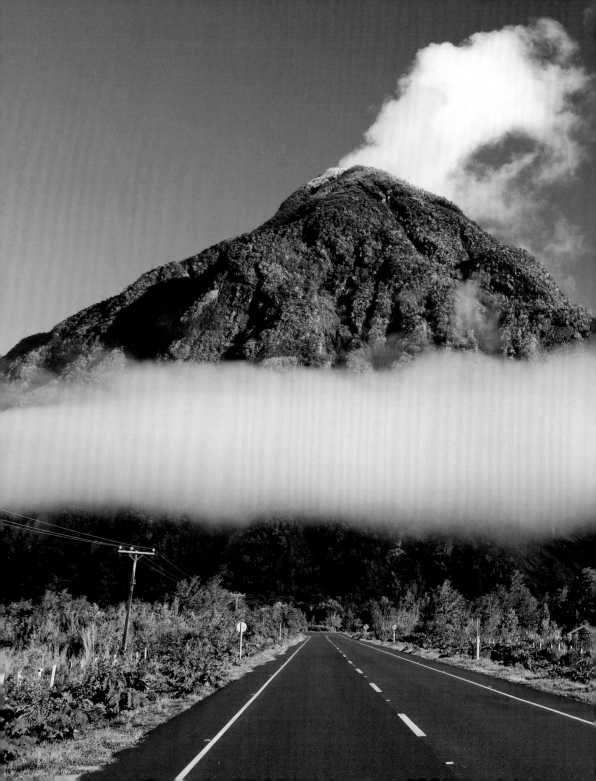

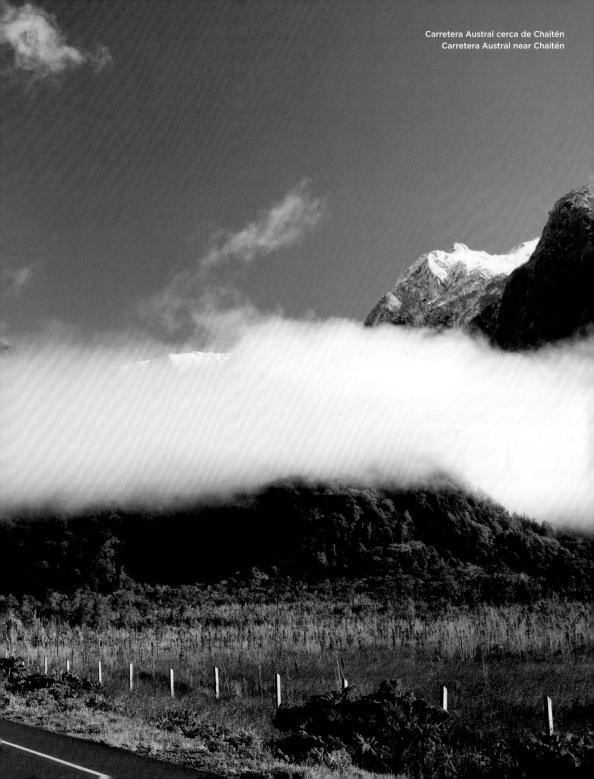

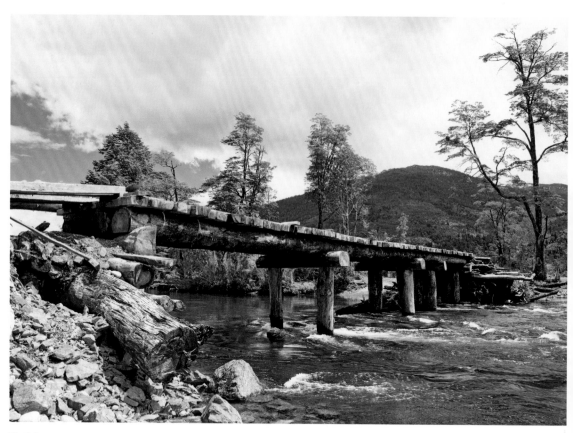

Río Palena
Palena River

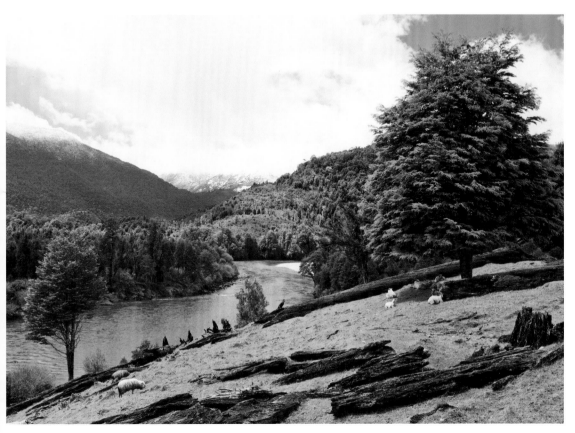

Río Palena
Palena River

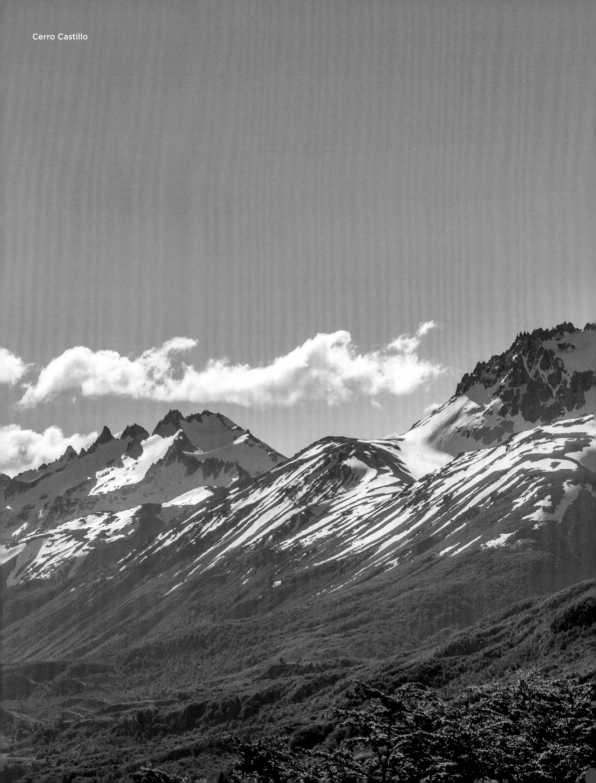
Cerro Castillo

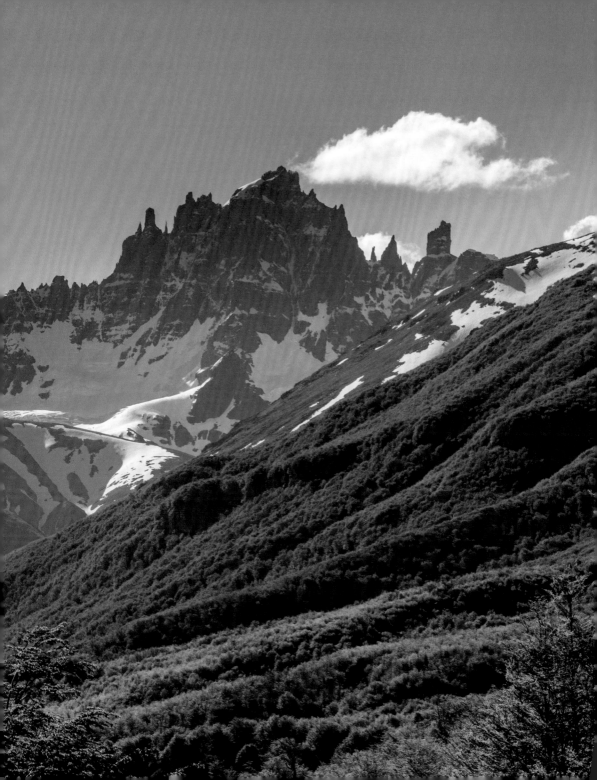

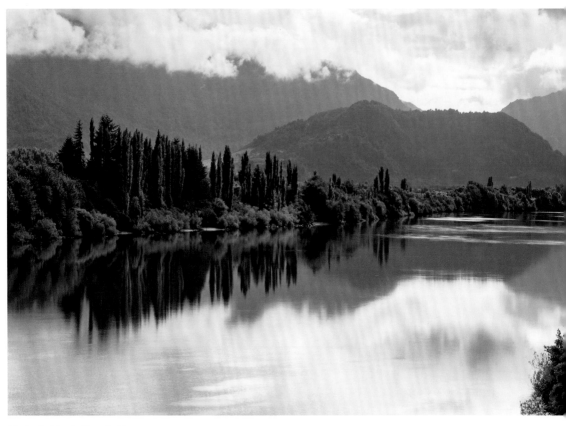

Río Aysén, Puerto Chacabuco
Aysén River, Puerto Chacabuco

General Carrera Lake

Lago General Carrera is the largest lake in Chile and the second largest in South America with an area of 2240 km² (865 sq mi). In the shadow of the Andes, it extends across the border with Argentina. At the Marble Cathedral, Chapel and Caves on the western shore of the lake at Puerto Tranquilo, the marble walls create fascinating patterns of color on the water.

Lac General Carrera

Le lac General Carrera, avec une superficie de 2240 km², est le plus grand lac du Chili et le deuxième d'Amérique du Sud. Il s'étend jusqu'en Argentine à l'ombre de la cordillère des Andes. Sur la Cathédrale, sur la Chapelle et dans les Caves de Marbre située sur la rive ouest du lac, à Puerto Tranquilo, les murs de marbre créent un fascinant jeu de lumière sur l'eau.

Lago General Carrera

Der Lago General Carrera ist mit einer Fläche von 2240 km² der größte See Chiles und der zweitgrößte Südamerikas. Im Schatten der Andengipfel erstreckt er sich bis nach Argentinien. Auf der Marmorkathedrale, der Marmorkapelle und in den Marmorkavernen am Westufer des Sees bei Puerto Tranquilo zaubern die hellen Marmorwände ein faszinierendes Farbenspiel aufs Wasser.

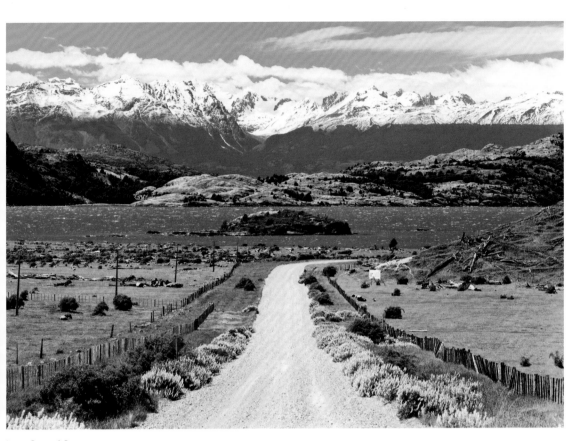

Lago General Carrera
General Carrera Lake

Lago General Carrera

Lago General Carrera es el lago más grande de Chile y el segundo más grande de América del Sur, con una superficie de 2240 km². Se extiende hasta Argentina a la sombra de los picos de los Andes. En la Catedral, la Capilla y las Cavernas de Mármol, en la orilla occidental del lago de Puerto Tranquilo, las brillantes paredes de mármol evocan un fascinante juego de color sobre el agua

Lago General Carrera

Il Lago General Carrera ha una superficie di 2240 km² ed è il più grande del Cile e il secondo dell'America del Sud. Si estende all'ombra delle Ande fino all'Argentina. Sulla Cattedrale, sulla Cappella e nelle Grotte di Marmo, sulla sponda occidentale del lago vicino a Puerto Tranquilo, le chiare pareti marmoree creano un affascinante gioco di colori nell'acqua.

General Carrerameer

Met 2240 km² is het General Carrerameer het grootste van Chili en het op één na grootste van Zuid-Amerika. Het strekt zich aan de voet van de Andes uit tot in Argentinië. Bij Puerto Río Tranquilo aan de westoever van het meer toveren de witte rotsen van de Marmeren Kathedraal, Kapel en Grotten een kleurig lichtspel op het water

Puente General Carrera
General Carrera Bridge

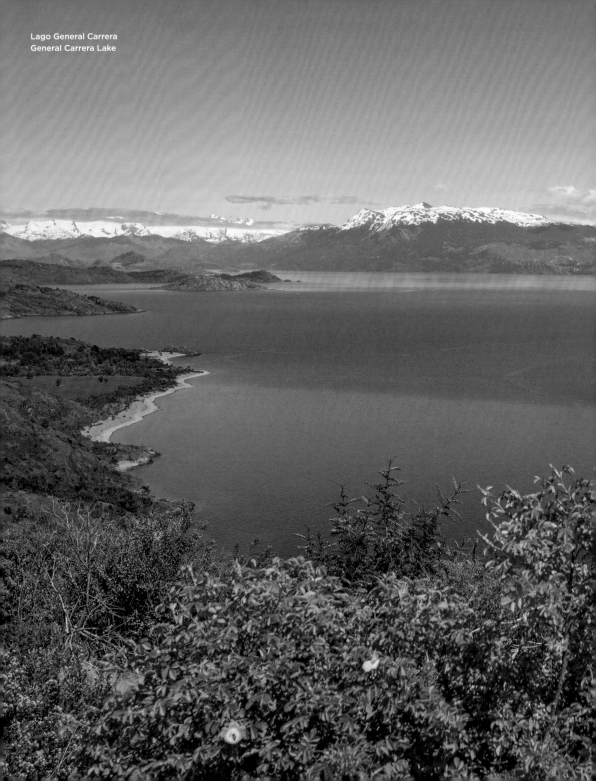

Lago General Carrera
General Carrera Lake

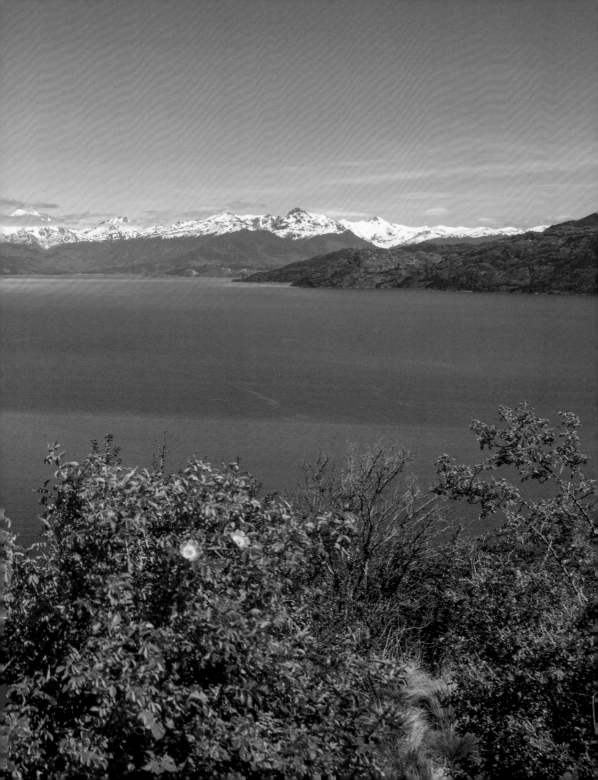

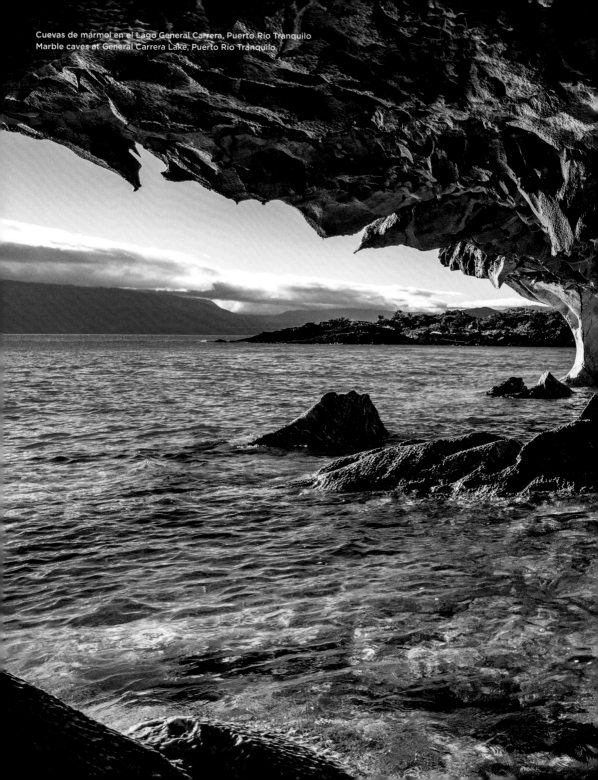

Cuevas de mármol en el Lago General Carrera, Puerto Río Tranquilo
Marble caves at General Carrera Lake, Puerto Río Tranquilo

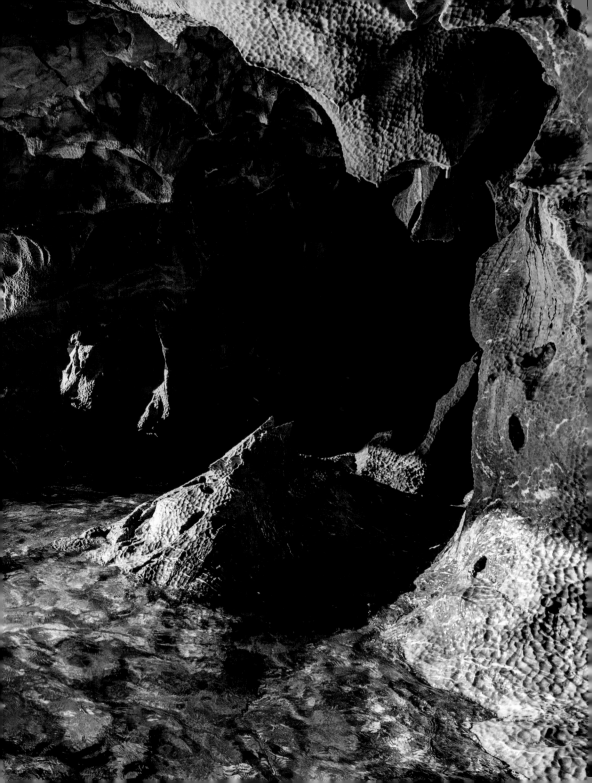

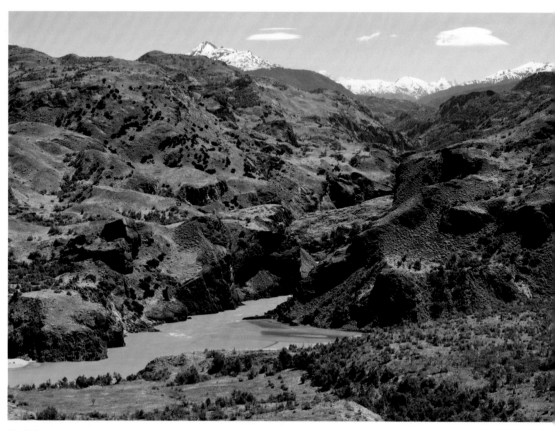

Río Baker
Baker River

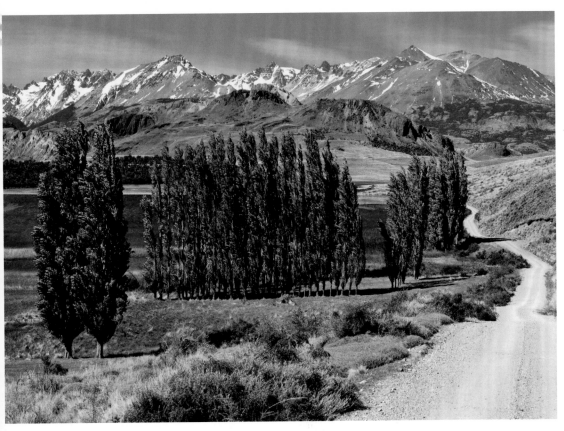

Río Chacabuco cerca de Cochrane
Chacabuco River near Cochrane

Ruta a Cochrane
Route to Cochrane

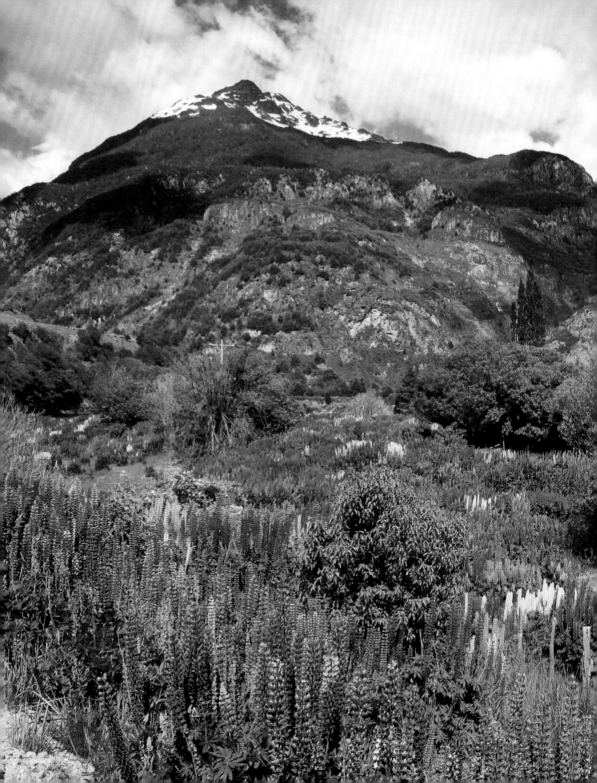

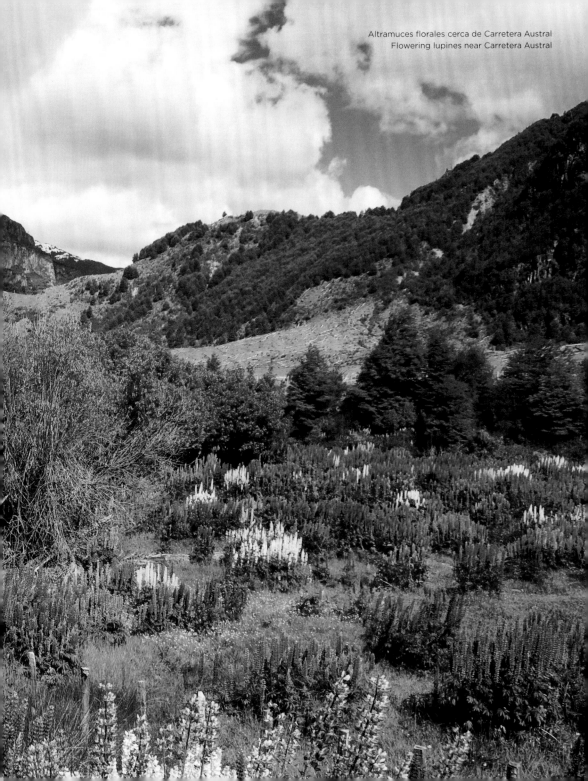

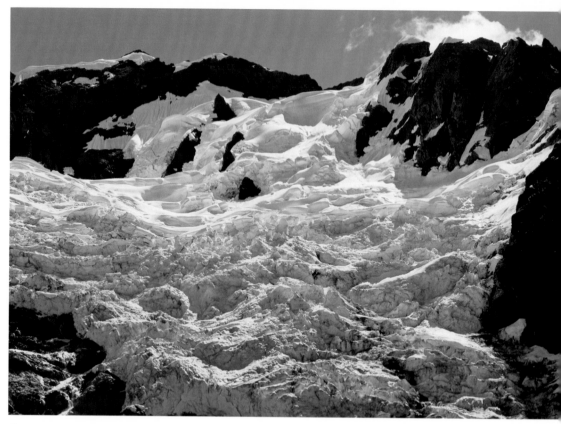

Glaciar cerca de Puerto Bertrand
Glacier near Puerto Bertrand

Guanacos

While llamas, alpacas, and vicuñas occur only in northern Chile, guanacos also live in the southern part of the country. Their two layers of fur insulate them against heat as well as against cold, rain and snow at altitudes of up to 4000 m (13,000 ft). Like all small camels, guanacos use a special weapon to protect themselves: they spit.

Guanacos

Alors que les lamas, alpagas et vigognes ne se trouvent que dans le nord du Chili, les guanacos vivent également dans la partie sud du pays. Leur fourrure, composée de deux couches, les isole aussi bien de la chaleur que du froid, de la pluie et de la neige, à des altitudes jusqu'à 4000 m. Comme tous les petits camélidés, les guanacos disposent d'une arme redoutable en cas de danger : ils crachent.

Guanakos

Während Lamas, Alpakas und Vikunjas nur im Norden Chiles vorkommen, leben Guanakos auch im südlichen Teil des Landes. Ihr aus zwei Schichten bestehendes Fell isoliert sie sowohl gegen Wärme als auch gegen Kälte, Regen und Schnee in Höhen bis zu 4000 m. Wie alle Kleinkamele greifen Guanakos bei Gefahr zu einer besonderen Waffe – sie spucken.

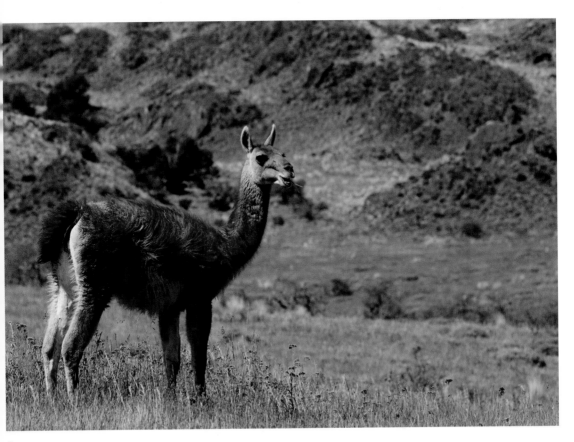
Guanaco

Guanacos

Mientras que lamas, alpacas y vicuñas sólo están presentes en el norte de Chile, los guanacos también viven en la parte sur del país. Su piel de dos capas les aísla contra el calor, así como contra el frío, la lluvia y la nieve a altitudes de hasta 4000 m. Al igual que todos los pequeños camélidos, los guanacos atacan con un arma especial cuando se encuentran en peligro – escupen.

Guanaco

Mentre lama, alpaca e vigogna si trovano soltanto al nord del Cile, i guanaco vivono anche al sud del paese. Il doppio strato di pelo li isola sia dal caldo che dal freddo, pioggia e neve permettendogli di vivere fino a 4000 m di altezza. Come tutti i camelidi anche i guanaco hanno un'arma segreta: sputano.

Guanaco's

Terwijl lama's, alpaca's en vicuña's alleen in Noord-Chili voorkomen, leven guanaco's in het zuiden van het land. Hun vacht bestaat uit twee lagen en isoleert de dieren tegen hitte en kou, en beschut ze tegen regen en sneeuw tot een hoogte van 4000 meter. Zoals alle lamasoorten gebruiken guanaco's bij gevaar een bijzonder wapen: ze spugen.

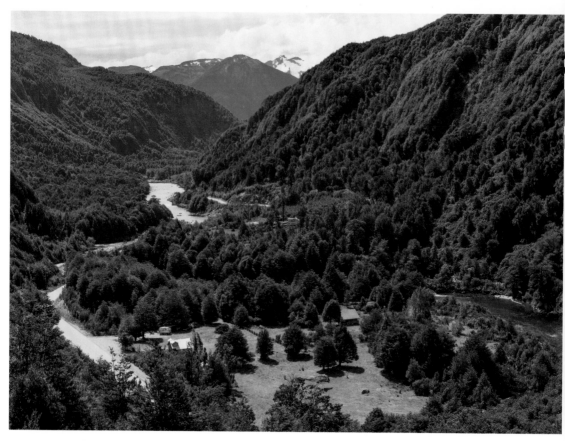

Valle del Cisnes cerca de Villa Amengual
Cisnes Valley near Villa Amengual

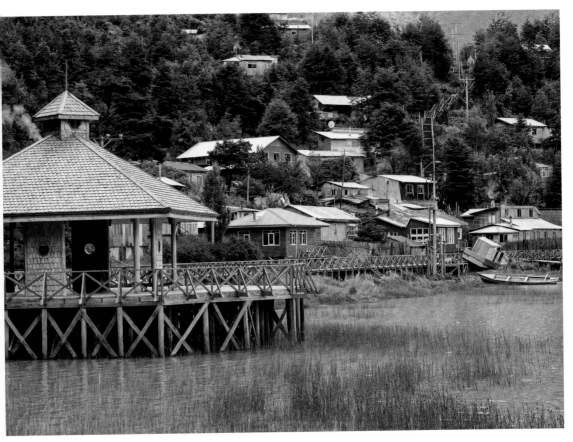

Caleta Tortel

Villa O'Higgins

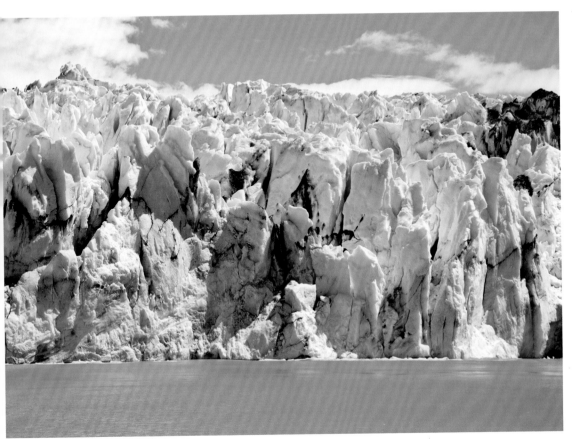

Lago O'Higgins con glaciar
Lake O'Higgins with glacier

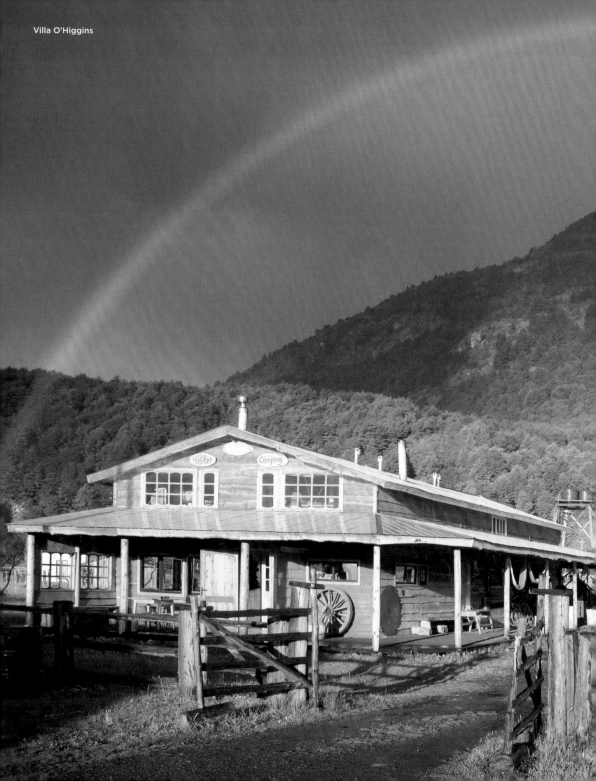

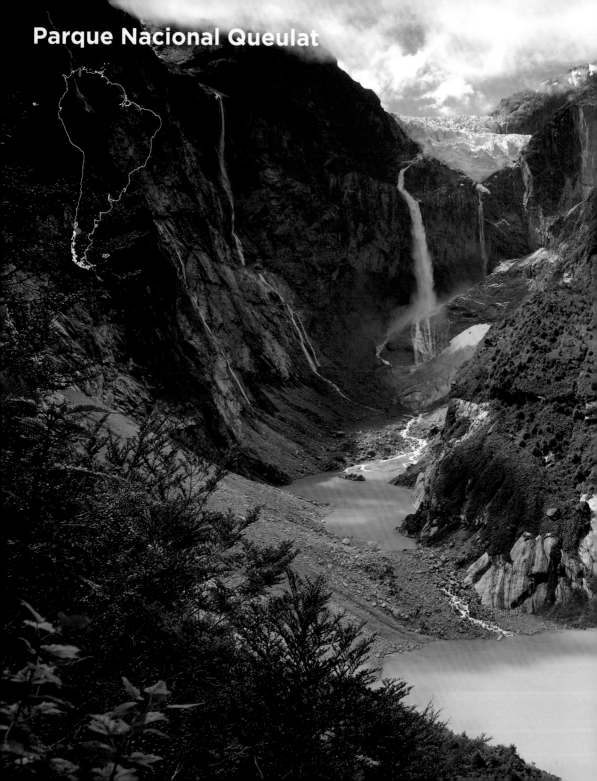

Parque Nacional Queulat

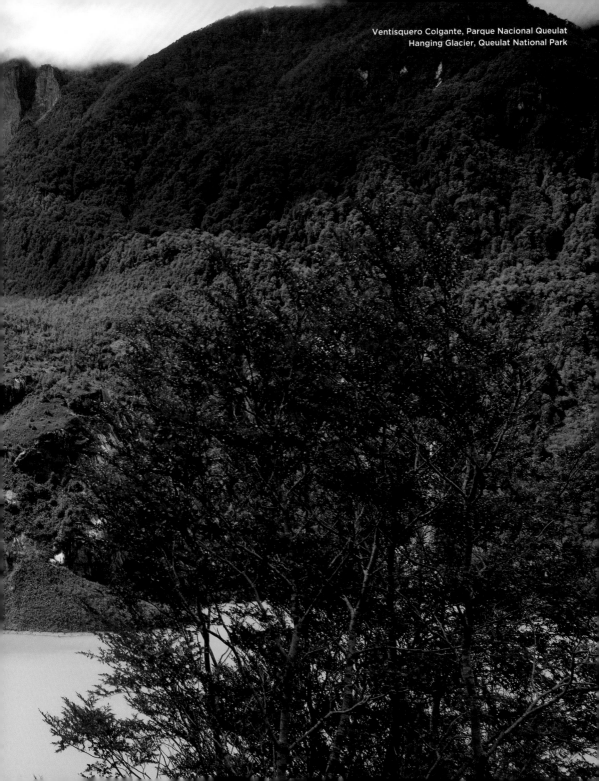

Ventisquero Colgante, Parque Nacional Queulat
Hanging Glacier, Queulat National Park

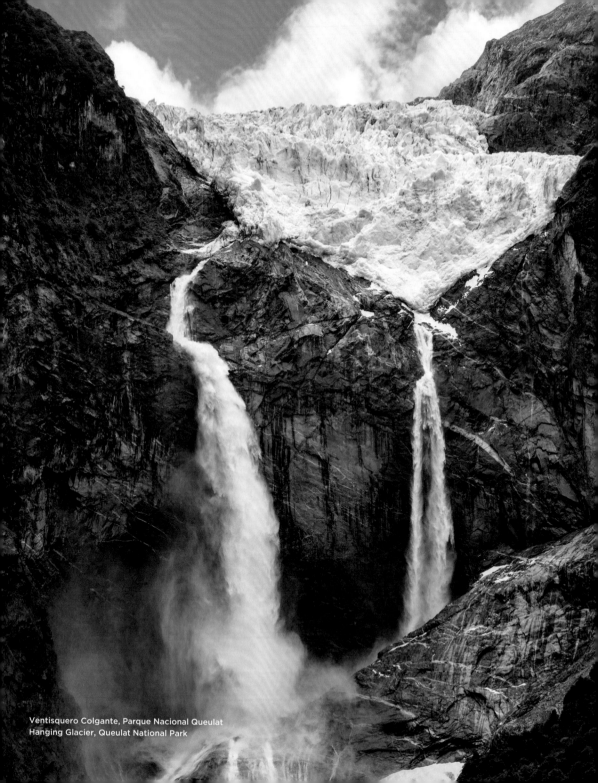

Ventisquero Colgante, Parque Nacional Queulat
Hanging Glacier, Queulat National Park

Ventisquero Colgante, Parque Nacional Queulat
Hanging Glacier, Queulat National Park

Queulat National Park

Glaciers and fjords, waterfalls and rushing streams, and more than 50 lakes and ponds in Queulat National Park create the backdrop for the star turn of the Patagonian cypress (Fitzroya cupressoides). Supporting roles in this dramatic landscape are played by pumas and güiñas, condors, Magellanic woodpeckers, and waterfowl like the black-necked swan and herons.

Parque Nacional Queulat

Glaciares y fiordos, cascadas y torrentes y más de 50 lagos y estanques dominan el paisaje en el Parque Nacional Queulat. Ante este imponente telón de fondo tiene el papel principal el ciprés de la Patagonia, también conocido como "secuoya chilena". En los papeles secundarios actúan los pumas y las güiñas, los cóndores, los carpinteros magallánicos y las aves acuáticas como los cisnes de cuello negro y las garzas.

Parc national Queulat

Le paysage du parc national Queulat est composé de glaciers et de fjords, de chutes d'eau et de torrents déchaînés et de plus de 50 lacs et étangs. Dans cet imposant décor, l'immense cyprès de Patagonie (Fitzroya cupressoides) tient le premier rôle, à côté des pumas, kodkods, condors, pics de Magellan et oiseaux aquatiques sauvages, tels que les cygnes à cou noir et diverses variétés d'ardéidés.

Parco Nazionale di Queulat

Ghiacciai e fiordi, cascate, ruscelli impetuosi e oltre 50 laghi e stagni formano il paesaggio del Parco Nazionale di Queulat. Davanti a questo scenario imponente il cipresso della Patagonia, conosciuto anche come "sequoia cilena", gioca il ruolo principale. Ma vi sono anche puma e kodkod, condor, il picchio di Magellano e uccelli acquatici come cigni dal collo nero e aironi.

Nationalpark Queulat

Gletscher und Fjorde, Wasserfälle und reißende Bäche sowie mehr als 50 Seen und Teiche bestimmen das Landschaftsbild im Nationalpark Queulat. Vor dieser imposanten Kulisse spielt die Patagonische Zypresse, auch als „Chilenischer Mammutbaum" bekannt, die Hauptrolle. In den Nebenrollen agieren Pumas und Chilenische Waldkatzen, Kondore, Magellanspechte und Wasservögel wie Schwarzhalsschwäne und Reiher.

Nationaal Park Queulat

Gletsjers en fjorden, watervallen en woeste bergbeken, en ruim vijftig meren en poelen bepalen het landschap van het Nationale Park van Queulat. In dit indrukwekkende decor speelt de Fitzroya-cipres, ook wel de 'Chileense reuzencipres' genoemd, een hoofdrol. Bijrollen zijn er voor de poema, de kodkod, de condor, de Magelhaenspecht en voor watervogels, zwarthalszwanen en reigers.

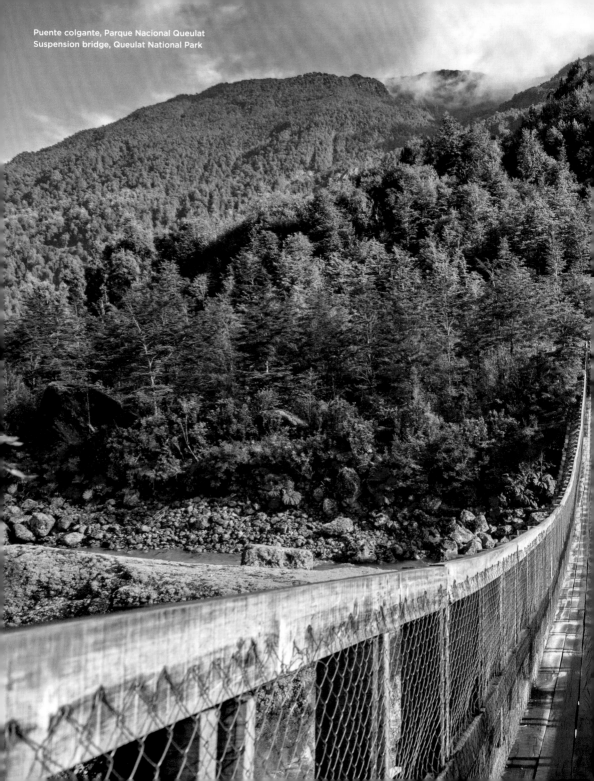

Puente colgante, Parque Nacional Queulat
Suspension bridge, Queulat National Park

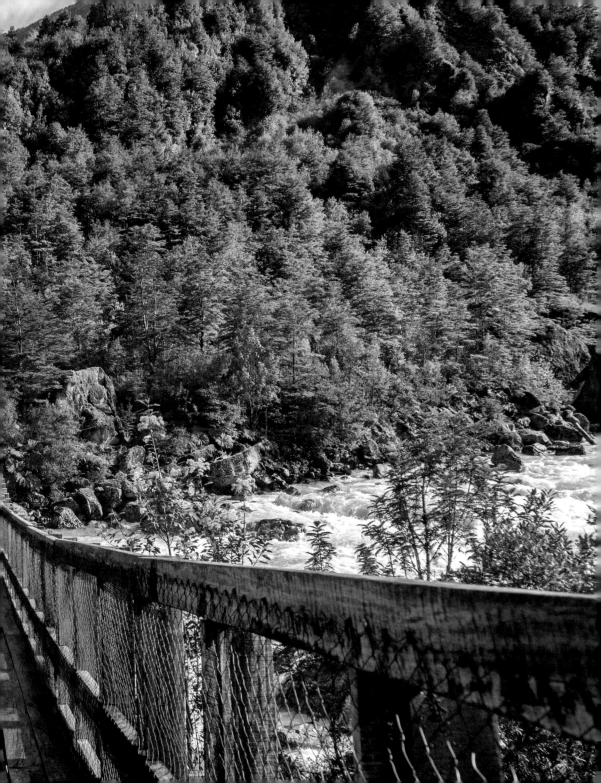

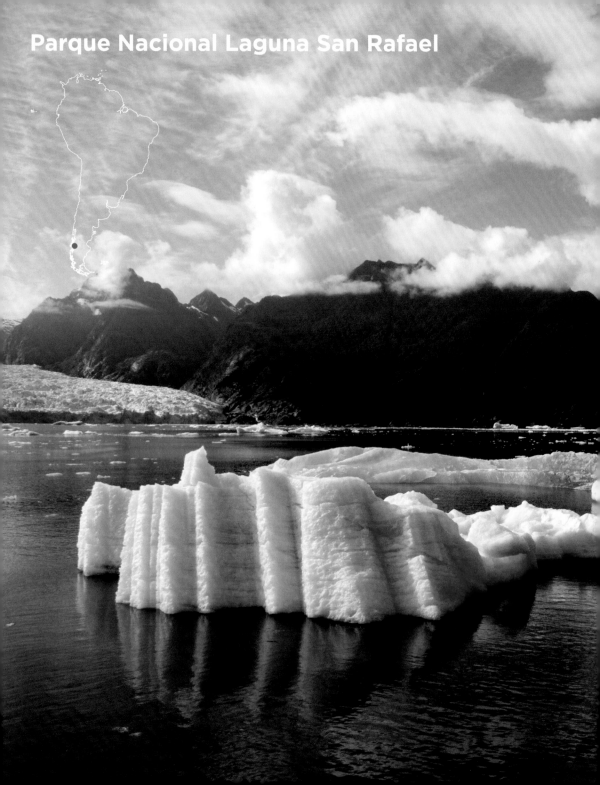

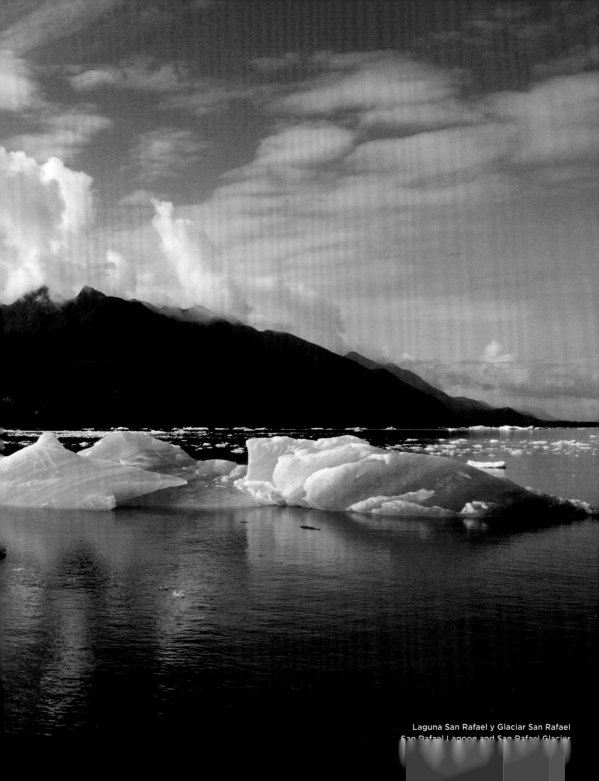

Laguna San Rafael y Glaciar San Rafael
San Rafael Lagoon and San Rafael Glacier

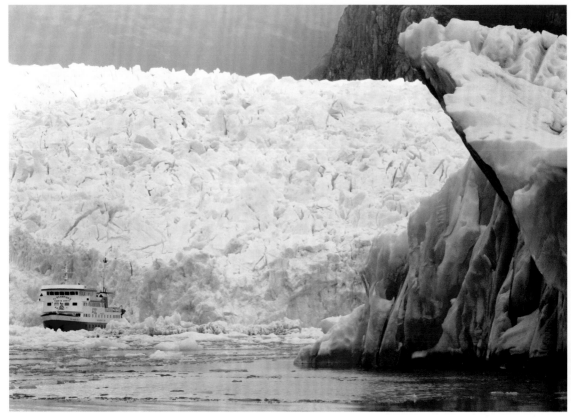

Crucero *Skorpios II* en Laguna San Rafael delante del Glaciar San Rafael
Cruise ship *Skorpios II* in San Rafael Lagoon in front of San Rafael Glacier

Laguna San Rafael National Park

Bizarre ice landscapes, blue glaciers, and deep lakes. A nearly silent, eerie world. The Laguna de San Rafael National Park can only be reached by ferry from Puerto Chacabuco. Its highest peak is Monte San Valentín, rising 4058 m (13,314 ft) from the massive North Patagonian ice field. Lower regions feature Magellanic southern beech which offer homes to guemals, güiñas, marine otters, and waterfowl.

Parc national Laguna San Rafael

Paysages glacés étranges, glaciers bleus et lacs profonds, le parc national Laguna de San Rafael est un monde silencieux et mystérieux. Il n'est accessible que par bateau depuis Puerto Chacabuco. Son plus haut sommet, le mont San Valentín (4058 m) s'élève au-dessus de l'immense champ de neige nord de Patagonie, alors qu'aux altitudes plus basses, les forêts de hêtres de Magellan constituent l'habitat des cerfs des Andes, kodkods, loutres marines et de diverses espèces d'oiseaux marins sauvages.

Nationalpark Laguna San Rafael

Bizarre Eislandschaften, blaue Gletscher und tiefe Seen. Eine stille, geheimnisvolle Welt. Der Nationalpark Laguna de San Rafael ist nur mit der Fähre ab Puerto Chacabuco erreichbar. Als höchste Erhebung ragt die Monte San Valentín (4058 m) aus dem riesigen Nordpatagonischen Eisfeld, und in den niedrigeren Gefilden bieten die Magellan-Südbuchenwälder Lebensraum für Andenhirsche, Chilenische Waldkatzen, Küstenotter und Wasservögel.

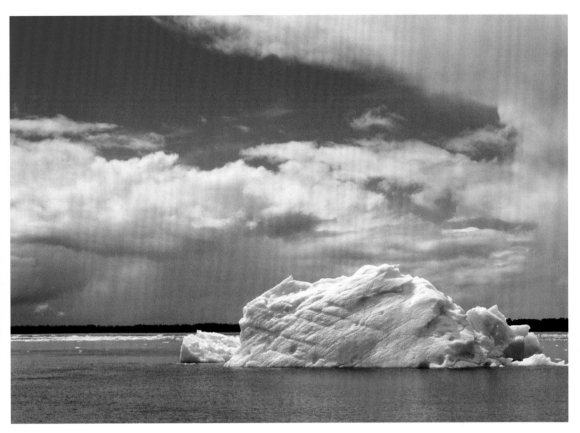

Iceberg en Laguna San Rafael
Iceberg in San Rafael Lagoon

Parque Nacional Laguna San Rafael

Extraños paisajes de hielo, glaciares y profundos lagos azules. Un mundo misterioso de silencio. El Parque Nacional Laguna de San Rafael sólo es accesible por ferry desde el Puerto Chacabuco. El pico más alto es el Monte San Valentín (4058 m) en el enorme Campo de Hielo Norte, y en las zonas inferiores encontramos los bosques de coihue de Magallanes que sirven de hábitat para la taruca, la güiña, el chungungo y aves acuáticas.

Parco Nazionale Laguna San Rafael

Bizzarri paesaggi di ghiaccio, ghiacciai blu e laghi profondi. Un mondo silenzioso e misterioso. Il Parco Nazionale della Laguna de San Rafael è raggiungibile solo con il traghetto da Puerto Chacabuco. Il rilievo più alto è il Monte San Valentín (4058 m) dall'enorme nevaio della Patagonia settentrionale; ad altitudini più basse i boschi di guindo offrono lo spazio vitale per cervi delle Ande, kodkod, lontre marine e uccelli acquatici.

Nationaal Park Laguna San Rafael

Bizarre ijslandschappen, blauwe gletsjers en diepe meren beheersen deze stille, geheimzinnige wereld. Het Nationale Park Laguna de San Rafael is alleen met de veerpont vanaf Puerto Chacabuco bereikbaar. Als hoogste punt torent de Monte San Valentín (4058 m) boven het reusachtige Noord-Patagonische IJsveld uit; in lager gelegen gebied leven huemuls, kodkods, kustotters en watervogels in bossen van de Magelhaenschijnbeuk.

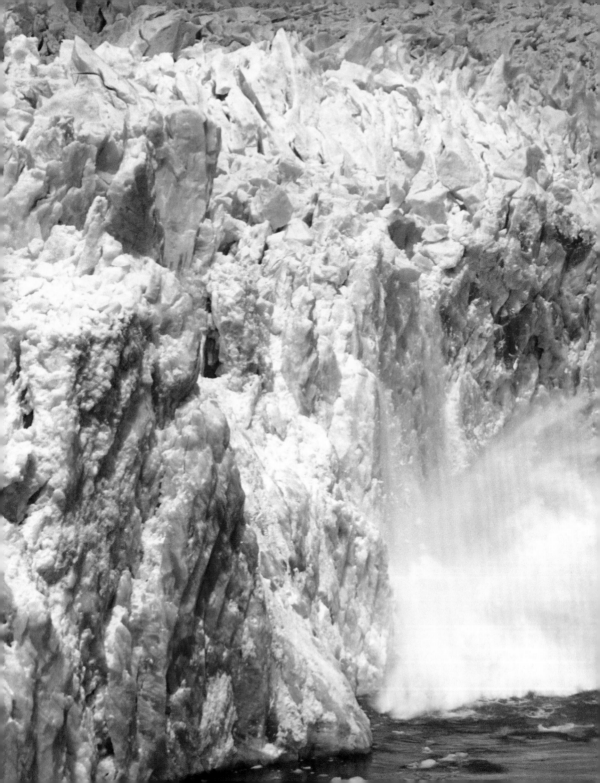

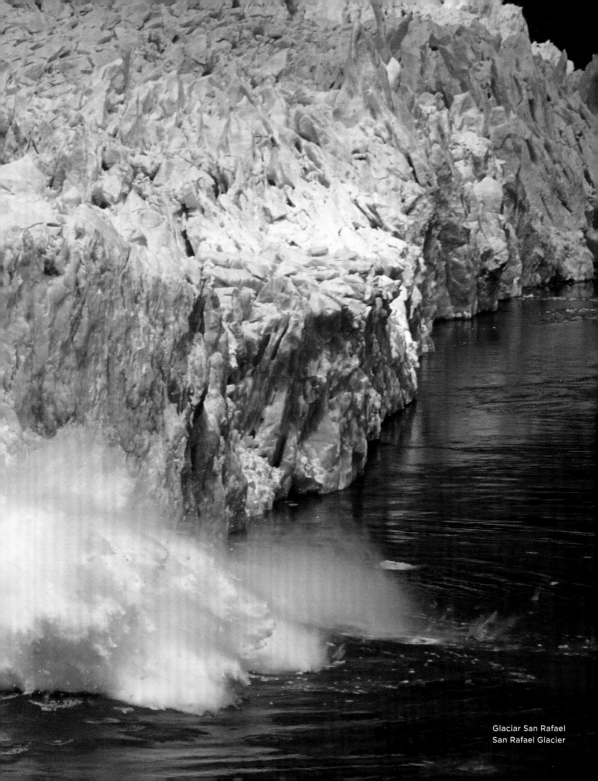

Glaciar San Rafael
San Rafael Glacier

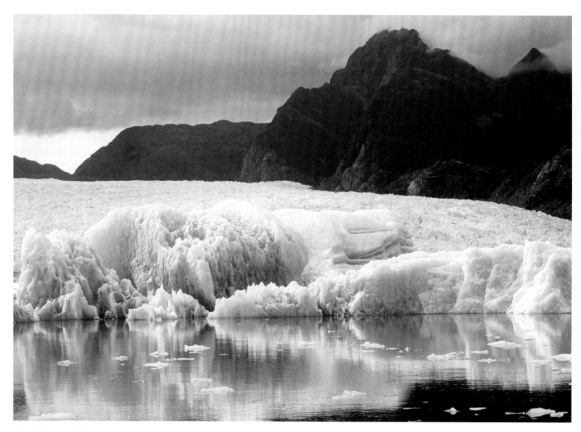

Glaciar San Rafael y Laguna San Rafael
San Rafael Glacier and San Rafael Lagoon

San Rafael Glacier
The San Rafael Glacier flows into the lagoon of the same name like an ice-cold, white stream of lava. The hanging glacier is a part of the North Patagonian Ice Field (Campo de Hielo Norte), covering some 4400 km² (1700 sq mi).

Glacier de San Rafael
Le glacier de San Rafael se jette dans la lagune éponyme telle une coulée de lave glacée blanche. Ce glacier suspendu fait partie du champ de glace Nord de Patagonie (Campo de Hielo Norte) et occupe une surface d'environ 4400 km².

San-Rafael-Gletscher
Wie ein eiskalter weißer Lavastrom ergießt sich der San-Rafael-Gletscher in die gleichnamige Lagune. Der hängende Gletscher gehört zum Nordpatagonischen Eisfeld (Campo de Hielo Norte) mit einer Fläche von rund 4400 km².

Lago Bertrand
Lake Bertrand

Glaciar San Rafael

Como un río de lava blanca helada se vierte el glaciar San Rafael vierte en la laguna del mismo nombre. El glaciar colgante es parte del Campo de Hielo Norte con una superficie de unos 4400 km².

Ghiacciaio di San Rafael

Il ghiacciaio di San Rafael si riversa come un gelido fiume di lava bianca nella laguna omonima. Il ghiacciaio sospeso appartiene al nevaio della Patagonia del nord (Campo de Hielo Norte) con una superficie di circa 4400 km².

San Rafael-gletsjer

Als een ijzige witte lavastroom mondt de San Rafael-gletsjer in de gelijknamige lagune uit. De gletsjer glijdt door een hangend dal en behoort tot het Noord-Patagonische IJsveld (Campo de Hielo Norte), met een oppervlakte van circa 4400 km².

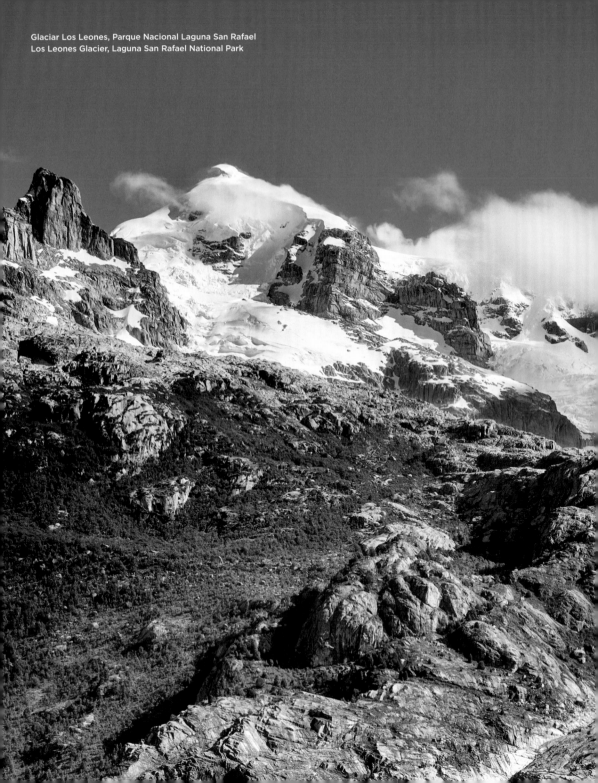

Glaciar Los Leones, Parque Nacional Laguna San Rafael
Los Leones Glacier, Laguna San Rafael National Park

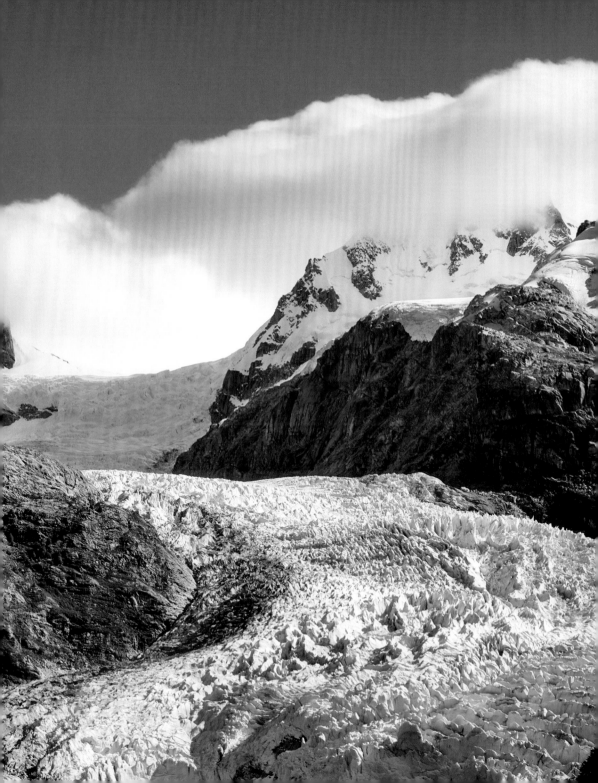

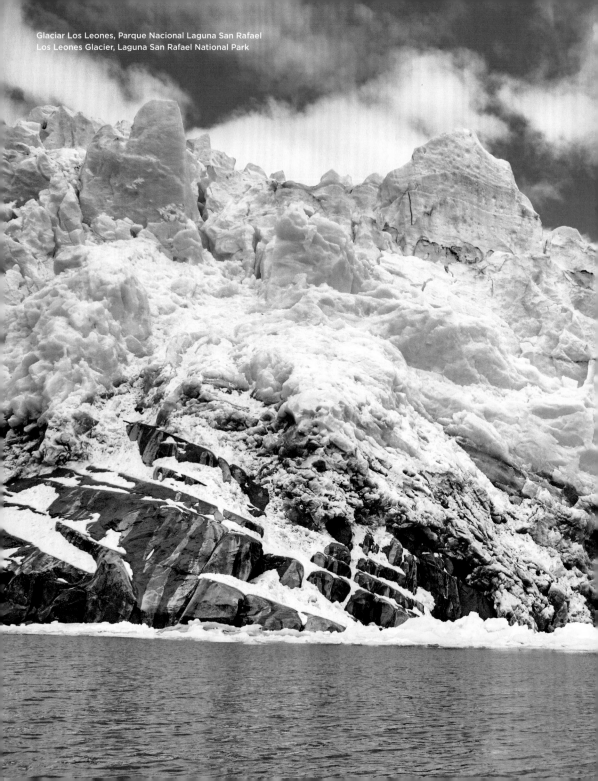

Glaciar Los Leones, Parque Nacional Laguna San Rafael
Los Leones Glacier, Laguna San Rafael National Park

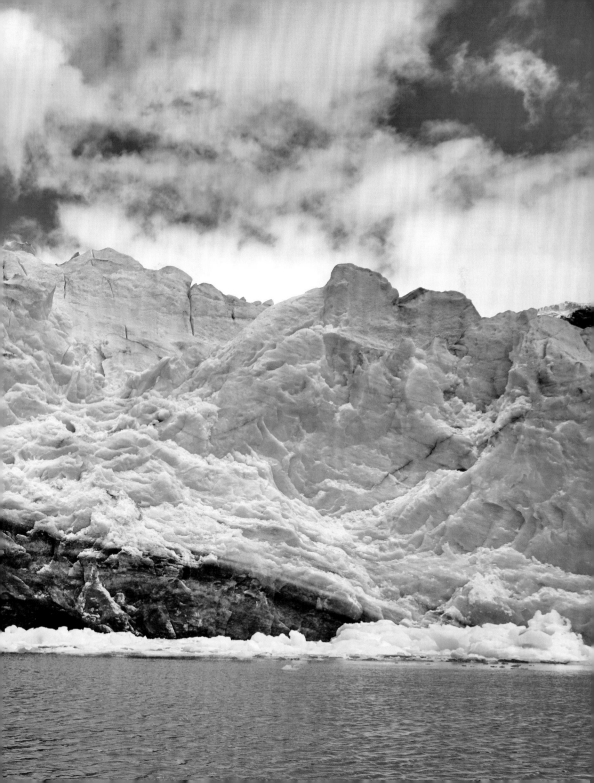

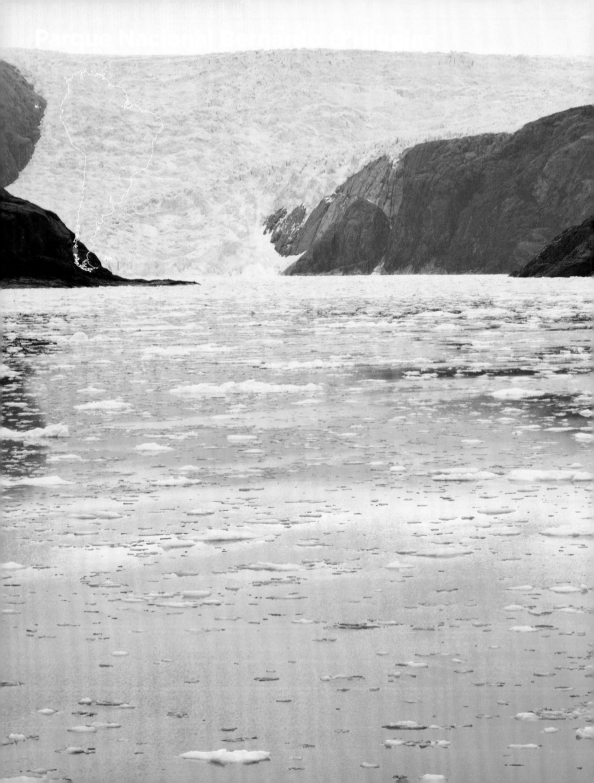

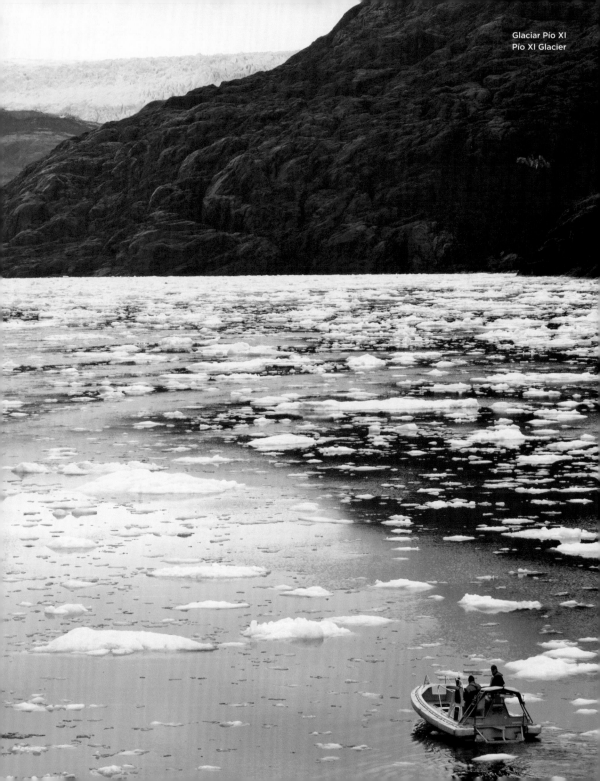

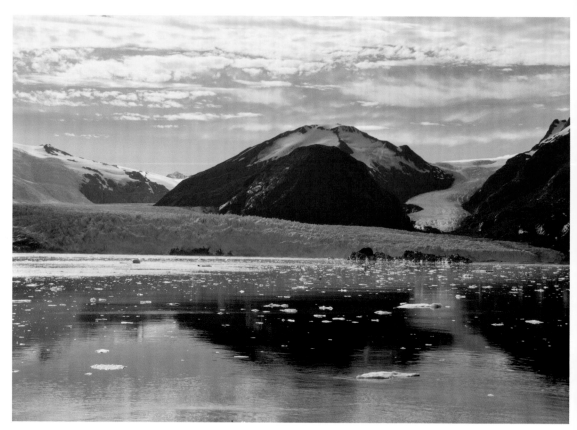

Glaciar Amalia
Amalia Glacier

Bernardo O'Higgins National Park

Última Esperanza ("last hope") is the
name of the province where a part of
Bernardo O'Higgins National Park lies.
It's no wonder since the first seafarers
to arrive here were certain they would
never escape this labyrinth of fjords and
islands, glaciers and moving icebergs.
Covering 35,260 km² (13,614 sq mi), this is
Chile's largest national park and has been
named after the country's first president.
Pío XI is the largest glacier in the southern
hemisphere outside of Antarctic and
covers 1265 km² (488 sq mi).

Parc national Bernardo O'Higgins

Última Esperanza (Dernier espoir), tel
est le nom de la province où est situé en
partie le parc national Bernardo O'Higgins.
Cette appellation n'a rien d'étonnant car
les premiers navigateurs faillirent perdre
espoir dans ce labyrinthe de fjords et d'îles,
de glaciers et d'icebergs mobiles. Le plus
grand parc national du Chili (35 260 km²)
porte le nom du premier président du
pays. En son centre trône le Pío XI, qui,
avec ses 1265 km², est le plus grand
glacier de l'hémisphère sud en dehors
de l'Antarctique.

Nationalpark Bernardo O'Higgins

„Letzte Hoffnung" (Última Esperanza)
heißt die Provinz, in der ein Teil des
Nationalparks Bernardo O'Higgins liegt.
Kein Wunder, denn die ersten Seefahrer
verzweifelten fast in diesem Labyrinth aus
Fjorden und Inseln, aus Gletschern und
treibenden Eisbergen. Der mit 35 260 km²
größte Nationalpark Chiles ist nach dem
ersten Präsidenten des Landes benannt.
Mittendrin der Pío XI, mit 1265 km² größter
Gletscher der Südhalbkugel außerhalb
der Antarktis.

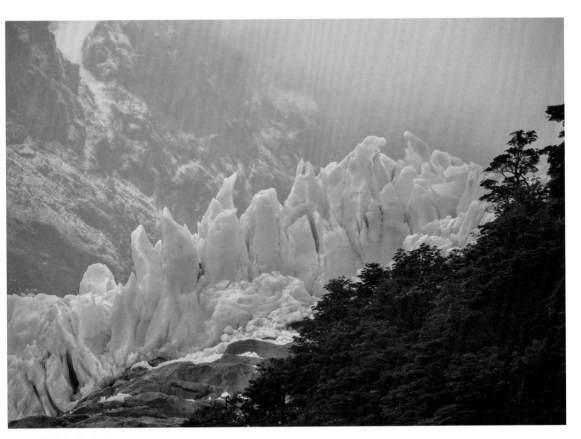

Campo de hielo, Glaciar Serrano
Ice field, Serrano Glacier

Parque Nacional Bernardo O'Higgins

Una parte de este Parque Nacional
Bernardo O'Higgins se encuentra en la
provincia que se llama "Última Esperanza".
No es de extrañar, ya que los primeros
navegantes casi se desesperaban en este
laberinto de fiordos e islas, de icebergs y
glaciares. El parque nacional más grande
de Chile, con 35 260 km² se llama como
el primer presidente del país. Justo en
el centro está el Pío XI, con 1265 km², el
glaciar más grande en el hemisferio sur
fuera de la Antártica.

Parco Nazionale Bernardo O'Higgins

"L'Ultima Speranza" si chiama la provincia
in cui si trova una parte del Parco
Nazionale Bernardo O'Higgins. Non c'è da
stupirsi che i primi navigatori quasi persero
le speranze in questo labirinto di fiordi e
isole, ghiacciai e iceberg alla deriva. Il più
grande parco nazionale del Cile, con i suoi
35 260 km², ha preso il nome dal primo
presidente della nazione. Al centro il Pio
XI, con 1265 km², è il più grande ghiacciaio
dell'emisfero meridionale al di fuori
dell'Antartico.

Nationaal Park Bernardo O'Higgins

'Laatste Hoop' (Última Esperanza) heet
de provincie waarin een deel van het
Nationaal Park Bernardo O'Higgins ligt.
Geen wonder, want de eerste zeevaarders
werden in dit labyrint van fjorden,
eilanden, gletsjers en ijsbergen bijna tot
wanhoop gedreven. Met 35 260 km² is dit
nationale park, vernoemd naar de eerste
president van Chili, het grootste van het
land. Centraal ligt de Pío XI-gletsjer, met
zijn 1265 km² de grootste op het zuidelijk
halfrond buiten Antarctica.

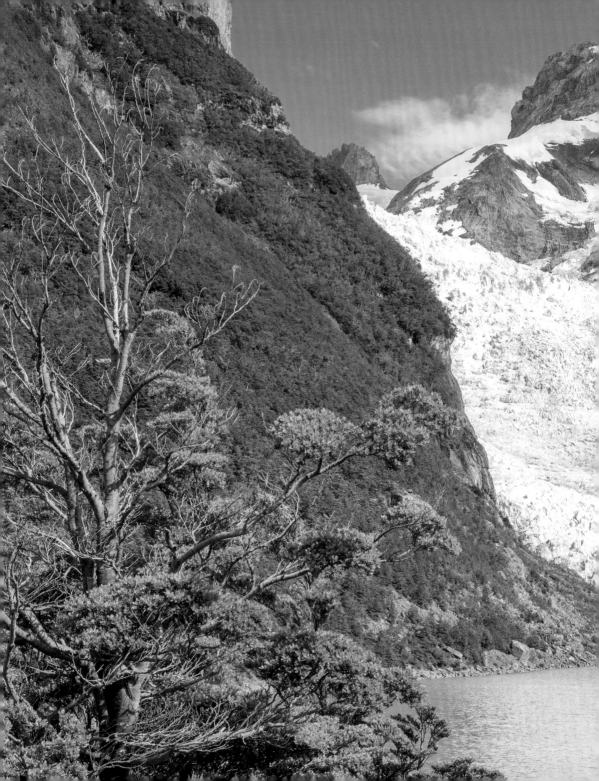

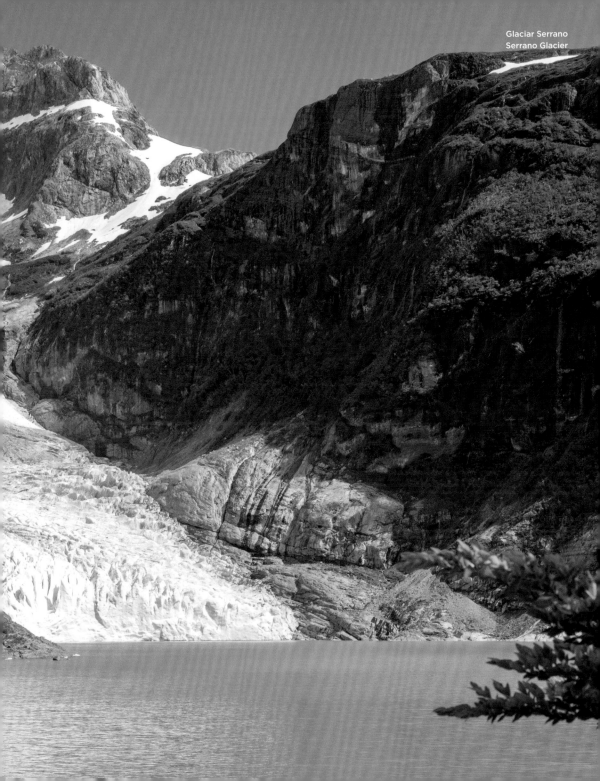

Glaciar Serrano
Serrano Glacier

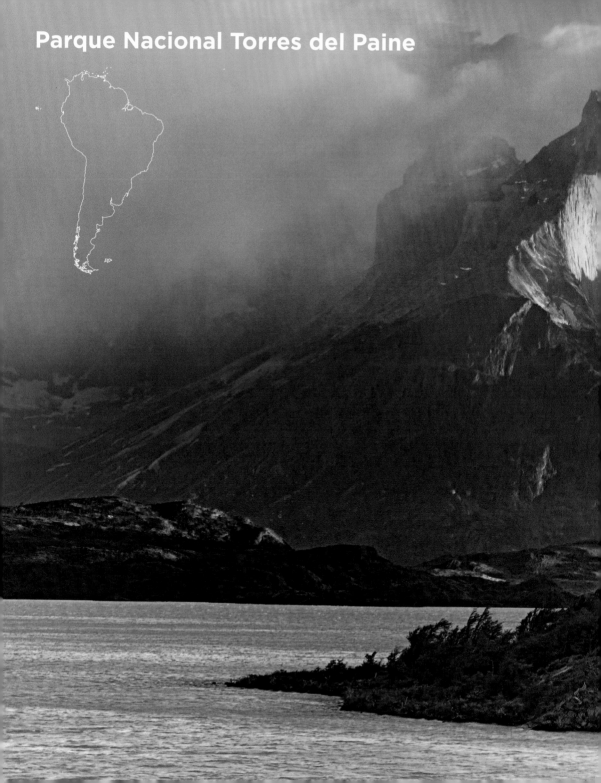

Parque Nacional Torres del Paine

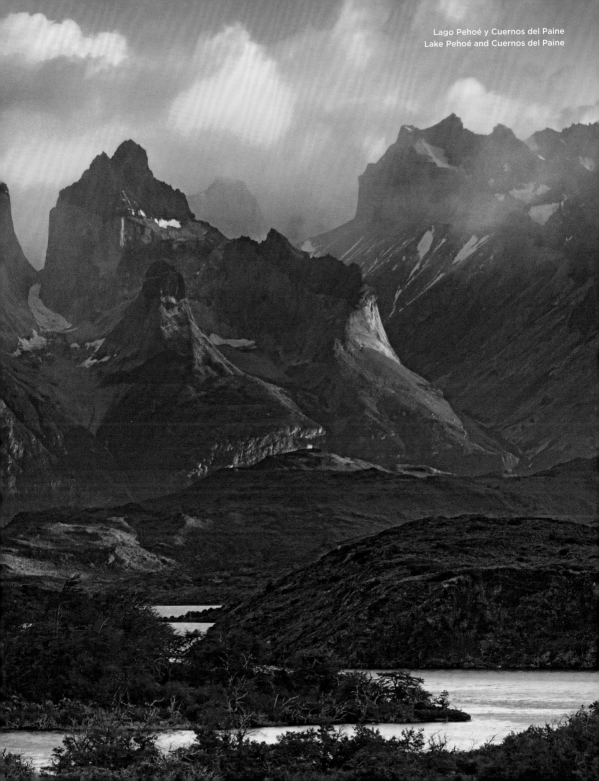

Lago Pehoé y Cuernos del Paine
Lake Pehoé and Cuernos del Paine

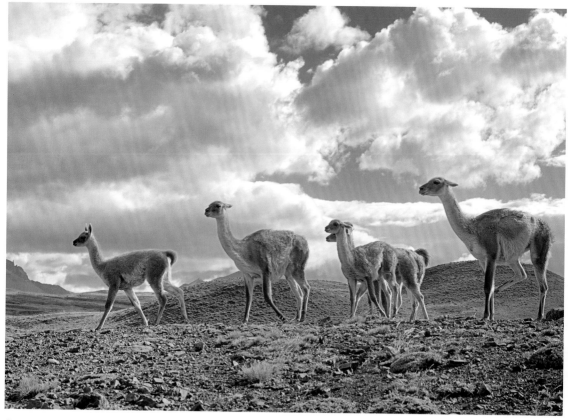

Guanacos en Parque Nacional Torres del Paine
Guanacos in Torres del Paine National Park

Torres del Paine National Park
The full breadth of nature's power is on evidence at Torres del Paine: mighty granite cliffs crafted into bizarre shapes by millions of years of glacial ice. Unmissable are the three granite needles, Torres del Paine, as well as the glaciers, lakes, mountains rising up to 3050 m (10,000 ft), deep valleys, and expansive steppes.

Parc national Torres del Paine
La puissance de la nature devient palpable dans le parc national Torres del Paine : au cours de millions d'années, la glace a modelé d'étranges formes dans les falaises de granite massives. Ce paysage surprenant englobe les trois aiguilles granitiques baptisées Torres del Paine, des glaciers et lacs, des montagnes s'élevant à plus de 3000 m, des vallées profondes et des étendues de steppe.

Nationalpark Torres del Paine
Die ganze Kraft der Natur wird im Nationalpark Torres del Paine erlebbar: mächtige Granitfelsen, über Jahrmillionen vom Gletschereis zu bizarren Gebilden geformt. Herausragend: die drei hoch aufragenden Granitnadeln Torres del Paine. Dazu Gletscher und Seen, Berge bis über 3000 m, tiefe Täler und weite Steppenlandschaften.

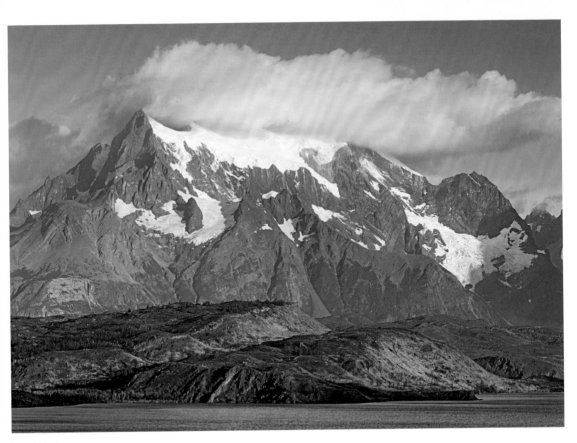

Lago Pehoé
Lake Pehoé

Parque Nacional Torres del Paine

Todo el poder de la naturaleza se puede experimentar en el Parque Nacional Torres del Paine: imponentes rocas de granito, de extrañas formas generadas durante millones de años de hielo de los glaciares. A destacar: las tres imponentes agujas de granito Torres del Paine. Así como los glaciares y lagos, las montañas de más de 3000 m, los valles profundos y los vastos paisajes de estepa.

Parco nazionale di Torres del Paine

Tutta la forza della natura diventa tangibile nel Parco nazionale di Torres del Paine: imponenti rocce di granito che sono diventate bizzarre creazioni formate in milioni di anni dai ghiacciai. Eccezionali le tre alte cime di granito di Torres del Paine. Inoltre ghiacciai e laghi, montagne fino a 3000 m, valli profonde e vasti paesaggi simili alla steppa.

Nationaal Park Torres del Paine

De ontzagwekkende macht van de natuur wordt in het Nationaal Park Torres del Paine voelbaar: enorme granietblokken zijn hier in miljoenen jaren door gletsjers tot bizarre formaties geslepen. Tussen de gletsjers, meren, diepe dalen, witte steppen en bergen tot een hoogte van meer dan 3000 m liggen de granietpieken van de Torres del Paine.

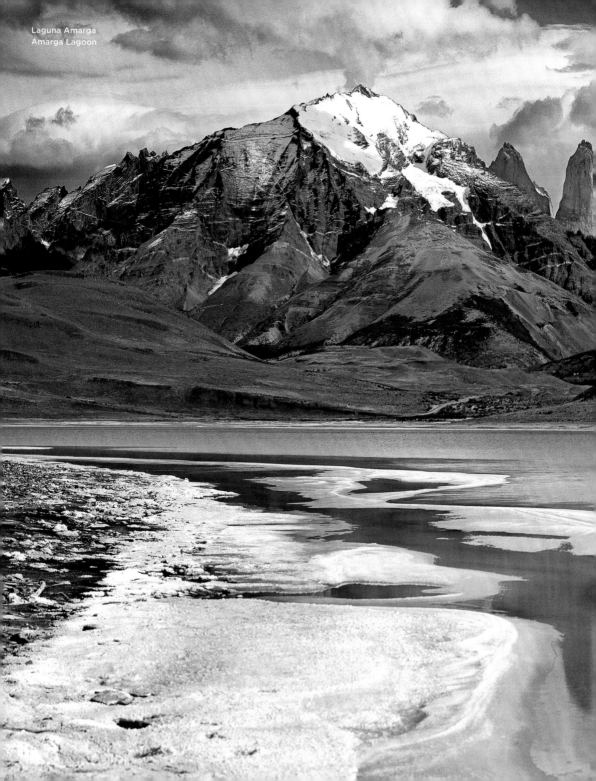

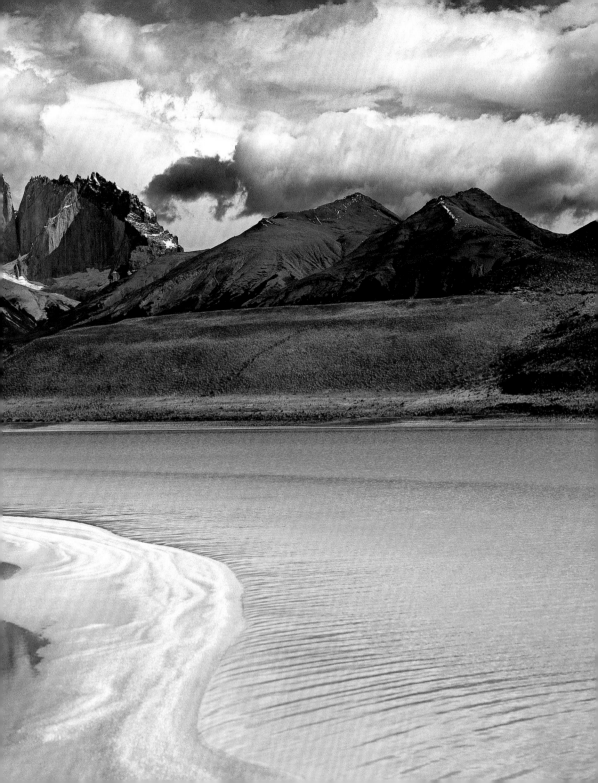

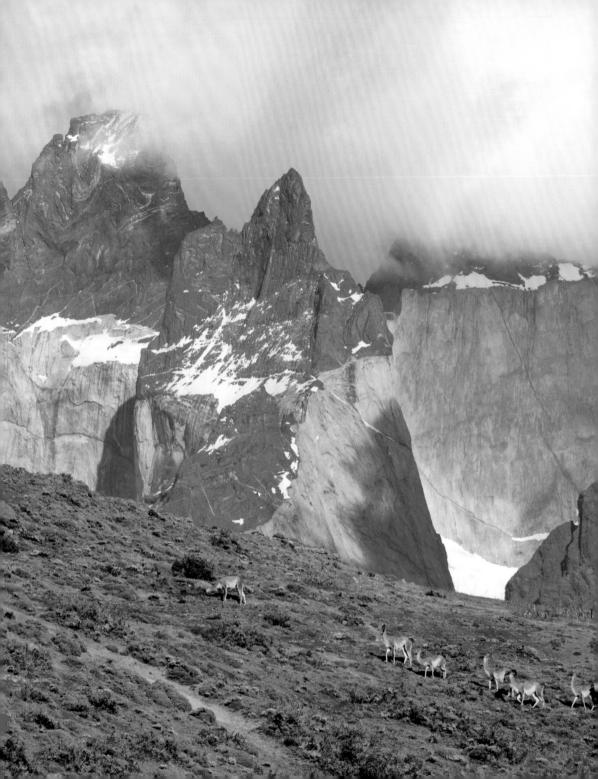

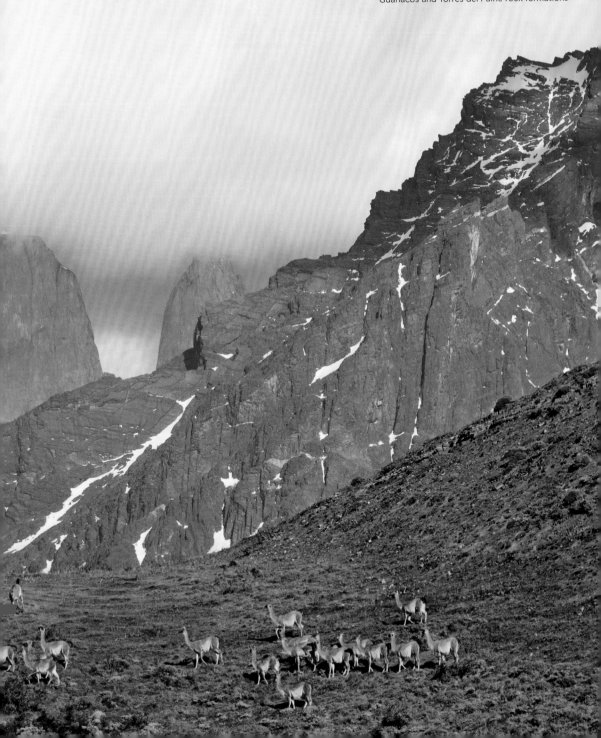

Guanacos con Torres del Paine
Guanacos and Torres del Paine rock formations

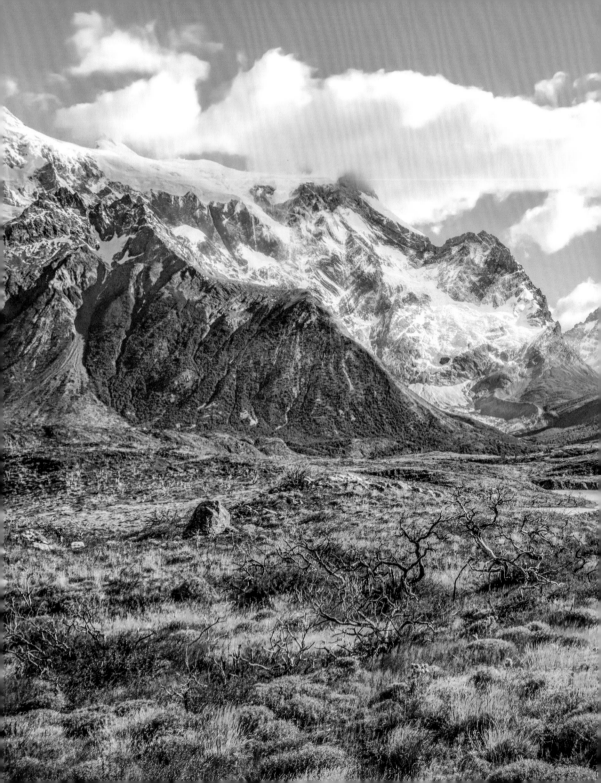

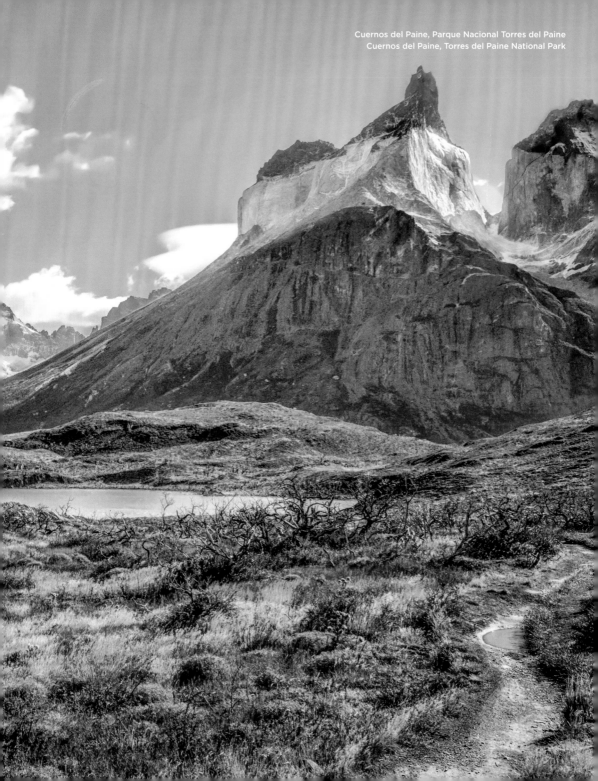

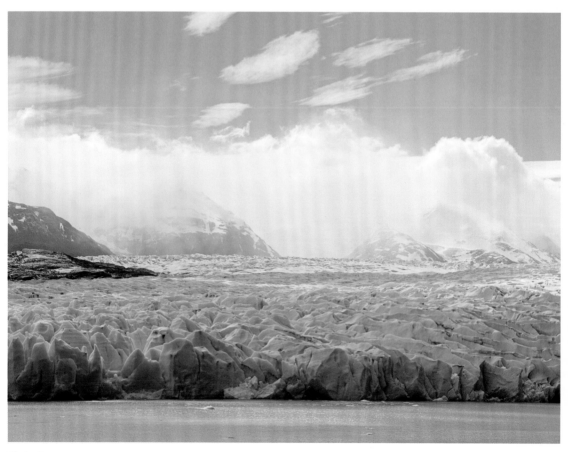

Glaciar Grey
Grey Glacier

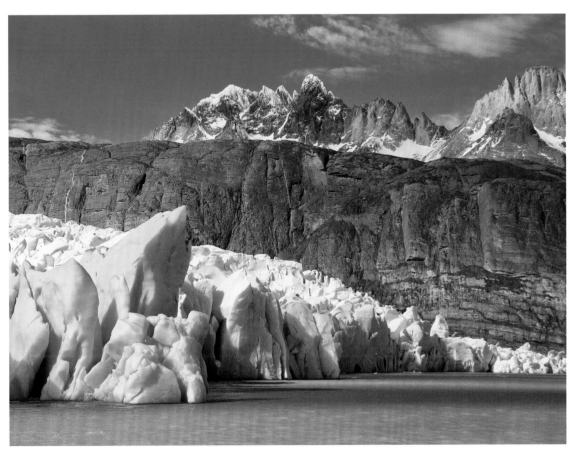

Lago Grey
Grey Lake

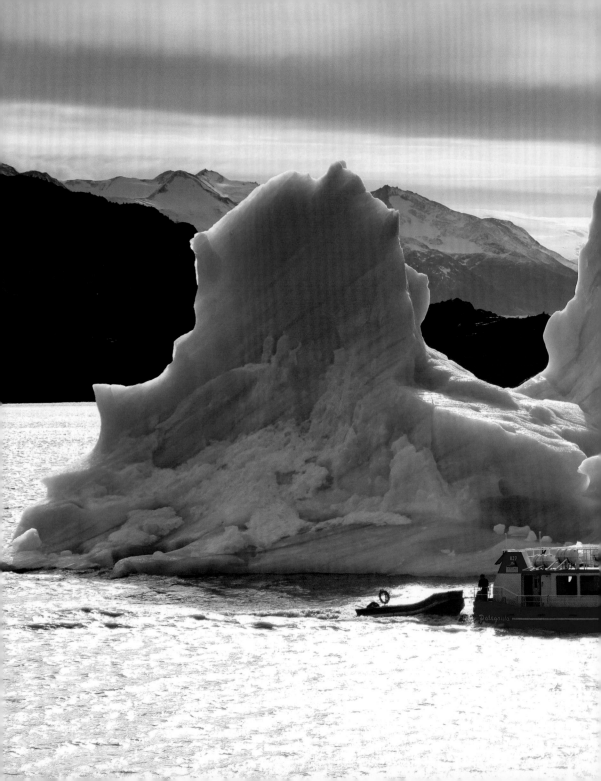

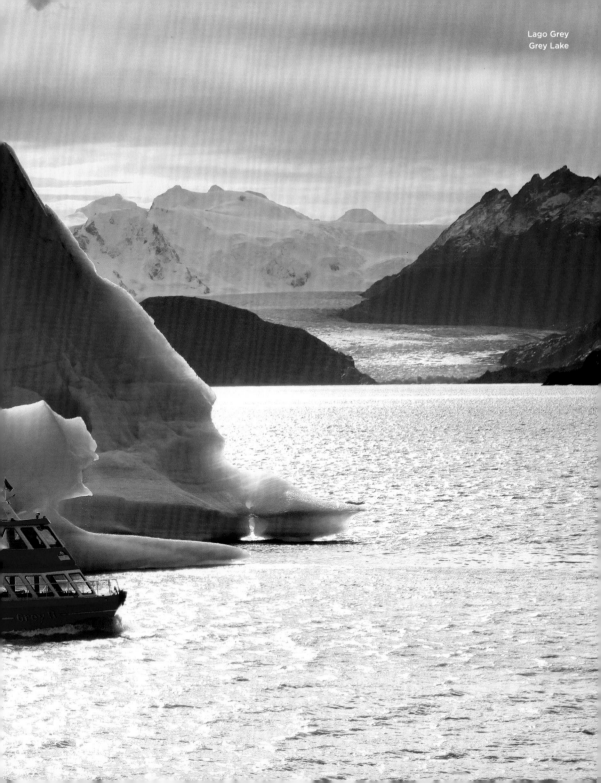

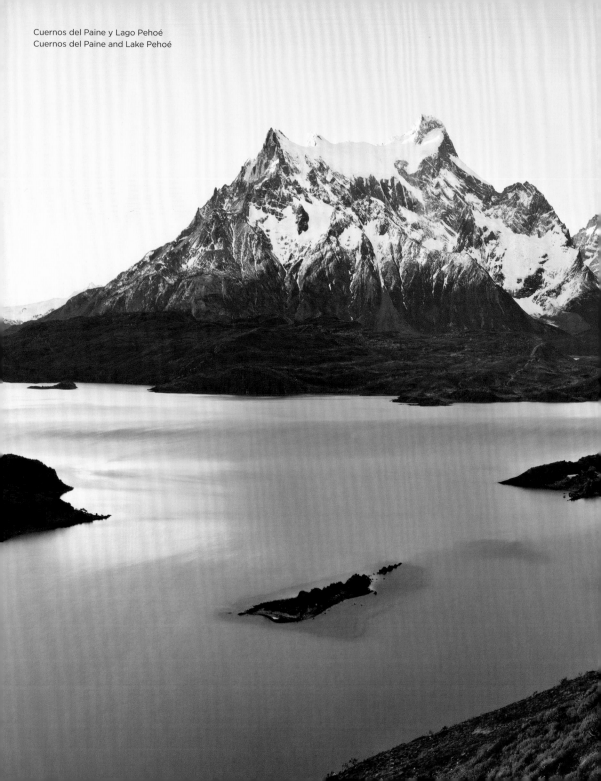

Cuernos del Paine y Lago Pehoé
Cuernos del Paine and Lake Pehoé

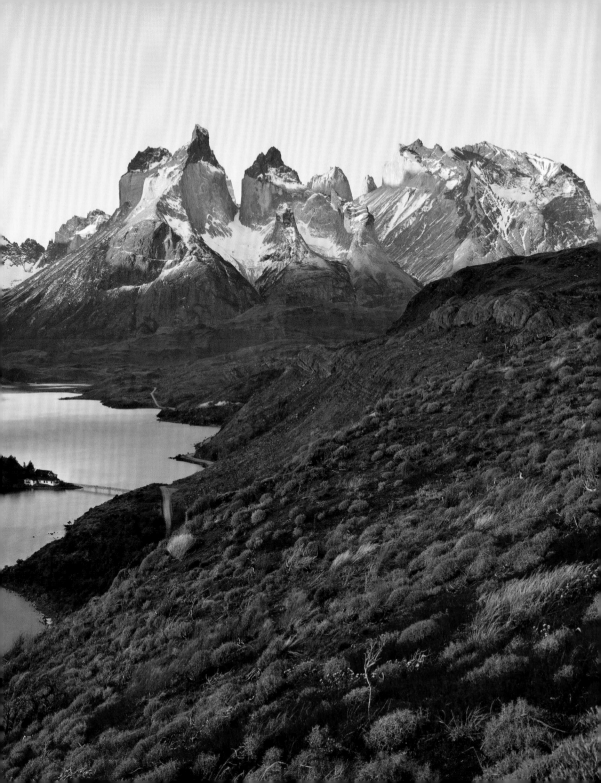

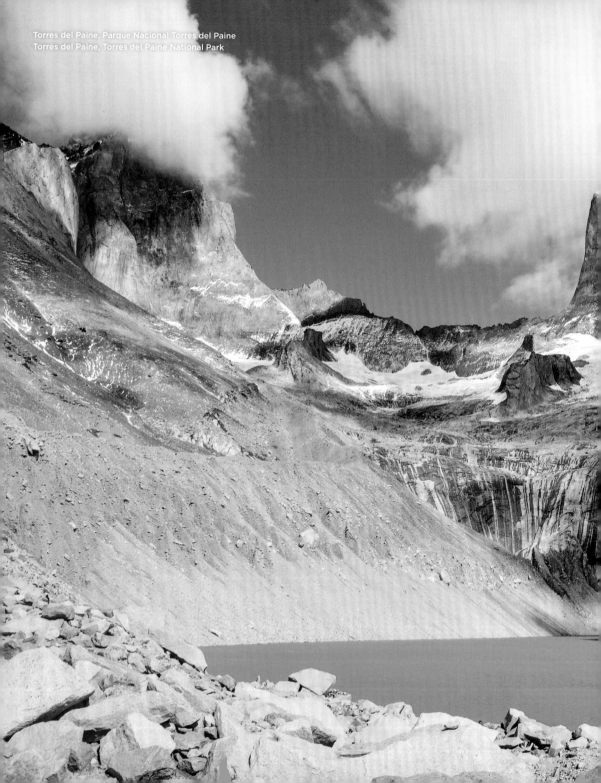

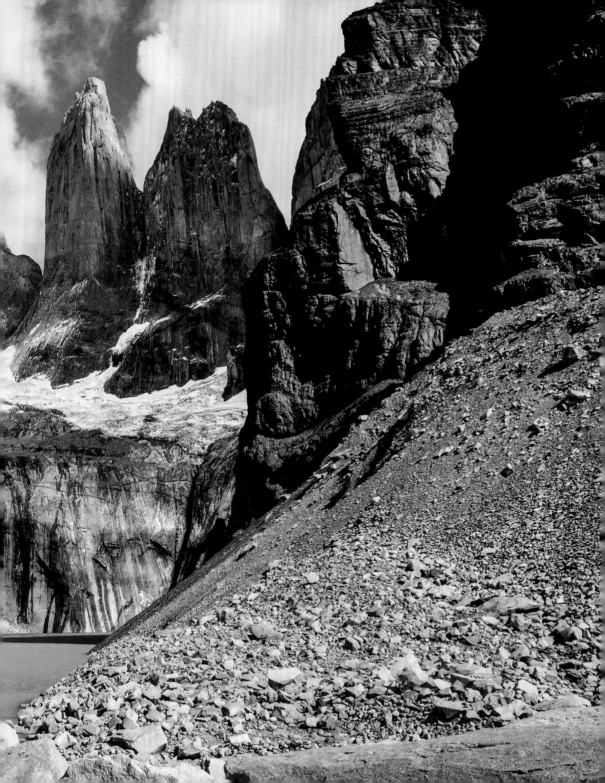

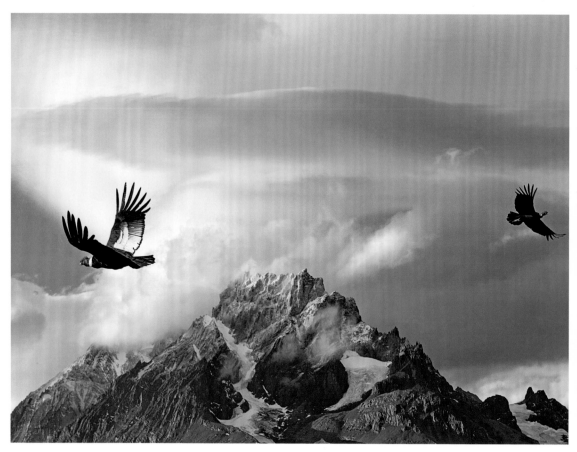

Cóndores andinos
Andean condors

Valle del Río Serrano
Serrano River Valley

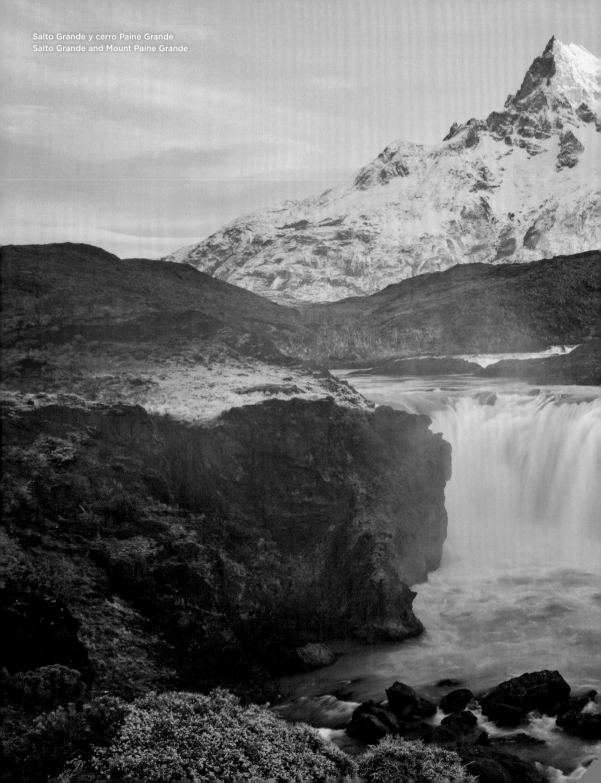

Salto Grande y cerro Paine Grande
Salto Grande and Mount Paine Grande

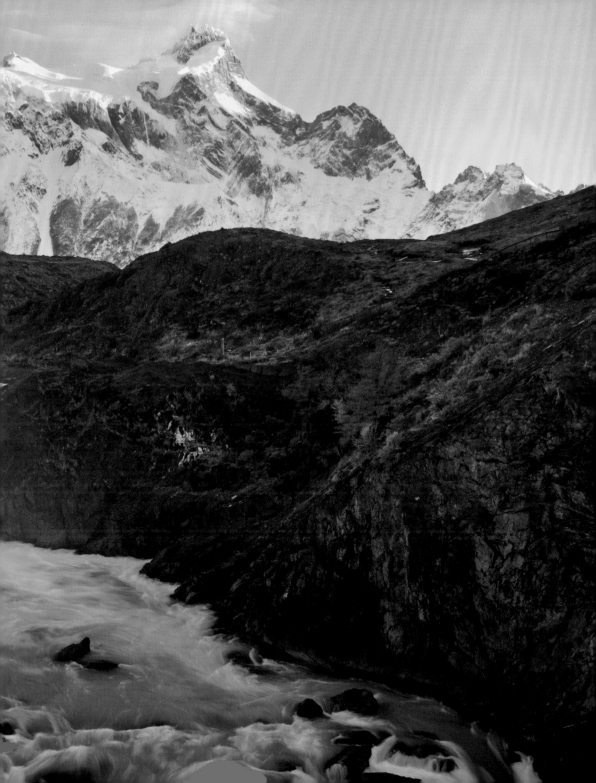

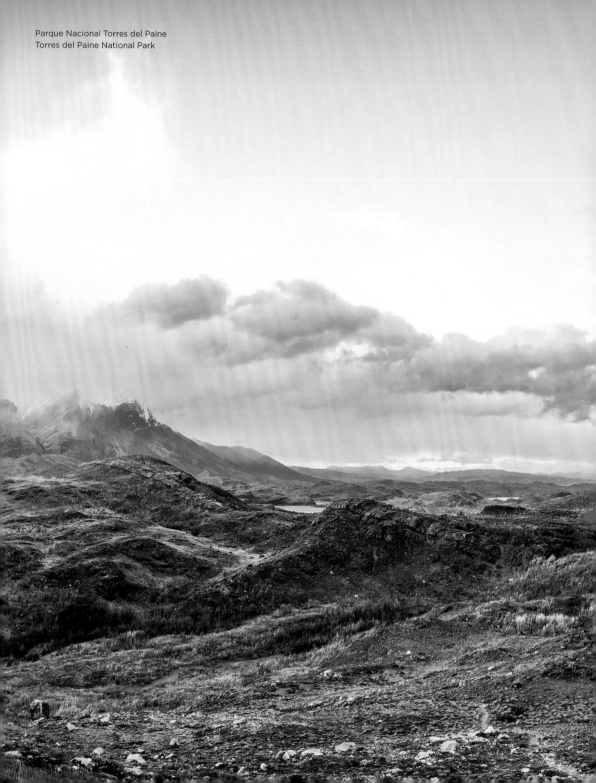

Parque Nacional Torres del Paine
Torres del Paine National Park

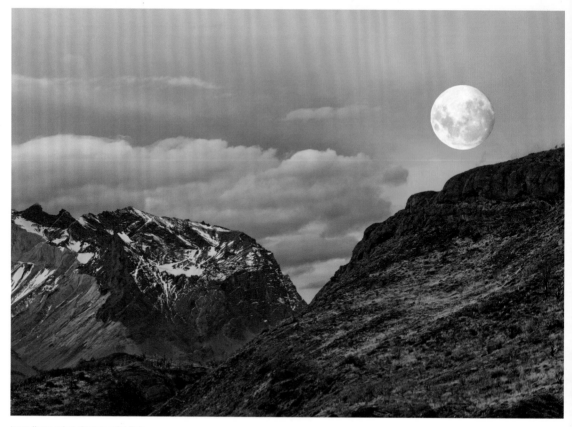

Luna llena sobre Cuernos del Paine
Full moon over Cuernos del Paine

Rich animal world

For nature lovers, Torres del Paine is one of the world's most beautiful places. It is home to guanacos, Darwin's rheas, and Andes condors. With a little luck, you might even catch a glimpse of a puma at twilight.

Une faune abondante

Pour les amoureux de la nature, le parc national Torres del Paine est l'une des plus belles régions du monde. Il abrite notamment des guanacos, des nandous de Darwin et des condors des Andes. Avec un peu de chance, on peut même y observer un puma à la tombée de la nuit.

Reiche Tierwelt

Für Naturfans zählt der Nationalpark Torres del Paine zu den schönsten Regionen der Erde. Hier leben unter anderem Guanakos, Darwin-Nandus und Andenkondore. Mit etwas Glück kann man in der Dämmerung sogar mal einen Puma entdecken.

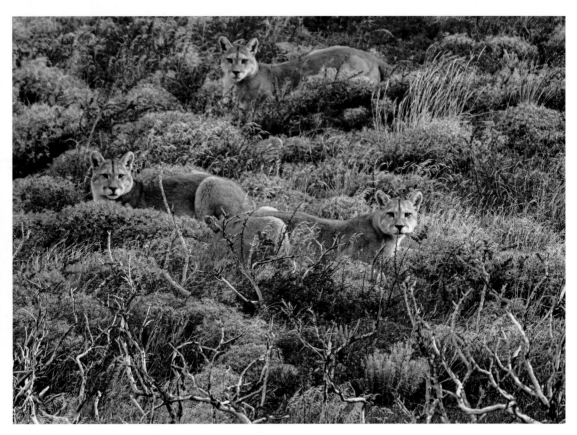

Pumas en Parque Nacional Torres del Paine
Pumas in Torres del Paine National Park

Mundo animal variado y rico

Para los amantes de la naturaleza, el
Parque Nacional Torres del Paine es una
de las regiones más bellas del mundo.
Aquí viven entre otras especies guanacos,
ñandúes de Darwin y cóndores. Con suerte,
se puede descubrir incluso un puma en
la oscuridad.

Ricca fauna

Per gli amanti della natura il Parco
nazionale di Torres del Paine appartiene
ad una delle regioni più belle del pianeta.
Qui vivono tra gli altri guanachi, nandù di
Darwin e condor delle Ande. Con un po' di
fortuna al crepuscolo si può vedere persino
un puma.

Rijke dierenwereld

Voor natuurliefhebbers behoort het
Nationaal Park Torres del Paine tot
de mooiste gebieden op aarde. Hier
leven guanaco's, Darwins nandoes en
Andescondors. Met wat geluk is in de
schemering soms een poema te ontwaren.

Lago Nordenskjöld
Nordenskjöld Lake

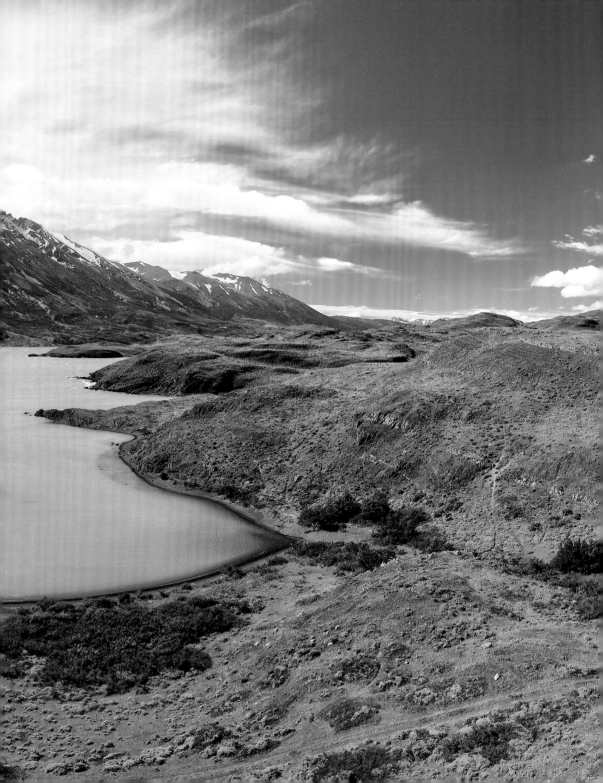

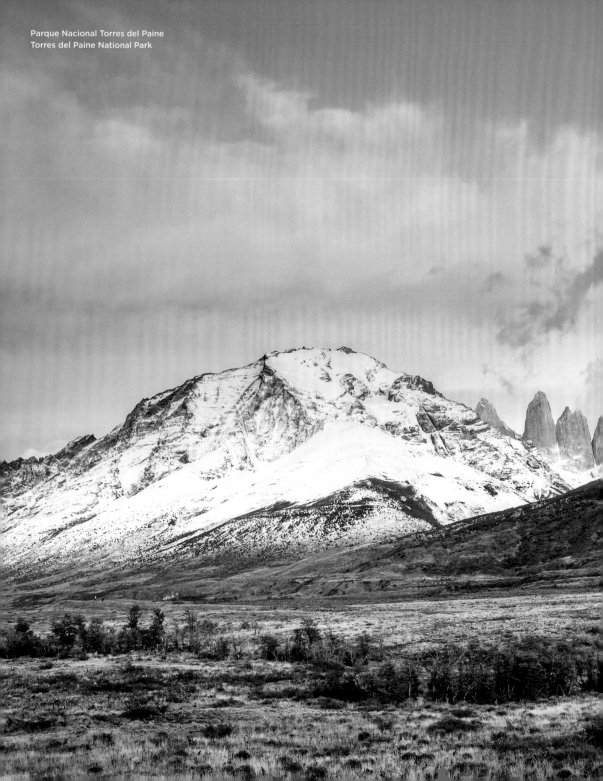

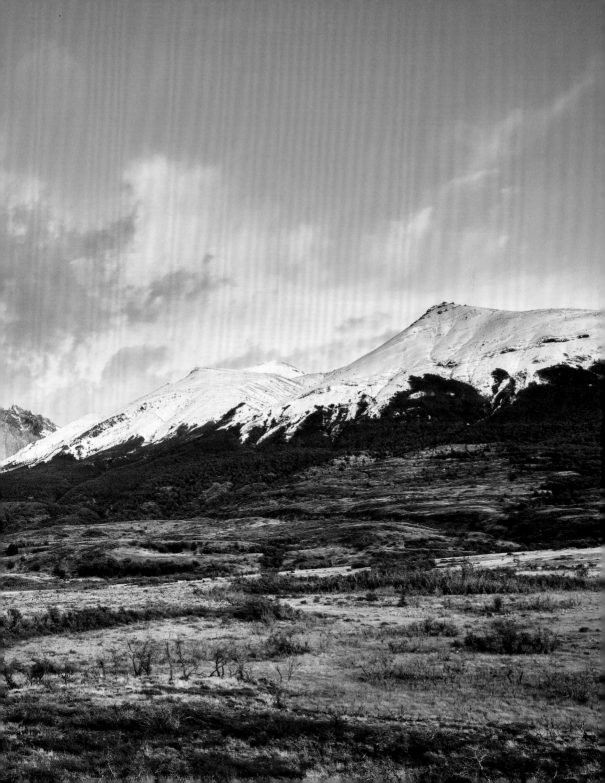

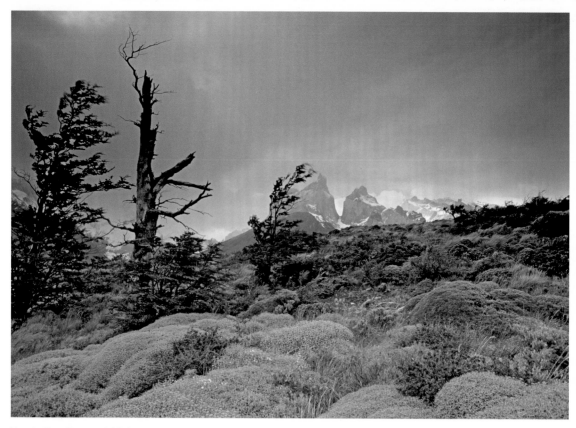

Vegetación y Cuernos del Paine
Vegetation and Cuernos del Paine

Chilean firebush

The Chilean firebush (*Embothrium coccineum*) almost appears as if it's lost its way from the tropics, but it makes its home here in the barren wasteland at Chile's southern tip. It can grow up to 15 m (50 ft) in height, although it tends to remain a small shrub given the harsh climate in southern Chile.

Le buisson de feu chilien

La présence de fleurs à l'aspect pratiquement tropical dans cette région désertique au sud du Chili semble tenir du prodige : le buisson de feu chilien (*Embothrium coccineum*) peut atteindre 15 m de haut. Dans les conditions extrêmes des terres australes du Chili, il prend souvent la forme d'un arbuste plus petit.

Chilenischer Feuerbusch

Es wirkt wie ein Wunder, dass in der kargen Einöde Südchiles fast tropisch anmutende Blüten leuchten: Der Chilenische Feuerbusch (*Embothrium coccineum*) kann bis zu 15 m hoch werden, wächst unter den extremen Bedingungen Südchiles aber meist als niedriger Strauch.

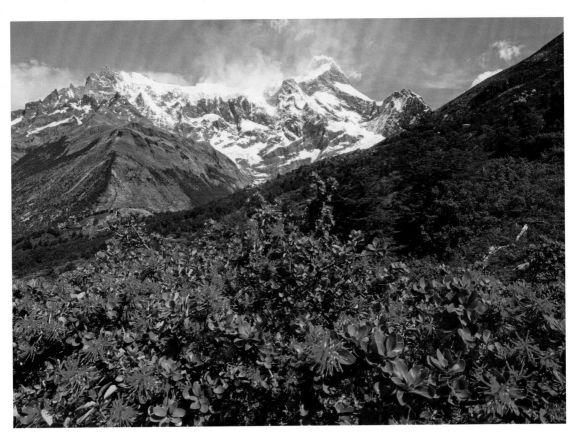

Notro, Parque Nacional Torres del Paine
Chilean firebush, Torres del Paine National Park

Notro

Parece un milagro que en el árido desierto
del sur de Chile se encuentren flores
casi tropicales: el notro *(Embothrium
coccineum)* puede llegar hasta los 15 m
de altura, creciendo en las condiciones
extremas del sur de Chile, pero sobre todo
se desarrolla como arbusto bajo.

Notro

Sembra un miracolo che nell'arido
deserto del Cile meridionale risplendano
fiori che sembrano quasi tropicali: il
notro *(Embothrium coccineum)* può
raggiungere un'altezza di 15 m, cresce nelle
condizioni estreme del Cile meridionale ma
soprattutto come cespuglio basso.

Chileense vuurstruik

Dat in de kale woestenij van Zuid-Chili
bijna tropisch aandoende bloemen groeien,
voelt bijna als een wonder: de Chileense
vuurstruik *(Embothrium coccineum)* kan
wel 15 m hoog worden, maar onder de
extreme omstandigheden van Zuid-Chili
blijft hij doorgaans een lage struik.

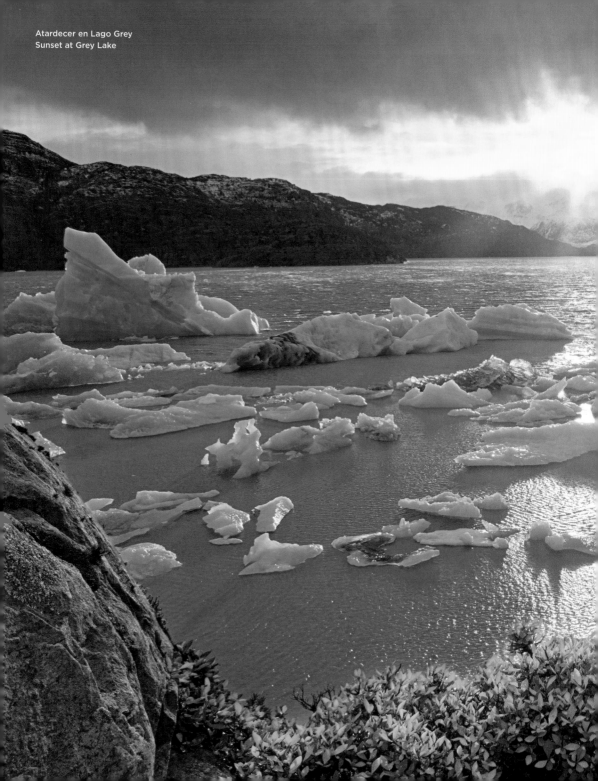

Atardecer en Lago Grey
Sunset at Grey Lake

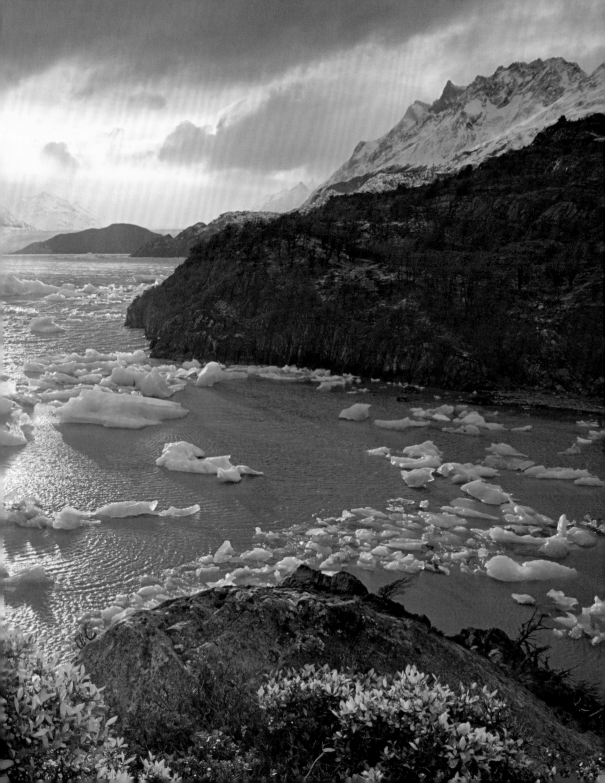

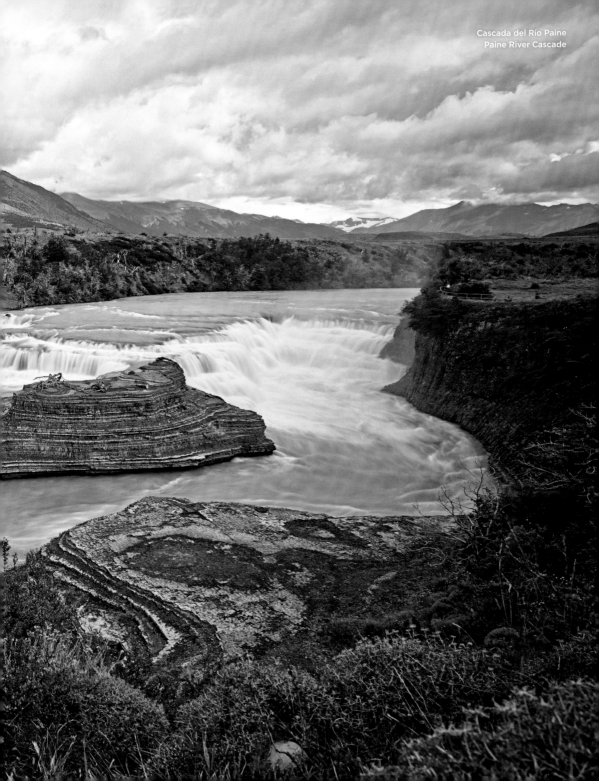

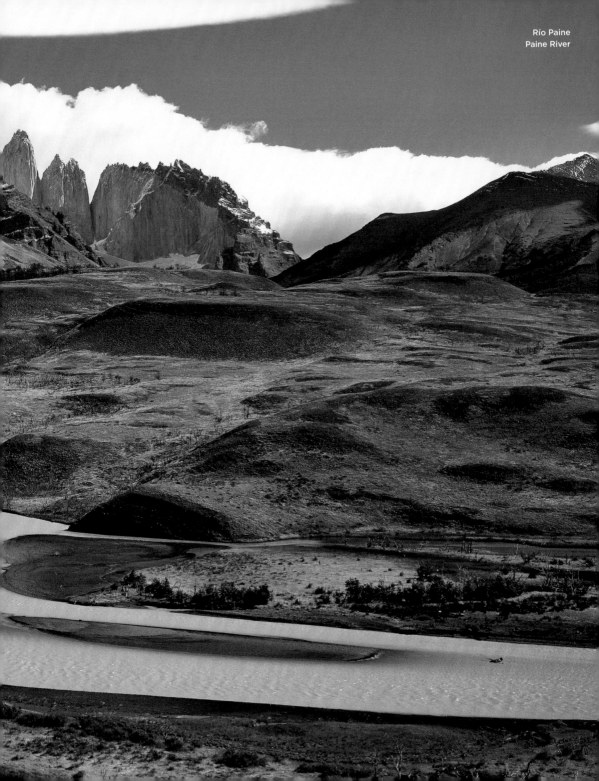

Flamencos chilenos, Parque Nacional Torres del Paine
Chilean flamingos, Torres del Paine National Park

Laguna Azul

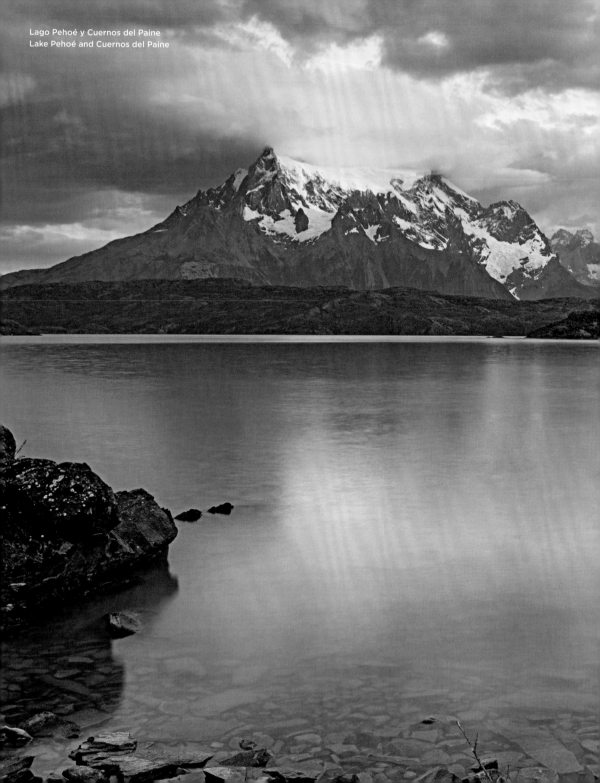

Lago Pehoé y Cuernos del Paine
Lake Pehoé and Cuernos del Paine

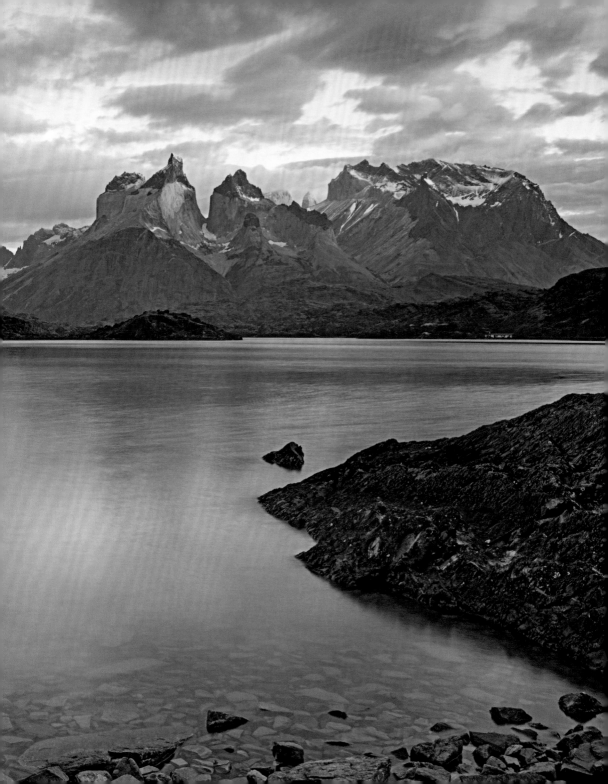

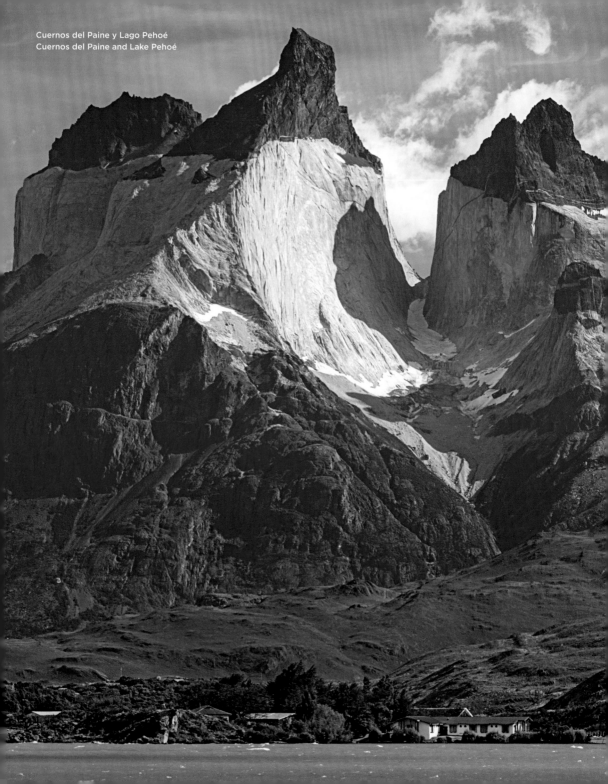

Cuernos del Paine y Lago Pehoé
Cuernos del Paine and Lake Pehoé

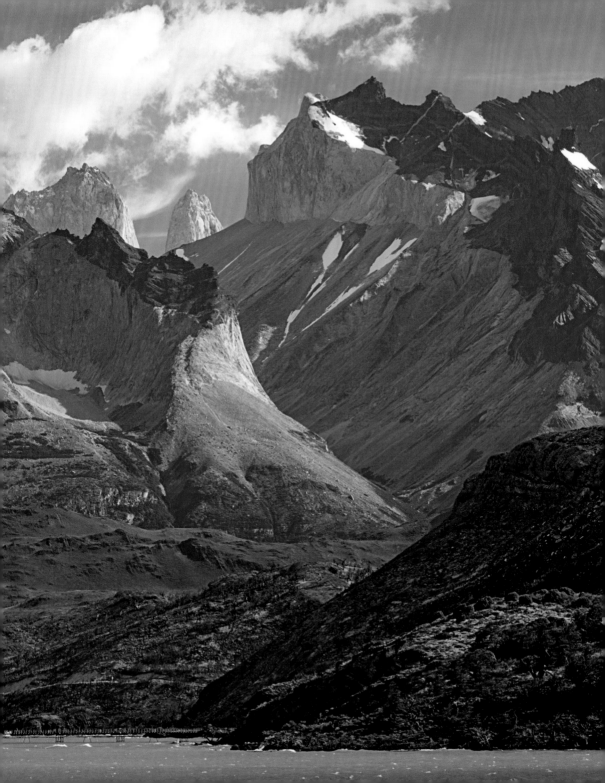

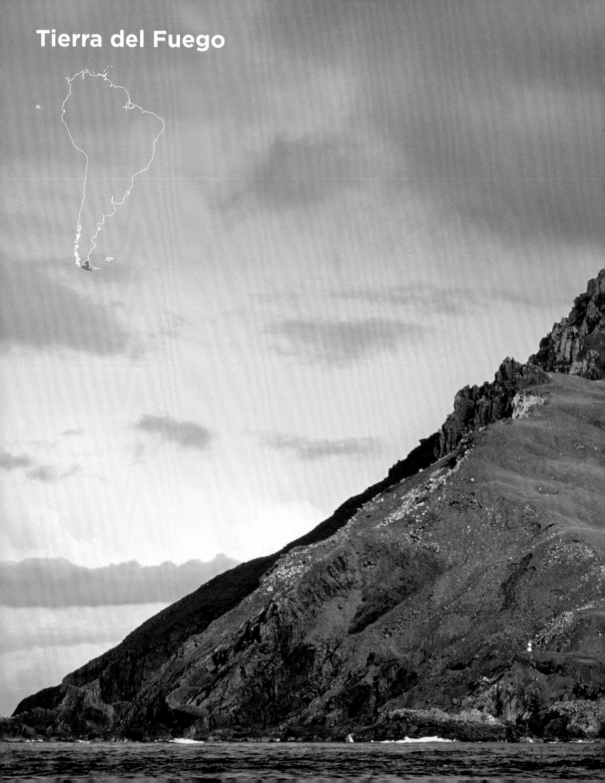

Tierra del Fuego

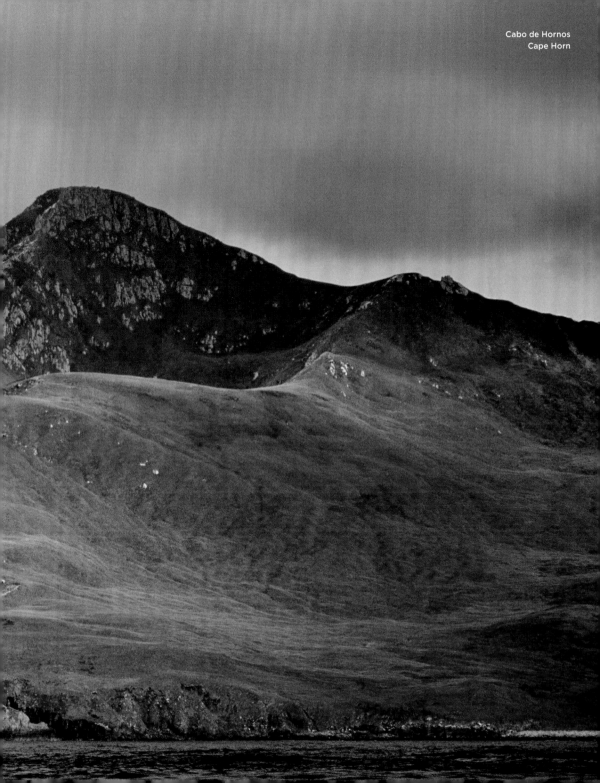

Cabo de Hornos
Cape Horn

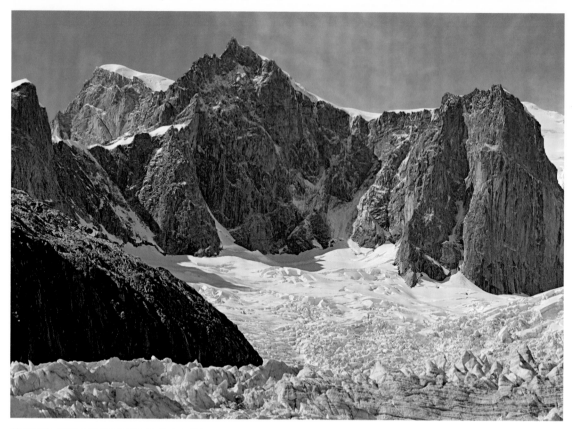

Glaciar Pía, Parque Nacional Alberto de Agostini
Pía Glacier; Alberto de Agostini National Park

Tierra del Fuego

Tierra del Fuego is not a single island, but a group of islands that lie south of the Straits of Magellan and are shared by Chile and Argentina. Only Isla Grande de Tierra del Fuego and Isla Navarino are inhabited by humans. Alberto de Agostini National Park in the archipelago contains many islets and fjords, and the Cordillera Darwin with its many glaciers.

Terre de feu

La Terre de feu n'est pas une île unique, elle désigne un archipel situé au sud du détroit de Magellan et divisé entre le Chili et l'Argentine. Seules les îles Isla Grande de Tierra del Fuego (Grande Île de Terre de feu) et Isla Navarino sont habitées. Le parc national Alberto de Agostini est situé sur l'archipel de la Terre de feu et inclut une multitude d'îlots et de fjords, la cordillère Darwin et de nombreux glaciers.

Feuerland

Feuerland ist mehr als eine Insel: Das „Land des Feuers" umfasst südlich der Magellanstraße eine ganze Inselgruppe, die sich Chile und Argentinien teilen. Bewohnt sind nur die Isla Grande de Tierra del Fuego und die Isla Navarino. Aus vielen Inselchen und Fjorden sowie der Darwin-Kordillere mit mehreren Gletschern besteht der Nationalpark Alberto de Agostini, der ebenfalls zum Feuerland-Archipel zählt.

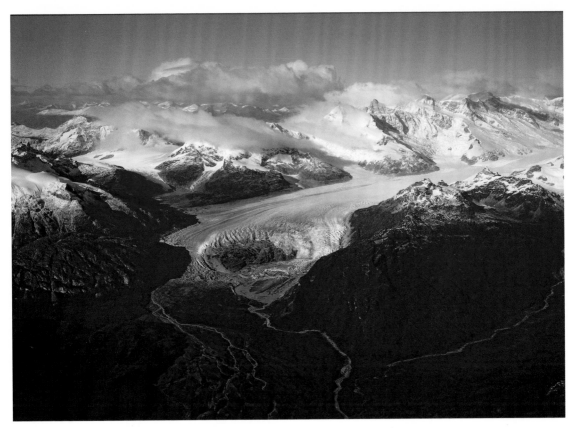

Glaciar en Cordillera Darwin, Parque Nacional Alberto de Agostini
Glacier in Cordillera Darwin, Alberto de Agostini National Park

Tierra del Fuego

Tierra del Fuego es más que una isla: la Tierra del Fuego, al sur del estrecho de Magallanes, abarca todo un grupo de islas que dividen a Chile y Argentina. Están habitadas únicamente la Isla Grande de Tierra del Fuego y la Isla Navarino. El Parque Nacional Alberto de Agostini está formado por muchas pequeñas islas y fiordos así como de la Cordillera Darwin con varios glaciares, que también pertenece al archipiélago de Tierra del Fuego.

Terra del Fuoco

La Terra del Fuoco è più di un'isola: comprende a sud della rotta di Magellano un intero arcipelago, che separa il Cile dall'Argentina. Solo la Isla Grande di Tierra del Fuego e la Isla Navarino sono abitate. Il Parco nazionale Alberto de Agostini è composto da molte isolette e fiordi, oltre che dalla cordigliera di Darwin con diversi ghiacciai, che fa parte anche dell'arcipelago della Terra del Fuoco.

Vuurland

Vuurland ligt ten zuiden van de Straat Magellaan en omvat een hele eilandengroep, die door Chili en Argentinië wordt gedeeld. Bewoond zijn slechts het Isla Grande de Tierra del Fuego en het Isla Navarino. Het Nationaal Park Alberto de Agostini, dat ook tot de Vuurlandarchipel behoort, bestaat uit talloze eilandjes, fjorden en de van gletsjers doorsneden Cordillera Darwin.

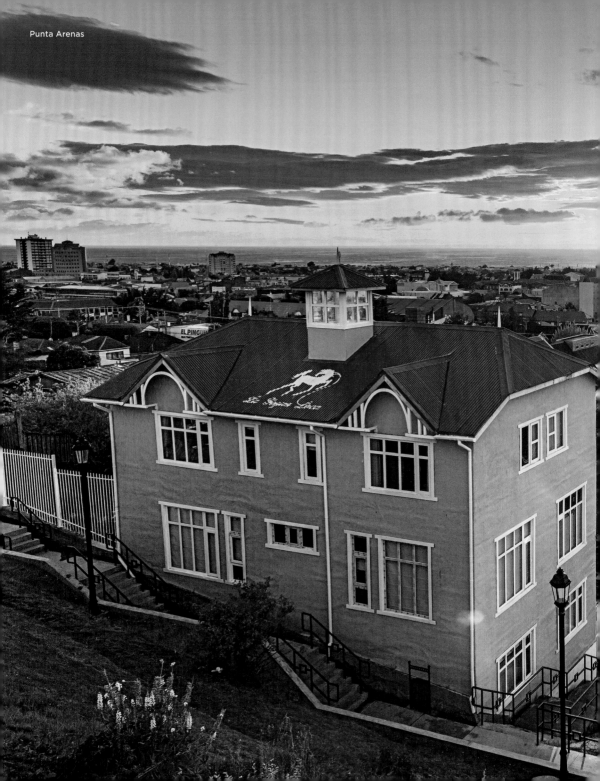

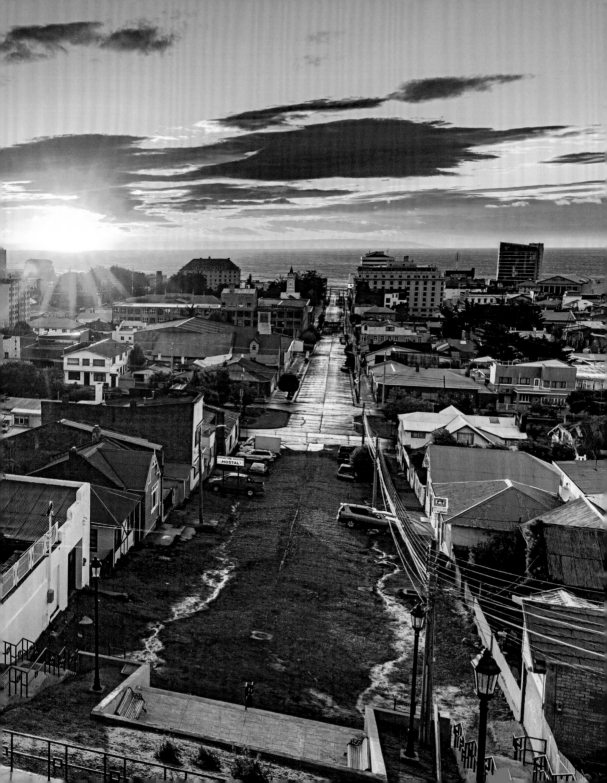

Mirador Cerro de la Cruz, Punta Arenas

Barcos en el puerto de Punta Arenas
Ships at the harbor of Punta Arenas

Punta Arenas

From Punta Arenas, located directly on the Magellan Strait, ferries depart for Tierra del Fuego and cruise ships take visitors to Antarctica and nearby penguin colonies. With its colorful houses, the well-kept city center, a cemetery designated as a national monument, and a reconstruction of the sailing ship of Ferdinand Magellan, the harbor town itself has a lot to offer.

Punta Arenas

C'est de Punta Arenas, située juste à côté du détroit de Magellan, que partent les ferrys pour la Terre de Feu, les navires de croisière pour l'Antarctique et des excursions en bateau vers les colonies de manchots proches. Avec ses maisons colorées, un centre-ville bien entretenu, un cimetière déclaré monument national et une reconstruction du voilier de Fernand de Magellan, la ville portuaire en elle-même a aussi beaucoup à offrir.

Punta Arenas

Vom direkt an der Magellanstraße gelegenen Punta Arenas legen Fähren nach Feuerland, Kreuzfahrtschiffe in die Antarktis und Ausflugsboote zu nahegelegenen Pinguinkolonien ab. Mit ihren bunten Häusern, dem gepflegten Stadtzentrum, einem zum Nationaldenkmal ernannten Friedhof und einer Rekonstruktion des Segelschiffs von Ferdinand Magellan hat die Hafenstadt selbst auch einiges zu bieten.

Punta Arenas

Desde Punta Arenas, que se encuentra directamente en el Estrecho de Magallanes, los ferris parten hacia la Tierra del Fuego, los cruceros a la Antártica y hay excursiones a las colonias de pingüinos. Con sus coloridas casas, el centro de la ciudad bien cuidado, un cementerio designado como monumento nacional y una reconstrucción del velero de Fernando de Magallanes, la ciudad portuaria en sí tiene mucho que ofrecer.

Punta Arenas

Da Punta Arenas, direttamente sullo stretto di Magellano, partono escursioni per la Terra del Fuoco, crociere per l'Antartide ed escursioni in barca verso le vicine colonie di pinguini. La città ha molto da offrire: casette colorate, un centro storico curato, il cimitero designato monumento nazionale, e una riproduzione della barca a vela di Ferdinando Magellano.

Punta Arenas

Punta Arenas ligt direct aan de Straat Magellaan en is het vertrekpunt voor veerboten naar Vuurland, cruiseschepen naar het Zuidpoolgebied en toeristenboten naar de naburige pinguïnkolonies. Met zijn bont geschilderde huizen en keurige centrum heeft de stad zelf ook het nodige te bieden: de reconstructie van het schip van Ferdinand Magellaan en een kerkhof dat een nationaal monument is.

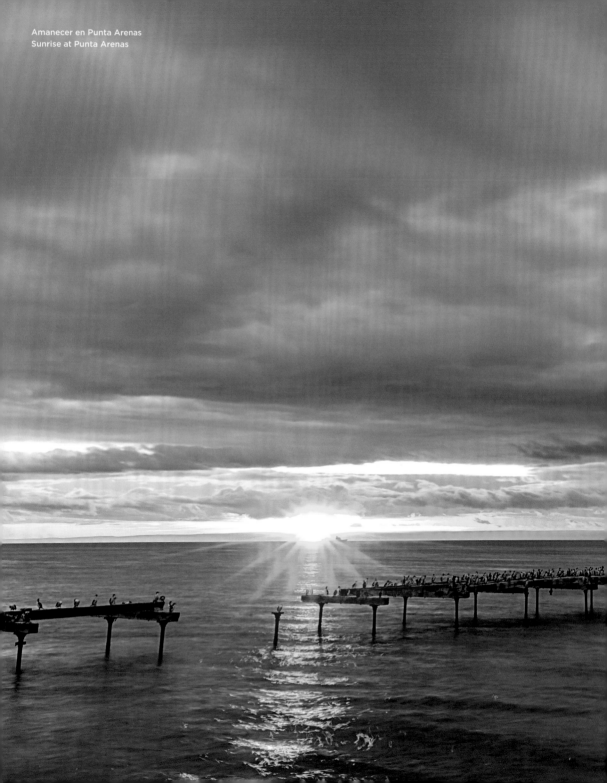

Amanecer en Punta Arenas
Sunrise at Punta Arenas

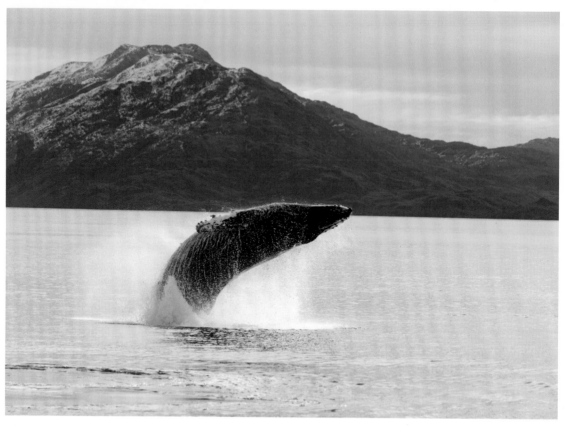

Yubarta, Parque Marino Francisco Coloane
Humpback whale, Francisco Coloane Marine Park

Cold south

While the north of the country can see temperatures rise in the summer to over 20 °C (70 °F), it is quite chilly in the south of the country, even in summer, with temperatures of around 11 °C (50 °F) in January. At night, temperates readily drop to freezing. The average annual temperature in Patagonia is only 6.5 °C (44 °F).

Froid du sud

Alors que les températures augmentent de plus de 20 °C dans le nord du pays en été, le sud du Chili est plutôt froid, même en plein été (janvier), avec des températures diurnes d'environ 11 °C. La nuit, elles peuvent descendre jusqu'à 0 °C. La température annuelle moyenne en Patagonie n'est que de 6,5 °C.

Kalter Süden

Während im Norden des Landes die Temperaturen im Sommer auf über 20 °C ansteigen, ist es in Chiles Süden auch im Hochsommer (Januar) mit Tagestemperaturen von etwa 11 °C ziemlich kalt. Nachts kann es mit bis zu 0 °C eisig werden. Die durchschnittliche Jahrestemperatur in Patagonien beträgt nur 6,5 °C.

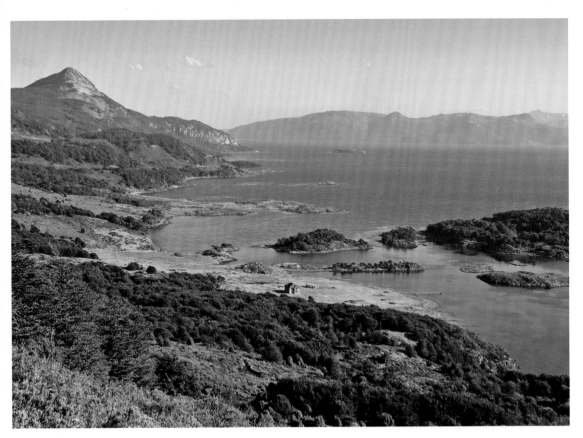

Bahía Wulaia, Isla Navarino, Cabo de Hornos
Wulaia Bay, Navarino Island, Cape Horn

Frío sur

Mientras que en el norte del país las temperaturas suben en el verano a más de 20 °C, hace bastante frío en el sur del país, incluso en el verano (enero) con temperaturas de alrededor de 11 °C. Por la noche puede helar con 0 °C. La temperatura media anual en la Patagonia es de solo 6,5 °C.

Il freddo sud

Mentre al nord del paese le temperature estive superano i 20 °C, anche in estate (gennaio) al sud del paese le temperature restano abbastanza fredde di giorno, intorno agli 11 C°. Di notte le temperature possono scendere sotto i 0 °C. La temperatura media in Patagonia durante l'anno è di 6,5 °C.

Het koude zuiden

Terwijl het in het noorden van het land 's zomers boven de 20 °C wordt, is het in het zuiden van Chili zelfs in de hoogzomer (januari) met gemiddelden van 11 °C tamelijk fris. 's Nachts kan de temperatuur tot het vriespunt dalen. De gemiddelde jaartemperatuur in Patagonië bedraagt slechts 6,5 °C.

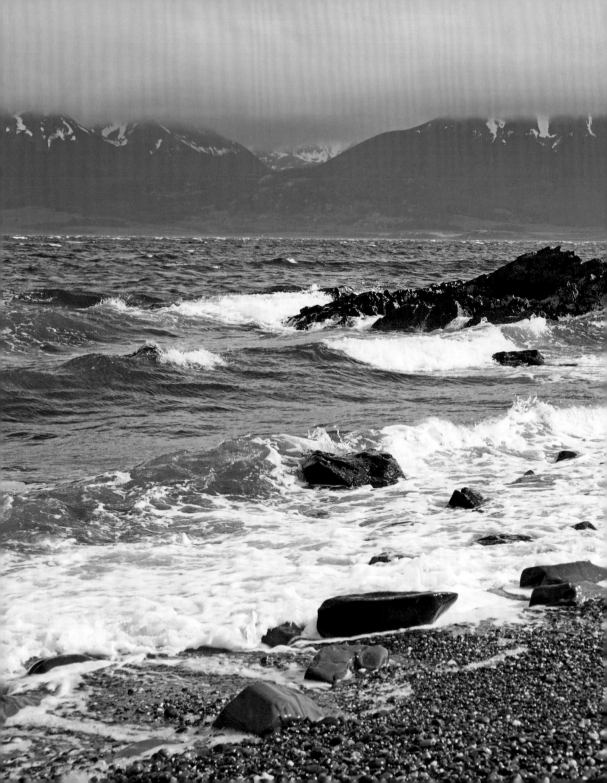

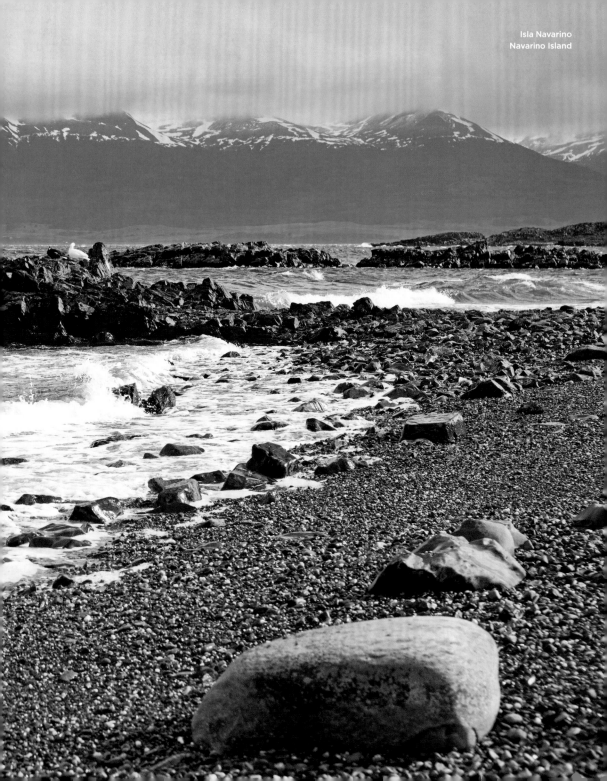

Isla Navarino
Navarino Island

Bandera chilena en Cabo de Hornos
Chilean flag at Cape Horn

Bahía Wulaia, Isla Navarino, Cabo de Hornos
Wulaia Bay, Navarino Island, Cape Horn

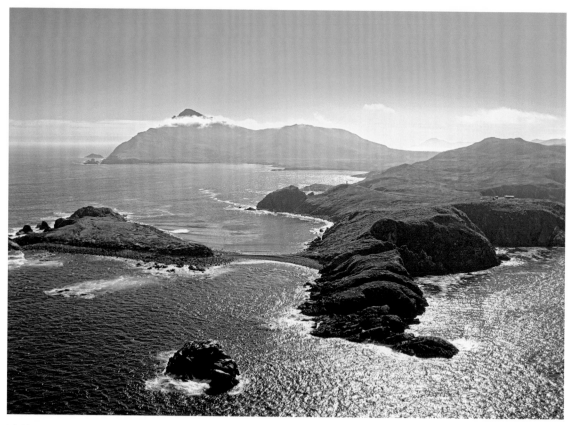

Isla Hornos
Hornos Island

Cape Horn

Cape Horn lies on Isla de Hornos in the Tierra del Fuego archipelago and is considered the southern tip of the Americas, even if the Diego Ramírez islands 100 km (60 mi) to the south are more southerly. It owes its name to the 1616 expedition of the Dutch Hoorner Austraalse Compagnie. Cape Horn National Park, which includes several rocky islands, is a good spot to watch whales and dolphins, sea lions, elephant seals, leopard seals, and penguins.

Cap Horn

Le cap Horn se trouve sur l'île Horn dans l'archipel de la Terre de Feu, et est considéré généralement comme la pointe australe de l'Amérique du Sud – bien que les îles Diego Ramírez à environ 100 km se trouvent encore un peu plus au sud. Il doit son nom à une expédition de la Compagnie Australe financée par la ville de Hoorn aux Pays-Bas en 1616. Dans le parc national du cap Horn qui comprend plusieurs îles rocheuses, on peut observer des baleines et des dauphins, des lions, éléphants et léopards de mer ainsi que des pingouins.

Kap Hoorn

Kap Hoorn liegt auf der Isla de Hornos im Feuerland-Archipel und gilt seit jeher als Südspitze Amerikas – auch wenn die etwa 100 km entfernten Diego-Ramírez-Inseln noch etwas südlicher liegen. Seinen Namen verdankt das Kap einer Expedition der Hoorner Austraalse Compagnie aus den Niederlanden im Jahr 1616. Im Kap-Hoorn-Nationalpark, der mehrere Felseninseln umfasst, kann man Wale und Delfine, Seelöwen, See-Elefanten, Seeleoparden und Pinguine beobachten.

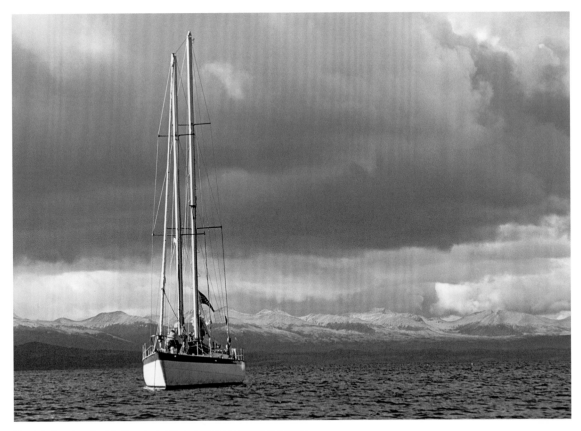

Canal de Beagle entre Isla Grande de Tierra del Fuego y Cabo de Hornos
Beagle Channel between Isla Grande de Tierra del Fuego and Cape Horn

Cabo de Hornos

Cabo de Hornos se encuentra en la Isla de Hornos, en el archipiélago de Tierra del Fuego, y siempre ha sido considerado como el extremo sur de América – aunque las Islas Diego Ramírez, a una distancia de aproximadamente 100 km, se encuentran todavía más al sur. Debe su nombre al cabo una expedición de la Austraalse Compagnie de Hoorn en los Países Bajos en 1616. En el Parque Nacional Cabo de Hornos, que incluye varias islas rocosas, se pueden observar ballenas y delfines, leones marinos, elefantes marinos, leopardos marinos y pingüinos.

Capo Horn

Capo Horn si trova sulla Isla de Hornos nell'arcipelago della Terra del Fuoco ed è considerato da sempre il punto più meridionale dell'America, anche se le isole Diego Ramírez, distanti circa 100 km, si trovano ancora più a sud. Il Capo deve il suo nome ad una spedizione della Austraalse Compagnie partita da Hoorn nei Paesi Bassi nel 1616. Nel Parco Nazionale Capo Horn, che comprende diverse isole rocciose, si possono osservare balene e delfini, leoni marini, elefanti marini, foche leopardo e pinguini.

Kaap Hoorn

Kaap Hoorn ligt op het Isla de Hornos in de archipel van Vuurland en geldt als de uiterste zuidpunt van Amerika – ook al liggen de Diego Ramírez-eilanden nog zo'n 100 km verder naar het zuiden. Zijn naam dankt de kaap aan een expeditie in 1616 van de Australische Compagnie uit het Nederlandse Hoorn. In het Nationale Park Kaap Hoorn, dat meerdere rotseilanden omvat, kunnen walvissen, dolfijnen, pinguïns en zeeleeuwen, -olifanten en -luipaarden worden bewonderd.

Faro, Puerto Williams, Isla Hornos
Lighthouse, Puerto Williams, Hornos Island

Monumento al Albatros y Pasaje de Drake, Cabo de Hornos
Albatross Memorial and Drake Passage, Cape Horn

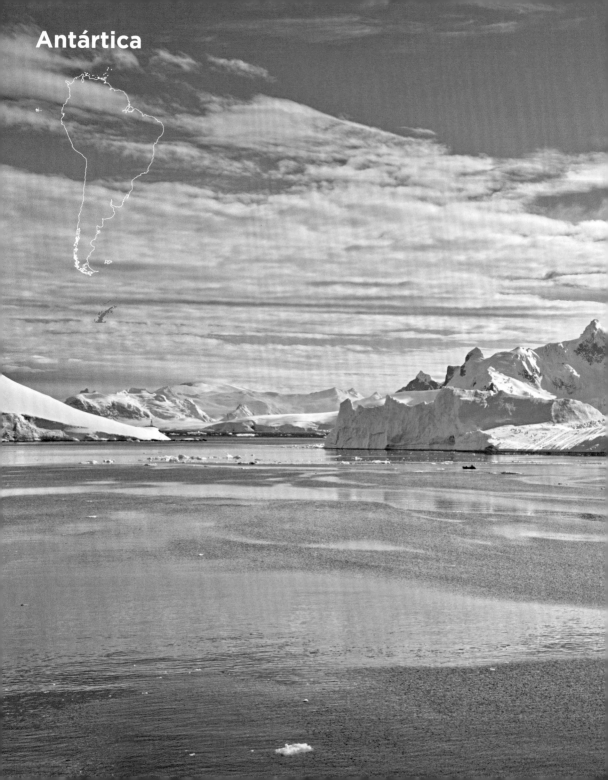

Antártica

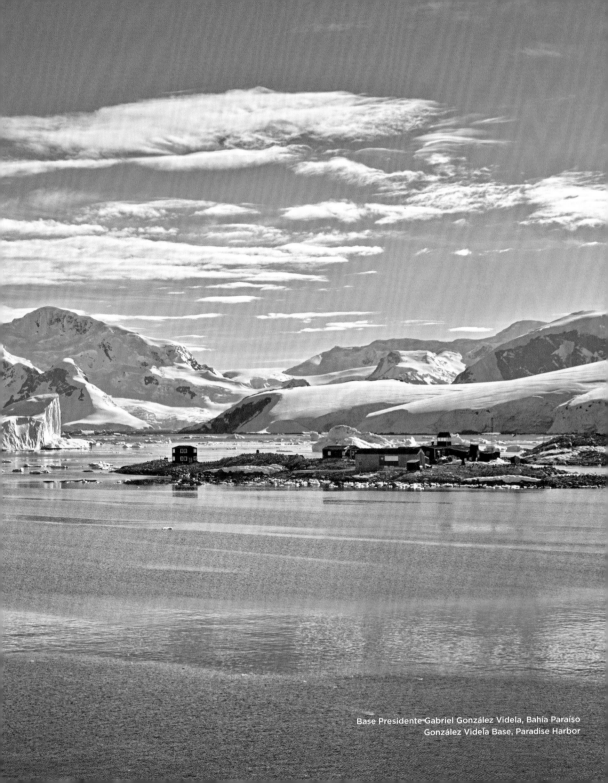

Base Presidente Gabriel González Videla, Bahía Paraíso
González Videla Base, Paradise Harbor

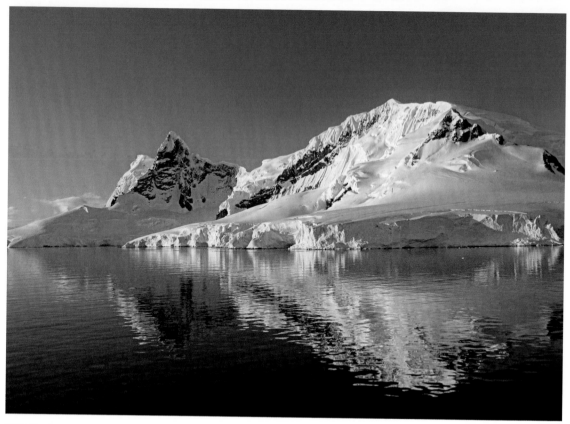

Bahía Paraíso
Paradise Harbor

Antarctic

The Antarctic Peninsula with a length of 1200 km (700 mi) is located about 1000 km (600 mi) from Cape Horn and is claimed by Chile, Argentina, and Great Britain. However, with the Antarctic Treaty of 1961, the countries agreed to let their territorial claims rest. Surrounded by icebergs and glaciers, in the picturesque bay of Paradise Harbor is an inactive Chilean research station, named after former President Gabriel González Videla.

Antarctique

La péninsule antarctique, d'une longueur de 1200 km, est distante d'environ 1000 km du cap Horn et est revendiquée à la fois par le Chili, l'Argentine et le Royaume-Uni. Mais avec le traité sur l'Antarctique de 1961, les États ont cependant dû renoncer à leurs revendications territoriales. Entourée d'icebergs et de glaciers, et située dans la pittoresque baie Paradise Harbor, une station de recherche chilienne inactive porte le nom de l'ancien président Gabriel González Videla.

Antarktis

Die Antarktische Halbinsel mit einer Länge von 1200 km liegt rund 1000 km von Kap Hoorn entfernt und wird gleichermaßen von Chile, Argentinien und Großbritannien beansprucht. Mit dem Antarktisvertrag von 1961 haben sich die Staaten jedoch verpflichtet, ihre Gebietsansprüche ruhen zu lassen. Eingerahmt von Eisbergen und Gletscherzungen liegt in der malerischen Bucht Paradise Harbor eine inaktive chilenische Forschungsstation, benannt nach dem früheren Staatspräsidenten Gabriel González Videla.

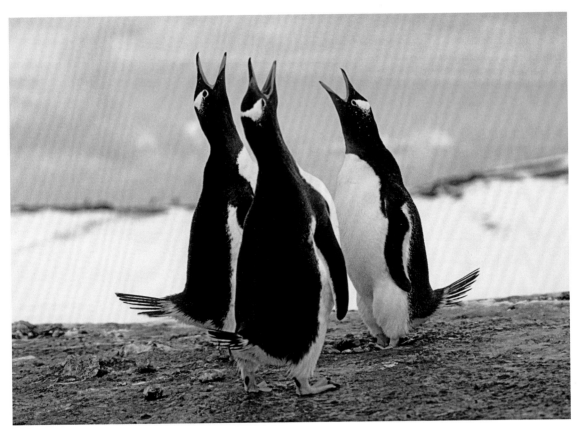

Pingüinos juanito, isla Rey Jorge, islas Shetland del Sur
Gentoo penguins, King George Island, South Shetland Islands

Antártica

La Península Antártica, con una longitud de 1200 km, se encuentra a unos 1000 km del Cabo de Hornos y es igualmente reclamada por Chile, Argentina y Gran Bretaña. Sin embargo, con el Tratado Antártico de 1961, los estados se han comprometido a dejar descansar sus reivindicaciones territoriales. Rodeado de icebergs y glaciares, en la pintoresca Bahía Paraíso, se encuentra una estación inactiva de investigación chilena, que lleva el nombre del ex Presidente del Estado, Gabriel González Videla.

Antartide

La penisola Antartica è lunga 1200 km, si trova a circa 1000 km da Capo Horn e la sua sovranità è contesa tra Cile, Argentina e Regno Unito. Con il trattato Antartico del 1961 i paesi sono però obbligati a rispettare i primi limiti territoriali. Nella suggestiva cornice di iceberg e lingue di ghiacciai della baia di Paradise Harbor si trova un centro di ricerca cileno inattivo, che prende il nome dall'ex presidente Gabriel González Videla.

Antarctica

Met een lengte van 1200 km ligt het Antarctisch Schiereiland op zo'n 1000 km van Kaap Hoorn en werd aanvankelijk door Chili, Argentinië en Groot-Brittannië geclaimd. Met het Verdrag inzake Antarctica van 1961 spraken de staten af hun gebiedsaanspraken te laten varen. Omlijst door ijsbergen en gletsjertongen ligt in de schilderachtige baai van Paradise Harbor een verlaten Chileens onderzoeksstation, dat is vernoemd naar de vroegere president Gabriel González Videla.

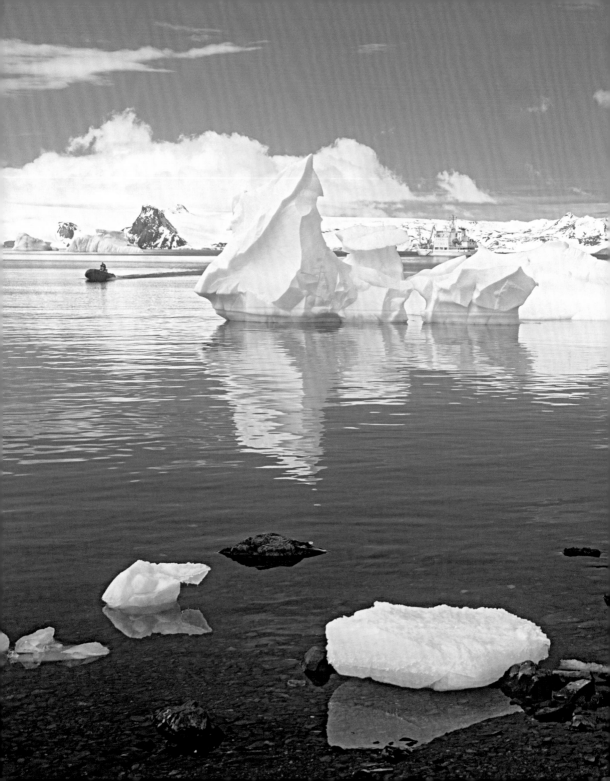

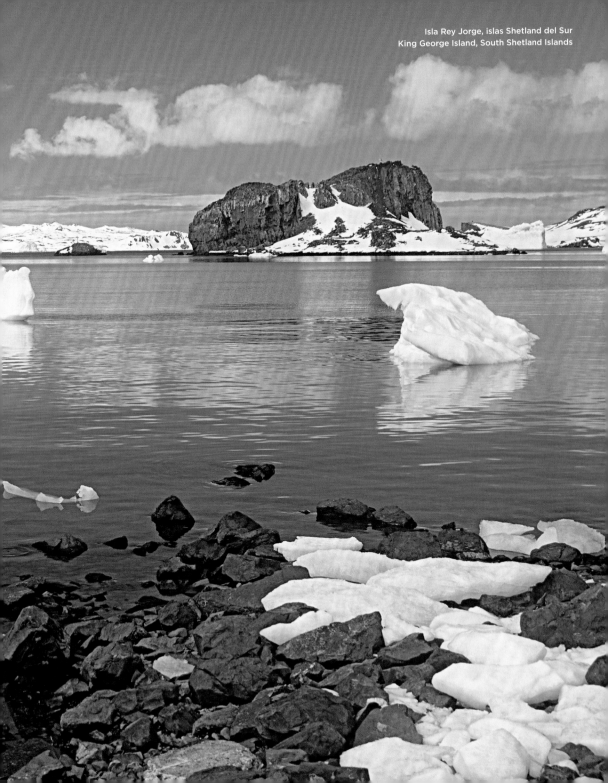

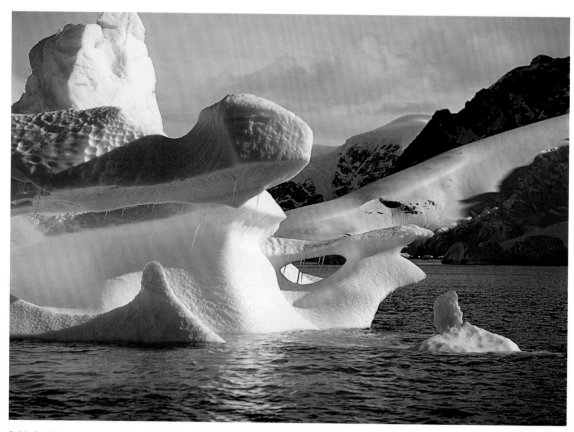

Bahía Paraíso
Paradise Harbor

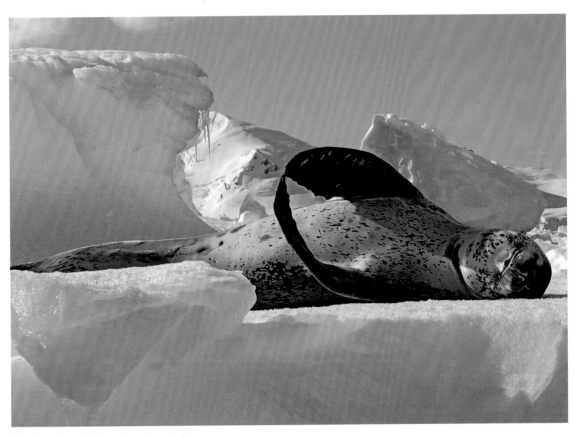

Foca leopardo sobre banquisa, Bahía Paraíso
Leopard seal on pack ice, Paradise Harbor

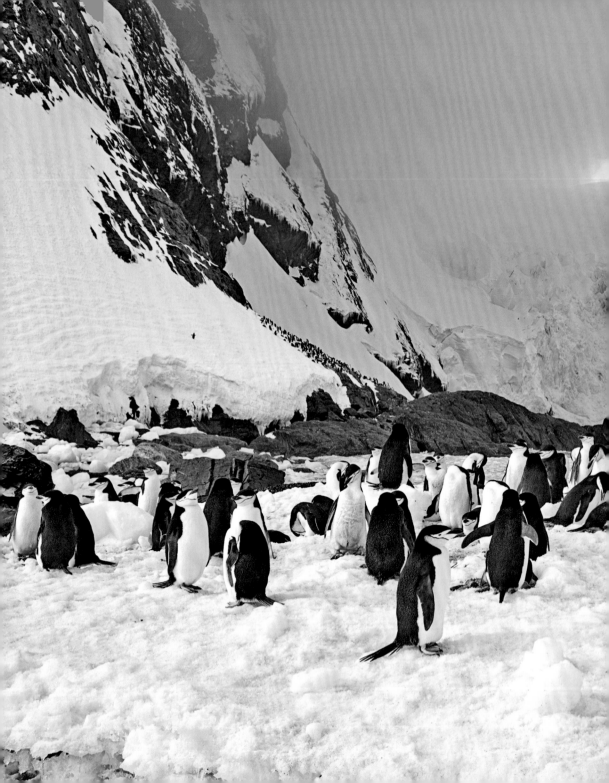

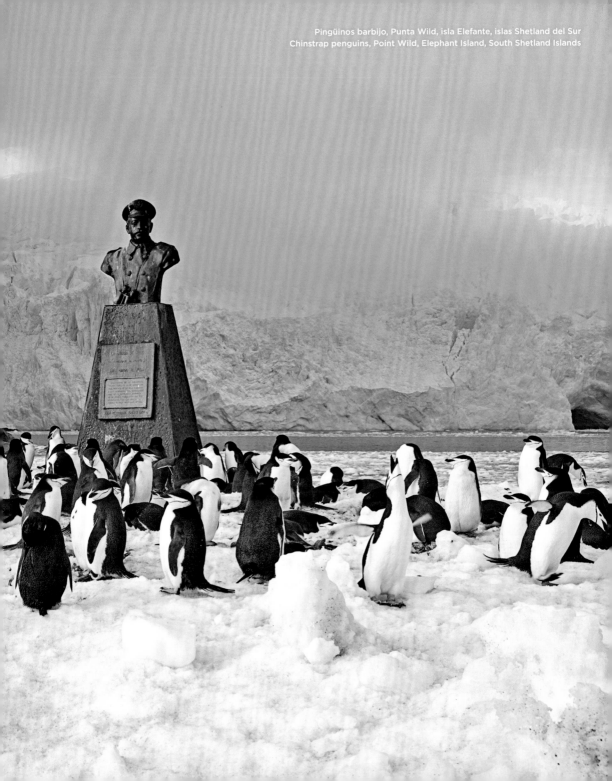

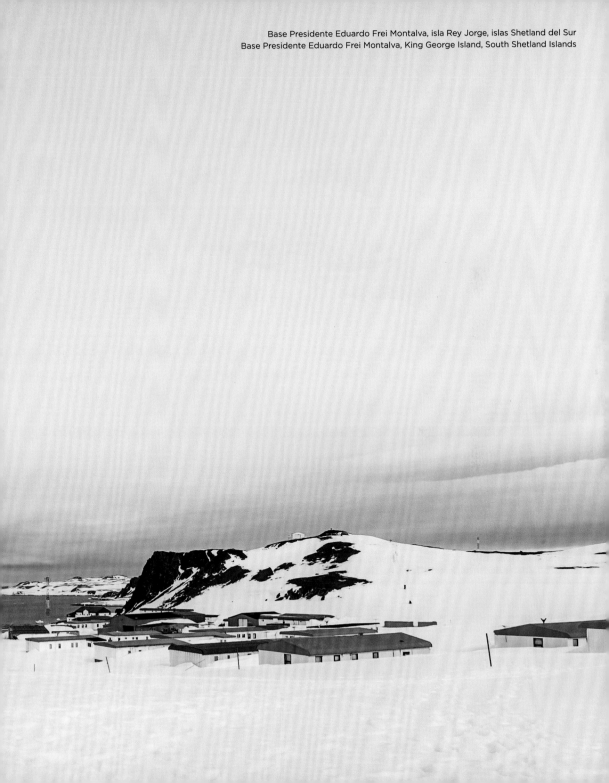

Base Presidente Eduardo Frei Montalva, isla Rey Jorge, islas Shetland del Sur
Base Presidente Eduardo Frei Montalva, King George Island, South Shetland Islands

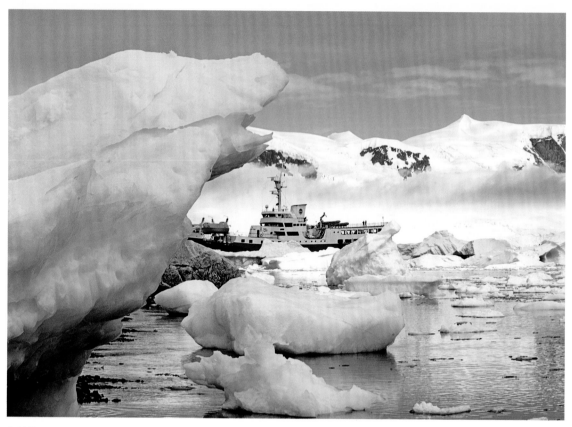

Antártica
Antarctic

South Shetland Islands

North of the Antarctic Peninsula lie the South Shetland Islands. The archipelago consists of eleven larger islands and several smaller islands and is partially strictly protected as a nature preserve. Colonies of donkey and reindeer penguins breed here on ice-free ground.

Îles Shetland du Sud

Les îles Shetland du Sud se situent au nord de la péninsule Antarctique. L'archipel se compose de onze grandes îles et plusieurs petites, et est en partie sous la protection de la nature. Des colonies de manchots papous et à jugulaire nichent sur une surface libre de glace.

Südliche Shetlandinseln

Nördlich der Antarktischen Halbinsel liegen die Südlichen Shetlandinseln. Der Archipel besteht aus elf größeren und mehreren kleineren Inseln und steht teilweise unter strengem Naturschutz. Kolonien von Esels- und Zügelpinguinen brüten hier auf eisfreiem Untergrund.

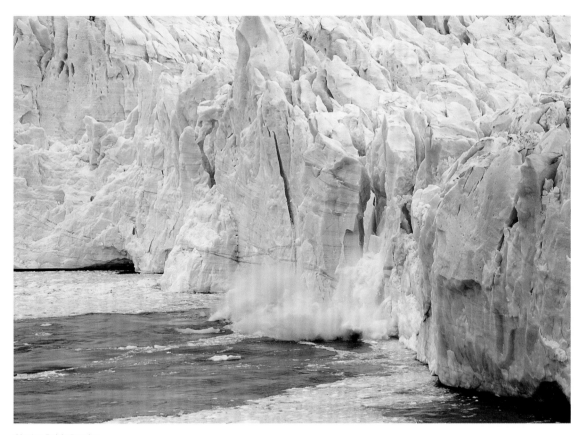

Glaciar, Bahía Paraíso
Glacier, Paradise Harbor

Islas Shetland del Sur
Al norte de la península Antártica se
encuentran las islas Shetland del Sur. El
archipiélago consta de once islas más
grandes y varias islas más pequeñas y
se encuentra parcialmente bajo estricta
protección. Las colonias de pingüinos
papúa y pingüinos barbijo se reproducen
aquí en tierra libre de hielo.

Isole Shetland Meridionali
Le Isole Shetland Meridionali si trovano a
nord della Penisola Antartica. L'arcipelago
è composto da undici isole grandi e altre
isole minori, ed è protetto per gran parte
da rigide regole di tutela ambientale. Su un
terreno libero dai ghiacci crescono colonie
di pinguini Papua e pigoscelidi antartici.

Zuidelijke Shetlandeilanden
Ten noorden van het Antarctisch
Schiereiland liggen de Zuidelijke
Shetlandeilanden, een archipel van elf
grotere en talloze kleinere eilanden waar
deels strenge milieuregels gelden. Kolonies
van ezels- en stormbandpinguïns broeden
hier op de ijsvrije grond.

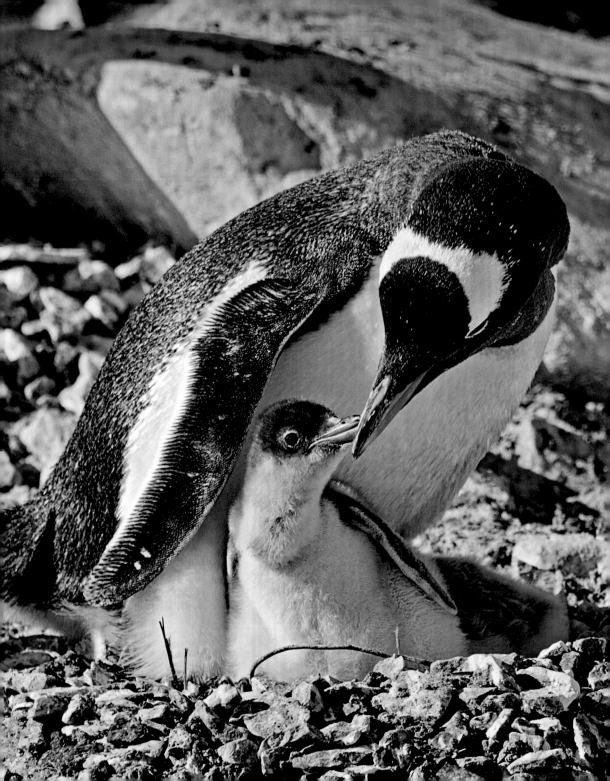

Base Presidente Gabriel González Videla, Bahía Paraíso
González Videla Base, Paradise Harbor

Pingüinos juanito
Gentoo penguins

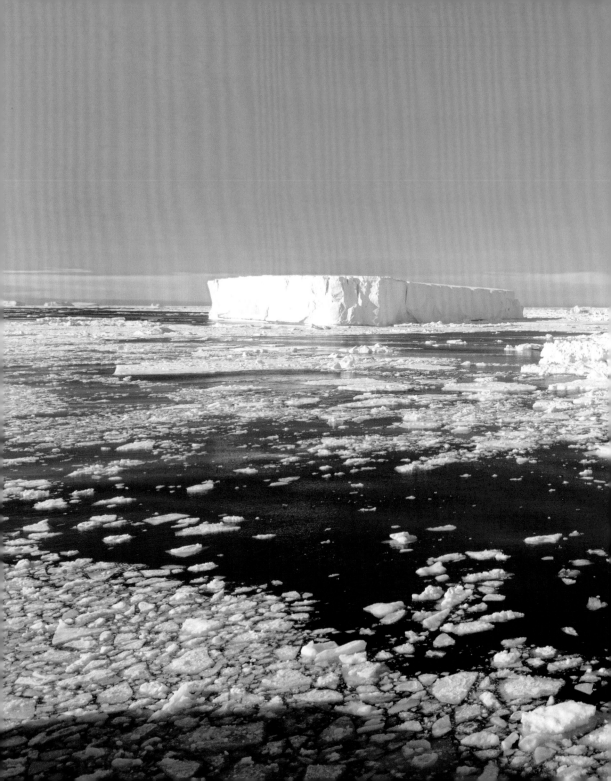

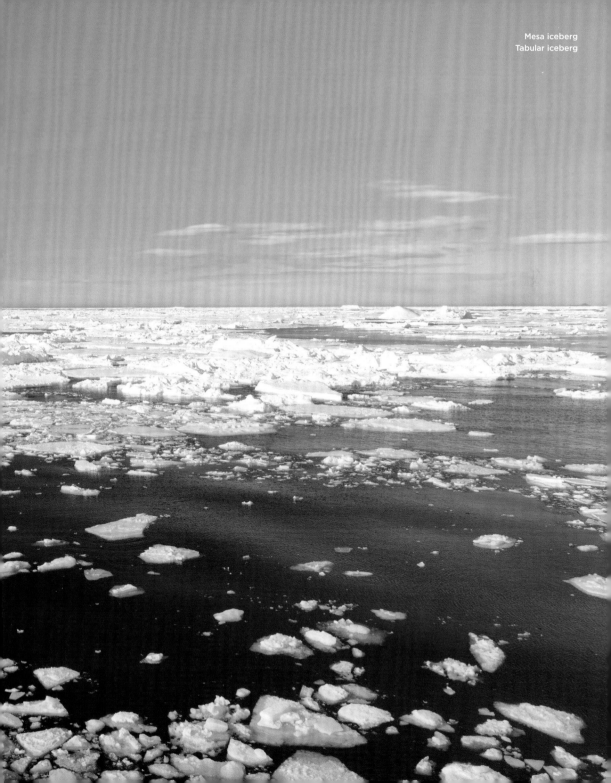

Mesa iceberg
Tabular iceberg

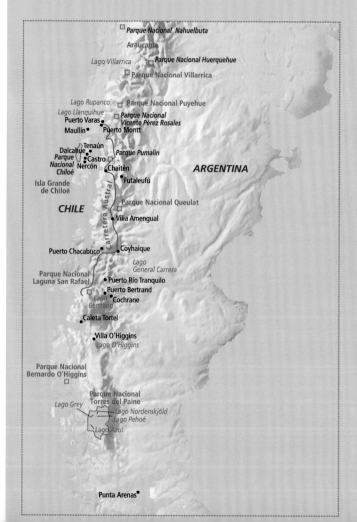

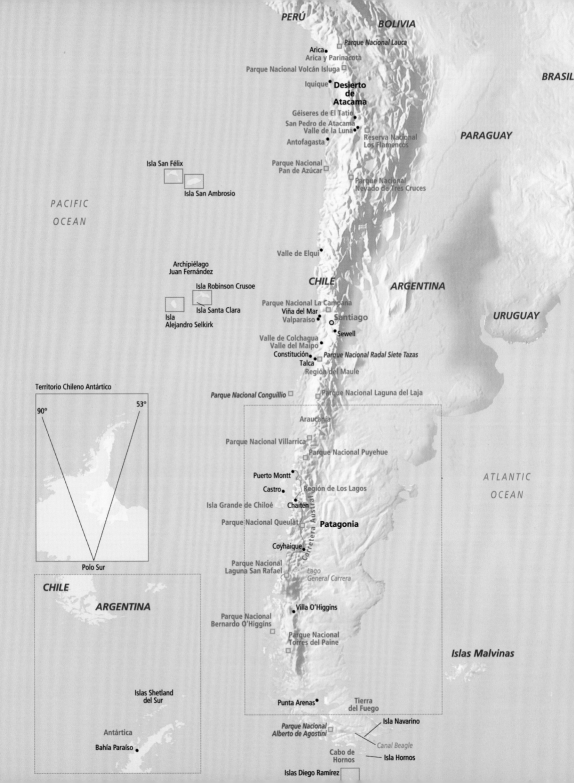

PERÚ

BOLIVIA

Parque Nacional Lauca

Arica
Arica y Parinacota

Parque Nacional Volcán Isluga

BRASIL

Iquique **Desierto
de
Atacama**

Géiseres de El Tatio
San Pedro de Atacama
Valle de la Luna

PARAGUAY

Antofagasta

Reserva Nacional
Los Flamencos

Parque Nacional
Pan de Azúcar

Parque Nacional
Nevado de Tres Cruces

Isla San Félix

PACIFIC

OCEAN

Isla San Ambrosio

Valle de Elqui

Archipiélago
Juan Fernández

CHILE

ARGENTINA

URUGUAY

Isla Robinson Crusoe

Isla Santa Clara

Isla
Alejandro Selkirk

Parque Nacional La Campana
Viña del Mar
Valparaíso

Santiago

Sewell

Valle de Colchagua
Valle del Maipo
Constitución
Talca

Parque Nacional Radal Siete Tazas

Región del Maule

Parque Nacional Conguillío

Parque Nacional Laguna del Laja

Territorio Chileno Antártico

90° 53°

Araucanía

Parque Nacional Villarrica

Parque Nacional Puyehue

ATLANTIC

OCEAN

Puerto Montt

Castro

Región de Los Lagos

Isla Grande de Chiloé

Chaitén

Polo Sur

Parque Nacional Queulat

Patagonia

CHILE

Coyhaique

ARGENTINA

Parque Nacional
Laguna San Rafael

Lago
General Carrera

Villa O'Higgins

Parque Nacional
Bernardo O'Higgins

Parque Nacional
Torres del Paine

Islas Malvinas

Islas Shetland
del Sur

Antártica

Punta Arenas

Tierra
del Fuego

Bahía Paraíso

Parque Nacional
Alberto de Agostini

Isla Navarino

Canal Beagle

Cabo de
Hornos

Isla Hornos

Islas Diego Ramírez

Photo credits

KÖNEMANN

© 2020 koenemann.com GmbH
www.koenemann.com

ÉDITIONS
PLACE DES
VICTOIRES

© Éditions Place des Victoires
6, rue du Mail – 75002 Paris
www.victoires.com
Depôt légal : 1er trimestre 2020
ISBN: 978-2-8099-1794-9

Series Concept: koenemann.com GmbH

Responsible Editing & Picture Editing: Jennifer Wintgens
Text: Marion Trutter, Jennifer Wintgens
Maps: Angelika Solibieda
Front cover: mauritius images/Michele Falzone/Alamy

English, Spanish, Italian & Dutch translations: textcase

Translation into French: Véronique Valentin

Design & Layout: ditter.projektagentur GmbH

Autorizada su circulación por Resolución Nº 31 del 28 de Marzo de 2018
de la Dirección Nacional de Fronteras y Límites del Estado.
La edición y circulación de mapas, cartas geográficas u otros impresos y
documentos que se refieran o relacionen con los límites y fronteras de Chile, no
comprometen, en modo alguno, al Estado de Chile, de acuerdo con el Art. 2º,
letra g) del DFL Nº 83 de 1979 del Ministerio de Relaciones Exteriores.

Printed in China by Shyft Publishing / Hunan Tianwen Xinhua Printing Co., Ltd.

ISBN: 978-3-7419-2534-4